The New Four Winds Guide to
American Indian Artifacts

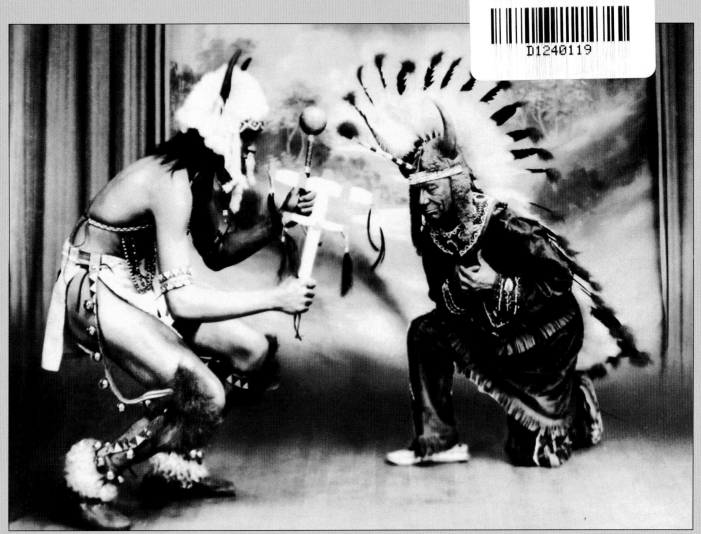

Preston E. Miller
&
Carolyn Corey

Schiffer Publishing Ltd

4880 Lower Valley Road, Atglen, PA 19310 USA

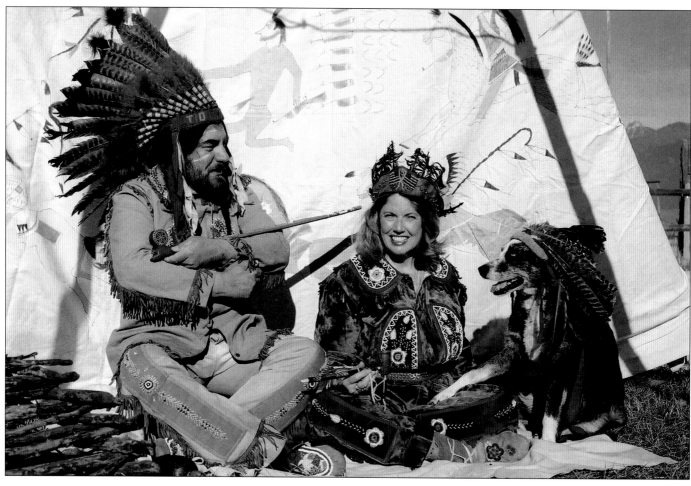

The authors and their dog Brownie wearing Improved Order of Red Men costumes (see pages 174-177).

Front cover: Photo of Baptiste Garnier seated with Red Cloud, c. 1897.

Title page: (clockwise, from top) The Death of Red Dog (see page 190); California baskets (see page 108); Improved Order of Red Men (see pages 147-177).

Copyright © 2006 by Preston E. Miller and Carolyn Corey
Library of Congress Control Number: 2005936712

Designed by Mark David Bowyer
Type set in Geometric 231 Hv BT / Korinna BT

ISBN: 0-7643-2391-1
Printed in China

Published by Schiffer Publishing Ltd.
4880 Lower Valley Road
Atglen, PA 19310
Phone: (610) 593-1777; Fax: (610) 593-2002
E-mail: Info@schifferbooks.com

For the largest selection of fine reference books on this and related subjects, please visit our web site at
www.schifferbooks.com
We are always looking for people to write books on new and related subjects. If you have an idea for a book please contact us at the above address.

This book may be purchased from the publisher.
Include $3.95 for shipping.
Please try your bookstore first.
You may write for a free catalog.

In Europe, Schiffer books are distributed by
Bushwood Books
6 Marksbury Ave.
Kew Gardens
Surrey TW9 4JF England
Phone: 44 (0) 20 8392-8585; Fax: 44 (0) 20 8392-9876
E-mail: info@bushwoodbooks.co.uk
Free postage in the U.K., Europe; air mail at cost.

Contents

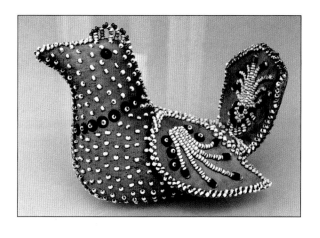

Introduction

How To Use This Book

The American Indian collectibles in this book were sold by Four Winds Indian Auction in St Ignatius, Montana. Included are genuine Indian-made items of both new and old vintage. The full range of items in each category with **descriptions, dates, price estimates, and prices realized** will provide useful information to both sellers and collectors.

The **title** of each item is named using terminology that is most accepted by experienced collectors. This is followed by a **date** approximating the year in which the item was made. Without certified provenance, it is difficult to be completely accurate when assigning dates to Indian material based solely on appearance, so that a date of "c. 1870" assumes that an item could have been made earlier or later.

Information on provenance, when available, is *italicized,* usually following the date.

The **descriptions** contain pertinent construction details, such as a detailed list of bead colors and materials used, as well as the size and condition of the item. All are very important factors in determining the value of an item. For instance, certain bead colors can help verify the age; usually the older a piece, the more it is worth. Also, the use of thread or sinew, brain tan or commercial hide, and whether or not the item is in good sound condition can be very important when assigning values. Many price guides fail to take these things into account when establishing an item's value. It is important to realize that a pair of moccasins with half the beads missing is worth considerably less than a pair with little or no damage. The same applies to torn rugs, damaged baskets, broken pottery, or stone artifacts; often the damaged item can be worth less than half the value of a similar but intact one. Sometimes an item will be so undesirable that you might have difficulty finding a buyer. The exception could be when an item has a provenance or rarity that makes it one-of-a-kind. For instance, a stiff torn moccasin with a positive provenance proving that it was picked up at the Battle of Wounded Knee or a damaged but a very rare early incised buffalo hide parfleche would both continue to fetch high prices.

Finally, we list the price for which each item was sold at our auction, preceded by the estimate range. For example: "Est. 400-800 **SOLD $250(98)**" The dollar amount following the word **SOLD** is the amount for which the item was sold and the numbers in parenthesis indicate the year that it sold. This is an accurate method for assigning values to artifacts. At auction, the highest price realized is determined by the bidders. It means that at least two people had similar ideas as to the value of an item. Also, it can be assumed that because participants in any one auction are limited, there must be other buyers outside the auction realm who will pay as much or more. The **estimate range reflects the current (2006) market value** as determined by our personal opinion guided by many years of experience. (Preston has been selling, buying, and collecting Indian artifacts for over fifty years). Sometimes the range can seem quite broad; for instance, "Est. 400-800" might leave you a little doubtful as to the real value. As the seller, you can always ask $800 and come down, but you can never ask $400 and go up when a customer is ready to buy. This principle works vice versa for the buyer. If you can buy or sell an item within our suggested estimate range, you can feel secure that your transaction was financially acceptable. **There are so many variables to every situation that it would be impossible to assign one price value to each artifact.**

It is important to note that if an item sold for a certain amount in 1988, it should have appreciated with time. Since there is no scale that can be assigned to evaluate the appreciation that accrued with time, you will have to use your personal judgment. Because some items appreciate slowly, some not at all, and some can even depreciate, this can only be determined by knowledge of the current trends in the marketplace.

Any omissions are due to information that was not available or could not be verified. For example, we have included some noteworthy items that did not sell at auction for which our estimates serve as a value guide.

Reasons for Collecting

Beginning in the 1970s, the collecting of Indian artifacts reached new levels of popularity, perhaps encouraged by the fact that several major antique and art auction houses began selling collections of old Indian-made items to high paying buyers. Prior to these auctions, Indian-made relics seemed to be viewed as merely craftwork having little or no art value. Because of the new demand, many old and heretofore unknown treasures were gradually unearthed from old family trunks, attics, and museum storage areas to be placed into the collectors' market. Today, there are more people collecting Indian artifacts and the number continues to grow. The reasons for collecting include investment potential, historical value, art and craft appreciation, home and business decoration, and personal adornment.

Investment Potential

Many collectors make an expenditure with the hope that their acquisitions will someday be worth more money. It is common to meet collectors who purchased a rug, basket, or beadwork item twenty or thirty years ago and report just having sold it for five or ten times their original purchase cost. Usually, it seems the best quality and most rare artifacts sell for increasingly higher prices. Mediocre and poor quality items can reach a peak and even go down in value. Education and reliable advice are the best deterrents against making a poor investment.

Historical Value

Quality and rarity alone do not always determine the price of an item. Unlike coins, stamps, and guns, Indian relics are most always one of a kind. No two pieces are exactly alike and some collectors will pay exorbitant prices to have the one they want. Perhaps they have a photo of great-grandfather and some famous Indian holding an item. This creates a sentimental attachment for which only they can determine the value. For others, it might be that in all their years of collecting they have never seen another like this one for sale. After all, if a collector has the cash and knows only one example exists and he must have it, only he knows what he will be willing to pay. But remember, this kind of demand cannot be predicted in a price guide. For example, the price realized for a war shirt worn by the famous Sioux chief Sitting Bull in an old photo does not determine the value of all similar war shirts.

Art and Craft Appreciation

Some collectors will make a purchase because they appreciate the amount of work that went into the making of a basket, stone axe, or beautifully beaded pair of moccasins. Not every one will see each item the same way. Past experience and especially whether or not you have tried the work yourself will enhance your appreciation of the finished product. If you have ever tried sewing beads with sinew, or gathered materials and woven a basket, you will most certainly have developed an expanded appreciation of the skills required to make these items. Combine this with the cultural insights and artistic abilities required and you will develop an entirely new realization of an item's value.

Home and Business Decorating

Nothing matches the beauty of Indian baskets, Navajo rugs, old beadwork, etc. tastefully displayed in a beautiful log home with a stone fireplace. Multiply this to include adobe haciendas, historical and modern houses, offices, restaurants, etc. and you can soon see the value Indian artifacts have to architects and interior decorators. The value can only be determined by the need, space, and finances available. And while you are enjoying the enrichment to your surroundings, the investment potential is probably going up.

Personal Adornment

Many collectors have experienced the fun of wearing a beautiful piece of southwest silver jewelry, a beaded or quilled buckskin jacket, or perhaps decorating their favorite Appaloosa with Indian horse gear. Re-enactors, buck skinners, movie personalities, cowboys, Indians, and others are among the increasing numbers of people who wear and use their collectibles. It is among these people that the collecting of replica artifacts has become understood and popular.

The visual beauty and construction of a Sioux fully beaded vest or an expertly painted Crow rawhide parfleche will provide many years of wonderful appreciation to its owner. One will never tire of looking at it and anticipating new discoveries about its design, construction, and history. For most collectors, this is the real reason for collecting. The pleasures experienced from collecting are many and varied. Each person will develop his or her own unique and interesting reasons.

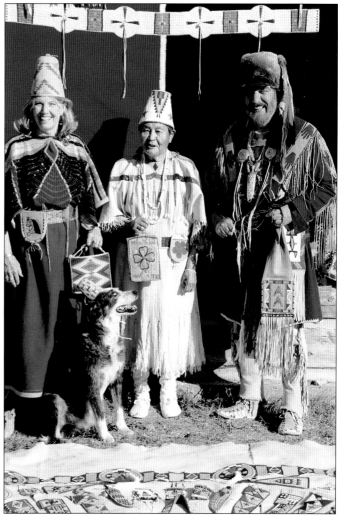

The authors pose with Cecile Lumpry, a Salish bead worker who has made the beadwork shown in this photo over the years for Four Winds. The floral beaded flat bag in Cecile's hand was made by her mother, who was from the Coeur d'Alene Res. Carolyn is wearing an old basket hat and the old Yakima dress shown on page 24. Cecile wears a beaded hat that she made and an old dress that belonged to Ellen Big Sam, a Salish woman. Preston made his "Chief's Coat" and Cecile made the beaded strips for it.

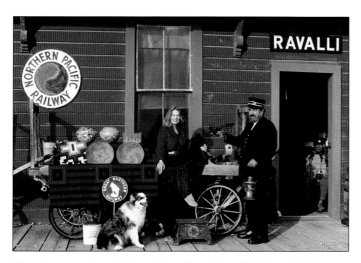

The authors are shown in front of the office of the c.1885 Ravalli Train Depot. This building was re-located to Four Winds as part of the historic village. Carolyn perches on a baggage cart that was part of the Gen. Dodge Collection from Council Bluffs, Iowa, 1905. The Navajo blanket described on page 123 as well as pots and baskets from the author's collection are also on the cart. Preston wears a Northern Pacific conductor's uniform.

Bead Glossary

Terms and abbreviations used in descriptions of GLASS BEADS in this book:

Bead Sizes
(refer to color bead chart)

"Seed" beads are the smallest beads, varying from Czech 10° (largest) to 22°. Czech 12°-13° and Italian 4° (see bead chart) were the most commonly found sizes on pre-20th century pieces.

"Pony" bead, more correctly called a "pound" bead, is a large seed bead (Czech size 5° or "I"—see largest beads on the bead chart—to Czech 9°) that usually pre-dates the use of smaller seed beads on Plains and Plateau items.

"Crow" bead is larger still and has large hole for stringing on necklaces or thong decorations on objects and clothing, etc. "Old-style" size approximately 7mm. to 9mm.

Bead Styles

"Basket" beads are cylinders cut from longer tubes manufactured since the mid-1800s (not currently being made to our knowledge). Very versatile use in sewing and stringing. Usually transparent, "lined" (with interior color), or **satin**, a gleaming satin-like finish.

"Bugle" beads are thin tubular beads.

"Cuts" or cut beads are single-faceted beads resulting in a sparkling effect. The best are still being made in Czechoslovakia in transparent, opaque, pearl (**lustre**), and **iris** (multicolor metallic). 19th century pieces frequently have "Czech" cuts in **t.** (transparent), **gr.** (greasy) and in even smaller sizes (even 20° and less!)

"Tile" bead is an opaque molded cylinder bead with straight sides. Primarily used strung in loop necklaces and thong decorations as early as the mid-19th century.

"Tri-cuts" are 3-cut faceted beads, larger than a **cut** (see above) and often used on Indian items made after the turn of the 20th century to the present. Usually pearl (**lustre**), **iris** (multicolor metallic), or **lined** (see below), also transparent and opaque.

Bead Colors

*No adjective with the bead color refers to an **opaque** or a solid color bead; i.e., red bead.*

"C. pink" or Chey. pink is the abbreviation for Crow or Cheyenne pink. Both refer to the same old-time bead color—a dusty muted pink, popularly used by those tribes in the 19th century and earlier.

"gr." or "greasy" refers to translucent (**transl.**) or cloudy (semi-transparent). Many old beads were made this way, and many are now being re-made in Europe today. Gives an old piece (or modern reproduction) a richly varying beadwork texture.

Opalescent (**opal.**) is a varying iridescent color, like an opal.

"Pony trader blue" or Trader blue is a rich "greasy" medium blue, in many color variations (darker than greasy blue and lighter than cobalt). This color was popular on the Plains in the early 19th century in a "pony" bead size along with white, black, and rose w. heart. Also **"Bodmer blue,"** an intense greasy blue named for Karl Bodmer, 1830s painter of Plains Indian subjects.

t. or **trans.** is the abbreviation for transparent or clear.

w. (white) lined (**w. heart** or **w. center**) all mean the same thing and refer to the color (in this case white) of the interior of a bead. Outer color is usually red, sometimes brick, pink, orange, green, yellow, or bright blue in modern reproductions. Can be any size of bead. A very old style of seed bead was a highly desirable rose or rose-red.

Beadwork Styles

Flat or appliqué. Used to cover large areas with solid beading; sewn straight or in curved rows. Overall appears flat and used by many tribes, i.e., Blackfeet, Plateau, and Cree.

Lane-stitch (previously called "lazy-stitch"). Multiple beads (5-12) strung and sewn down to create humped or raised rows; often used to cover large areas. Principally used by the Sioux, Cheyenne, Arapaho, and Ute; a modification used by the Crow.

Embossed or raised. Beads sewn in a crowded arched stitch for a 3-D effect, as found on Iroquois and other Eastern tribes beadwork.

Peyote or gourd. A netting technique usually used to cover solid objects, i.e., fan handles, key chains, ballpoint pens, etc. Common on contemporary Indian beadwork items.

For further information on tribal styles and how-to techniques see:

Miller, Preston. *Four Winds Indian Beadwork Book*. St. Ignatius, Montana, 1971.

Dean, David. *Beading in the Native American Tradition*. Loveland, Colorado: Interweave Press, 2002.

Whiteford, Andrew H. *North American Indian Arts*. New York: Golden Press, 1970. Concise visual and factual guide to quick identification of material culture objects.

GENERAL CARD "W"

SIZES						STRIPED BEADS	
14/0		3		732			
5/0		Snow white (4)		616			
13/0		28		18 1/2			
4/0		823		507			
12/0		824		18			
3/0		828		102			
11/0		828 1/2		63			
2 0		11		64			
10,0		13		735			
0		801		103			
9/0		806		27 1/2			
c		807		27			
8/0		807 1/2		20			
7/0		808		20 N			
d		812 1/2		31			
e		813		30 1/2			
f		810		30			
g		811		464			
h		803		448			
i		805		49			
l		38		695			
COLOURS		6		Black (40)			
Cristalux		7		STRIPED BEADS			
Cristalux extra		678		CSS 1 R			
2		523		6599			
41		22		6697			
				6721			
				CSS 2			
				6631			
				205			
				6687			
				6657			
				06671			
				06679			
				06686			

SLIGHT DEVIATIONS FROM COLOURS AND SIZES TO BE TOLERATED

Card #1, Edition 1962 from Societa Veneziana Conterie, Italy in 1970. This card displays both Italian sizes (0° to 5°) and Czech. sizes (7° to 14°). Notice that bead colors are identified by numbers. 19th century bead cards also use numbers for identification of colors. Notice the many shades of blue, green, and red. #28 is greasy yellow; #810 and #811 are white lined reds.

Abbreviations and Definitions

Definitions of materials used for artifacts:

HIDES: "**Brain-tanned**" or "**Indian-tanned**" buckskin refers to the original hand-worked and organic process of rendering a hide white, soft, supple, porous, and easy to pierce with a needle for beadwork. *The saying goes that each deer has enough brains to tan his own hide!* Considerable time and effort are expended in scraping and stretching by hand. Smoking darkens and waterproofs it.

"**Commercial (comm.) hide tanning**" is a modern mechanical and chemical process that doesn't break down the grain (in comparison to brain-tanning,), so that the hide is not porous, as supple, or easily pierced with a needle; also, it has a chemical odor. Usually has a smooth and rough side. The color is usually not a tan or light brown like a smoked hide, but more of a gold tone. Costs much less than a brain-tan hide.

TRADE WOOL: "**White Selvedge**" Trade Wool or "**Undyed Selvedge**" or "**SAVED* LIST.**" Wool of this terminology is usually navy (indigo) or red; it is distinguished by the white (undyed) selvedge (edge or LIST) that made it the most popular and widely distributed trade cloth to North American Indians as early as 1700.

"**Rainbow**" **Selvedge Trade Wool** has a woven multi-colored edge also called "fancy" list in the early fur trade journals.** It was especially popular on the Southern Plains and later, after "saved list" was no longer available, it was widely distributed in the North in the 20th century.

Saving is the hand-done process of leaving the selvedge white. The term "saved list" was used in early fur trade ledgers, and is the most accurate description.

*Corey, Carolyn. *The Tradecloth Handbook*. St. Ignatius, MT, 2001. Details the saving process and history of trade cloth; "rainbow," "stroud," and "saved list."

**Corey, Carolyn. "Coveted Stripes," in *The People of the Buffalo, Vol. 2*. Wyk, Germany: Tatanka Press, 2005: 131-146.

Special tribal designations and terms used in this book:

Intermontane refers to a geometric decorative beadwork style shared by Plateau, Crow, and some Basin tribes (spanning a large geographic area).

See Conn, Richard. *A Persistent Vision*. Seattle: University of Washington, 1986: 128-131.

Blackfoot or Blackfeet. In modern times, Indians of the Blackfoot Confederacy refer to themselves as **Blackfoot** from Canada; and **Blackfeet** from the United States. We use this designation in the book.

See Hungry Wolf, Adolph & Beverly. *Indian Tribes of the Northern Rockies*. Summertown: Good Medicine Books, 1989: 2-4.

Abbreviations used in this book, listed alphabetically *(see also bead definitions for bead color abbreviations):*

alt. = alternating
apx. = approximately
avg. = average
betw. = between
bkgrd. = background
blk. = black
c. = circa
char. = characteristic
comm. = commercial
cond. = condition
Czech. = Czechoslovakia
D. = deep (depth)
diam. = diameter
diff. = different
dk. = dark
ea. = each
ex. = example
exc. = excellent
excl. = excluding
Fdn. = Foundation
H. = high (height)
incl. = including
Is. = Island (place name)
L. = long (length)
lt. = light
mocs = moccasins
nat. = natural
No. or N. = North
nr. = near
opal. = opalescent
pred. = predominantly
pr. = pair
prob. = probably
prov. = provenance
pt. = point
R. = River (place name)
Res. = Indian Reservation or Reserve (Canada)
So. or S. = South
transl. = translucent
turq. = turquoise
VG = very good
w. = white
W. = wide (width)
yrs. = years

1. Clothing and Accessories

Men's Clothing and Accessories

War Shirts, Leggings, and Pants

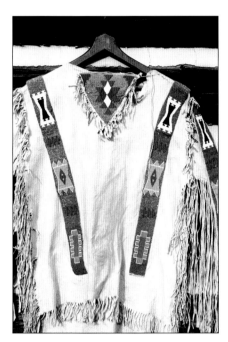

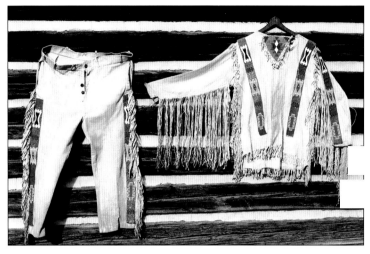

YAKIMA WARSHIRT and MATCHING BUCKSKIN PANTS c.1930?
Indian-tanned buckskin with appliqué beaded strips (2"W) on sleeves, shirt front, pants, and front bib. Blue tri-cut bkgrd. with old-time traditional designs in opaque beads: mustard, black, white, red, cobalt, and Sioux green motifs. Beautiful buckskin narrow fringes on sleeves (16"-18"L). Old-time side open shirt ties with buckskin thongs. Fringed on hem, pants side seam. Shirt: 46" underarms, 28"L. Pants are nicely tailored; front inside button placket, loops for belt. 45" waist. 40"L. Exc. cond. Shows age. Est. 2750-5000

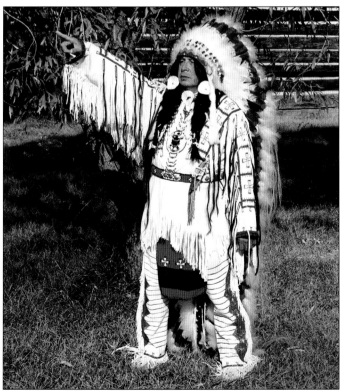

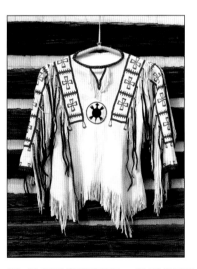

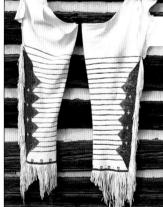

NO. PLAINS WARSHIRT and LEGGINGS
Soft white comm. hide (looks like brain-tan) has partially-beaded panels in Maltese cross motif: tri-cut white outlined in gunmetal and t. green. Border is cobalt and t. red. Center front rosette has black turtle motif with red border. Hair locks protrude from c.1900 brass shell casings (front and back). Red blanketing bound neck opening. Long fringes on sleeve (front and back) are 12"L + sleeve seam fringe 4"L. Shirt hem also fringed. New cond. 54" underarms, 36"L including fringe. Leggings are white buckskin with matching color beads same as shirt. Painted black stripes. 12"W at top, 8.5" bottom x 37"L + 6"L bottom fringe. Side fringe 4"L. New cond. Est. for set 850-1500 **SOLD $2250(99)**
NOTE: See headdress description on p. 22.

Jerry (Pinto) McClure is seen here wearing entire outfit. He is Salish-Pend O'reille from the Flathead Reservation and is Chief Charlo's great-grandson.

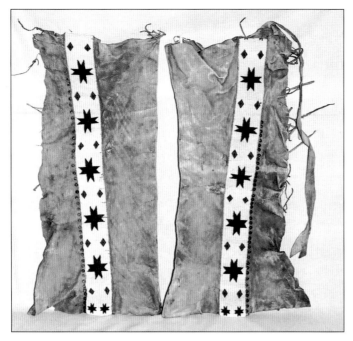

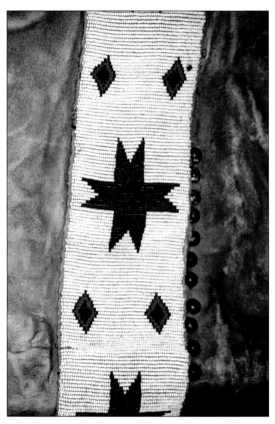

NO. PLAINS BEADED BUCKSKIN LEGGINGS c.1890
Prob. Blackfeet. White background appliqué beaded 8-pointed star and diamond motifs in t. dk. cobalt, faceted brass and unusual faceted green gilt metallic with gr. red sewn on canvas. Just a few white beads missing here and there. Dk. patinated buckskin is stiff, will soften with hand rubbing. Back has faint remnants of green paint. Brass spots along strips have heavy patina. Metallic beads need cleaning with brush to remove surface oxidation. This restoration job requires no new materials, just cleaning to restore to original condition. Good overall cond. Strips 3" x 32". Leggings 32" x 15"W at bottom. Est. 300-650 **SOLD $550(04)**

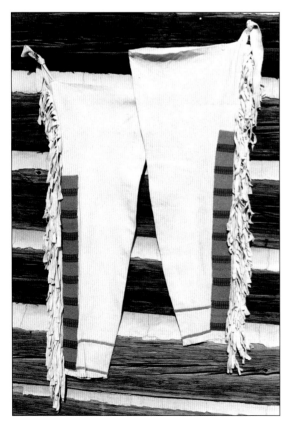

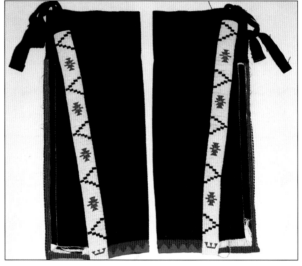

PLATEAU BOY'S NAVY STROUD LEGGINGS WITH BEADED STRIPS c.1890
Heavy indigo dyed wool trade cloth has triple indigo striped "saved list"* with red silk binding. White silk border mostly disintegrated. Interesting green wool triangular cut hem binding over red silk ribbon. Appliqué-beaded strips (1.75"W) are lt. blue with Chey. pink and black step triangles interspersed with rose w. heart and apple green abstract motifs. 26"L x 10"W. Exc. cond. Est. 750-1500 **SOLD $800(04)**

 *19th century Hudson's Bay "Stroud" is character-ized as cloth with a triple stripe selvedge (whether "saved"—undyed—or dyed a solid color). See Corey C., *The Tradecloth Handbook*, 2001.

PLATEAU BEADED BUCKSKIN MAN'S LEGGINGS c.1930?
From Warm Springs Res., Oregon. Soft and supple buckskin. Beaded strips are gr. blue, t. red and cobalt. Periwinkle horizontal stripes at bottom. 33"L. Side fringes 5"L. Exc. cond. Good wearable piece. Est. 310-600 **SOLD $335(98)**

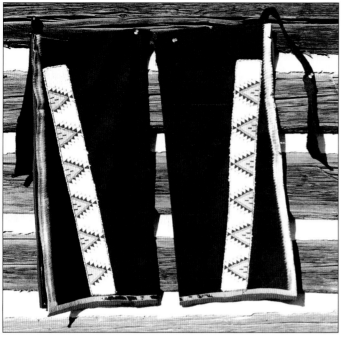

NEZ PERCE TRADE WOOL LEGGINGS c.1890
Bead strips are white lane-stitched with beautiful chevron patterns in gr. yellow, cobalt, periwinkle, t. red, and apple green-remnants of red silk binding. Indigo saved list wool has red and yellow silk ribbon binding on hem and back edges; bottom edges only, frayed from wear. 13"W x 29.5"H. Est. 900-1500 **SOLD $850(99)**

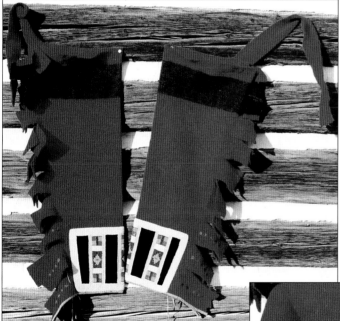

PLATEAU BLANKET PANEL LEGGINGS c.1910
Red wool blanket with wide black stripe. Green wool felt panels have beautiful abstract floral motifs in many colorful hues of cut , tri-cut and old seed bead colors diff. each side. Border and buffalo pound abstract symbol are lane-stitched lt. blue seed beads. Buckskin thong fringes. Bound with blue-grey ribbon bordered and edge-beaded in tiny gr. yellow seed beads. A few edge-beads missing on one legging. Exc. cond. 13" x 36"H. Est. 750-1200 **SOLD $800(05)**

NEZ PERCE MAN'S BLANKET LEGGINGS c.1900
Red blanket with black stripe, wide side fringes woven with green wool strips for decoration. Panels have 1" wide lt. blue beaded borders all around with cut beads in beautiful geometric appliqué in gr. red, lt. blue apple green, gr. yellow, and cobalt with black velvet insets bordered in white beads. Sinew and thread sewn. A gorgeous parade item. 30"L x 12.5"W bottom x 14" top W. Panels are 8"L x 15"W. Blanket ties are 27"L x 2"W. Exc. cond. Est. 940-1250 **SOLD $950(01)**

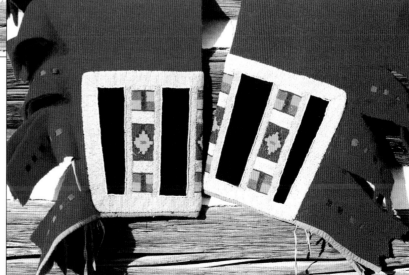

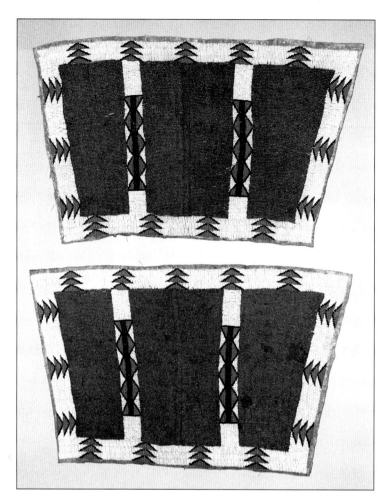

CANADIAN (STONEY?) FULLY-BEADED MEN'S LEGGING PANELS
c.1890
Great colors: solid gr. blue interior panels (appliqué stitch). Outlined with three lanes of white bkgrd. and gr. pumpkin triangles outlined in cobalt. Buckskin and thread shows age. All beads are intact. 18"W x 11"H. Exc. cond and patina. Est. 1250-2000
SOLD $1350(03)

Vests

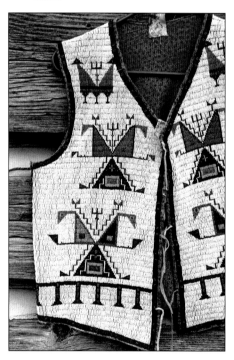

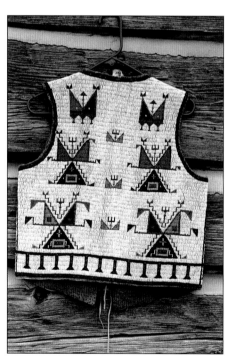

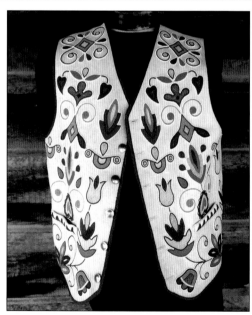

SIOUX FULLY-BEADED VEST c.1890
Purchased in Great Falls, Montana. Hayes Otoupalik Collection. Collected on the Blackfeet Res. in Montana. Characteristic Sioux geometric designs on white lane-stitched and sinew-sewn. Use of pastel color and delicate intricate designs suggest a Fort Peck Reservation, MT. provenance. Asymmetric use of colors: Apple green, periwinkle, rose w. heart, metallic brass cuts, t. dk. cobalt. Interesting 2-color red calico lining. Est. $9000-14,000

See *Four Winds Guide to Indian Artifacts*, pp. 82, 106 and 89, for three documented examples of this style of beadwork.

HIGH PLAINS METIS PARTIALLY-BEADED VEST
Contemp.
Made by Metis bead worker Gary Johnson. Note the similarity in abstract floral style to the old vest pictured on opposite page. Gary states that when verifying Metis tribal styles, if the floral beaded item was made before 1880, it is more likely to be Metis than Sioux or Cree, etc. He believes that the Santee Sioux floral style was probably a result of the influence of Metis beadwork, rather than vice-versa. Also see his Metis frock coat illustrated in *Four Winds Guide to Trade Goods*, p. 192.
Gary Johnson, personal communication, 5/05.

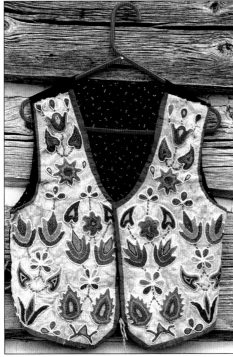

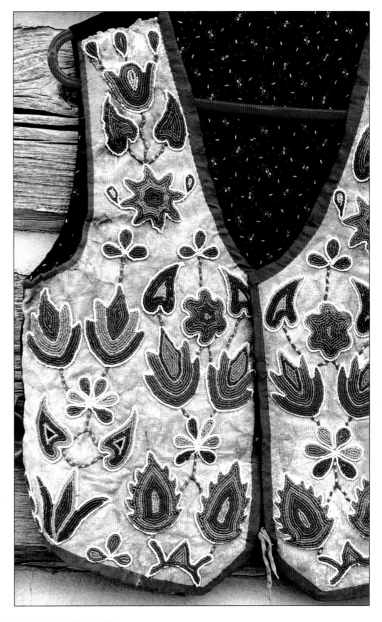

HIGH PLAINS METIS* PARTIALLY-BEADED VEST c.1870-90
*Collected in the 1930s from the trading post at Busbee, Montana,
Cheyenne Res. Hayes Otoupalik Collection.* Characteristic profuse abstract
floral beadwork on light-colored hide. Beautiful array of bead colors; each
motif outlined in single line of white. Blue cloth binding. Black tailored wool
back. Black and white calico lining. Est. $5000-10,000
According to Gary Johnson, the non-tailored style of this vest suggests
that it was made for an Indian. It was probably made in the same region, but
not necessarily by the same person, as the one worn by Garnier in the
photos shown next. *Personal communication, 5/05.*

*This is a regional style that was developed mainly by the Sioux,
Cheyenne, Ute, or Shoshone Indian (or mixed blood) wives of French
Canadian scouts and trappers who were from the St. Louis/Lower Missouri
River who settled on the high plains of America. This style is in contrast to
the more realistic floral style of the Cree and Ojibway Metis people of
Canada. Because of their profuse use of floral designs, the Metis people
were known to the Sioux as the "Flower Bead Work People."
See Barwell, Dorion and Prefontaine. *Metis Legacy.* Saskatoon,
Canada: Gabriel Dumont Inst. 2001: 184.
Also see *Expressing Our Heritage,* Saskatoon, Canada: Gabriel
Dumont Inst., 2002, 85-89,199 for discussion of the three groups of Metis
beadwork that make up the "High Plains" classification: 1) Lower Missouri
River; 2) Red River area Metis; 3) Great Lakes Chippewa-Metis.

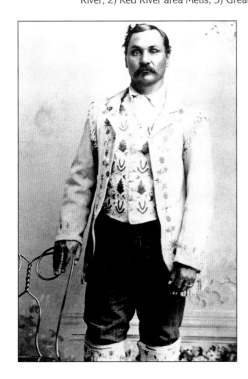

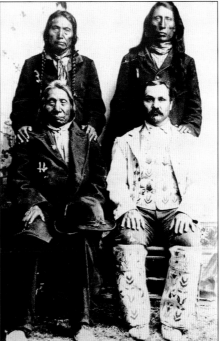

Baptiste Garnier, also known as "Little Bat," a
famous Metis scout and interpreter for the U. S.
Army at Fort Laramie and Fort Robinson, is
pictured here with Red Cloud wearing a similar
vest c. 1888. His father was French, his mother
Sioux. The vest could have been made by his wife
Julia or his sister Eulalia, who were well known
for their beadwork. According to the census of
1896, Julia was enrolled at Pine Ridge. Julia's
father, Louis Mousseau, was a French-Canadian
trapper who also had a trading post at Wounded
Knee. Her mother was Sioux.
Cook, James L. *Fifty Years on the Old
Frontier.* Norman, University of Oklahoma Press,
1957: 71. Photo of Baptiste Garnier.
Bureau of Ethnology and Custer National
Battlefield Monument, c. 1897: Photo of Baptiste
Garnier seated with Red Cloud. Also shown in
Gilbert, Hila."*Big Bat" Pourier.* Sheridan, WY:
Mills Co., 1968: 70.

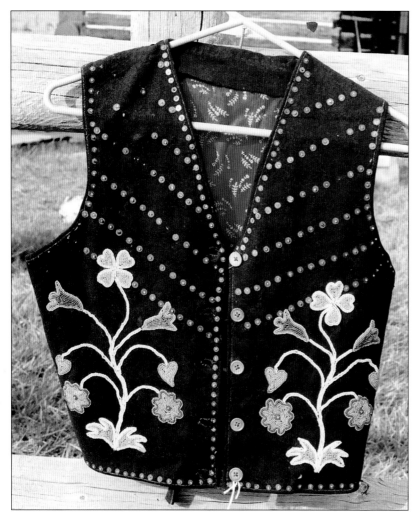

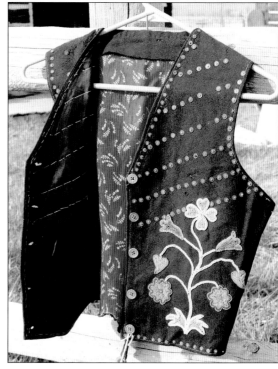

PLATEAU PARTIALLY-BEADED WOOL VEST c.1880-90
This is the type often seen in old photos but seldom found today. Diagonal brass-sequin stripes and borders on fine indigo wool vest with black cotton back and buckle strap. Beautiful abstract floral beaded (tiny 13-15) in gorgeous pastels: pale blue stems with apple green, Sioux green and t. forest green, also t. pink, Crow pink, periwinkle and cobalt. Very delicate. Bone? buttons. Back lining (looks like madder?-dyed) rich red-orange cotton with white floral motifs. 20"L. A few sequins missing; easy replacement job. Great patina of age. Est. 750-1300 **SOLD $800(05)**

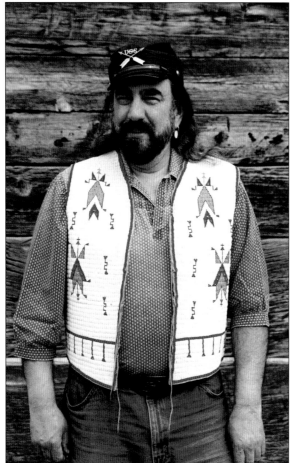

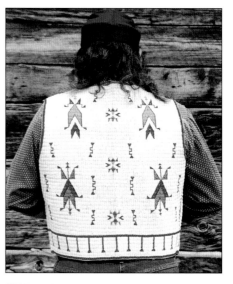

SIOUX FULLY-BEADED MAN'S VEST
c.1900-1915.
Unusually large size. *Purchased from a Sioux family from So. Dakota; was packed away in a trunk for many years.* Lane-stitched and sinew-sewn. White bkgrd. in char. geometric patterns in red w. heart, apple green, cobalt, and brass metallic cuts. Borders and outlined all in red w. heart. Heavy brain-tan deer. Thong ties. Exc. cond. 22"L x 48" chest. Est. 2500-5500 **SOLD $3000(99)**

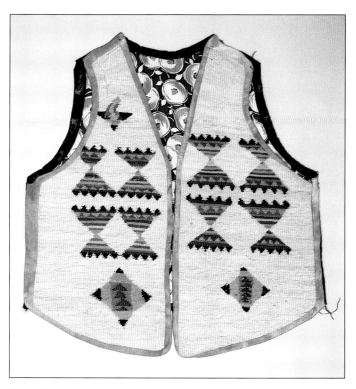

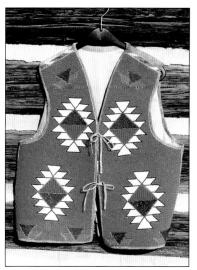

NEZ PERCE CORN HUSK VEST c.1900?
RARE. Appears to have been made as a vest (not a re-make from a bag). Very fine weave. Complex hourglass shaped triangular motifs are unfaded dk. red, gold, lt. yellow, green, lt. blue and black. Lower squares are pink, lt. blue, dk. red with black tips. Front buckskin bound. Back is brown striped rayon. Lined with campy blue stylized apple calico. 35" chest . 19"L. Exc. cond. Est. 575-1500 **SOLD** $925(04)

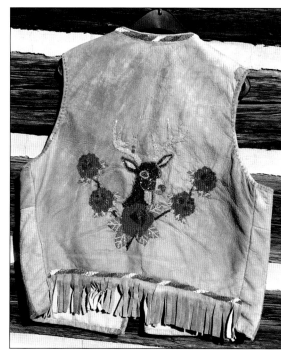

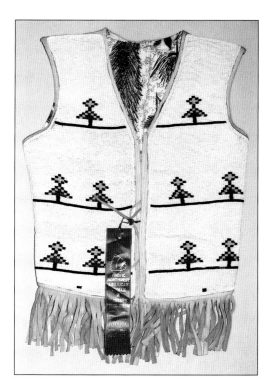

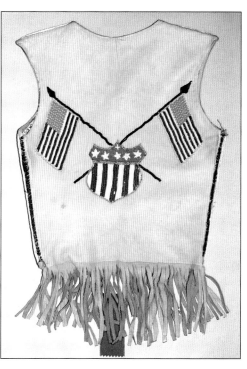

BLACKFEET FULLY-BEADED VEST c.1970
Beautiful classic old-style step-triangle patterns on white appliquéd background; t. bottle green, t. rose, Crow pink, and black. Back is comm. leather (color of nat. tan) with dramatic patriot symbols: crossed flag and patriotic crest motifs in t. red bugles, white, lt. blue and periwinkle with t. yellow. Black iris tri-cut flag masts. Lower leather fringes are 4" front; 6" back. Large print calico lining. *Includes blue ribbon 1st prize won in July 1971 at the Pacific Northwest American Indian Show.* Exc. cond. Shows no wear. Fits chest size 36" x 20"L + fringes. Est. 875-1500 **SOLD** $925(04)

Accessories: Breastplates, Collars, Armbands, Breechclouts, Etc.

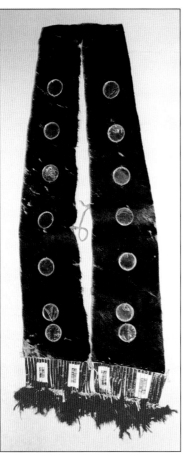

SIOUX QUILLED HORSE-HAIR BREASTPLATE c.1890
Red quill wrapped slats have early concentric box motifs in white and purple. Horsehair body has seven (1.5") old-time mirrors hanging on either side. Red feather fluffs dangle from the ends of tin cones at bottom. Rare good cond. 35" total L. x 6.5"W. Est. 500-800
SOLD $700(99)

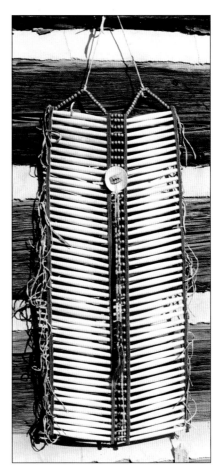

PLAINS BONE HAIRPIPE BREASTPLATE c.1930.
88 (4") pipes separated with heavy harness leather strips and brass beads. Pink conch shell ornament has rhinestone pin at center with early multi-colored tile bead drops with red horsehair and tin cones. (13"L) All strung on buckskin. Nice age patina. Exc. cond. 9.5"W. Hangs 23"L. Est. 800-1200

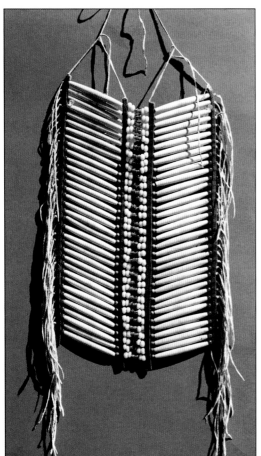

PLATEAU MAN'S BREASTPLATE c.1920
The 3.5" old hairpipes are actually celluloid (look like bone) with a great patina from age! (No longer manufactured after 1930s). Re-strung with old materials so that it is now wearable. Vertical harness leather spacers strung with buckskin thongs have brass beads and red w. heart Crow beads. Central panel strung with early wire-wound Crow beads in lt. blue and t. gold. 15"L x 10.25"W. Buckskin fringes are apx. 9"L. Est. 300-900

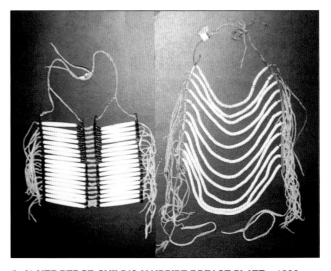

(Left) **NEZ PERCE CHILD'S HAIRPIPE BREAST PLATE** c.1890
Rare t. rose-red, lt. blue, and gr. yellow wampum? beads in center. Bone hair pipes are 3" and 3.5" and have a smooth polish patina. Fringe is 6.5"L. 7.75"L x 9"W. Exc. cond. Est. 500-800 **SOLD $500(99)**
(Right) **NEZ PERCE WAMPUM LOOP NECKLACE** c.1890
Shell wampum discs are 1/4" diam. 14" twisted buckskin side fringes. Harness leather supports have a nice sheen. Loops graduated 10"-14". Exc. patina and cond. 10"L. This is the real thing! Est.1000-1500 **SOLD $1100(99)**

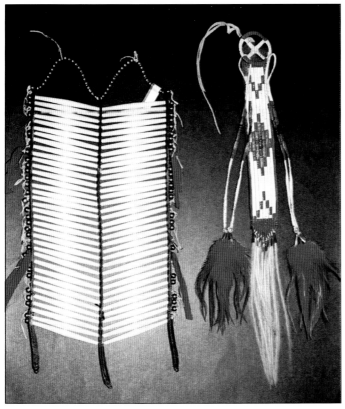

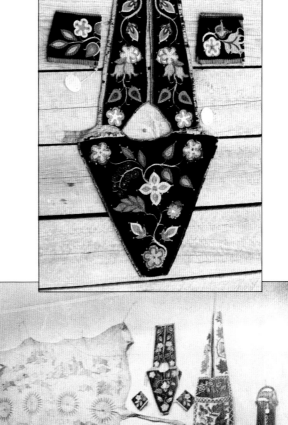

(Left) PLAINS CELLULOID HAIRPIPE BREASTPLATE c.1920
4" Hair pipes strung on leather thongs with latigo spacers. Brass bead trim on sides and top. Newer red wool ties on side. Hangs apx. 18"L. Nice natural patina. Est. 350-500 **SOLD $175(00)**

(Right) LAKOTA QUILLED HAIRPIECE
Quill-wrapped rawhide slats, wheel, and thongs are natural white with red, blue, purple, and orange. Rust-dyed comm. hide backing. Red hackle feather suspensions on dangles. Bottom has row of tin cones with white horsehair. Exc. cond. Hangs 21"L. Est. 200-350 **SOLD $175(00)**

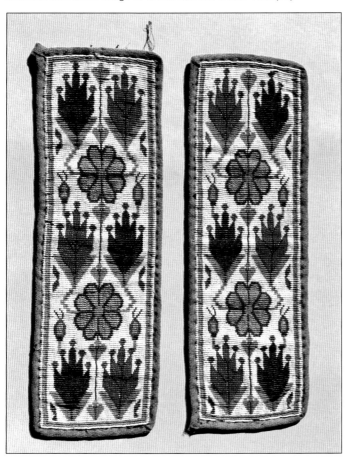

OJIBWA LOOM-BEADED PANELS c.1880
RARE. Most likely these are shirt strips; could be garters. Exquisite stylized floral pattern in luscious pastel shades: Chey. pink, brick, lt. blue, mustard, t. gold, metallic brass cuts, apple green, t. bottle green, and cobalt. Soft green wool Fox braid binding (faded from bright Kelly green on back.). Canvas backed. Remnants of red wool lining along edges. A few cobalt beads missing on one panel, otherwise exc. cond. Great patina. 4.5"W x apx. 14"L. Est. 350-750 pr. **SOLD $350(05)**

CHIPPEWA PARTIALLY-BEADED MAN'S SHIRT ORNAMENTS c.1890
O. Kather Coll. Oct. 1932 Burlington, Iowa. Oval brown (with age) tag reads *"Cuffs for Sioux Squaw Ft. Peck Montana."* Lapel tag reads *"Breast Ornament for Sioux Squaw..." These were mislabeled by the collector, because it was the style of Ft. Peck women to wear Woodlands bandoliers and beadwork with their buckskin dresses in the 1920s.* Included is a photo of the collection displaying this set. Black velvet with beautiful abstract floral designs that are completely intact! C. pink, rose w. heart, gr. blue, gr, yellow, pumpkin, three shades of green with clear stems. Celluloid sequins; metal and silver lined all in exc. shape. All bound with bright pink silk ribbon that is somewhat disintegrated. Wonderful set. Front is 17"L. Back is 16"W x 15.5"L. Pair of cuffs are 5.5"W x apx. 11". Est. 1000-1500 **SOLD $825(99)**

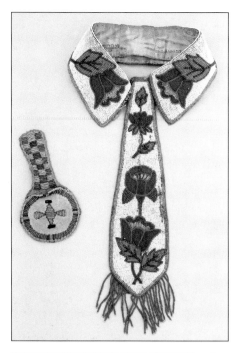

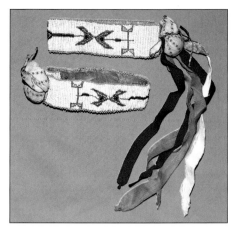

UTE FULLY-BEADED ARMBANDS c.1880
RARE. Loom-woven using tiny size 14 seed beads: white with delicate Sioux style pattern in Sioux green, gr. yellow, rose w. heart, dk. cobalt, gr. yellow bead edging. Old calico medicine (tobacco?) bags with red and gold silk ribbon drops and remaining rawhide of ermine! Exc. cond. and patina. Est. 600-1000 **SOLD** $750(02)

NEZ PERCE FULLY-BEADED NECKTIE and COLLAR SET c.1910
Tiny 13°-14° white bead bkgrd. with lovely cranberry and gr. yellow cut beaded tulips outlined with cobalt; three color t. green leaves. Border is t. rose and t. yellow green. 11"L. Red and t. cobalt cut beaded fringes 2"L. Collar lined with old Arrow shirt collar, size 14.5" neck. Good patina and condition. Est. 250-475 **SOLD** $275(02)

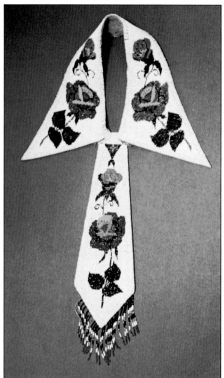

NEZ PERCE BEADED NECKTIE and COLLAR SET c.1900
Appliqué beaded white bkgrd. with tri-cut rose floral design in deep shades of t. cranberry, t. bottle green, pink satin, t. gold, t. blue, t. cobalt, and corn yellow. Bead fringe (75% intact). Tie 12" + 2.5" fringe. Collar 6.5"W at front. VG cond. Est. 250-500 **SOLD** $300(98)

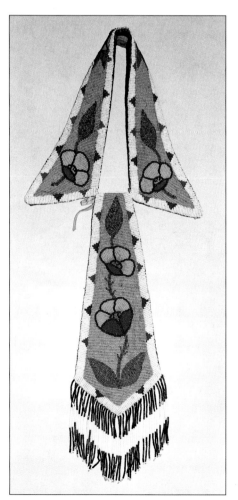

PLATEAU FULLY-BEADED COLLAR and NECKTIE c.1940?
Lt. blue bkgrd. with stylized California poppies in yellows and reds outlined in cobalt. Sioux green leaves with yellow-orange and cobalt geometric motif at collar back. White lane border with alternate red and cobalt triangles. Appliqué stitched. Bottom of tie has bead fringe: t. cobalt bugles and white seed beads. Lined with purple floral calico. Buckskin thong tie. Exc. cond. 18" circum. neck; tie hangs 13" includ. fringes. Very nice wearable piece. Est. 300-450 **SOLD** $350(03)

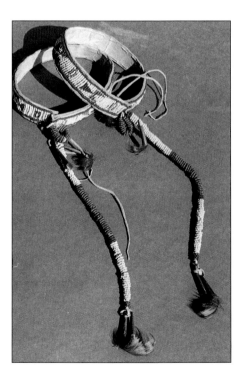

SIOUX FULLY-BEADED ARMBANDS c.1880
Collected on the Fort Peck (Assiniboine-Sioux) Res. in Montana. White bkgrd. with delicate motifs in cobalt, Sioux green, and rose w. heart bands with 11"L bead-wrapped suspensions in same beautiful colors. Tin cones with red fluff at top and bottom of drops. Buckskin covered rawhide. Exc. cond. with everything intact, exc. patina. Lazy-stitched and sinew-sewn. Est. 650-1200 **SOLD** $650(99)

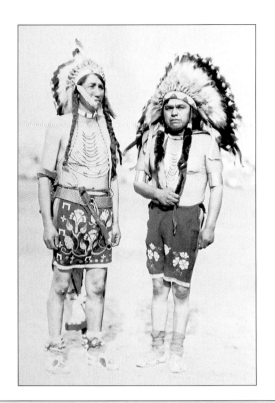

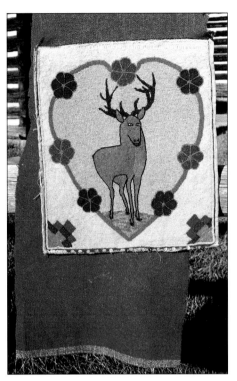

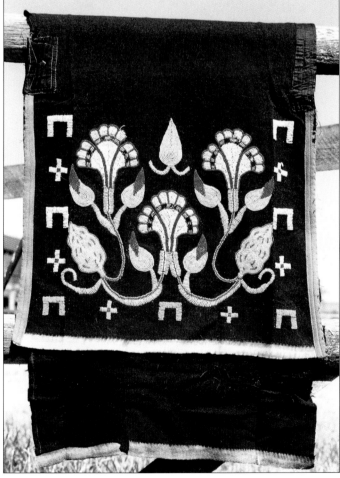

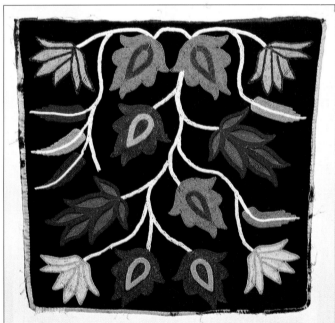

GREAT LAKES BEADED DANCE APRON c.1890
Classic asymmetrical bold stylized floral design in luscious colors: gr. Crow pink, t. rose, gr. blue, mustard, white, t. blue, t. emerald green, pale turquoise and t. yellow. Black velvet with black and beige tiny polka dot cotton backing. Bound on three sides with lt. green silk ribbon partially disintegrated. Exc. condition. Delicate age patina. 20.5" square. Est. 375-600 **SOLD $400(04)**

NEZ PERCE MEN c.1900
Man on right has been identified as Albert "Tex" Williams (*Nakai Williamson, personal communication, 7/03*). Unidentified man (left) wears the breechclout described below.
NEZ PERCE BREECHCLOUT c.1900
Preston Miller Collection Elaborately beaded saved list "hider" or apron-style breechclout includes horse track and abstract floral motifs. Bound with green wool. Having a photo of a man wearing this item increases its value. Est. 750-1200

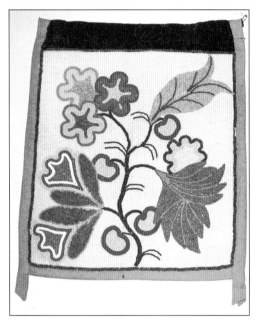

CHIPPEWA DANCE APRON c.1890
Typical stylized floral with rich colors: C. pink, t. rose, t. cobalt, gr. yellow, t. gold, t. red, and four colors of green. Made long ago from a bandolier square. Gold wool felt binding; black cotton sateen lined. 13"W x 15"L. Exc. cond. Est. 310-500 **SOLD $400(99)**

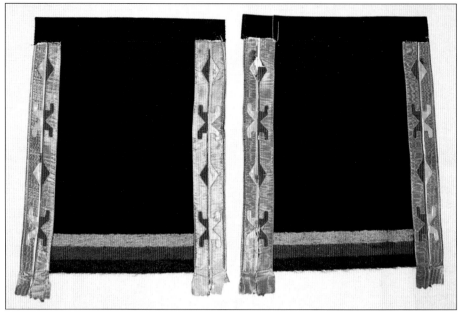

OSAGE RIBBONWORK DANCE APRON SET c.1890
RARE. Super fine wool is navy with mohair yellow, red and blue "rainbow" selvedge. Silk ribbon work is red and yellow with lt. blue overlaid. Silk is frayed at bottom edges slightly on design area. In great cond., considering age! Cloth is pristine. 12.5"W x 16"L. Est. 310-500 **SOLD $310(98)**

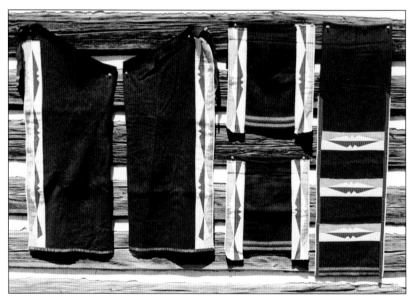

PAWNEE/OKLA. MAN'S STRAIGHT DANCE SET c.1930
Rainbow selvedge trade wool is navy with fantastic ribbon work in two shades of green and red. Red ribbon bound legging hem and breechclout. All are white edge-beaded. Leggings are 36"L x 14.5"W. Clout is 11"W x 40"L. Aprons are 13.5"W x 15.5"L. A rare chance for a pristine condition ribbon work outfit. Est. 675-1250 **SOLD $600(02)**
 See Corey, Carolyn. *The Tradecloth Handbook.* St. Ignatius, MT, 2001 for discussion and more examples of rainbow selvedge list.

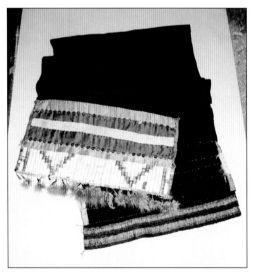

SIOUX QUILLED BREECHCLOUT c.1890
Quill-wrapped slats (2.5"L) are on painted parfleche (slight bleed-through from green paint onto the white quills) in bright pink, purple, and white. Tiny tin cone bottom fringes have bright pink fluffs. Apple green, navy, and white silk ribbons are intact. Celluloid sequin borders. Panel bound with red wool Fox braid. Other end has three broad green ribbons with selvedge showing. Cloth is indigo navy wool, dense seven-band mohair rainbow selvedge, originally in three separate strips sewn together. Many Indian-made garments with selvedge edges have pieced cloth to conserve the costly and important edge. 13.5"W x 49"L. Exc. cond. Est. 450-700

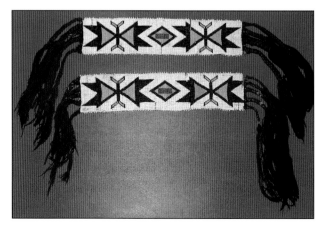

PRAIRIE LOOM-BEADED GARTERS c.1870
RARE. White bkgrd. apx. size 9° (early bead) with beautiful stylized butterfly-like designs and central diamond motifs in dk. cobalt, gr. yellow, and rose w. heart seed beads (apx. size 12°). Just a few white beads missing. 3" x 13.5" panels. Turkey red wool yarn braided fringes, apx. 12"L. Est. 500-950 **SOLD $600(00)**

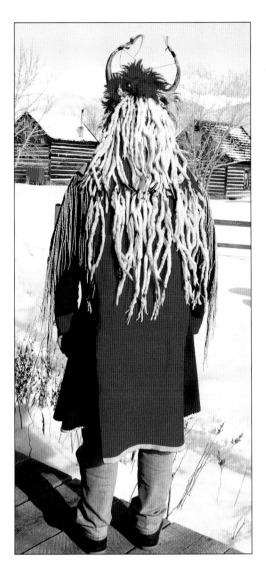

Headgear: Bonnets, Hats, and Hair Ornaments

NEZ PERCE SPLIT HORN ERMINE HEADDRESS c.1870

Collected at Nespelem, Washington. This was a popular style worn by prominent men during the late 1800s and early 1900s. This is an exceptional example and has been authenticated by a photo of the original Nez Perce owner, from Nespelem, Washington, wearing it. The cap section is decorated with two split and rolled cow horns. By splitting and rolling the horns, a smaller diameter base was produced. The tips of the horns are decorated with wrapped beadwork and yellow dyed horsehair. The cap is covered with white cut ermine skins and red hackle feathers. The brow band is decorated with brass shoe buttons. The trade cloth backdrop is decorated with tubes of ermine skin reinforced with native hemp.

This headdress is rare and highly prized by museums and collectors. Buyers must be wary, as many replica headdresses have been made through the years. Other tribes made variations of these and values may be higher or lower depending on the style, condition, and provenance. Est. $25,000 to $50,000

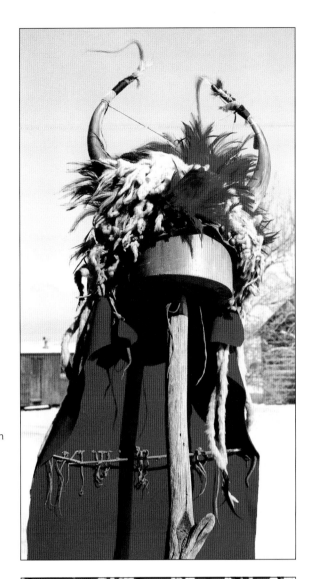

The scarlet "saved list" wool drop is apx. 4'L x 20"W. The texture is remarkably soft suggesting that it is "superfine" and made from the highest grade of merino wool. The bright red shade was very likely made from early expensive cochineal dyes, which do not easily fade. This cloth is of exceptional quality.

For more information on trade cloth see:
Corey, Carolyn. *The Tradecloth Handbook.* St. Ignatius, MT, 2001
Corey, Carolyn. "Coveted Stripes," in *The People of the Buffalo, Vol. 2.* Wyk, Germany: Tatanka Press, 2005: 131-146.

The headdress is shown in Bill Holm's studio worn by his famous articulated model, Ken.

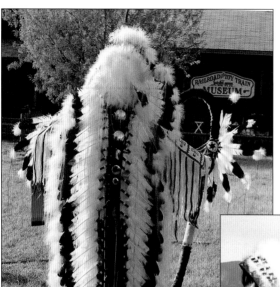

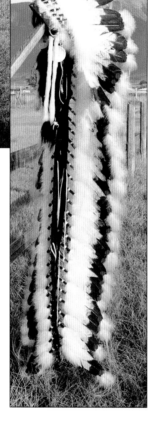

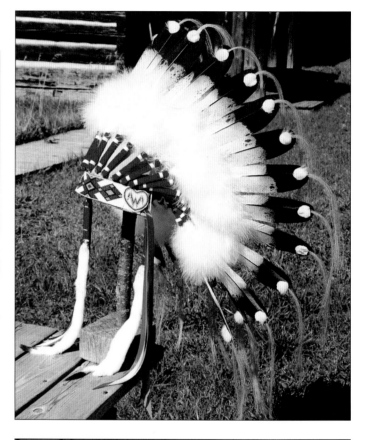

DOUBLE TRAILER FEATHER BONNET Contemp. *Metis-made.* Contains 83 painted eagle feathers black wool bound, each with white fluffs, red wool spot, and long white horsehair suspension. Bonnet is covered with white fluffs and has a heavy leather base. Beaded brow band has same colors as leggings, with mirrors each side and black hair braids with 3" conch shells and colorful beaded suspensions either side. Navy wool trailer is split for riding, has brass conchos down center. Hangs apx. 6'L. Est. 800-1500 **SOLD $1100(99)**

SIOUX FEATHER WAR BONNET Contemp. *Made by Earl Tail of Browning, Montana. Yes, this is the Blackfeet Reservation but Earl is Sioux married to a Blackfeet!* The first thing that strikes one about this bonnet is the large scale, beautifully hand-painted golden eagle tail feathers—34 in all. Each is 2.5"W x apx. 15-16"L. White feather fluffs at base; red felt wrapped with 10"L white horsehair drops from 1" diam. white fur "spots." Loom-beaded brow band (2"W) is white with red, yellow, and black, has cut-beaded hearts on either side with whole ermine and ten ribbon (five colors) drops. Felt hat crown base. Unworn new cond. Exc. construction. Est. 550-900 **SOLD $500(05)**

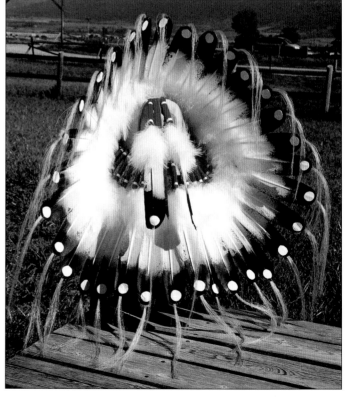

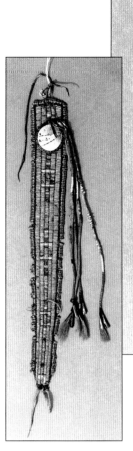
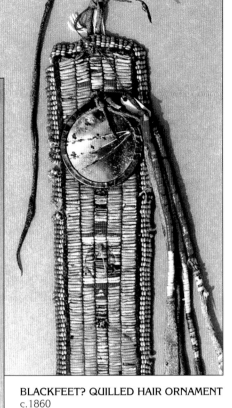

BLACKFEET? QUILLED HAIR ORNAMENT c.1860

Collected by Paul Janetski of Great Falls, Montana. Displayed at the West Yellowstone Museum for apx. thirty years prior to its sale in 2001. Simple band sewn quillwork in varying shades of pumpkin and pale indigo blue with clear red and natural white. Interesting 4-bead wide beaded edging is periwinkle and apple green (about 75% intact). Quillwork amazingly intact with just terrific patina of age. 1.5" round mirror has brass frame. 12"L yellow-ochred thongs are quill-wrapped in red, natural white, and green (about 60% intact) with pale green horsehair tin cone drops (five of eight still have horsehair). Genuine old unrestored piece. 16"L x 2" tapering to 1"W. Est. 1500-2000 **SOLD $1800(05)**

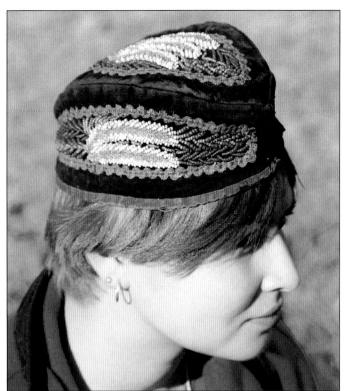

IROQUOIS GLENGARRY BEADED CAP c.1850

Char. embossed pony beads in abstract motifs: white, opales., green center brick (very early bead), gr. blue, t. gold, etc. Beaded sections outlined with ribbon lace. Black velvet nap worn. Faded red cotton binding somewhat frayed. Muslin lined. Dark patina. Good cond. All beads and lace intact. 10.5"L. Est. 325-550 **SOLD $425(99)**

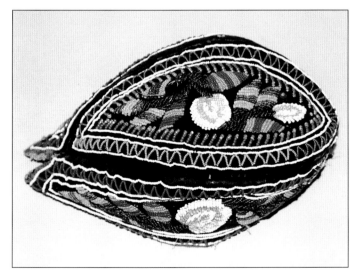

IROQUOIS GLENGARRY BEADED CAP c. 1860-90

A style probably copied from Scottish military hats. Gentlemen wore hats like this while smoking their pipes in elite men's clubs . Black velvet with worn red velvet ribbon binding. Rich variety of beautiful pastel shades, both ponies and seed beads incl. early green center bricks; white outlined panels with "zigzag" motif in gr. blue, t. rose, and Chey. pink seed beads. A few blue zigzag beads missing and a few ponies on top. Large brass sequin trim, several missing. 11"L. Est. 600-900 **SOLD $650(05)**

See Phillips, Ruth B. *Trading Identities.* Seattle: University of Washington Press, 1998: 223. c.1863 painting of Iroquois beadwork sellers holding similar cap and photo of a similar cap described as a "traveling cap," 246-7.

RARE SIOUX PORCUPINE and DEER HAIR ROACH c.1940 or earlier.

Collected from a Rocky Boy Cree lady in 1969. She stated that it belonged to her Sioux husband. This headdress has a finely woven clipped deer hair base made with white, red, and natural colored hair. Roaches with hair bases are among the finest made and owned by Indian dancers. It is 15" long with two rows of 7" porky hair on the front. The deer hair on the outside layer has a white background with red, purple, and Sioux green stripes and the inner layer is white. This is a beautiful roach in exc. cond and showing careful use. Includes wrapping stick and cloth. Est. 800-1500 **SOLD $850 (02)**

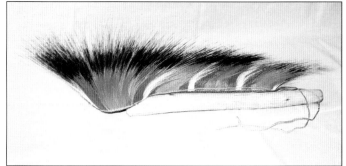

ROCKY BOY CREE PORCUPINE and DEER HAIR ROACH c.1967.
Made for Preston Miller when teaching school at Rocky Boy, by Charlie Dog Sleeps. Woven wool yarn base colored blue and pink is 14.5"L. The two rows of front porky hair are apx. 8"L. The outer layer of deer hair is medium blue with orange and white stripes and the inner is white. Excellent useable cond. Est. 600-950

Women's Clothing and Accessories

Dresses, Dress Tops, and Vests

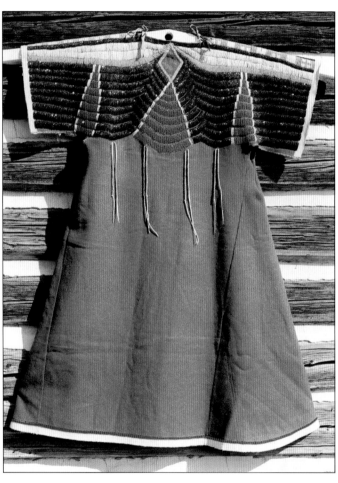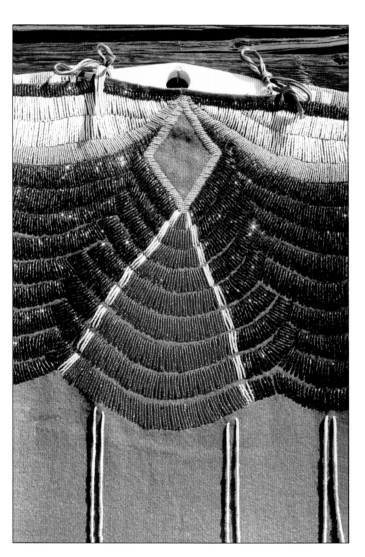

YAKIMA BEADED TRADE CLOTH DRESS c.1900
Old design configuration yoke in black iris tri-cuts, red w. heart, Crow pink, pale blue satin tri-cuts are a dynamic and elegant contrast to the bright green "saved list" wool. T. blue basket beads on 12"L thongs hang below yoke. Red silk ribbon above white selvedge hem. Plaid calico yoke lining. Wearable cond. 48" underarms x 51"L. Exc. cond. Est. 3500-5500

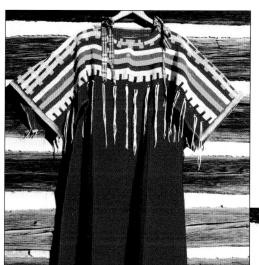

YAKIMA BEADED TRADECLOTH DRESS
c.1920s

Red wool white selvedge ("saved list") with geometric fully-beaded yoke; lt. blue, corn yellow, t. cobalt, gr. green, pale green, bottle green, C. pink, and tiny squares of orange provide a beautiful contrast to the red wool. Striped ribbon ties at neck opening. Buckskin thongs (8-10"L) below yoke. White selvedge at sleeve hems, neck, one gusset bottom and hem. Very tastefully made. Exc. cond. 44"L. 52" underarms. 80" bottom hem circumference. Est. 950-1500 **SOLD $1200(00)**

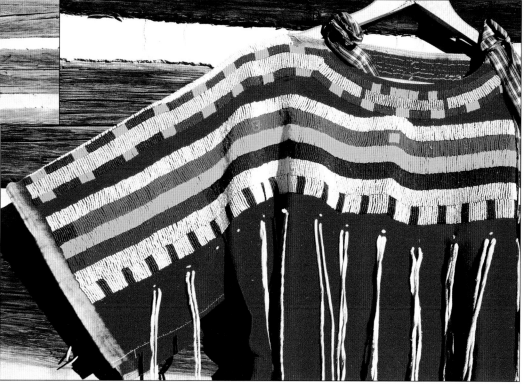

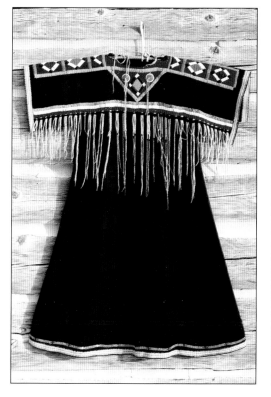

PLATEAU NAVY STROUD* BEADED DRESS
c.1940

Cloth is c.1900 or earlier. Carefully packed in a trunk in Walla-Walla, Washington all these years by the Indian family that owned it. Dense indigo dyed wool, double gusseted at sides (characteristic of Plateau dresses). In this case, the triple indigo striped selvedge has been added to hem and sleeves—3.5" strip on bottom hem and 2" strips on sleeves. It is not an uncommon practice for Indians to conserve valuable cloth this way. Sewn with French felt seams. The material for edges and body is the same heavy dense deep indigo fabric. Triangular yokes (both sides) and shoulders are red wool with ALL CUT BEAD lane-stitching in colorful geometric patterns: white, t. dk. cobalt, gr. green, black, pale blue, and pumpkin with periwinkle borders. Yoke bottom has triple lanes in periwinkle, white, and red cut beads. Long thong dangles with white tile beads alternating with lt. blue facets on one side; the other side has Sioux green tile beads. Bottom delicate beaded border (1/2"W) same cut beads: periwinkle with tiny crosses. Excellent unworn condition. 45" underarms, 46"L. Est. 1500-3000 **SOLD $1300(04)**

*19th century Hudson's Bay "Stroud" is characterized as cloth with a triple stripe selvedge, either "saved" (undyed) or dyed a solid color. *See* C. Corey, *The Tradecloth Handbook*, 2001.

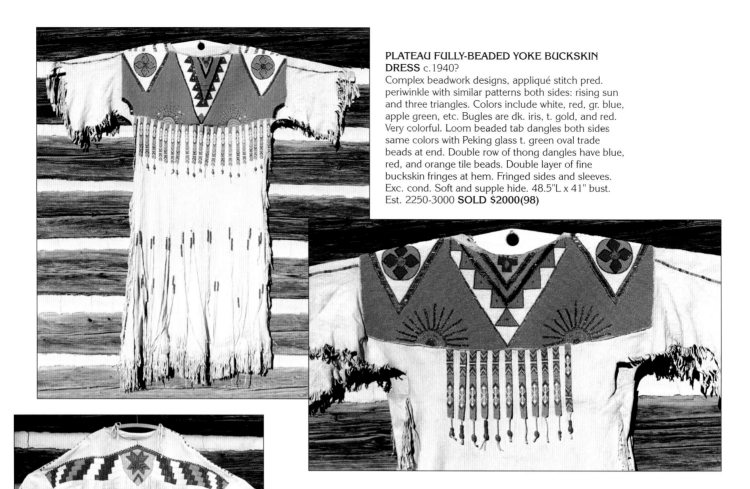

PLATEAU FULLY-BEADED YOKE BUCKSKIN DRESS c.1940?
Complex beadwork designs, appliqué stitch pred. periwinkle with similar patterns both sides: rising sun and three triangles. Colors include white, red, gr. blue, apple green, etc. Bugles are dk. iris, t. gold, and red. Very colorful. Loom beaded tab dangles both sides same colors with Peking glass t. green oval trade beads at end. Double row of thong dangles have blue, red, and orange tile beads. Double layer of fine buckskin fringes at hem. Fringed sides and sleeves. Exc. cond. Soft and supple hide. 48.5"L x 41" bust. Est. 2250-3000 **SOLD $2000(98)**

FLATHEAD BEADED BUCKSKIN DRESS
Made by Cecil Lumpry's grandmother, Susan Abel Brazil, about 1935. This elegant dress is in perfect condition. Beautiful soft white brain-tan with beaded step-pattern on yoke, very different colors each side. FRONT: Lane-stitch yoke in white, cobalt, lt. blue, and dk. pumpkin with tri-cut appliqué center panel BACK: Appliqué central diamond is white, gr. red, gr. yellow, apple green, white, and cobalt. Black iris bugle beads in zig-zag pattern nr. hem and above yoke both sides and at shoulders. Fringed at hem, sleeves, and side seams. Wearable. 42" underarms. 52"L. Est. 3500-6000 **SOLD $3500(00)**

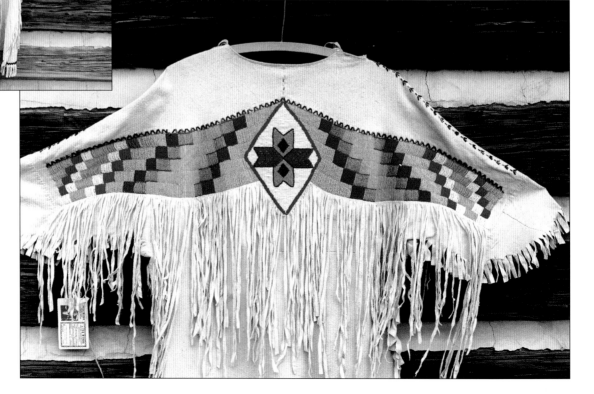

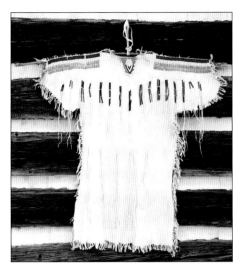

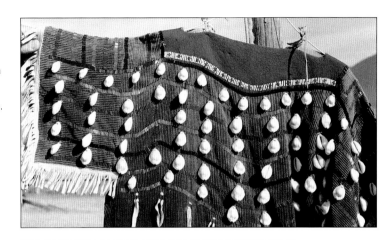

NEZ PERCE GIRL'S BUCKSKIN DRESS
c.1950
Fringed white brain-tanned buckskin with double row of buckskin thong dangles on each side. Top row of thongs has bronze and purple iris tube beads. Shoulders adorned with red, clear, and t. blue small bugle beads. Neck beaded each side with slightly different abstract floral tri-cut red and lt. blue + white, cobalt and periwinkle. Nice patina of age. Some red bugles loose/missing at shoulder, otherwise exc. cond. 34" chest. 31"L. Est. 470-650 **SOLD $450(04)**

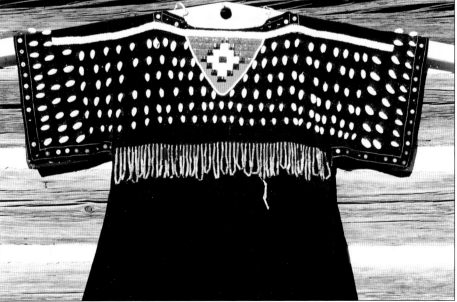

PLATEAU CORDUROY BEADED DRESS c.1950
Faded purple wide-wale corduroy has rows of large (1"-1.5") old monie cowrie shells with sewn bands of bugle beads: t blue, t. green, and black. Yoke top is deep blue wool felt with white lane-stitched row with red cross motif, same both sides. 2"L brain-tan fringe at bottom and sleeve hem. Calico lined top. Buckskin thongs hang below yoke and on dress bottom. 42" underarms x 48"L. Est. 400-600 **SOLD $100(99)**

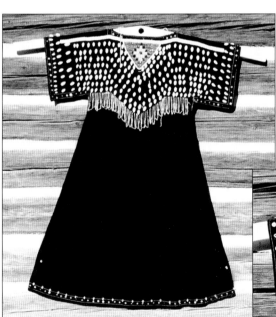

PLATEAU BLACK VELVETEEN DRESS
c.1940
Collected on the Yakima Res., Washington.
White olivella shell yoke decoration with V-shaped bibs in t. orange tri-cuts with lt. blue , t. blue, pumpkin, red; iris bugles similar each side. Basket bead buckskin thongs clear and t. green front, with red additional on back. White lane-stitched row at shoulders both sides. Neck opening and sleeves trimmed with brass sequins (a few missing); hem also has sequins and tiny olivella shells. Very beautiful dress in exc. cond. 42" at bust; 50"L. Est. 625-850

27

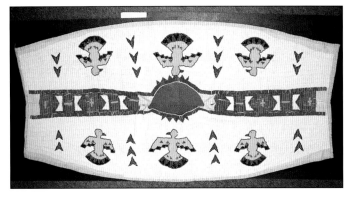

PLATEAU FULLY-BEADED DRESS YOKE c.1940
Lane-stitch white bkgrd. with dynamic yellow bird motifs with red, cobalt outlines, and copper tri-cuts. Shoulder sections are orange with white and green geometric patterns. All beads intact. Ready to Powwow! 45" x 22" open. Exc. cond. Est. 750-975

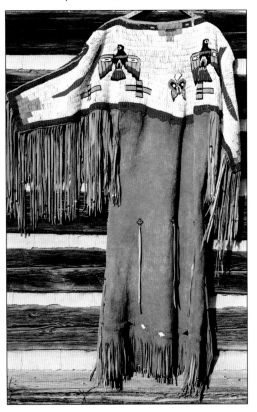

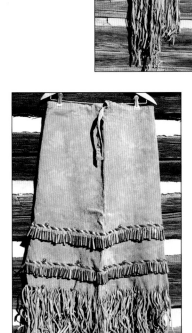

CANADIAN CREE BEADED MOOSE HIDE DRESS
c.1950
Diff. yoke design lane-stitched each side: white bkgrd. with bright colors of two thunderbirds flanking central butterfly with cross motifs. Cobalt blue borders. Tiny beaded crosses on skirt each side. Hem has green bkgrd. lane-stitched row both sides. Dk. tan commercial moose hide suede out. Long thong fringe on sleeves (13"L) with Crow bead and tin cones. 5-6" hem fringes have tin cone ends. 50" under-arms. Apx. 52"L incl. bottom fringe. Est. 695-1200 **SOLD $800(00)**

APACHE 2 PCE. DRESS
c.1980?
Traditional old-time design with narrow (1/2") diagonal bands of beadwork: white pearl, black, red, and cobalt on comm. hide. Classic very long fringes and hand-made tin cone fringed bodice. Same both sides except silver bell trim on one side, silver spots the other. Top hangs 36"L. Bottom skirt has max. 36" drawstring waist; double tiers of tin cone fringe and beaded bands with silver bell trim and 8" bottom fringe. 31"L, incl. fringes. Hundreds of tin cones on this outfit! Great Pow Wow dress! Est. 600-900 **SOLD $400(01)**

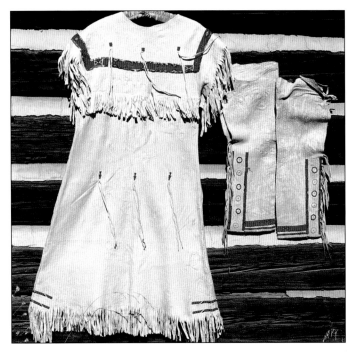

ARAPAHOE BEADED BUCKSKIN DRESS and MATCHING LEGGINGS c.1940
Harold L. Shilling Collection. Red lane-stitched borders have geometric designs in Sioux green, cobalt, lt. blue, orange. Hide is soft supple brain-tan. Dress yoke beadwork outlined in rows of gold celluloid sequins. Gold bugle bead trim. Sleeve and yoke fringes 4"L. Double red lane-stitch bands on bottom gussets. Beadwork trim at shoulder and skirt thongs. 34" underarm. Bottom fringes 3"L. Welted side seams. Dress length 42" incl. fringes. LEGGINGS have matching red beaded borders with Sioux green bead edging. Lt. blue and cobalt 1" circles in side panels. Buckskin tie thong side fringes. 22.5"L, 7"W bottom x 9"W top. Est. 400-850 **SOLD $400(01)**

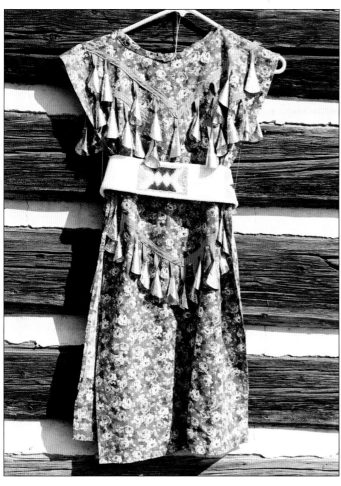

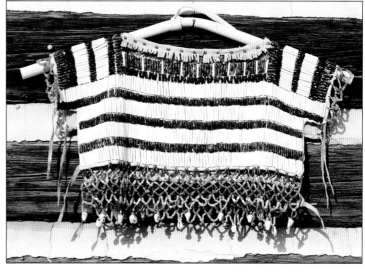

GIRL'S JINGLE DRESS OUTFIT
Fully-beaded belt and pouch are white appliqué stitch with tasteful panels of turq., C. pink, burgundy, and dk. brown. White rolled beaded edges. Lined with blue cotton. Fits 24" waist x 2.75"W. Overdress matches belt in dk. turq with pink rose pattern. Deep pink cotton binding trim with *"RIEDWOOD"* snuff can lid hand-made jingle dangles. Open on both sides, 17"W x 32"L. each panel. Made to go over a dress. Exc. cond. Est. 80-175 **SOLD $150(03)**

BLACKFEET BUGLE and BASKET BEAD DRESS TOP c.1915
1-1/8"L porcelain white tube bead rows alternate with t. cobalt and t. gold basket bead rows. Bottom and armhole net beaded fringe also has t. emerald green, blue, and pink-lined basket beads with old cowrie and trade bead dangles. Neck opening is fringed buckskin with w. center rose pony bead trim. Beautiful, fully-beaded piece on heavy canvas. 24"W x 14"L. Exc. cond. Est. 950-1600 **SOLD $950(01)**

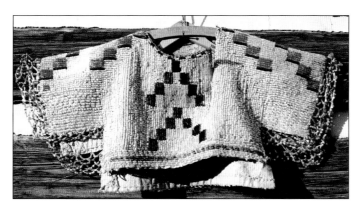

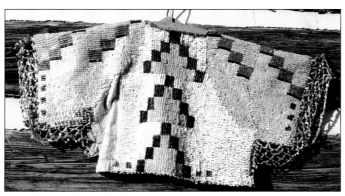

CROW FULLY-BEADED BASKET BEAD TOP c.1900?
Frequently worn by Crow Male Grass Dancers even today.
Gorgeous colors and dramatic step-triangle motifs: white satin bkgrd. front with yellow-lined, red-lined, and black basket beads. Back has same colors with pale pink-lined bkgrd. 2.5" net beaded fringe on sleeves is turquoise satin and pumpkin-lined. On heavy canvas. Someone removed 3"W swath of white beads side front. 24"W + fringe x 12"L. Est. 450-800 **SOLD $315(01)**

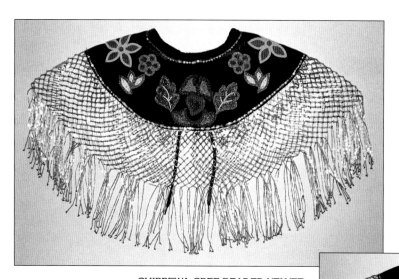

CHIPPEWA-CREE BEADED VELVET
CAPE/YOKE c.1920

Typical beautiful floral designs in t. red, blue, gold green, and amethyst; opaque red, lt. blue, lt. green, mustard bordered w/celluloid sequins. Net beadwork is all bugle beads in clear, t. gold, and orange. A few breaks need repair but no beads missing. A lovely wearable piece. 15"W +10"L network and bead dangles. Neck is 16" circumference. Est. 300-500

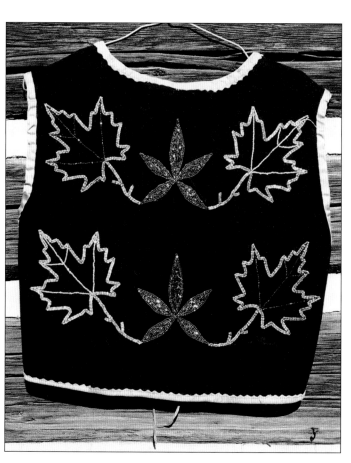

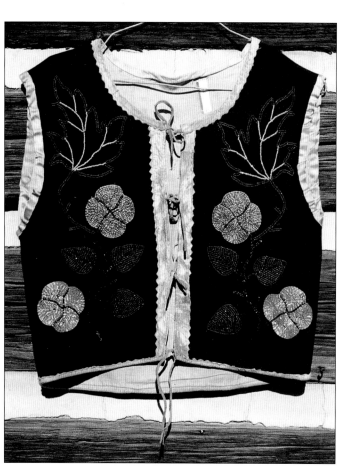

CANADIAN CREE WOMAN'S BEADED VEST c.1920

Charming style pinked buckskin bound and front ties. High quality black wool with lt. blue and pink satin seed beaded flowers and maple leaves; t. dk. red stems and t. green leaves. Lt. blue satin bound armholes. Muslin lining. 36" underarm measurement, 33" at waist. 17"L. Pristine cond. Est. 325-500

Leggings

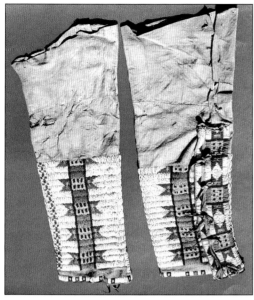

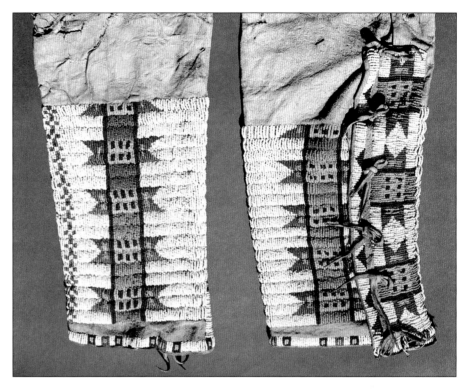

CHEYENNE WOMAN'S LEGGINGS c.1880
Superb design and color combinations. White with Sioux green, gr. yellow, rose w. heart, cobalt. Sinew-sewn and lane-stitched. Heavy buckskin has rich dark patina of age and a few tears on upper portion only. 1" narrow border missing on one legging, otherwise all beads intact. Exceptional collector's piece. 19"H x 6" bottom W. Est. 1800-3000 **SOLD $950(99)**

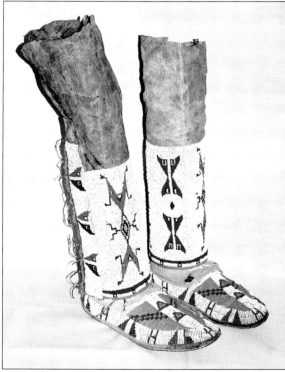

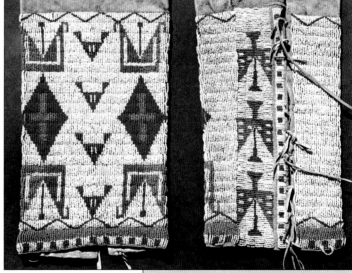

SIOUX WOMAN'S FULLY-BEADED LEGGINGS c.1880
Fantastic tiny beads size 14° or smaller; classic white ground with exquisite geometric patterns in CUT BEADS: Sioux green, rose w. heart, t. cobalt, gr. yellow, red w. heart, and brass. Rose w. heart lane nr. bottom. Bottom and sides delicately edged in gr. yellow. "Lane" stitched (only 1/4"W!) and sinew-sewn. Every bead intact! Buckskin is somewhat stiff but not brittle—has a great patina. Tiny buckskin thong ties. 6"W x 16.5"H. Est. 2250-2800 **SOLD $2500(03)** NOTE: See moccasin description, page 44.

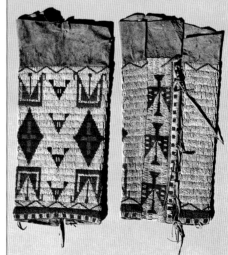

SIOUX WOMAN'S FULLY-BEADED LEGGINGS
c.1870
Absolutely incredible design motifs in classic lane-stitched colors: cobalt and periwinkle blue, rose w. hearts, Sioux green, t. gold, and t. green. These are the nicest of this style we have ever seen! Wonderful old patina on buckskin. Sinew-sewn; no beads missing. 13"H x 6.5" widest part. Est. 2000-3500 **SOLD $3250(05)**

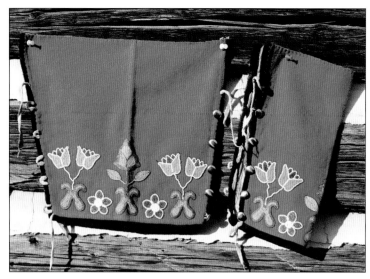

PLATEAU WOMAN'S TRADECLOTH BEADED LEGGINGS c.1900
Bright green wool complements lovely beaded stylized floral patterns in pastel old colors: gr. yellow, periwinkle, lt. blue, two shades of t. rose, t. yellow, and white. Black velvet bound. Brass buttons buckskin laced; buckskin loops. Striped mattress ticking lined. Pristine cond. 13"H x 5.5" bottom W. Est. 500-750 **SOLD $650(01)**

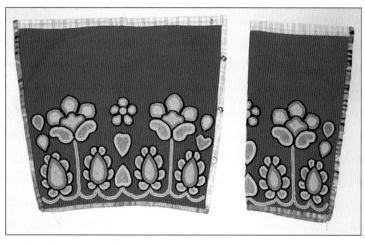

PLATEAU TRADECLOTH BEADED WOMAN'S LEGGINGS c.1900
Probably Nez Perce. Heavy red wool with beautiful abstract floral design: opal. pink, lt. blue, gr. yellow, apple green, all outlined with amethyst cuts. Lined with two color plaid cotton, forms top binding. Green rayon ribbon bound. Snap closures. Pristine cond. 12.5"H. Est. 800-1000 **SOLD $575(00)**

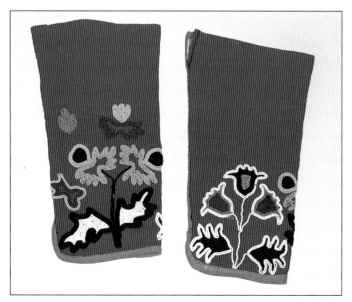

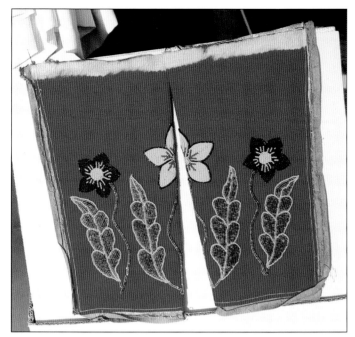

PLATEAU RED TRADECLOTH BEADED LEGGINGS c.1920
"Saved list" wool has bright floral pattern: yellow, gr. green, t. lt. green, mustard, t. cobalt, lt. blue, and black iris tri-cuts. Lined with calico print. Pink cotton binding. 14"H x 15"W at top . 12"W at bottom. Exc. cond. Est. 625-950 **SOLD $650(03)**

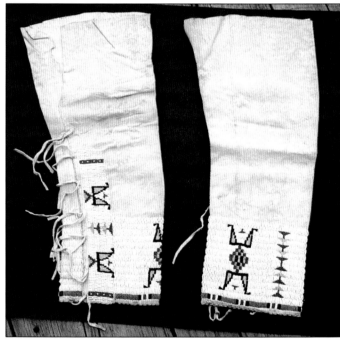

ARAPAHOE FULLY-BEADED WOMEN'S LEGGINGS c.1930
Harold L. Shilling Collection. Made of thick unsmoked buckskin (elk?). Sinew-sewn and lazy-stitched. White bkgrd. geometric patterns in Sioux green, lt. blue, dk. red, black, and corn yellow. Lt. blue edge-beaded. 20"H x 7"W at bottom. Est. 400-600 **SOLD $325(01)**

PLATEAU TRADECLOTH BEADED WOMAN'S LEGGINGS c.1880
Probably Nez Perce, although design elements resemble those of the Tlingit. Red twill-weave with green wool felt binding. Early style, very abstract contour floral beadwork: bottle green, gr. yellow, lt. blue, cobalt and dk. cobalt, white, t. gold, gr. yellow, mustard, and pink. Plain cotton lined. 12.5"H. A few moth holes, otherwise exc. cond. Est. 600-950 **SOLD $670(00)**

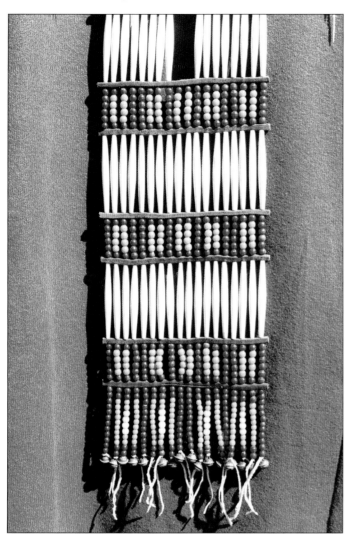

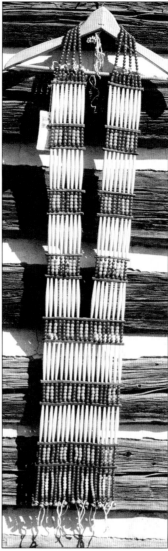

PLATEAU WOMEN'S SIOUX-STYLE BREASTPLATE c.1890
Collected on the Nez Perce Res. Nr. Lewiston. RESTORED. The old cloth string and harness leather are disintegrated (sent along with the necklace). All of the old bone hairpipes and dk. blue and Bodmer blue prosser beads are re-strung on aged brain-tan buckskin. The hairpipes have a nice patina and polish from use. Bottom beaded fringes also have off-white prossers and small hawk bell drops. Harness leather spacers are from solid old harness leather 5/16" thick. Hangs apx. 50"L. Est. 800-1500

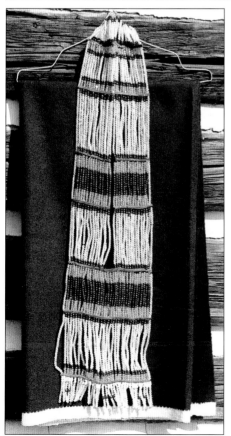

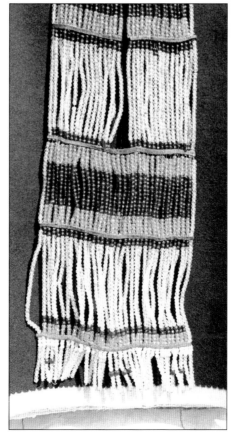

CHEYENNE WOMAN'S BEADED BREAST-PLATE/NECKLACE c.1900?
Collected on the Cheyenne Res., Birney, Montana. Made entirely of 6mm. faceted beads; clear, t. cranberry, and t. topaz. Sinew-strung. Heavy harness leather spacers. Bottom fringes include t. cobalt and gr. white necklace beads. Pristine cond. Hangs 31"L x 7.5"W. Est. 450-800
SOLD $425(03)

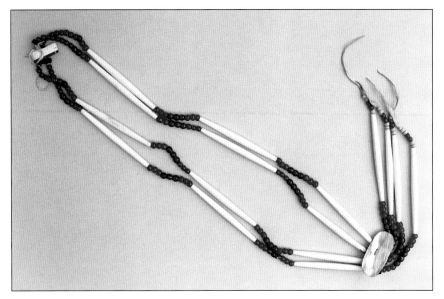

NEZ PERCE HAIRPIPE BANDOLIER/NECKLACE c.1900 *Steve Shawley Coll.* 5" bone hairpipes strung on buckskin thongs with beautiful rose w. heart and cobalt wire-wound trade beads. Abalone shell ornament with hand-perforated edge. Hangs 34"L. Est. 250-400 **SOLD $200(99)**

PLAINS-PLATEAU DENTALIUM EARRINGS 19th century *RARE.* Smooth old dentalium with latigo spacers strung on sinew. T. cobalt, t. blue tube bead dangles with yellow monie cowries. Silver ear wires with lt. blue facet and t. red basket beads with brass bead at top. Nice patina. Some dangles strung on cotton string. Apx. 9"L x 1.25"W. Nice old piece. Est. 250-500 **SOLD $200(98)**

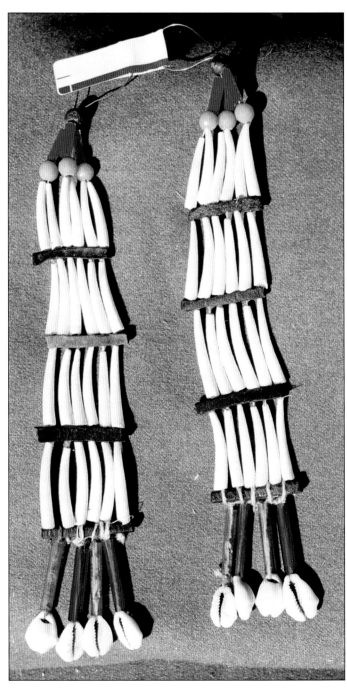

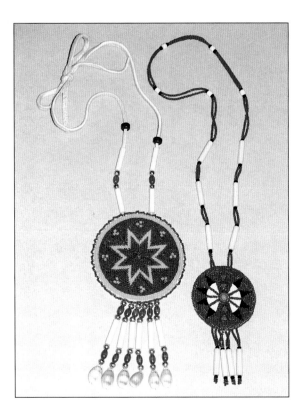

NO. PLAINS FULLY-BEADED MEDALLION NECKLACE c.1970
(Left) T. yellow, t. dk. cobalt, and t. orange beautiful star motif (3.5" diam.); t. orange edge-beaded. Strung on white buckskin thong with plastic hairpipes, oval orange wooden beads, cobalt Crow, brass and monie cowries. Hangs 18"-22". Est. 35-75 **SOLD $45(03)**
(Right) c.1970 Assiniboine stylized feather motif in black and white with cobalt and periwinkle on red bkgrd. ALL CUT BEADS. Hangs on double strand red beads alt. with hairpipes and black bead spacers. Medallion 2.5" diam. Hangs 17"L. Est. 35-75 **SOLD $35(03)**

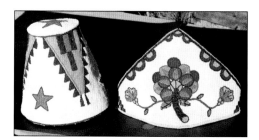

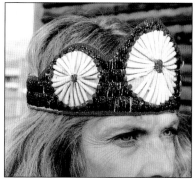

NEZ PERCE DENTALIUM CROWN
c.1910
RARE. Bronze tri-cut bkgrd. bordered with t. red tri-cuts. Three smooth dentalium rosettes, each shell sewn with red facet trade bead at end. Central rosette shells are 1.25"L; two side rosettes have 1"L shells. Canvas backed-black elastic band for secure fit. 4"W center, 1.5" back W, 22" circumference. Est. 250-400 **SOLD $300(02)**

(Left) PLATEAU FULLY-BEADED HAT c.1970
Made by Cecile Lumpry, Salish-Coeur d'Alene from the Flathead Ind. Reservation, Montana. Typical basket hat motifs plus stars appliqué stitched on white background. Old-time colors: gr. yellow, t. dk. cobalt, red white hearts, and gr. blue. Calico lined. 7"H. 7" diam. Est. 600-800

(Right) SALISH FULLY-BEADED PRINCESS CROWN c.1915
Flathead Reservation, Montana. Characteristic Flathead stylized flower beaded on white with half circle and step-rectangle border trim. Fantastic bead colors: red w. heart, t. red, t. amethyst, rose w. heart, gr. yellow, gr. blue, cobalt cuts, forest green, bottle green, and pale blue edging. 22" circumference. 7" peak. Est. 400-750

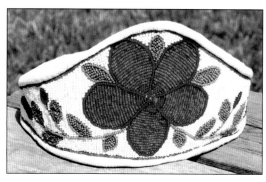

PLATEAU BEADED PRINCESS CROWN Contemp.
Fully-beaded appliqué beaded white ground with blue, lt. green, and red floral pattern. Est. 200-350

Jackets

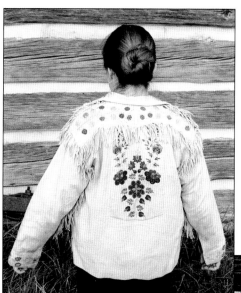

CREE SILK EMBROIDERED BUCK-SKIN SHIRT c.1890-1920
Collected on the Flathead Res. in Montana. Expertly sewn delicate flower and bud designs on front and back yoke, placket, collar, pocket, and cuffs. Back yoke has exquisite four-flower pattern in burgundy, pink, purple with lt. blue, and green leaves and stems. Remaining designs are dk. rose, pink, rust, and greens. Pocket embroidery lettering *"U.tell-em"*. Long fringes 8" on back yoke, 5" at sleeves, 3" bottom hem. Supple buckskin, nice age patina. 25"L x 44" chest; sleeves 26"L. Colors still bright. Est. 800-1250 **SOLD $550(98)**

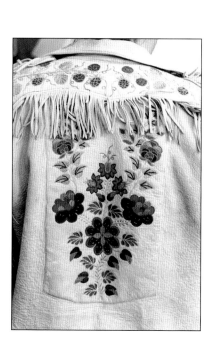

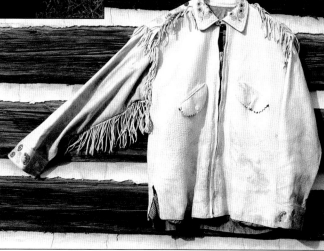

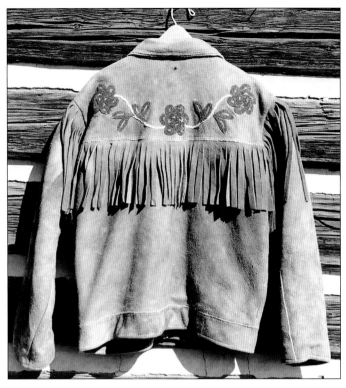

CANADIAN CREE MOOSE HIDE JACKET c.1960s
Made by Harriet Sylvester, Bush Cree from Buffalo Narrows, Canada.
Heavy fringed jacket with subtle floral patterns on front and back yokes. T.
red iris, t. blue iris, t. purple iris flowers with pink pearl and white lined clear
trim. T. green leaves. Pinked collar, yoke, and pocket trim. Zipper front.
Fully-lined. 26"L. 46" underarms. Exc. cond. Est. 500-950 **SOLD $495(05)**

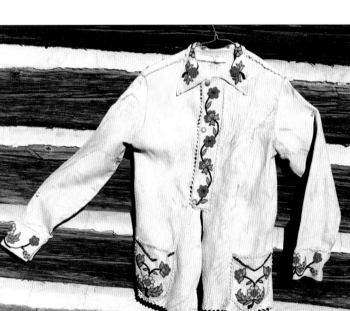

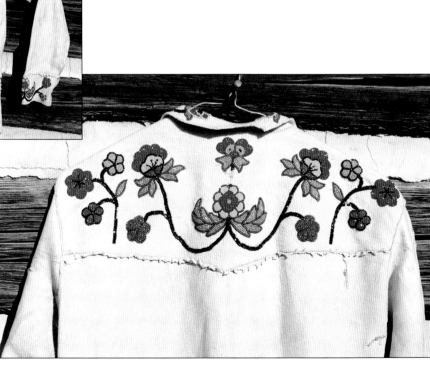

Customer Jill Hatier poses at Four Winds with her new jacket.

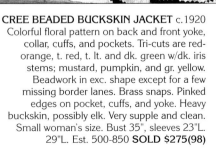

CREE BEADED BUCKSKIN JACKET c.1920
Colorful floral pattern on back and front yoke,
collar, cuffs, and pockets. Tri-cuts are red-
orange, t. red, t. lt. and dk. green w/dk. iris
stems; mustard, pumpkin, and gr. yellow.
Beadwork in exc. shape except for a few
missing border lanes. Brass snaps. Pinked
edges on pocket, cuffs, and yoke. Heavy
buckskin, possibly elk. Very supple and clean.
Small woman's size. Bust 35", sleeves 23"L.
29"L. Est. 500-850 **SOLD $275(98)**

Belts and Sashes

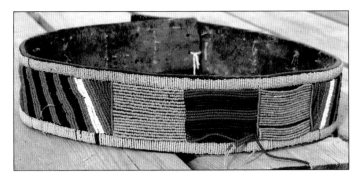

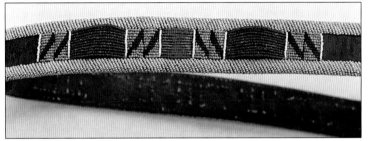

PLATEAU FULLY-BEADED PANEL BELT c.1870
Purchased from Mrs. Brock, Millwood, Washington in 1972. Two diagonal stripe panels (periwinkle, black and brick) flank horizontal loose strung beaded panels (lime green; rose w. heart and dk. cobalt; Ital. 4 lt. blue; pumpkin and black). Border edges are Chey. pink. Sinew and thread-sewn. A few loose rows, minor repair. Heavy harness leather belt. 2"W x 36.5"L. Est. 350-600 **SOLD $275(98)**

CROW BEADED PANEL BELT WITH DROP c.1880
Preston bought this at Madison Square Garden, New York, in 1962 for $6.00. Beautiful tiny seed beads (apx. size 14°) rose w. heart cuts, Crow pink, red w. heart, t. green and t. rose cuts—very delicate shades. Diagonal rolled edges are lt. blue. All sinew-sewn. Heavy latigo 1.25"W includ. belt drop of 34"L (all one piece leather). Fits 33"-38" waist. Hard to find one in such perfect shape. Est. 400-800 **SOLD $550(00)**

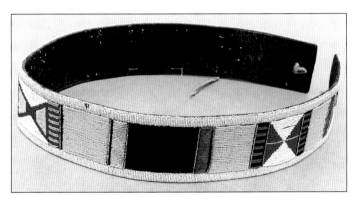

PLATEAU BEADED PANEL BELT c.1880
Collected on the Yakima Res., Washington. Incredibly intact; all tiny cut beads (sizes 14 and smaller) in fantastic colors: rolled beaded edge is pale lavender with horiz. beadwork in gr. yellow, Crow pink, Crow pale blue, cobalt, white and red w. hearts. Vertical lines of silver metallic cuts separate panels. No beads missing. Thread sewn, no restoration. Heavy harness leather in good shape. 2.5"W x 36"L. Est. 600-900 **SOLD $650(05)**

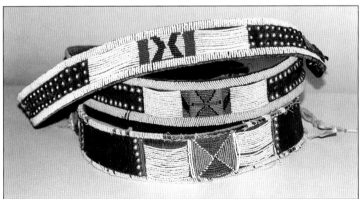

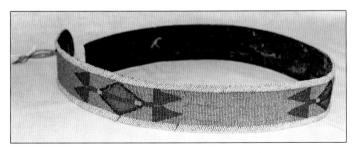

BLACKFEET FULLY-BEADED PANEL BELT c.1890-1900
All size 13 and smaller beads. Lt. periwinkle bkgrd. with rolled beaded edges in pale blue. Geometric motifs are primarily rose w. heart with apple green cuts, tiny red w. hearts and gr. yellow. Heavy harness leather belt is completely covered with beads. Buckskin ties. Thread sewn. Lovely lt. patina. Two rows edge beading missing (apx. 10 beads total), otherwise all intact and exc. cond. 2"W x 39"L. Est. 450-700 **SOLD $450(03)**

NEZ PERCE PANEL BELTS c.1880
Each is beaded on heavy harness leather with brass tack ornamentation. (Top) Pred. lt. blue size 12 and 13 seed beads with design panels in gr. yellow, t. rose, and cobalt. One horiz. row lt. blues missing, easy repair—otherwise remarkably exc. cond. and patina. 1.5"W x 39" waist. Est. 500-600 **SOLD $425(99)**
(Center) Crow pink diag. beaded border with delicate cut bead design panels: size 14? pale periwinkle, rose w. heart, apple green, and black. A few pink beads missing, otherwise exc. cond. 1.75"W x 35" waist. Est. 435-550 **SOLD $550(99)**
(Bottom) Beadwork apx. 80% intact. ALL CUT BEADS. Lt. blue borders with design panel in t. rose, red w. heart, apple green, and white. 1.75"W x 36" waist. Est. 200-350 **SOLD $225(99)**

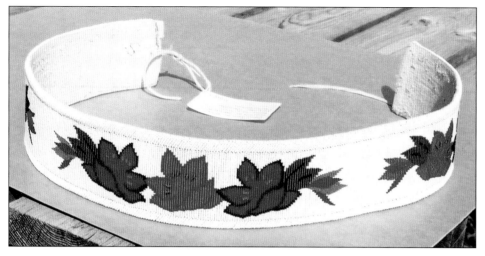

CROW TRADITIONAL BELT Contemp.
Crow Res., Montana. Typical white bkgrd. with white diagonal rolled beaded edges on heavy canvas. Crow-stitched. Beautiful transparent bead flowers are t. red, t. blue, t. forest green, t. cobalt cuts, burgundy, black, and orange cuts. Perfect cond. 3"W. Fits 30"-34.5" waist. Est. 250-600 **SOLD $275(05)**

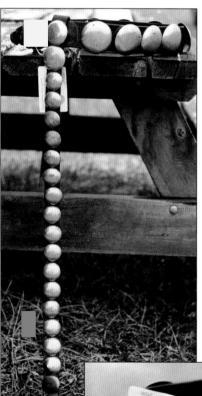

SIOUX GERMAN SILVER CONCHO BELT and DROP c.1870
Rare complete set. These conchos were traded to Indians, who then made them into belts, etc. Eleven (2.5") domed conchos on heavy harness leather belt (2"W x 34"L); tapered drop (36"L) and graduated (2"to 1") domed conchos. Attached with brain-tan thong on back. Nice patina of age. Wearable. Est. 1500-2700 **SOLD $1700(00)**

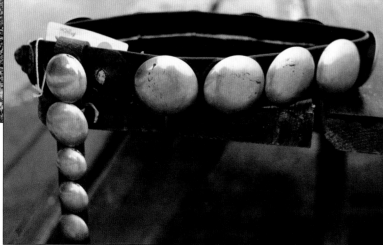

SIOUX/CHEYENNE HAIR PLATES FROM A BELT DROP c.1870
German silver trade item. Early cupped dome style. Graduated (2" to 1") copper loops on back; strung on brain tan thong. Thirteen in all. Nice patina. Est. 300-500 **SOLD $325(00)**

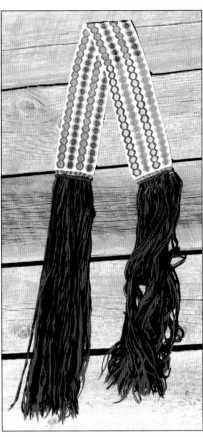

CHIPPEWA LOOM-BEADED SASH c.1900 White bkgrd. with pumpkin, gr. yellow, t. blue, gr. blue, and t. rose beautiful "chain" pattern. Alt. red and black yarn fringe, 20"L. A few loom threads broken, otherwise exc. shape. Beaded portion is 29" x 3.75"W. Est. 250-400 **SOLD $200(99)**

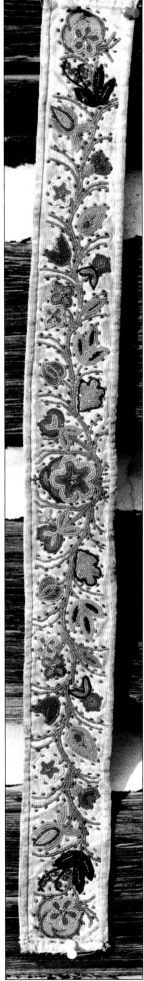

NO. CALIF. LOOM-BEADED BELT c.1910 *Pitt River tribe.* Attractive design and colors: white with geometric motifs in Sioux green, t. cobalt, and t. rose. T. rose edge-beaded. 2-3/8"W x 32"L. Eyelet closures form 29" belt. Exc. cond. Est. 200-300 **SOLD $125(03)**

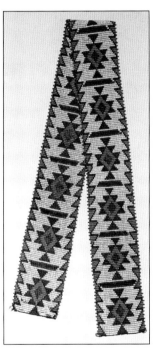

CREE BEADED BELT c.1890-1915 Marvelous floral pattern in size 13° and smaller ALL CUT BEADS: t. turq. stems with scattered metallic brass, silver cut flower centers. Colors: C. pink, t. rose, t. red, pumpkin, gr. rose, gr. green, gr. blue, t. amber, apple green, emerald green, t. lt. green, t. cobalt, porcelain white. Silk backed. Heavy patina of age. Buckskin bound. 3"W x 30"L. Exc. cond. Metallic beads are in pristine cond. Est. 400-650 **SOLD $550(01)**

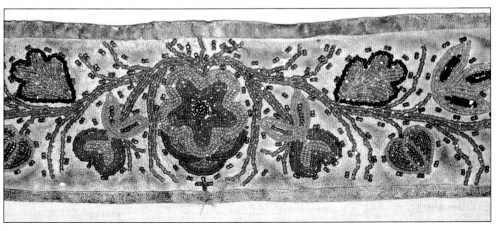

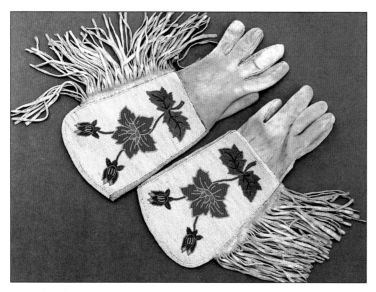

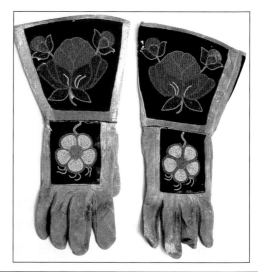

CROW FULLY-BEADED MAN'S GLOVES c.1900
Typical large panels and day lily motif; pale turquoise appliqué bkgrd. with cut beaded floral pattern red, t. cranberry, mustard, Sioux green, t. green, cobalt, and gr. blue. Roll beaded tops. Calico lined cuffs. Buckskin gloves are two different patterns! Age the same on both. Buckskin side fringes, 6"L. Nice patina. Panel is 10"H. Exc. cond. Est. 750-1200 **SOLD $750 (00)**

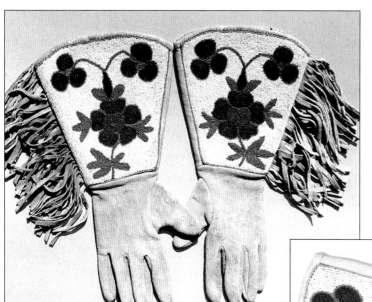

PLATEAU BEADED GLOVES c.1900
Exquisite cut beaded stylized floral designs over black wool insets. Cuff: rose design in red w. hearts, t. red, t. pink w. hearts, two shades green, and tiny brass metallic beads. Glove: pink, rose w. hearts, t. gold, two shades green. Welted seams. Dk. buckskin gloves, heavy patina of age and wear. Wool has some mothing. Sewn star design on cuff backs. Est. 200-400 **SOLD $175(02)**

PLATEAU FULLY-BEADED MEN'S BUCKSKIN GLOVES c.1900
White flat-stitched bkgrd. with lovely stylized flowers in rose w. heart, t. cranberry, t. yellow, and Sioux green all outlined with a single row of lt. blue. Expertly made. Calico lined cuffs. Buckskin fringes 5"L. Large man's size. Shows no wear. Pristine. Cuffs are 8"W x 8"L. 16" total L. Est. 550-875

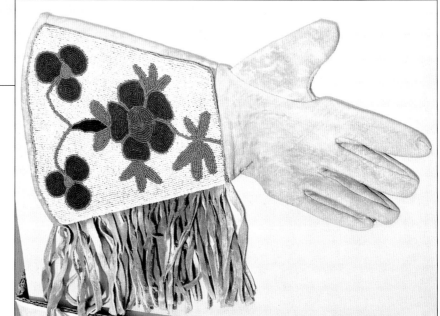

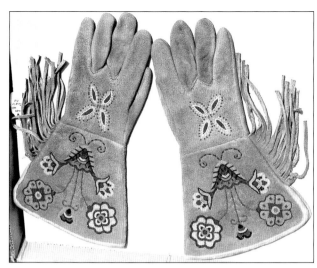

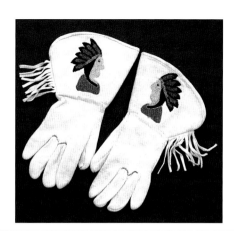

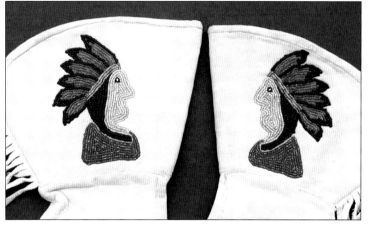

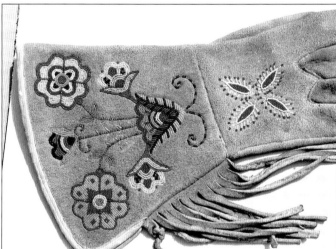

SHOSHONE PARTIALLY-BEADED GAUNTLET GLOVES c.1943
Harold L. Shilling Collection. Includes typed and handwritten papers documenting provenance of Fort Washakie, Wyoming. Beautiful soft brain-tan with 3" side fringes. Cuffs have desirable Indian head pictorial motifs in all tri-cut beads: pink-lined, t. rose-red, black, t. grey, t. pale yellow, and t. turquoise. Expertly made. Cat motif cotton lined cuffs. All welted seams. Ladies small size. Exc. cond. 12"L. 5" gauntlets. Est. 200-350 **SOLD $200(01)**

SANTEE SIOUX BEADED MEN'S GLOVES c.1890?
Preston Miller Collection, purchased in 1969 from Clarence Hauhauser, Intercourse, Pennsylvania. Highly desirable symmetrical abstract floral pattern in a multitude of colorful and beautiful tiny cut seed beads which are all intact. Elk hide gloves with nice patina. Cuff lined with plaid cotton. Est. 1000-1800 **SOLD $1400(02)**

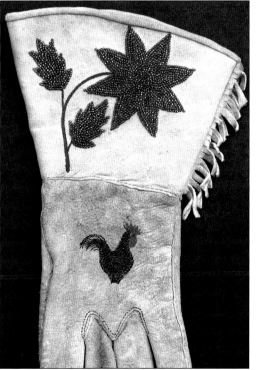

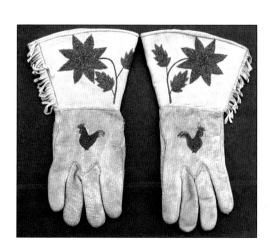

PITT RIVER BEADED BUCKSKIN GLOVES c.1930 No. Calif.
Harold L. Shilling Collection. Includes handwritten story, 1979, and typed account of acquiring these gloves from Daisy Starr. Apparently, Harold had to illegally transport a hide to her under the hood of his car! He wore these gloves "while riding in the Pioneer Day parades in Lander, WY from 1943-57." Expertly made and silk embroidered with a "Plymouth Rock Rooster" on glove and spot-stitched silver-lined blue flower with t. rose and t. pale green on cuffs. Smoked buckskin gloves and un-smoked cuffs with fringes. Rayon-lined cuffs. Welted seams. Man's large size. 13"L. 5" cuffs. Exc. cond. Est. 350-500 **SOLD $350(01)**

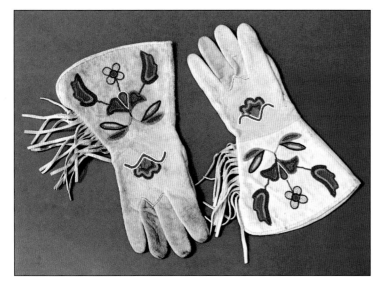
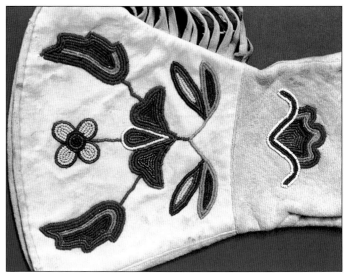

PLATEAU BEADED GLOVES
Probably Flathead. Beautiful early abstract floral in ALL TINY CUT BEADS in a myriad of colors: pale blue, gr. yellow, metallic cut brass, transl. robin's egg blue, t. dk. cobalt, Crow pink, red w. heart, etc. Pristine condition. Est. 650-1200

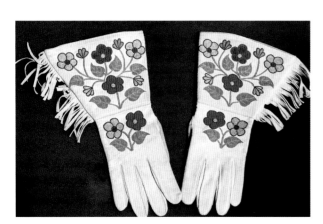

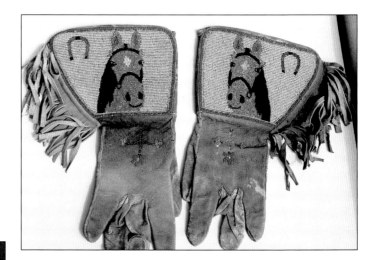

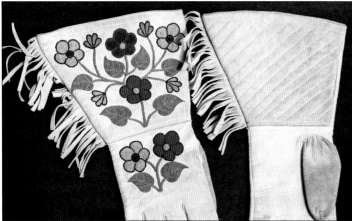

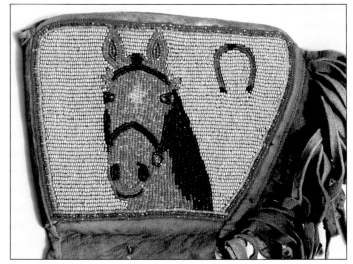

CANADIAN SILK EMBROIDERED MEN'S GLOVES c.1900?
Possibly Kootenai. Exquisite unfaded pink, red, and purple flowers outlined in burgundy. Two color green leaves. Beautifully tailored buckskin with side fringes. Large men's size. Est. 800-1200

PLATEAU BEADED GLOVES c.1920
Fully beaded cuffs in charming horse head and horseshoe motifs. Pale periwinkle background with t. rose , black and clear tri-cuts and red border with small flower motifs on glove (stems missing on one). Dark smoked buckskin with fringes. Palms show use. Welted seams. Med. woman's size. Est. 600-800

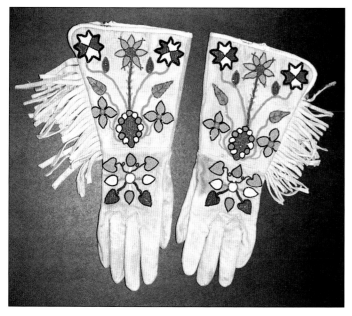

NEZ PERCE CUT BEAD GLOVES c.1890
Lovely symmetrical stylized floral pattern in delicate and beautiful pastel ALL CUT BEADS. Colors: Chey. pink, t. rose, rose w. heart, apple green, with black outlines. Also gr. yellow, t. topaz, and periwinkle. Beautifully made of soft smoked buckskin. Woman's size. One of the nicest pairs we've ever seen. Calico lined cuffs. 14"L x 7"W at cuffs. Est. 1150-1500

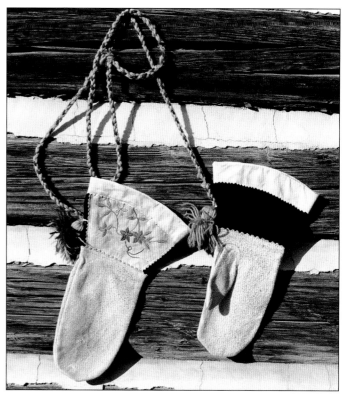

ATHABASCAN SILK EMBROIDERED MOOSE HIDE MITTENS c.1920
Buckskin and black velvet cuffs with pastel floral design. Pink and green braided yarn with pompom tassels. One leaf and a few surface moth holes, otherwise exc. cond. 14"L. Large man's size. Est. 150-300

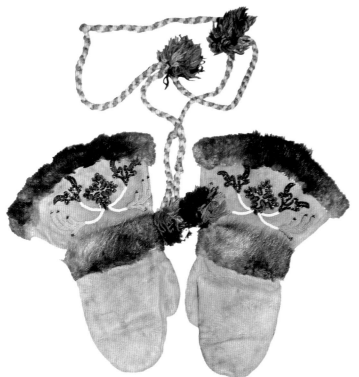

ATHABASCAN BEADED MITTENS c.1910
Soft moose hide trimmed with beaver fur at cuff and wrist. Beautiful intact beaded abstract motifs are tri-cuts: metallic, t. cobalt and red. plus opaque white and lt. blue. Flannel lined. Braided wool yarn neck straps with four tassels: lt. purple, white, turquoise, and olive green. These show use but not abuse! Man's large size. Est. 300-450 **SOLD $280(04)**

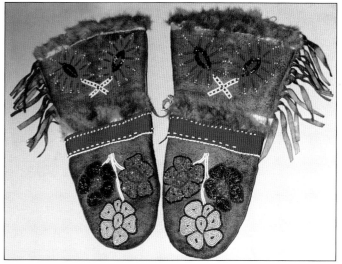

ATHABASCAN PARTIALLY-BEADED MITTENS c.1920
Tri-cut colors: cobalt, t. green, clear pink-lined, t. red, and orange in bold floral motif; also tomato red, navy and white beads on smoked moose hide. Buckskin fringed cuffs. Heavy blanket lined with seal fur lined cuffs. Red wool and beaver fur trim at wrists and hem. (Fur is slightly bug eaten, but is still in good cond.) Dk. wear patina on palm. 14"L x 8"W at cuffs. Wearable cond. Est. 200-300 **SOLD $125(99)**

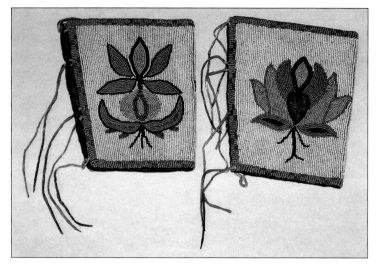

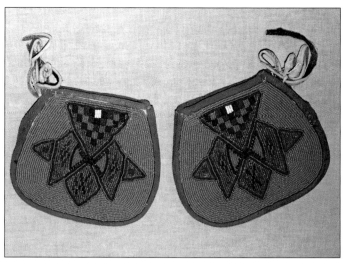

PLATEAU FULLY-BEADED CUFFS c.1880
Flathead. Appliqué-stitched pale blue background with delicate stylized floral pattern, different each side: apple green, Crow pink, gr. yellow cuts, t. gold, t. rose cuts, and pale periwinkle. Leaves outlined in t. navy cut beads. 1/2"W border is lt. blue with mustard. Red cotton bound. Buckskin ties. Great patina. Superb condition. 4.5" x 6.5"H. Est. 435-750 **SOLD $435(05)**

FLATHEAD FULLY-BEADED CUFFS Contemp.
Made by Cecile Lumpry. Striking appliqué geometric patterns in old-time bead colors: lt. blue bkgrd. with gr. pink, mustard, t. red, and t. cobalt. Smoked buckskin bound. Woven cotton lined. Beautiful pair. New. 6.5"W x 5.5"H. Est. 175-250 **SOLD $125(01)**

Footwear: Moccasins

Plains and Plateau

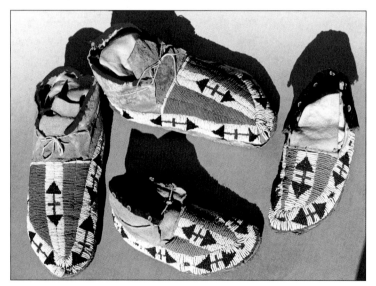

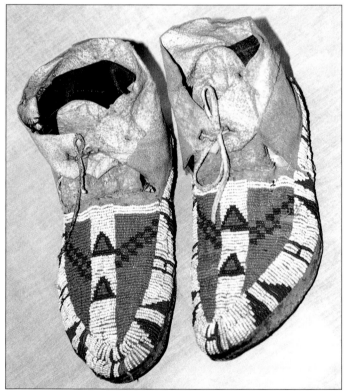

TWO MATCHING PRS. SIOUX FULLY-BEADED MOCCASINS c.1890
Dennis Lessard Collection. Classic designs in lane-stitch; sinew-sewn: Sioux green upper panels bordered in white, with dk. cobalt triangles connected by rose w. heart crosses. Adult pr. has red trade wool bound cuffs; child's pr. cuff bound with navy polka dot calico. Both have rawhide soles. Lessard's description in an April 1997 letter reads: "Father/son matching pr. of Sioux mocs, ca. 1890. They sure look like they were made by the same woman. VG cond. Minor wear to the red trade cloth." Also, a few beads missing toe and heel adult pr. only, otherwise exc. cond. showing nice patina of age. Small 7.5"L. Adult 10.5"L. Est. 3400-4000 both pairs **SOLD $3400(98)**

CLASSIC SIOUX FULLY-BEADED MOCCASINS c.1880
Preston Miller Collection. Fantastic colors, design, and patina of age. Apple green with white; geometric motifs are in rose white hearts, cobalt, and periwinkle. Sinew-sewn and "lane" stitched. Single lane up back seam. A few beads missing, unrestored original cond. Beautiful dark patina. Rawhide soles show wear. 10"L. Est. 900-1800 **SOLD $1000(05)** Also see p. 31, with leggings.

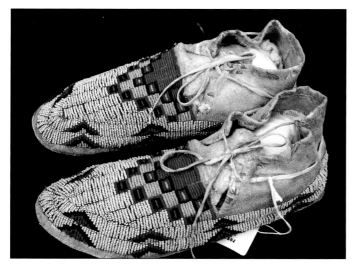

FT. PECK? SIOUX MOCCASINS c.1880
Unusual color combination: lane-stitched in pale blue bkgrd. with red w. heart, gr. blue, dk. cobalt, and gr. yellow. Calico bound tops. Exc. cond. Est. 1250-1800

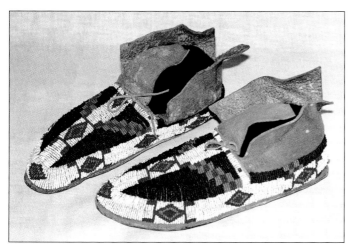

ARAPAHO/CHEYENNE FULLY-BEADED MOCCASINS c.1880
Unusual and rich color combination: t. bottle green and white with geometric motifs in lush gr. pumpkin, rose w. heart, and cobalt. Sinew-sewn "lane" stitched. Dark patina buckskin and rawhide soles. 8.75"L. Est. 1250-2000 **SOLD $1500(03)**

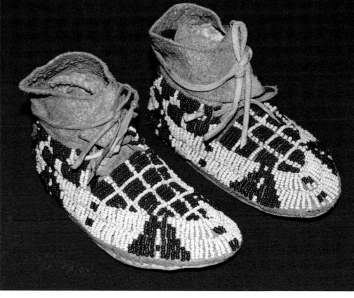

SIOUX FULLY-BEADED CHILD'S MOCCASINS c.1870
Checkerboard pattern in cobalt and white on vamp and all around top; border is white with rose w. heart and cobalt triangular patterns. Lane-stitched and sinew-sewn. Heavy rawhide soles. Exceptional design, patina, and condition. 5.25"L. Est. 700-950 **SOLD $700(00)**

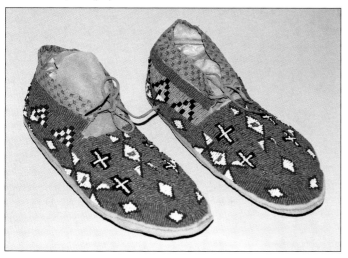

TURTLE MTN. SIOUX FULLY-BEADED MOCCASINS
Collected by Maurice Oliver betw. 1895-1920. He owned the drug store in Oberon, North Dakota and took items in exchange for goods from his store. Includes booklet "Maurice Oliver Collection," which pictures these moccasins. Periwinkle blue and Sioux green with white diamond and cross motifs with brass cut beads outlined in cobalt blue. Lane-stitched. Side strip is apple green with step-triangles in t. cobalt, white, lt. blue. One side is gr. yellow; other side t. cobalt, t. rose, white, and gr. yellow. Not a single bead missing! Muted red/rose tiny calico print bound cuffs. Buckskin soles (never worn). 10"L. Exc. cond. with lt. patina of age. Est. 1200-1800 **SOLD $1700(03)**

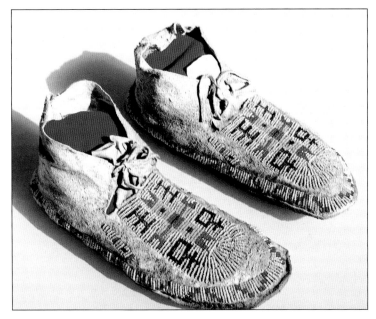

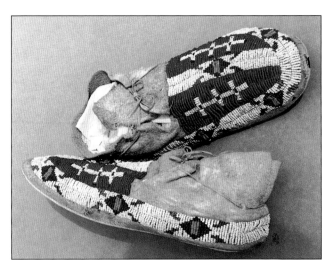

SIOUX FULLY-BEADED MOCCASINS c.1880
Lane-stitched and sinew-sewn. T. lt. cobalt with white double lane borders and central strip. Accented with gr. robin's egg blue, rose-red w. heart, and Sioux green in small cross and diamond motifs. Rawhide soles, good patina. Exc. cond. 10.5"L. Est. 1200-1900 **SOLD $1200(05)**

SO. PLAINS PARTIALLY-BEADED MOCCASINS c.1920s
Probably Ute, but could also be Cheyenne, Arapaho, or Shoshone. *St. Francis College at Ft. Wayne, Indiana. Collected by the sisters teaching in the west. Includes original 1987 letter documenting the collection written by Sister Scheetz, President of St. Francis College.* Unusual colors and designs. U-shaped front panel in pale turquoise blue with gr. yellow and orange has cross with unique symbol motifs in t. amethyst tri-cuts. Single lane border along sole in same colors. Unusual elk hide brain tan soles have rolled edges suggesting Ute construction. Exc. patina and condition. 10"L. Est. 975-1800 **SOLD $1100(05)**

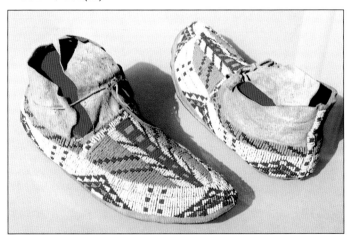

SIOUX/CHEYENNE FULLY-BEADED MOCCASINS c.1890
Ex. Palmer Collection, So. Dakota. Beautiful atypical pattern, white with Sioux green, t. red w. heart, cobalt, periwinkle, and gr. yellow. Side profile, beaded lane up the back seam and design suggest Cheyenne. Rawhide soles show wear. Sinew-sewn; lane-stitched. Beadwork in perfect cond. 10"L. Est. 975-1800 **SOLD $1800(05)**

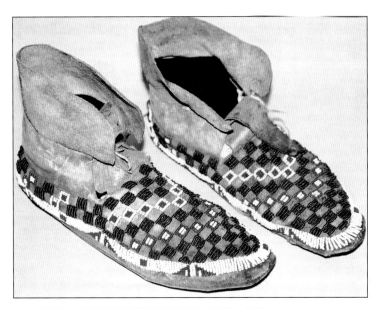

SIOUX PARTIALLY-BEADED MOCCASINS c.1890
So. Dakota. These "checkerboard" patterns were popular from about 1880-1910. Gorgeous bead colors: white, t. bottle green, rose w. heart, and cobalt. Rich dark patina. Sinew-sewn. Rawhide soles show heavy Indian use and interesting re-soling long ago. Beads all intact. Apx. 10"L. Est. 800-1500 **SOLD $850 (02)**

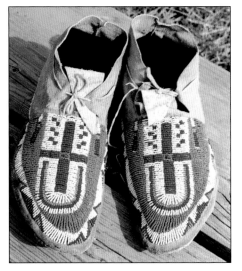

SIOUX FULLY-BEADED MOCCASINS c.1880
Preston Miller Collection. Colors and design suggest Ft. Peck Res., Montana. Marvelous traditional colors: Sioux green with white early U-shaped pattern and lovely rose-red with heart large cross accented with cobalt, lt. blue, and silver metallic cuts. White lane-stitched, all-around border with same colors as in triangle motifs. Sinew-sewn. Rawhide soles and buckskin show patina of age, light wear. Pristine cond. All beads intact. 10.5"L. Est. 2000-3000

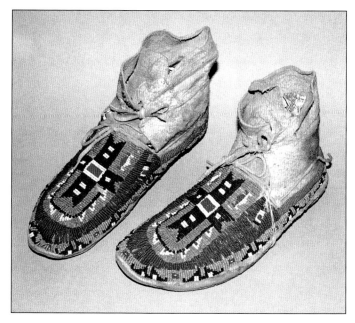

CHEYENNE FULLY-BEADED MOCCASINS c.1890
Beautiful color combination of pred. Cheyenne pink with striking dk. cobalt cross central motif with Sioux green panel and red w. heart and white smaller motifs. Characteristic vertical row back seam. Rawhide soles. Sinew-sewn. 1/2" of beads missing, otherwise superb cond. Exc. patina. 10"L. Est. 1500-1800 **SOLD $900(98)**

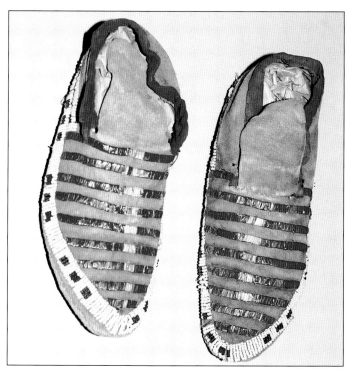

SIOUX QUILLED MOCCASINS c.1880
Classic red line pattern said to be a protection for the wearer. Lane-stitched beadwork in early "box" pattern in rose w. heart and t. cobalt white. Red cotton binding. Rawhide soles. Hard to find in such good overall condition. Est. 1100-1800 **SOLD $1250(02)**

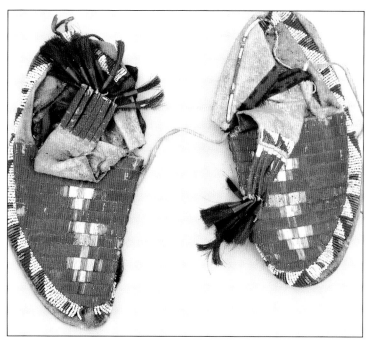

SIOUX FULLY-QUILLED MOCCASINS c.1890
Unfaded red sewn quilled uppers with purple, white, and green step-triangles; tongue has six red quill-wrapped slats with ten intact red horsehair/tin cones! Sinew-sewn. Beautiful single row lane-stitch bottom border and tongue in white rose w. hearts, periwinkle, Sioux green, and cobalt. Quill-wrapped thong ties at ankle. Rawhide soles. Even has two quill wrapped tabs at heel (missing on one moc). Quillwork about 95% intact. Tasteful red calico sewn cuff binding. 9.25"L. They are stiff and flattened. Est. 500-800 **SOLD $950 (02)**

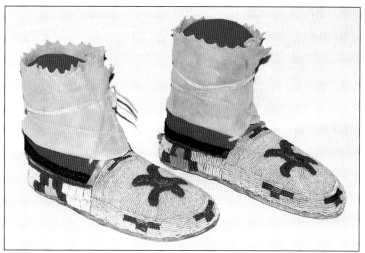

NO. PLAINS FULLY-BEADED MOCCASINS c.1890
Possibly Cree or Blackfoot. Contoured Crow pink center panel bordered with appliqué lt. blue with deep rose w. heart, cobalt, and brass metallic motifs. Center motif is unusual asymmetric abstract shape; brass metallic outlined in dk. cobalt. Back has lane-stitched black motifs, diff. colors each side of heel: 1) white with gr. yellow, dk. cobalt and dk. rose w. heart; 2) inside Crow pink with gr. green and pumpkin. Red super-fine wool cuffs with strip of navy wool. Back heel has fringed buckskin. Sinew-sewn. Rawhide soles. Ankle-wrap buckskin has scalloped edge. Unique design. Exc. cond. and beautiful patina of age. 9"L. Est. 800-1500 **SOLD $1300(04)**

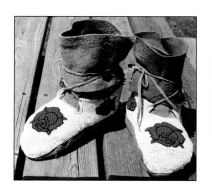

PLATEAU FULLY-BEADED ANKLE WRAP MOCCASINS
Flathead Res. Montana. Appliqué stitch white bkgrd. with red rose motifs outlined in dk. iris tri-cuts on toe and sides. Red wool hand-pinked cuffs. Apx. 10"L. Est. 700-1200 **SOLD $695(01)**

47

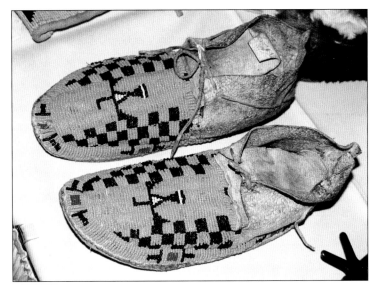

CHEYENNE FULLY-BEADED MOCCASINS c.1890
Unusual gr. yellow bkgrd. with characteristic central thunderbird motif and understated elegance of colors and design. Checkerboard design in t. bottle green; minimal additions of t. red and white. Lane-stitched and sinew-sewn. Close examination reveals that the brain-tan hide is pigskin. Rawhide soles. Pristine cond. Nice patina. A few beads missing on toe of one moc, barely noticeable. 9"L. Est. 900-1500 **SOLD $850(99)**

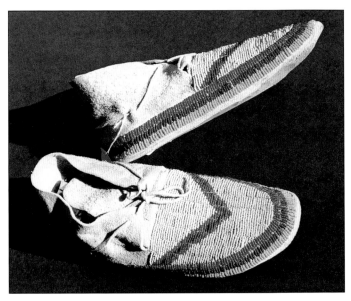

ASSINIBOINE FULLY-BEADED MOCCASINS c.1880
This Chevron design was popular with the Gros Ventre and Assiniboines on the Fort Belknap Res. in Montana. Purchased by Preston Miller in 1970. Interesting colors: Chey. pink and lt. blue with red w. heart, cobalt, and mustard stripes. Sinew-sewn. Rawhide soles. Perfect cond. with nice patina of age. 10"L. Est. 1200-2000 **SOLD $1350(00)**

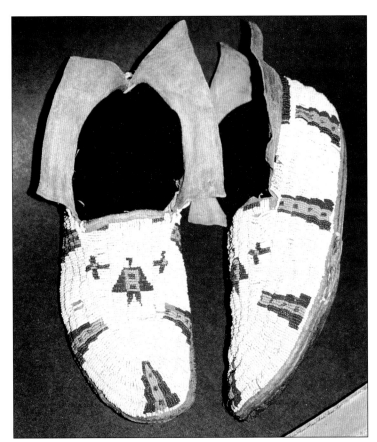

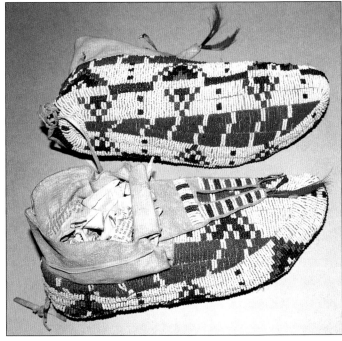

SIOUX FULLY-BEADED CEREMONIAL MOCCASINS c.1880
Predominantly white with wide band of gr. blue on central bottom and top nr. cuff. Step triangles are rose w. heart, dk. cobalt, and apple green. Split tongues (same colors) have tin cones with red horsehair (missing 4 of 8); otherwise overall perfect cond. Leather thong dangles at heel. Supple and beautiful with light patina. Lane-stitched and sinew-sewn. 10"L. Est. 2500-4000 **SOLD $2750(99)**

CLASSIC CHEYENNE FULLY-BEADED MOCCASINS c.1870-80
Sinew-sewn and lane-stitched in tiny 13° or smaller beads; white bkgrd. Stylized thunderbird central motif; beautiful alt. color border triangles are t. rose, gr. yellow, and cobalt cuts with tiny squares of t. forest green cuts and cobalt cuts, lt. blue and t. rose with rose w. heart squares. Very dark rawhide soles. Only a few beads missing. Elegant and understated simplicity of design. ONLY drawback is that they are completely stiff. 9"L. Est. 1050-1500 **SOLD $1150(00)**

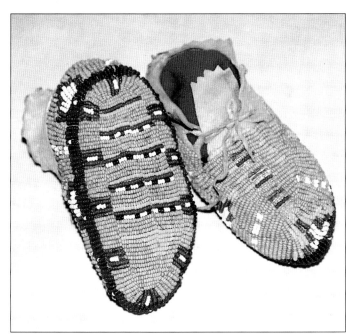

SIOUX CHILD'S FULLY-BEADED CEREMONIAL MOCCASINS c.1880
Possibly Ft. Peck Res., Montana. Lt. blue with lovely gr. yellow, rose w. heart, white, brass metallic cuts and t. dk. cobalt. Apx. 5-6"L. Est. 800-1500

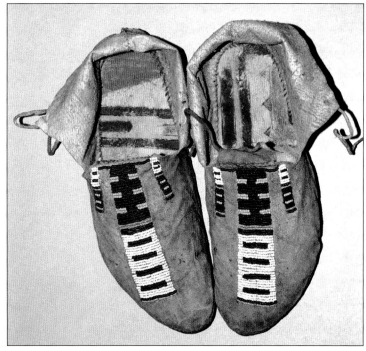

ASSINIBOINE PARTIALLY-BEADED MOCCASINS c.1870
Probably from Ft. Belknap Res. in Montana. Rich unusual colors: t. blue, white, t. green, gr. yellow and Chey. pink in an old geometric design. Painted parfleche rawhide insoles, brightly colored interior. 9.75"L Est. 1000-1750 **SOLD $900(98)**

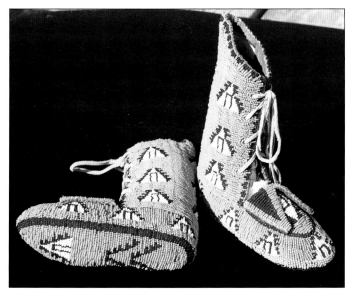

NO. ARAPAHO FULLY-BEADED BABY BOOTS c.1940
Completely covered with beadwork on soles, tongue, and uppers. Lt. blue with t. red, cobalt, and white "tipi" motifs. Front lacings. Comm. leather. Pristine cond. 6"L. x 7"H. Est. 300-450 **SOLD $325(00)**

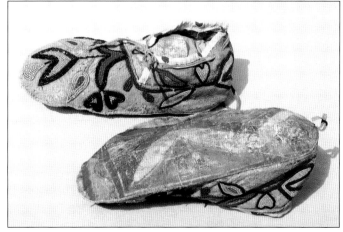

BLACKFEET BEADED MOCCASINS WITH PAINTED PARFLECHE SOLES c.1890
Colorful tri-cut abstract floral: red, grey iris, pink-lined with t. red, gr. yellow, and opal. white. Polka-dot calico bound tops. Fantastic complex painted designs in red, blue, yellow, and green are on the outside bottom soles—usually on the insole as in previous pair. Unusual collectible. Large 11" x WIDE 4.75". Est. 1200-1800 **SOLD $1400(04)**

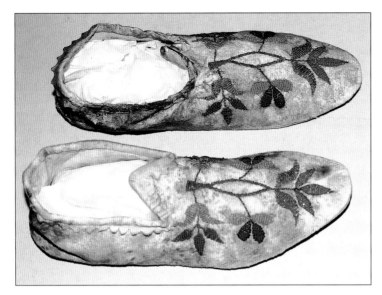

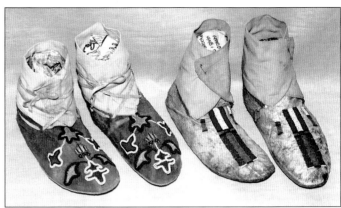

SANTEE SIOUX PARTIALLY BEADED MOCCASINS c.1870
Delicately beaded in characteristic stylized floral symmetrical pattern—very tiny beads: size 20° rose w. hearts, t. lime green, t. rose, t. robin's egg blue, t. gold, cobalt, and periwinkle. Sinew-sewn, not a bead missing. Muslin lined uppers of buckskin. Rawhide soles. Nice patina of age. Ladies "slipper-style" opening. Could be Metis. 9.5"L. Est. 1000-1600 **SOLD $900(02)**

(Left) SANTEE SIOUX or METIS BEADED ANKLE-WRAP MOCCASINS c.1880
Ivan Zimmer Collection. Displayed for many years in his Sod Buster Museum at Moccasin, Montana. Sold at auction in Lewistown, Montana in April 2003. Typical highly desirable abstract floral motif with central patriotic shield. Gorgeous bead colors: t. forest green, t. rose, lt. gr. blue, t. lt. yellow, t. gold, white, t. dk. cobalt, and clear. Rich dk. smoked hide with rawhide soles. Muslin wrap tops with brain-tan thong. 10"L. Est. 950-1800 **SOLD $850(04)**
(Right) EARLY ASSINIBOINE BEADED ANKLE-WRAP MOCCASINS c.1870
From Ft. Peck Res., Montana. Typical rectangle design in beautiful color combination: dk. cobalt, rose w. heart, unusual t. lt. green, white, and untarnished faceted brass metallic beads. Sinew-sewn. Rich age patina on hide and rawhide soles. Delicate red printed calico bound tops and muslin wraps. Exc. cond. 10.5"L. Est. 1200-2000 **SOLD $2600(05)**

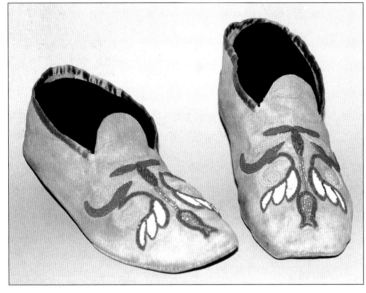

SANTEE SIOUX PARTIALLY-BEADED MOCCASINS c.1890
ALL CUT BEADS delicate stylized floral pattern: brass facets, t. rose, rose w. heart, gr. blue, gr. yellow, white, and cobalt, tiny size 13° and smaller. Lt. blue silk ribbon bound. Rawhide soles show wear. Nice all-over patina. Could also be Metis. Exc. cond. 10"L. Est. 500-1000

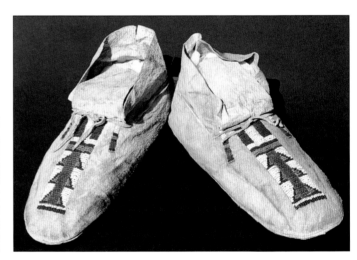

CHEYENNE PARTIALLY-BEADED MOCCASINS c.1910
From Montana. Beautiful contrasting bead colors: white, dk. cobalt, Sioux green, and red w. hearts in rectangular central panel flanked by smaller strips. Welted back seam with two small buckskin dangles. All beads intact. Characteristic sloping profile. Sinew-sewn. Rawhide soles. Rich patina of age. Exc. cond. 10.5"L. Est. 450-675 **SOLD $475(02)**

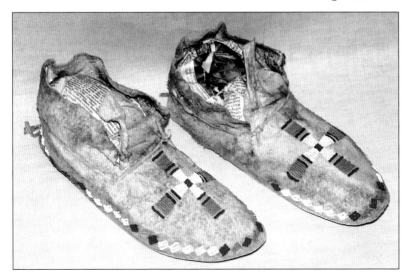

SIOUX PARTIALLY BEADED MOCCASINS c.1880
Ivan Zimmer Collection. Displayed for many years in his Sod Buster Museum at Moccasin, Montana. Sold at auction in Lewistown, Montana in April 2003. India Ink Accession #1080/347. Typical large Maltese cross with checkerboard-style border along seam. Lovely bead colors (every bead intact): apple green, white, red w. heart, dk. cobalt, and gr. yellow. Wonderful age patina on buckskin and rawhide soles. 10"L. Est. 750-1500 **SOLD $850(04)**

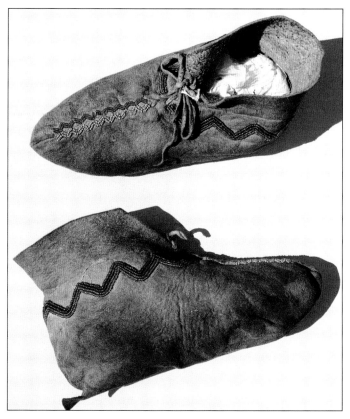

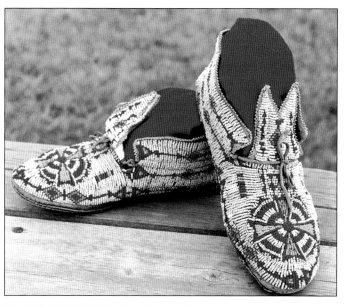

CHOCTAW MOCCASINS c.1900?
RARE. Characteristic configuration and beadwork designs. Soft-sole smoked buckskin with sewn center seam with zig-zag motifs in Chey. pink and t. lt. blue. Tops around ankles have wide zig-zag pattern in transl. pink and t. green. Simple but very nice. Dark patina of age. Worn but exc. cond. 10"L. Est. 600-950

SO. CHEYENNE FULLY-BEADED MOCCASINS c.1940?
Intricate design, lane-stitch pred. white with red, dk. periwinkle, lt. blue, and yellow. Fully-beaded tongue and cuffs have lt. blue bead edging. Sinew-sewn. Soles show wear. Exc. cond. 9.5"L. Est. 440-675 **SOLD 475(98)**

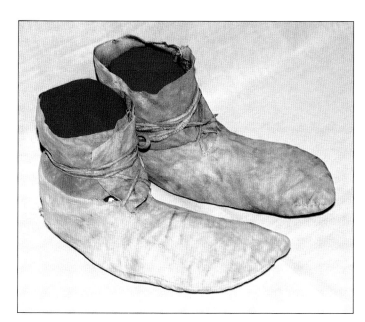

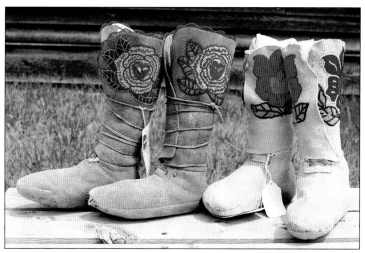

ASSINIBOINE HI-TOP BEADED MOCCASINS c.1940s
Ft. Peck Res., Montana. (Left) Two realistic rose motifs each side of tops (4"H x 6"W): 1) three shades blue; 2) red and porcelain white. Two shades green leaves. Fancy bead edging is t. red cuts and cobalt. Smoked moose hide. Soft sole. 9.5"L. A few holes on soles from wear. Tops exc. cond. Est. 200-350
(Right) Large bold double floral motif each side (5"W and H): 1) t. cobalt with red centers outlined in porc. white; 2) red with yellow-gold centers outlined in t. red. Two shades green leaves. A few holes on soft soles and same hide repairs. Lt. smoked buckskin possibly moose. 12"H. 9.5"L. Est. 150-250

KOOTENAI SIDE SEAM BUCKSKIN MOCCASINS c.1900
Unadorned everyday pair, plain mocs—rarely found because they were usually worn out! Smoked buckskin; ankle-wrap. Back fringed heel tab and interesting side pointing toe construction. Great patina of age, yet still supple. 10.25"L. Est. 250-350 **SOLD $300(04)**

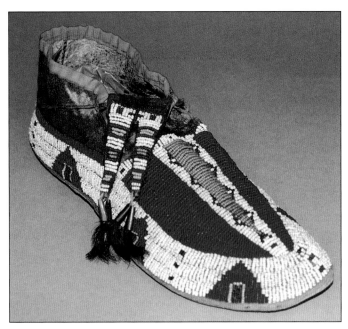

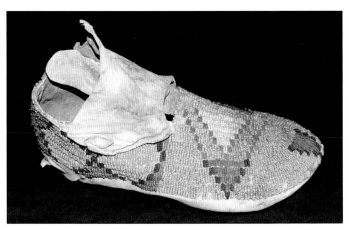

PLATEAU? FULLY-BEADED SINGLE MOCCASIN c.1860
Could be Kootenai. RARE and EARLY SIDE FOLD STYLE. Narrow lane-stitch thread-sewn; all over triangle and diamond pattern. Front is periwinkle with gr. yellow, rose w. heart, dk. cobalt. Side is Sioux green with Chey. pink diamonds outlined in dk. cobalt. Dark patina. VG cond. A few spots of missing beads. Ankle wrap buckskin apx. 2/3 gone. 9"L. Est. 400-900 **SOLD $700(00)**. Pair probably would be worth $1200-1800.

SIOUX SINGLE FULLY-BEADED MOCCASIN c.1870
Lane-stitched and sinew-sewn. Cobalt and white with apple green, rose w. heart, gr. yellow. Classic pattern. Tongue is fully beaded (same colors) with rose horsehair tin cone dangles. All intact. Cuff bound with yellow cotton. Rawhide sole shows wear. Desirable dark patina of age. 11.5"L. Est. 300-600 **SOLD $425(00)**

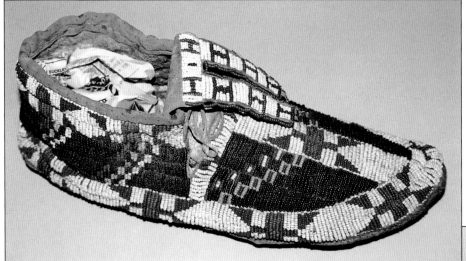

SINGLE CHEYENNE? FULLY-BEADED MOCCASIN c.1885
Wonderful complex design patterns and colors. Pred. t. bottle green and white with motifs in rose w. heart, cobalt, gr. yellow, and apple green. Split tongue same colors edged in rose w. heart. Rawhide soles. Wonderful heavy patina of age. Exc. cond. 11"L. Est. 400-800 **SOLD $550(99)** A complete pair probably worth $2000-3000

ASSINIBOINE-SIOUX? FULLY-BEADED SINGLE MOCCASIN c.1880
Unusual colors and style suggest Fort Peck, Montana. Center piece is solid t. bottle green spot-stitched. Bordered by four lane-stitched rows forming a semi-checkerboard pattern of white, t. bottle green with gr. yellow and C. pink with tiny rows of lt. blue! 5" narrow beaded tongue is checkerboard pattern of t. bottle green and gr. yellow with white edge beading and tiny tin cone ornaments. All beads and tin cones amazingly intact. Sinew-sewn. Red wool cuff binding 40% intact. Rawhide soles. Heel portion is stiff. Dk. age patina. 10"L. Est. 300-450 **SOLD $325(05)**

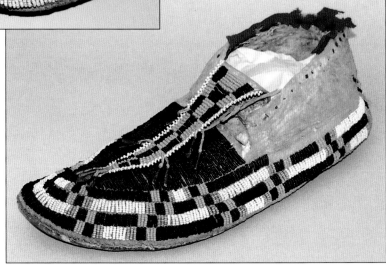

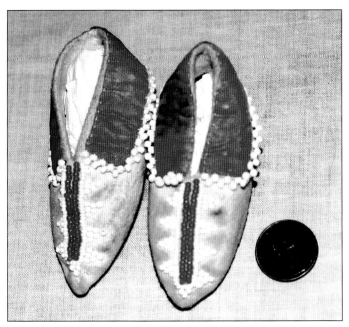

HURON? MINIATURE BEADED MOCCASINS c.1880
Darling pair of front seam, one piece construction, soft supple buckskin. Peach silk ribbon trimmed cuffs, white pony edge-beaded. Front seam disguised with gr. blue bordered with white seed bead trim. Silk intact but has light dirt stain. 3"L. Est. 100-250

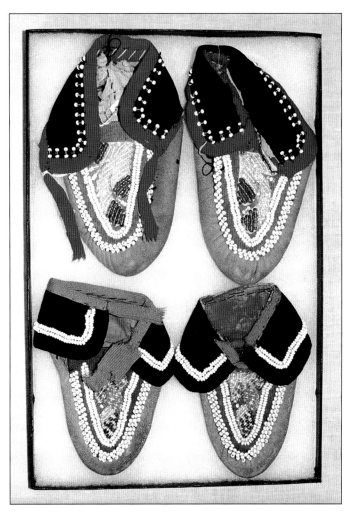

IROQUOIS CHILD'S MOCCASINS c.1880
(Top) Pink cotton vamp outlined in white pony bead borders with embossed design in clear, t. forest green, and t. rose ponies. Black velvet cuffs are red cotton bound with white and t. green border. Red wool Fox braid ties (wool half gone on one). Muslin lined. Cuffs are unattached but complete. Leather and beads all intact. VG cond. 5.5"L. Est. 175-250 **SOLD $150(01)**
(Bottom) Purple cotton vamp outlined in white ponies with embossed motif: robin's egg blue, clear t. rose, and t. gold ponies. Black velvet cuffs have double white pony bead border. Blue wool Fox braid ties: one tattered, other half gone. Red muslin lined. Exc. cond. 4.5"L. Est. 195-250 **SOLD $200(01)**

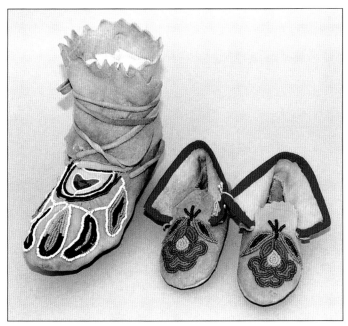

(Left) **SINGLE PRAIRIE STYLE? CHILD'S MOCCASIN** c.1890
Pucker-toe with unusual stylized pastel floral motif outlined in white. Rose w. heart, forest green, and gr. blue cuts on vamp; gr. yellow, black, and lt. blue on toe. Scalloped ankle wrap top. Exc. cond. Shows wear on sole. Double "ears" at back heel. 6.5"L. Est. 200-400 **SOLD $350(05)**
(Right) **SIOUX-METIS BEADED BABY MOCCASINS** c.1890
Collected from Sioux at Devil's Lake, North Dakota. Superb pastel beaded stylized floral designs in pale green, forest green, gr. blue, t. pink, t. rose, and gr. yellow. Cuffs bound with red grosgrain ribbon. Tiny fringes under cuff. Two piece construction. Wonderful collectible. Perfect cond. 4.5"L. Est. 200-350 **SOLD $300(05)**

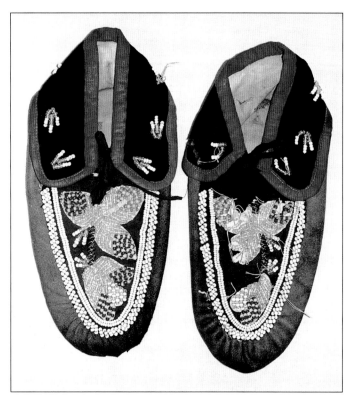

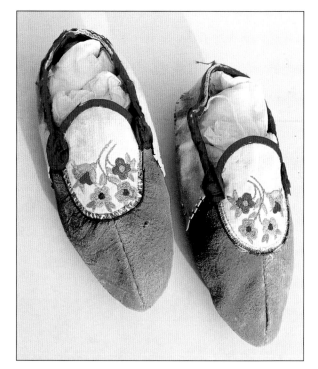

CREE SILK and QUILL EMBROIDERED MOCCASINS c.1900
Smoked moose hide with white deerskin vamps and fancy cut-border cuffs. Vamps have pastel flowers in silk with multi-color plaited quill borders and dk. red quill-wrapped horsehair edge! Quilled trim missing on one, 80% intact on the other. Cobalt blue unfaded (frayed in back) silk ribbon binding and two silk ribbon rosettes each side of vamp. Quite interesting! 9-3/4"L Appear to be never worn. Est. 175-400 **SOLD $275(02)**

IROQUOIS MEN'S MOCCASINS c.1880
Black cotton vamps outlined with white ponies; embossed leaf motif in clear, C. pink, t. rose, gr. yellow, and pumpkin, lt. blue and t. cobalt and t. forest green with white satin basket beads. Black velvet cuffs bound with red muslin. Pony bead designs in clear and white. Fully muslin lined. One moc has apx. 20% beads missing on central vamp; also 2" tear on cuff of same moc. 10.25"L. Includes separate hard soles, used to be stitched on. Est. 300-450

NOTE: Large quantities of Iroquois moccasins were made to order for the Improved Order of the Red Men Fraternal Organization. In 1880, for example, this organization had almost 30,000 members, by 1900 over 200,000 members. There are some with cowhide soles sewn to them which may indicate Red Men use. See Chapter 7, page 175, for catalog illustration, etc.

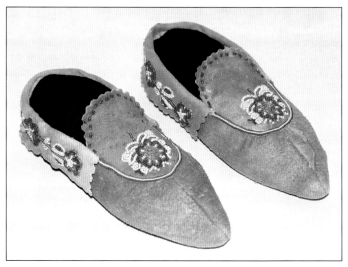

CANADIAN CREE MOOSE HIDE MOCCASINS c.1920
Traditional vamp, soft sole construction with cuffs. Vamp welting is two rows dk. red thread wrapped horsehair with center row white wrapped horsehair. Dark smoked moose hide. Floral beadwork on vamp and along cuffs is tri-cut white lined, red iris, lt. blue, red-orange, and orange floral pattern. Cut scallops along vamp and cuff edges. Show light wear. Exc. cond. 9.5"L. Est. 75-175 **SOLD $85(04)**

CANADIAN METIS MOCCASINS
c.1900
Striking navy wool vamps and red fine wool cuffs. Vamp is outlined with red and green silk wrapped horsehair. Charming spot beadwork vamp borders in white, t. red and green and t. blue. Smoked moose hide. One piece construction. Pinked cuffs. 11"L. Est. 280-500 **SOLD $280(02)**

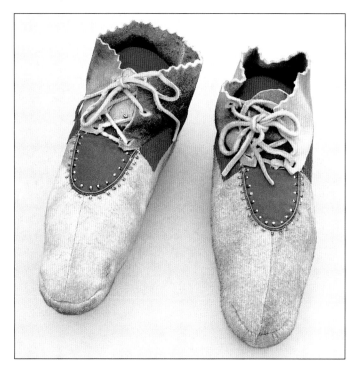

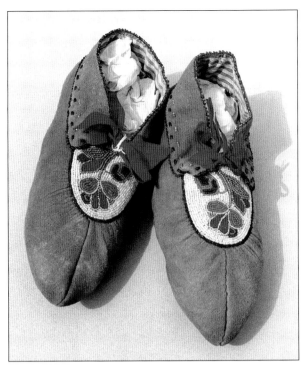

CREE BEADED VAMP MOCCASINS c.1915
Vamps have varied milky white bkgrd. with abstract floral in apple green, t. gold, t. rose, red tri-cut, lt. blue, gr. robin's egg blue, and cobalt. Outlined and edge-beaded in t. cranberry tri-cuts. Spot-stitched cuffs in t. lt. green and t. blue. Red silk ribbon ties. Cuffs lined with narrow black and white striped cotton. Beautiful smoked hide. Never worn. 10.5"L. Est. 250-450 **SOLD** $250(03)

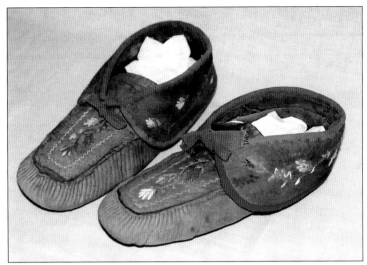

HURON MOOSEHAIR EMBROIDERED MOCCASINS c.1840
Delicately colored floral embroidery on vamps and cuffs. Unmatched pair by the same maker. Comm. dk. brown hide, which is very common on early Iroquois/Huron style mocs. Red twill tape binding and ties. One is 9.75"L, the other is 9"L. Minor bug damage to three flowers on the cuffs, otherwise exc. cond. Very rare style of moc. Est. 175-400 **SOLD** $200(04)

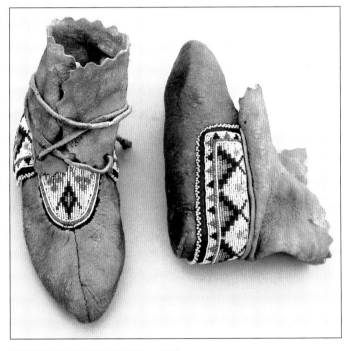

CREE BEADED MOCCASINS c.1910
Beautiful beaded cuffs and vamp in white with t. red, gr. blue, and gr. yellow, t. green step-diamonds; red silk bound with lt. blue bead edging. Vamps (same colors) have remnants of horsehair from wrapped quillwork border. Pinked ankle wrap, soft sole deer hide. VG cond. 9"L. Est. 250-500 **SOLD** $250(02)

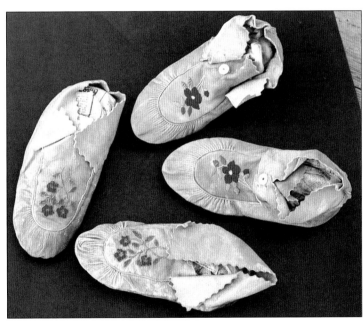

NASKAPI/MONTAGNAIS MOCCASINS c.1880
Collected by the missionary Rev. Callender from Makkovik, Labrador. Ex-Colin Taylor Collection, England. (Left) Appears to be wool embroidery delicately "enhanced" with painted colors on threads. 8.75"L. Est. 225-325 (Right) Soft-soled buckskin with welted vamps decorated with silk embroidered leaves and wool flowers. "Pinked" ankle wrap buckskin tops. Mother-of-pearl button closing. 9.5"L. Never worn. Exc. cond. Pristine, showing age but wearable. Est. 250-350 **SOLD** $275(02)

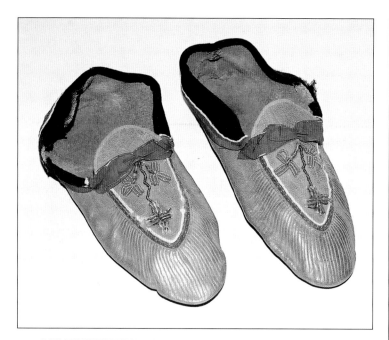

CANADIAN PARTIALLY-BEADED MOCCASINS c.1900
Montagnai from James Bay, Canada. Interesting brown comm. leather has a smooth surface with distinct "pucker marks" around vamp. Vamp beadwork is gr. blue, t. gold, and t. forest green. Vamp and cuffs have red and white narrow middy braid trim; black wool cuffs bound with purple silk ribbon forms ties. Green cotton bound vamp top. 9.5"L. Est. 200-550 **SOLD $175(03)**

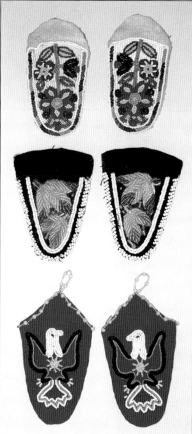

Bottom to top:
TLINGIT MOCCASIN VAMPS c.1900
Heavy red wool felt with partially-beaded symmetrical eagle motif: white, gr. blue, black, and gr. yellow. Top has clear and milky white loop bead embellishment. One tiny moth hole in each; otherwise pristine cond. 5.5" x 3.25"W. Est. 75-150 pr. **SOLD $90(99)**
IROQUOIS MOCCASIN VAMPS c.1890
Embossed clear ponies with pastels outlined in white seeds. Black velvet; paper backed and bordered with white ponies. Exc. cond. 5" x 3"W. Est. 90-150 pr. **SOLD $80(99)**
WOODLANDS MOCCASIN VAMPS c.1900
Lavish and colorful tri-cut and seed bead floral motifs; white bkgrd on buckskin. A few white beads on border gone, otherwise completely intact. 5" x 3" Est. 80-150 pr. **SOLD $85(99)**

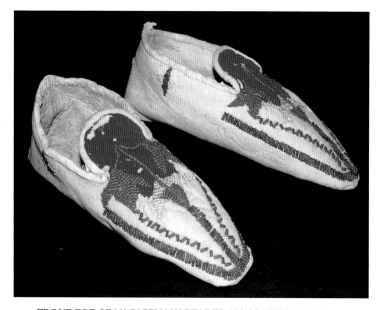

FRONT TOE SEAM PARTIALLY-BEADED MOCCASINS c.1885?
RARE. The tag reads: *"Doll mocassins* [sic] *made by Klamath Indian children and brought into Ft. Klamath, Ore. and presented to Bessie...they received sugar sometimes a doll or other toy. about 1885."* More likely from Canada, i.e., Tahltan or similar tribe.* Very rare front seam style with gr. blue, t. red, clear and opal. white leaf and diag. stripe designs and red wool inlay. Morning star on either side with stripe on heel. Buckskin bound opening. Soft-sole 1 piece construction. 8.5"L. A few moth holes on cloth otherwise exc. supple cond. Est. 450-900 **SOLD $450(00)**
 *See Duncan, Kate C. *No. Athapascan Art.* Seattle: University of Washington Press, 1989: 170.

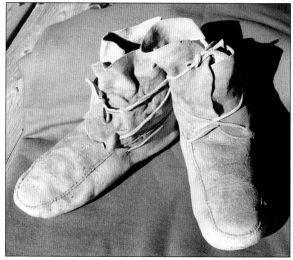

CREE PLAIN BUCKSKIN MOCCASINS c.1900
Characteristic soft-sole, welted vamp ankle-wrap style. Nice age patina. Exc. cond. 11"L. Est. 135-250 **SOLD $100(98)**

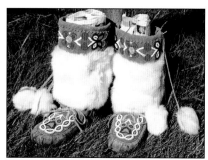

CANADIAN CREE BEADED MOOSE HIDE MUKLUKS
Contemp.
Brightly colored stylized floral beadwork on vamp and top. White rabbit "leggings" and tassels. Soft sole commercial hide looks like brain-tan. Minor sole wear. Cotton lined. 11"L. Exc. cond. 14"H. Est. 200-300 **SOLD $200(02)**

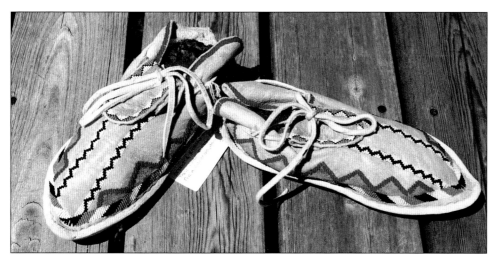

APACHE MOCCASINS Contemp.
Expertly made in classic design: white, black, t. red, and lt. green. Zig-zag red border is red ochred inside; rest of moc is yellow ochred. Tongue has beadwork border. Shape and beadwork style is identifiably Apache and has heavy alum? tan turned up sole. Never worn, pristine cond. Soft brain-tan. Fits 10"L. foot. Est. 395-650 **SOLD $475(99)**

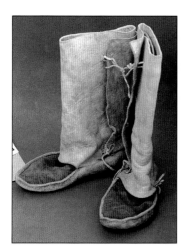

SOUTHWEST MOCCASIN BOOT c.1940
Pointed toes suggest Apache. This traditional style has been worn for hundreds of years in the southwest. Thick cowhide soles, rust red uppers and heavy brain-tan elk? hide wraps are sewn into the mocs and form a legging. (9"H.) Buckskin ties. 9" soles (for 8.5+ foot). Show wear but are extremely durable. Est. 185-250

Ornamented Robes and Blankets

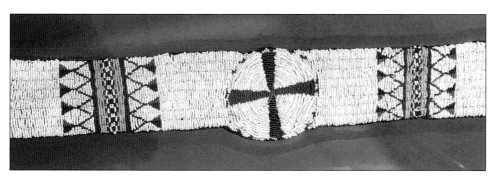

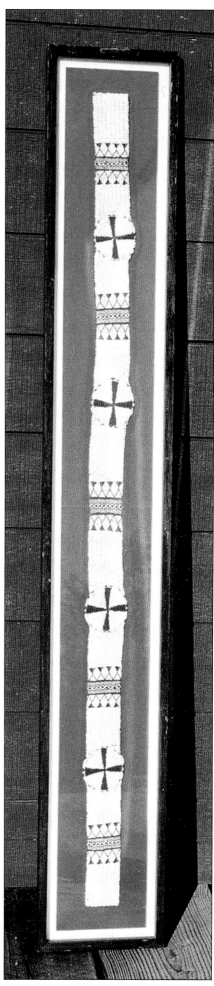

CLASSIC SIOUX BEADED BLANKET STRIP, FRAMED c.1880
White blkgrd. with gorgeous rose w. hearts and cobalt crosses on 3-5/8" rosettes; narrow border around rosettes is same colors with small triangles. Intricate geometric motifs are gr. yellow and Sioux green as well as cobalt and rose w. heart. 3"W strip is eight lanes wide; sinew-sewn "lazy" or lane-stitched. Mounted on medium cobalt blue textured matt, 7.5"W x 67.5"L. White border under matt. Dk. stained solid wood custom frame, 10.75"W x 71.5"L. Exc. cond. Est. 2250-3500 **SOLD $2550(03)**

INDIGO DYED "SAVED LIST" TRADECLOTH BLANKET c.1880-1900
Came from a Nez Perce-Cayuse family in Washington, where it was stored in a trunk for many years. Highly desirable deep blue color and interesting wide (1.5") white selvedge. 72"L (selvedge side) x 51"W. Dense unworn nap. Has three spots of mothing, one apx. 1"L. Otherwise exc. cond. Est. 2000-2500 **SOLD $2250(01)**

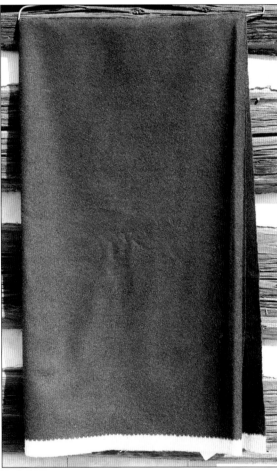

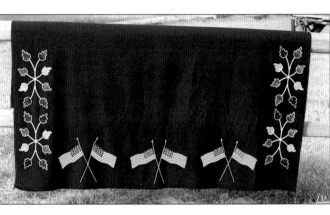

SIMILAR TO ABOVE. *Also from a Plateau Indian family, stored away for future use.* Apx. two yds. long x 52"W. Selvedge apx. 1-1/4"W. Est. 1800-2500 **SOLD $2000(02)**

OSAGE COURTING BLANKET c.1910-20
"Super fine" broadcloth trade wool with unusual four narrow yellow stripe selvedge. Dynamic design elements expertly made. Crossed American flags are red, white, and blue with t. yellow staffs; typical Osage stylized floral patterns on either side are t. gold, red, t. green, and black iris outlined in white. Magenta silk ribbon bound (2" piece torn away). Pristine cond. 70"W x 58"H. Est. 1250-2000 **SOLD $1300(99)**

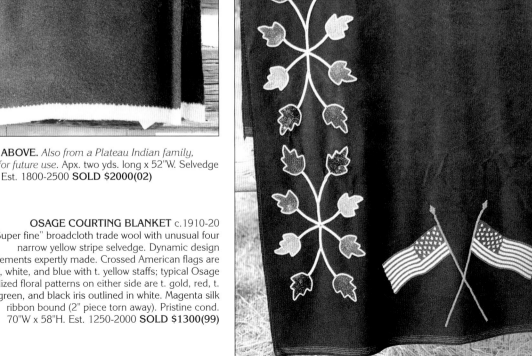

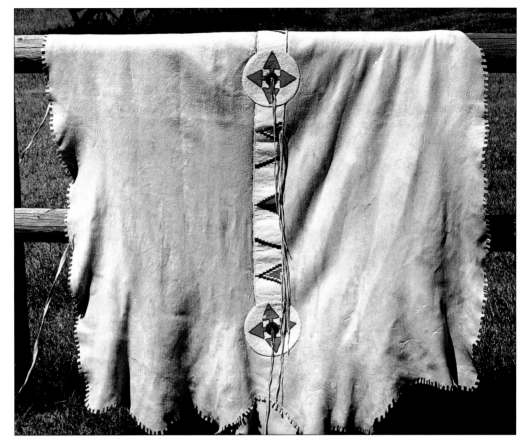

PLATEAU ELK ROBE WITH BEADED STRIP c.1940
Probably Yakima in Washington state. Classic large white brain-tanned wearing robe with delicately cut edges. Appliqué beaded strip is white with orange, outlined in cobalt rosettes; step-triangles are dk. cobalt, apple green with red. Superb item rarely seen for sale. Est. 2500-4000 **SOLD $2200(00)**

Dance Outfits

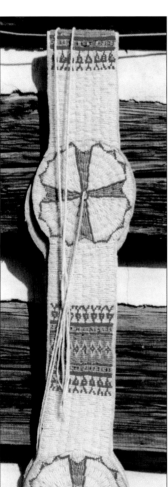

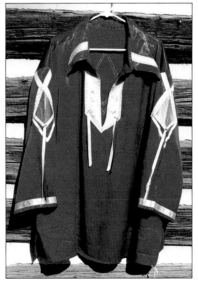

PLATEAU SIOUX-STYLE BLANKET STRIP This lane-stitched piece has predominantly turquoise and red design elements with pale blue and lt. green lane. Atypical colors and thread-sewing are clues to its origins. A Sioux piece would probably be sinew-sewn with classic contrasting dark bead colors, as on page 57. Est. 900-1250 **SOLD $900(98)**

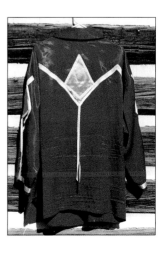

FLATHEAD MAN'S RIBBON SHIRT c.1970
Worn by Alec Vanderburg and made by the late Agnes Vanderburg, Flathead Res., Arlee, Montana. Deep burgundy rayon with tasteful appliqué of wide turq. with turq. and white geom. pattern and white on lapel, back, and sleeves. Streamers have additional red ribbons. Exc. cond. 60" chest x 34"L. Est. 40-85 **SOLD $75(99)**

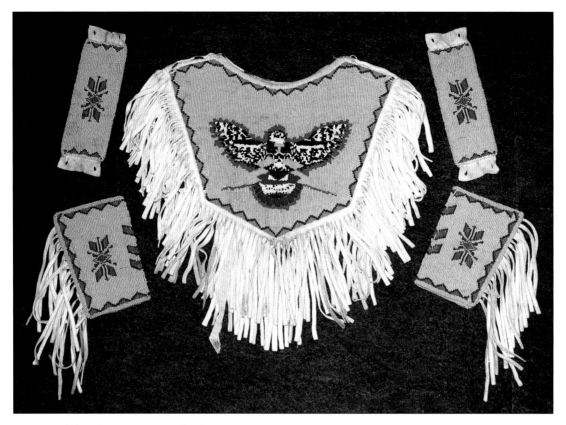

NO. PLAINS GIRL'S POWWOW DANCE SET c.1990
Fully-beaded "lane" stitched: pale blue bkgrd. cape, armbands, and cuffs. Fringed buckskin cape has eagle motif in brown and white, with yellow and red outlined in periwinkle. Plain buckskin front. Yellow cotton lined. All pieces have triangle border motif in orange and cobalt. Armbands 8"W. Fringed cuffs are 8"W. Exc. cond. All beads intact. Very light use. Est. 175-300 **SOLD $200(03)**

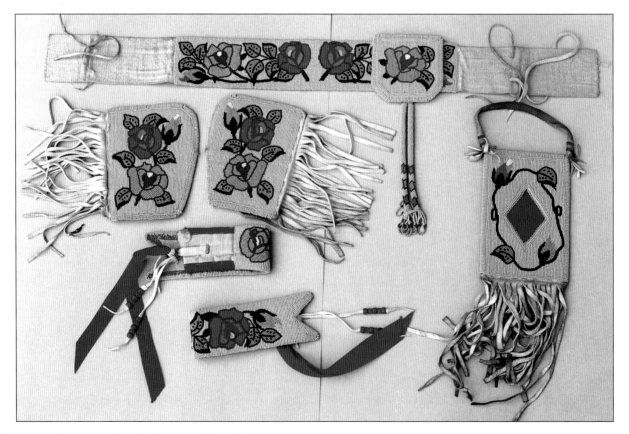

CROW FULLY-BEADED MAN'S DANCE SET Contemp.
Beautiful Crow pale blue appliqué bkgrd. Set includes mirror bag (beaded on both sides), belt and attached pouch with peyote stitch drops, armbands with red ribbons, and cuffs with white buckskin fringes. Floral motif in tasteful pink, orange, outlined with cobalt and burgundy; rolled beaded edges. Masterfully beaded. Exc. cond. Belt: 26" waist x 3.25"W. Armbands fit 10" circumference. Cuffs have 9" bottom opening. Est. 625-950 **SOLD $500(99)**

2. Containers, Pouches, and Bags (Quilled, Beaded, and Painted)

Large Bags and Pipe Bags

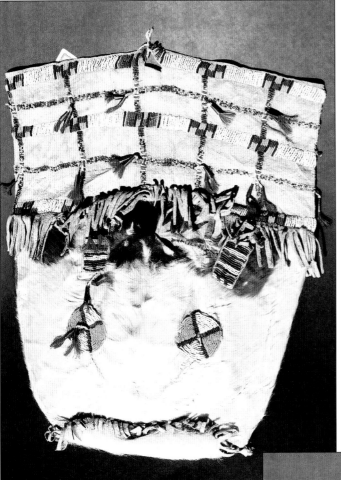

CHIPPEWA GREAT LAKES BANDOLIER BAG c.1890 Characteristic profuse stylized floral motifs in rich colors, including robin's egg blue, t. pink, C. pink, amethyst, four shades of green, etc. Lower panel on black velvet, re-bound with blue twill tape. Bottom fringe is gold and turq. basket beads with faded purple yarn tassels. A few basket beads missing, otherwise exc. cond. Hangs apx. 48"L x 15"W. Est. 1500-2000 **SOLD** $1575(99)

RARE SIOUX CALF HEAD MEDICINE BAG c.1880 *So. Dakota. Used by the Sioux and Cheyenne to hold sacred medicine articles. We have heard that these bags might have been used by secret beading/quilling societies and in a special dance.* Buckskin top and hair-on calf bottom. Bottom has beaded circles for eyes and tabs for ears, both sides of bag, from which hang tin cone dangles with red horse hair. Apple green, Sioux green, cobalt, C. pink, rose w. heart, t. rose, and lt. blues on one side; other side has white, dk. blues, lime green, and t. rose. Upper panel has lane-stitched lines: white, rose w. heart, gr. yellow, Sioux green, and three shades of dk. blue. In between these lanes are 1/4" lanes with "salt and pepper" mixed old seed bead colors. Tin cones with red horsehair at intersecting lanes. Buckskin fringes at middle seam and around bottom. Only a few tin cones are missing. Wonderful patina and exc. cond. 18"H x 15"W. Est. 2500-4000 SOLD $1900(02)

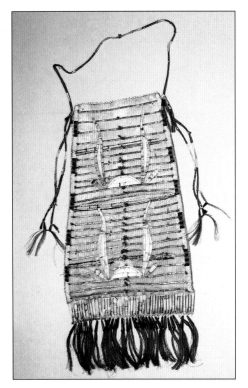 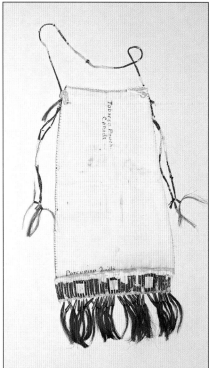

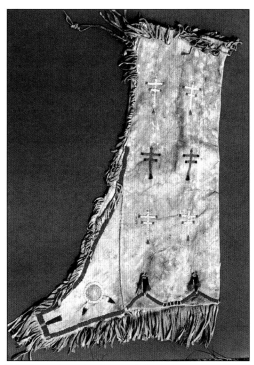

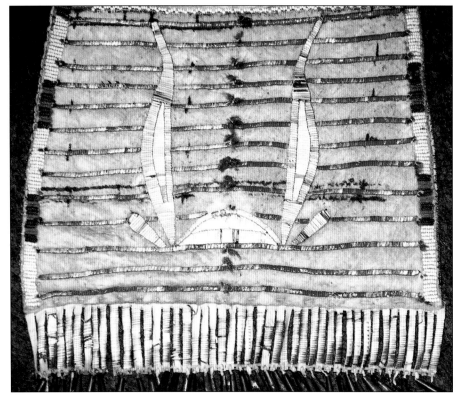

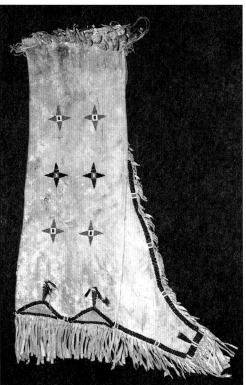

SIOUX QUILLED TOBACCO POUCH c. 1880?

RARE. Double front buckskin pockets with highly desirable simple band quilled stylized antler/horn symbols and quilled red line background. *These symbols are a source of controversy and discussion. Some scholars and Indian elders believe they could symbolize antelope, deer, or elk spike antlers. Recently, a theory has been proposed that these may be abstract female buffalo horns with ears and as such are a female protective symbol. The red line motifs are usually considered a female protective symbol.* Bottom rawhide quilled slats have unfaded red horsehair tin cone suspensions. Vertical lane-stitched tiny seed beaded strips are white, Sioux green, rose w. hearts, and dk. cobalt. White edge-beaded pockets. All sinew-sewn. Buckskin hanger and side thongs are alt. red and white quill-wrapped with faded purple horsehair/tin cone drops. Canvas backing was long ago labeled with India ink: *"Tobacco Pouch, Canada"* and *"Porcupine Quills."* Sewn quillwork on this piece is apx. 95% intact. Red is fairly bright but the purple horn outline and yellow are faded. The front of the lower quilled slats is faded but back is bright and unfaded. Overall very good cond. with excellent patina from age. 15"L + 5" lower panel with drops. 6.5" top W x 9.5" bottom W. Est. 2500-4000 **SOLD $2600**(04)

CHEYENNE BEADED PIPE BAG c. 1880

RARE "LEGGING" STYLE. Characteristic stylized dragonfly on one side and morning star motifs on the other side; Arapaho (lt.) green, black and white. T. dk. cobalt lane border with t. emerald green. One side extension has white beaded circle with green painted interior. Also, lower hem has red-ochre within beadwork. Buckskin fringed on two sides, 1"L. Bottom fringes 2.5"L. Top has bead-edging in alt. white, Arapaho green, and cobalt. Sinew-sewn. Superb cond. Beautiful age patina. Supple buckskin. 20"L + fringes; width including side extensions is 14". Est. 3500-5000 **SOLD $3200**(04)

Lanford, Benson, 1995. "Collecting American Indian Art, Part 2," *Tribal Arts Magazine* Vol. II, #1: 66. Color photo of a similar bag given by Sitting Bull to Philip Bullhead in 1883 at Fort Yates, Dakota Territory. now in the No. Dakota State Hist. Soc.

SIOUX/CHEYENNE BEADED PIPE BAG
c.1870
RARE "LEGGING" STYLE. Sinew-sewn, lane-stitched subtle colors: lt. blue, dk. cobalt, rose w. heart and white (same both sides). Supple buckskin with pinked edges; side extensions also have perforations. Faded inked lettering one side, *"TOBACCO PIPEBAG."* 16"L x 6" extensions 20". Est. 1200-2500 **SOLD $1000(04)** See Viola, Herman J. *Little Bighorn Remembered.* Times Books, NYC, 1999: 65. Photo of No Two Horns, close companion of Sitting Bull, holding a similar bag.

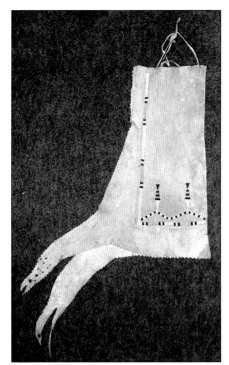

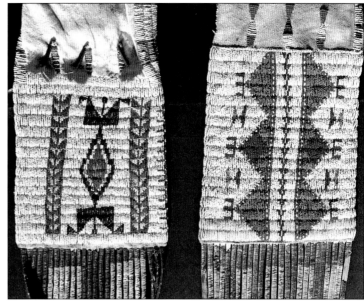

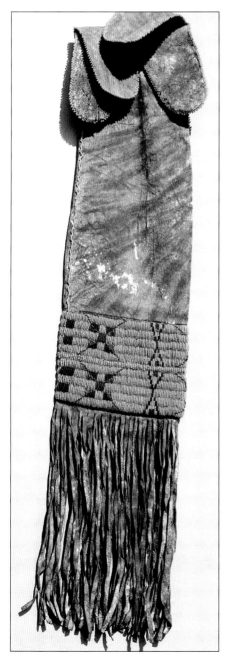

EARLY ASSINIBOINE or BLACKFEET BEADED PIPE BAG
c.1870
Use of pastel colors is characteristic of Ft. Peck Montana Assiniboine, whereas the four tab top flaps are typical of Blackfoot pipe bags and geometric motifs are similar to those used by the Arapaho. Lane-stitched in very tiny beads, probably size 18°. Transl. robin's egg blue background with subtle pastel geometric motifs in rose-red w. hearts, gr. yellow, t. forest green, and bright untarnished brass metallic beads with gr. pale blue center stripe. All beads intact. Same tiny pale blue beads edge top flaps and side of bag. Supple but old patina buckskin bag is completely red ochred as are bottom fringes. Beaded panel is 5"W x 3.5". Hangs 28"L. Exc. cond. Est. 2000-3000 **SOLD $1800(04)**
See pipe bag examples in *Four Winds Guide to Indian Artifacts*, pp. 80-84.

(Left) SIOUX BEADED PIPE BAG WITH QUILLED SLATS c.1890
Designs and bead colors suggest Ft. Peck-Sioux, Montana. White bkgrd. lane-stitched and sinew-sewn with typical complex geometric patterns in gr. red, rose w. heart, orange, amethyst, t. lt. green, apple green, brass facets, cobalt, apple green, and t. red. Different design panels each side (7.5"W x 8"H). Three lane vertical strips and one lane top strip. Six tin cones stuffed with red yarn. Quilled panels are red with yellow and white box pattern. Side slats have a few quills broken or loose but all 100% intact (7" x 4"). Bottom buckskin fringe apx. 9"L. Hide supple and clean. 33" total L. Exc. cond. Est. 2000-3500 **SOLD $1750(00)** See *Four Winds Guide to Indian Artifacts* for documented similar example, p.82.
(Right) SIOUX BEADED PIPE BAG WITH QUILLED SLATS c.1880?
Classic style; lane-stitched and sinew-sewn. White bkgrd. different designs each side: 1) central diamonds with triangles in red w. heart, cobalt, Sioux green, gr. yellow, and brass facets; 2) same colors with sideways triangles along central vertical panel. Quilled slat panel (8"W x 5.5") is bright red, with faded purple and bright yellow classic early box pattern. Rawhide is earlier painted parfleche. 11" buckskin fringe. 8.25"W x apx. 38"L. Heavy supple hide beadwork is pristine. Quillwork 80% intact. Years ago, to "enhance" missing quill areas, red nail polish? was applied. Est. 3000-5000

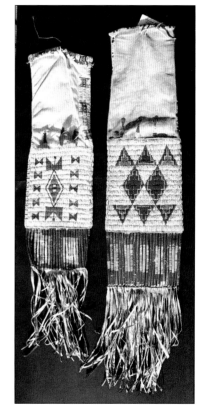

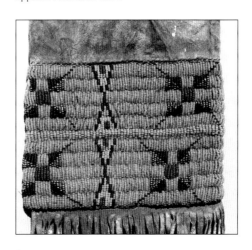

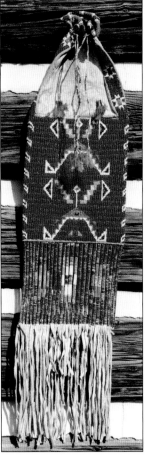
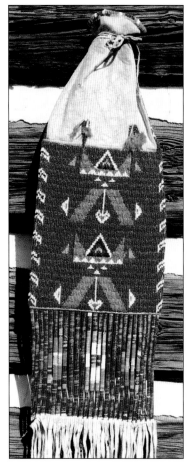
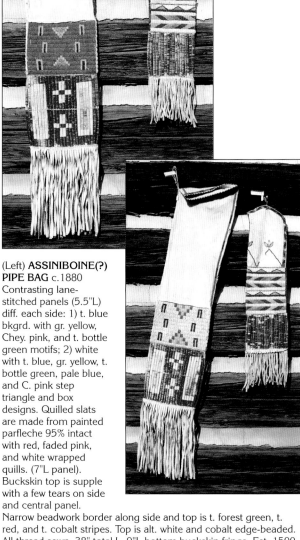

SIOUX FULLY-BEADED PIPE BAG WITH QUILLED SLATS c.1890-1900
Superb workmanship and color combinations. Unusual red-orange* bkgrd. with atypical geometric motifs (similar both sides) in gr. blue, cobalt, pumpkin, white, Chey. pink, t. brown, and touches of gr. yellow, Sioux green, and metallic brass. Quilled slats are a pred. matching red range with purple, turquoise, white, and orange box motif. Long quill-wrapped thongs at rolled beaded top are purple with tiny tin cone/yellow fluff suspensions. Three additional prs. of tin cones/yellow fluffs above beaded panels. 33"L x 8"W. Exc. patina and cond. Est. 3000-5000 **SOLD $3200(99)**
See bead chart on p. 7, color #808.

(Left) **ASSINIBOINE(?) PIPE BAG** c.1880
Contrasting lane-stitched panels (5.5"L) diff. each side: 1) t. blue bkgrd. with gr. yellow, Chey. pink, and t. bottle green motifs; 2) white with t. blue, gr. yellow, t. bottle green, pale blue, and C. pink step triangle and box designs. Quilled slats are made from painted parfleche 95% intact with red, faded pink, and white wrapped quills. (7"L panel). Buckskin top is supple with a few tears on side and central panel. Narrow beadwork border along side and top is t. forest green, t. red, and t. cobalt stripes. Top is alt. white and cobalt edge-beaded. All thread sewn. 38" total L. 9"L bottom buckskin fringe. Est. 1500-2500

(Right) **CROW(?) PIPE BAG** c.1890
Unusual diagonal stripe and triangle motif lane-stitched panels with white stripes in pastel colors: Crow pink, periwinkle, cobalt, t. rose, gr. yellow, and gr. robin's egg blue; rolled edge and top border are t. red, clear and t. forest green. Leaf motif and triangles in similar colors on partially-beaded top. Quill-wrapped rawhide slats are red and apx. 90% intact. 22" total L. x 5.25"W. Buckskin is supple with lt. patina. A few t. red and clear beads missing on partially-beaded top; otherwise exc. cond. Est. 2500-3500 **SOLD $2500(99)**

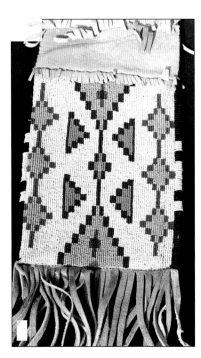
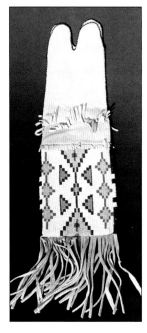

BLACKFOOT FULLY-BEADED PIPE BAG c.1900
Very striking beaded panels: white bkgrd. with lt. blue, pumpkin, Chey. pink, dk. cobalt, dk. gr. blue, and rose w. heart step-triangle and diamond patterns. Same both sides. Rolled beaded edges in alt. white and black. Top and sides have black edge-beaded trim. Characteristic four tab top with row of short fringe on buckskin top, 6"L buckskin fringes on bottom. Thread-sewn. All beadwork intact. Buckskin soft and supple. 24"L x 6"W. Est. 1200-1750 **SOLD $1200(98)**

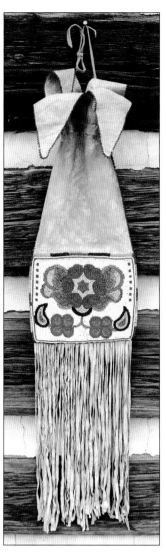

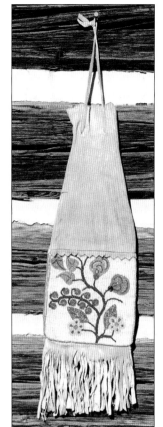

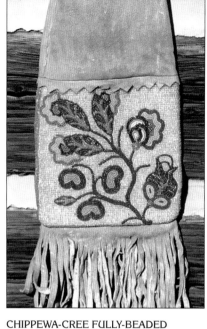

CREE BEADED PIPE BAG c.1880
This is a prime example of the profuse floral style of this tribe. Beautiful symmetrical pattern different each side. Rose w. heart, five shades t. and gr. greens, t. rose, C. pink, gr. blue, gr. yellow, periwinkle, t. gray, lt. blue, and black. Note unusual addition of tiny geometric blocks. Entirely edged in bottle green. Panel has roll beaded edge of alt. blocks of greens, black, and opal clear. Very supple hide body and fringe. Hangs apx. 31"L. Panel 7"W x apx. 5.5"L. Pristine cond. Est. 3000-4500

CHIPPEWA-CREE FULLY-BEADED PIPE BAG c.1890?
Clear bkgrd. stylized floral beaded panels (different each side) in rich and subtle pastel hues: gr. yellow, pumpkin, gr. blue, t. rose, Crow pink, t. cobalt, periwinkle, four diff. greens, brick and brass facets bordered by t. gold. Smoked buckskin soft and supple, 5" bottom fringes. 6.75" x 22" total L. Exc. cond. Est. 700-1100 **SOLD $850(98)**

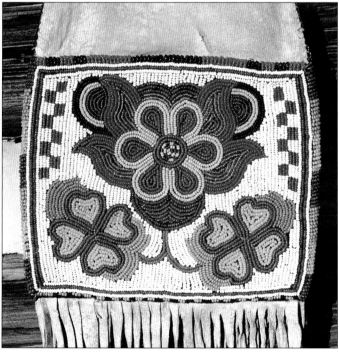

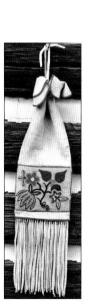

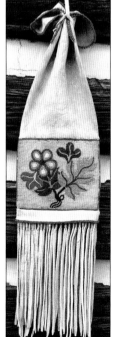

CREE BEADED PIPE BAG c.1890
Collected on the Rocky Boy Res. in Montana. Classic stylized asymmetric floral designs, different each side in apple green, t. emerald green, cobalt, lt. blue, Crow pink, red w. heart, rose w. heart, t. amethyst, brass facets, white, gr, lt. periwinkle, gr. yellow, pumpkin, and black. Bottom and top edge-beaded in gr. blue. Clear bead appliqué bkgrd. Heavy hide appears to be lt. smoked elk. Bottom fringes have clear basket beads at top. Hangs 29"L. Beaded panels are 7"W x 5.5"H. Beautiful lt. patina of age. Est. 1200-1800 **SOLD $1200(03)**

65

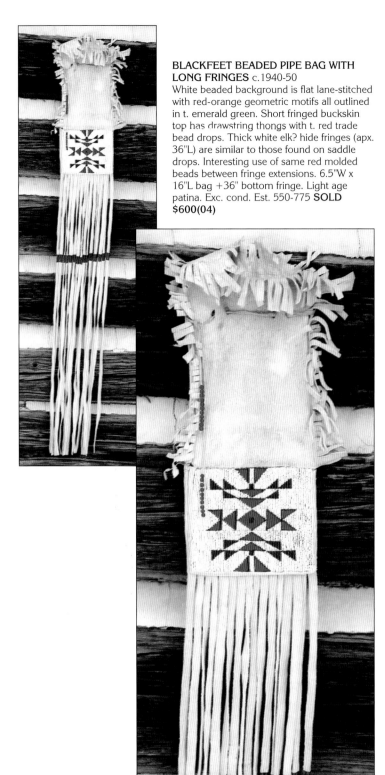

BLACKFEET BEADED PIPE BAG WITH LONG FRINGES c.1940-50

White beaded background is flat lane-stitched with red-orange geometric motifs all outlined in t. emerald green. Short fringed buckskin top has drawstring thongs with t. red trade bead drops. Thick white elk? hide fringes (apx. 36"L) are similar to those found on saddle drops. Interesting use of same red molded beads between fringe extensions. 6.5"W x 16"L bag +36" bottom fringe. Light age patina. Exc. cond. Est. 550-775 **SOLD** **$600(04)**

Plateau Flat Bags

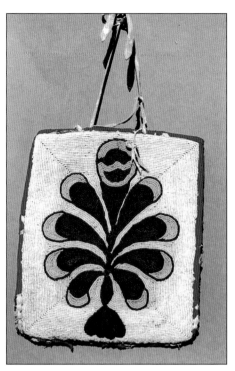

EARLY FULLY-BEADED FLAT BAG c.1870?

Simple yet beautiful abstract symmetrical design in t. dk. navy and gr. yellow with varying gr. white semi-contoured background. Red wool bound (70% intact). Back navy wool cut away to reveal floral calico lining. Buckskin handles. Fantastic patina of age! 8.5" x 10.5"H. Est. 800-1500

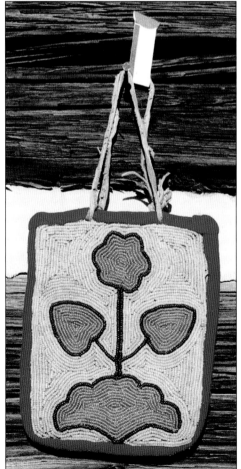

EARLY CONTOURED FLAT BAG c.1870?

RARE. Opal. white contoured bkgrd. with abstract floral in t. yellow outlined with t. bottle green. Red wool bound. Gold wool felt backed. Blk. and white calico lined. Exc. cond. Nice patina. 6"H x 5"W. Est. 600-850 **SOLD** **$435(98)**

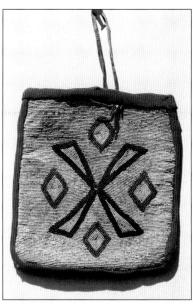

EARLY BEADED FLAT BAG c.1880?
Collected on the Flathead Res., Montana.
Typical simple appliqué-stitched geometrics with red wool binding. Fully-beaded in Crow pink bkgrd. rose w. hearts, gr. yellow, and t. dk. cobalt. Exc. cond. 8.5" x 9"H. Est. 750-900

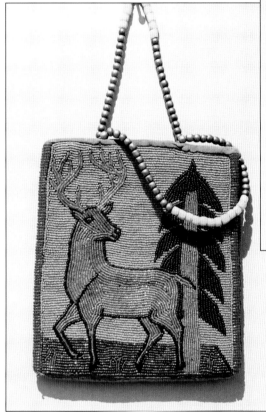

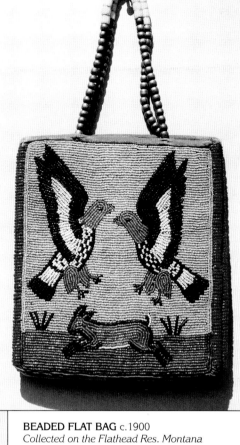

BEADED FLAT BAG c.1900
Collected on the Flathead Res. Montana from a Salish-Puyallup Indian family. Fully beaded both sides in very desirable pictorial style: 1) fanciful hawks and deer are white, tri-cuts in black and t. gold. Lt. blue sky; t. olive tri-cut ground; 2) med. blue sky with graceful deer in tri-cut golds and brown and stylized pink tree in t. bottle green and amethyst. Red tri-cut rolled beaded sides. Buckskin bound top and bottom. Handle has unusual pale blue Russians and brass beads. Lining has two different calico prints with pocket each side. 7"W x 7.5"H. Exc. cond. Nice age patina. Est. 900-1500

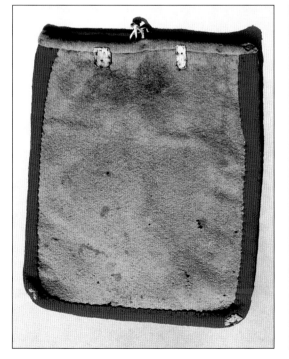

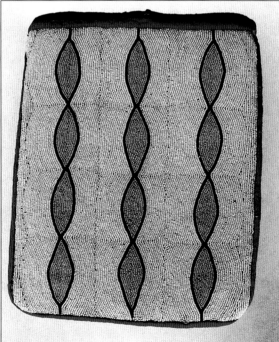

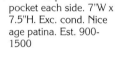

EARLY CONTOUR FLAT BAG c.1860
Italian irregular tiny seed bead (13°-15°) background is pale blue contoured around the Crow pink vertical elliptical motifs outlined in black. Red wool bound with typical faded green wool back. Some mothing in back and binding. 10"H x 9"W. Remnants of buckskin straps on back. Est. 850-1800 **SOLD $850(04)**

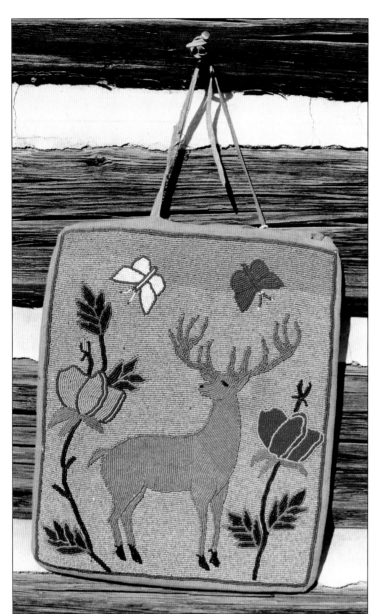

FULLY-BEADED ELK PICTORIAL FLAT BAG
c.1890
Highly desirable elk subject with beautiful lt. and med. blue mixed color bkgrd. Elk is t. gold; flowers are Crow pink and t. rose; butterflies white and rose w. heart outlined in cobalt. Dk. blue calico lined. Rose flannel backed. 12.5"W x 14.5"H. Est. 1000-1500 **SOLD $1200(98)**

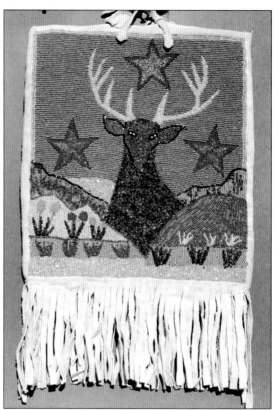

LARGE FULLY-BEADED PICTORIAL BAG c.1920
Desirable elk and star motifs in tri-cut browns, dk. iris clear and t. red. Background is med. blue with hills in turquoise, pale and med. green. Charming flowers are red, yellows, and yellow-orange. Buckskin bound and 5"L bottom fringes. Burgundy corduroy backed. Turquoise velveteen lined. Exc. cond. 11.5"W x 13"L. Est. 850-1600

NEZ PERCE FULLY-BEADED FLAT BAG
c.1900
Appliqué beaded highly desirable elk motif. Two elk are in a forest of Sioux green and aqua pine trees on a transl. robin's egg blue satin beaded bkgrd. Gr. yellow and pumpkin top border. Elk are in 3-cut transl. brown and bronze with t. amethyst antlers. Tiny flowers in foreground are white, cobalt red, and cranberry. Old canvas back. Buckskin bound and bottom fringes (6"L) with old monie cowries. Very nice age patina. Panel is 10.5" x 12"H. Exc. cond. Est. 900-1500

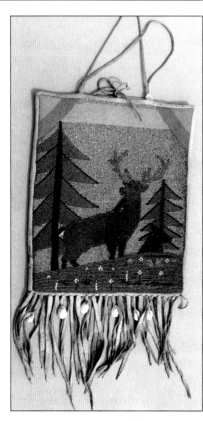

FULLY-BEADED ELK PICTORIAL BAG
c.1920
Highly desirable design is appliqué white bkgrd. with elk in three shades of t. golds. Stylized flowers are gr. red, pink-lined tri-cut, t. cranberry tri-cut, t. indigo, lt. blue satin. Leaves are three shades of t. green outlined in black iris tri-cuts. Beautiful subtle color combinations. Bound with soft gold worn velveteen. Grey twill woven back. Lined with floral calico. Buckskin handles. 10.5"W x 13"H. Exc. cond. Est. 750-1200 **SOLD $750(01)**

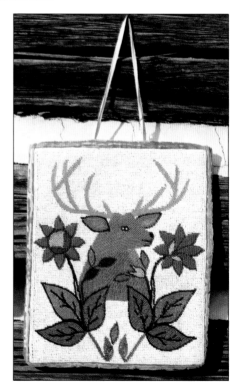

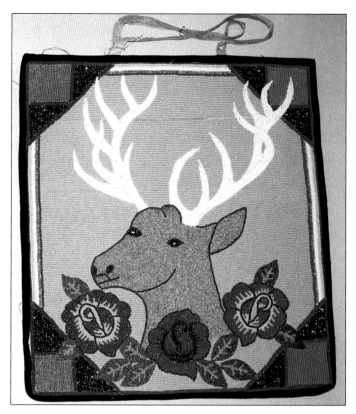

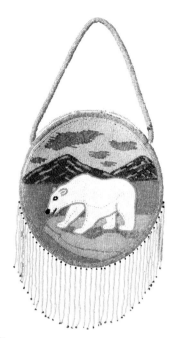

PICTORIAL FULLY-BEADED BAG
c.1910-20
Fabulous designs expertly beaded: 1) deer in forest with fallen tree. ALL CUTS except for the deer. Lt. blue sky, t. green grass with t. dk. green, white, t. amethyst, etc.; 2) polar bear on ice floe. ALL CUTS except the white bear. T. turq., lt. blue, t. amethyst, t. lt. yellow, etc. Rolled edge-beaded and handle are pink-lined trans. cut beads. Bead fringes are gr. yellow w. t. red facets at ends. 9" diam. Metal zipper closing. Black with white polka dot lining. Est. 750-1200 $500(03)

VERY LARGE YAKIMA PICTORIAL FULLY-BEADED FLAT BAG c.1940
Lt. blue bkgrd. with t. gold elk head with white antlers surrounded with beautiful roses and fancy border in orange, yellow, bronze tri-cuts with cobalt outlines. Expertly crafted. Cotton quilted back; red plaid lining. Black velvet binding. 16" x 18"L. Exc. cond. Est. 600-1000

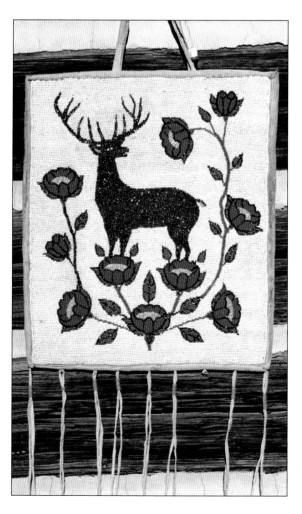

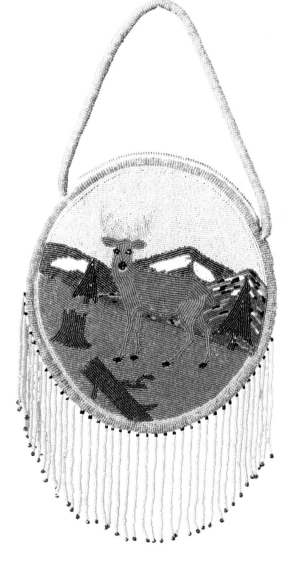

FULLY-BEADED ELK PICTORIAL FLAT BAG c.1930
Collected on the Yakima Res., Washington. White bkgrd. with dramatic elk and floral pattern. Elk is t. brown and iris gold tri-cuts; flowers are gr. red, Sioux green, and tri-cut green with white satin and cobalt tri-cut accents. Buckskin binding and dangles. Plaid cotton lined. Black cotton backed. Very classic bag design. Exc. cond.14" x 16". Est. 600-950 **SOLD** $560(98)

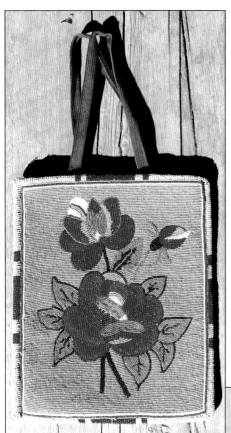

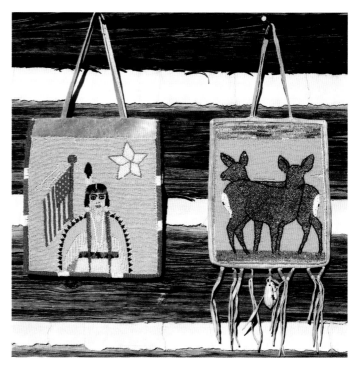

NEZ PERCE BEADED FLAT BAG c.1910

ALL CUT BEADS, tiny size 13° and 14°s. Fully beaded both sides: 1) rose in six shades of pink and red (t. rose, red w. hearts, Crow pink, etc.) with Sioux green and t. bottle green leaves on a periwinkle bkgrd. 2) dramatic geometric pattern is red, t. green, cobalt, and pumpkin on lt. gr. blue bkgrd. Rolled beaded edges are lt. blue and t. red. Rose grosgrain ribbon handles. Superb cond. 7.5" x 9"H. Est. 950-1200 **SOLD $800(99)**

(Left) **FULLY-BEADED PICTORIAL FLAT BAG** c.1940
Interesting and colorful patriotic piece has contoured Indian Princess, flag, and star motif on lt. blue ground. Other side is bald eagle with banners and flowers each side, roll beaded edges in blocks of red, blue, and white! Buckskin top and carrying strap. Cloth lined. Perfect cond. 10.5"H x 9". Est. 600-950 **SOLD $550(02)**

(Right) **FULLY-BEADED PICTORIAL FLAT BAG** c.1920
Beautiful design of overlapping elk in tri-cut grey with white tails; mustard background (several beads missing) with t. green grass and robin's egg blue and t. rose sky. Exquisite piece. Buckskin bound edges and carrying strap. Bottom buckskin fringes have tile beads and central large shell. Cotton sateen lining. 8"W x 10" bag+ 5"L fringes. Est. 600-800 **SOLD $275(02)**

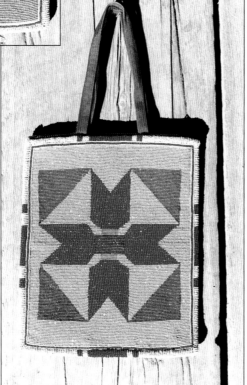

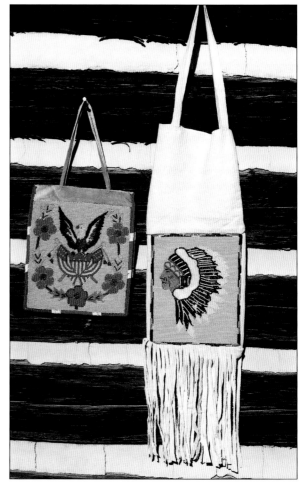

(Left) Reverse of Indian Princess bag; see previous description.
(Right) **PLATEAU PICTORIAL FULLY-BEADED PIPE BAG** c.1930
Contour beaded Indian head profile with war bonnet on lt. blue ground bordered with multi-colored tri-cuts. White buckskin bag , long fringes, and carrying strap. Red plaid cotton lined panel. Exc. cond. 30"L + strap x 8.5"W. Est. 300-500

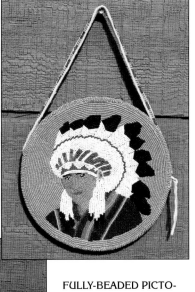

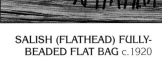

FULLY-BEADED PICTORIAL PURSE c.1920
Wonderful contour beaded Indian head with war bonnet on periwinkle background. Other side is lovely butterfly in yellows and gold with orange tulip on white ground. Roll beaded edges and metal zipper closure. Beaded strap is blocks of periwinkle and t. red. Like new. 8" diam. Est. 650-900

SALISH (FLATHEAD) FULLY-BEADED FLAT BAG c.1920
Beaded both sides; unusual configuration: 1) single stylized rose is orange and red on turquoise bkgrd. with silver tri-cut stem and gr. green leaves; 2) striking geometric on white in bronze and red tri-cuts; periwinkle and orange outlined with cobalt. Lt. blue rolled edges. Multi color bead bottom dangles. Plaid cotton lining. Lovely piece. Exc. cond. 7.25"W x 7"H. Dangles fringe 2"L. Est. 350-600 **Sold $175(98)**

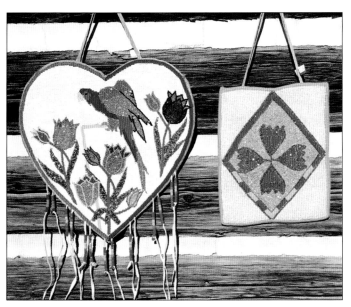

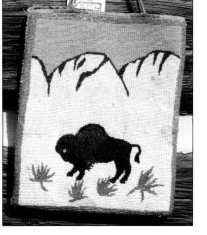

BEADED FLAT BAG
c.1920
Beaded both sides: 1) white snowy mountain bkgrd with two shade tri-cut brown buffalo. Lt. blue sky; 2) multi-colored tri-cuts in asymmetric geometric pattern. Rolled beaded edges both sides. 9" x 10.5"H. Good cond. Est. 450-600 **SOLD $350(98)** NOTE: although this is a pictorial, price not high due to mediocre designs, technique, and bead color combinations.

(Left) **FULLY-BEADED HEART SHAPED FLAT BAG** c.1920-1930
Collected on the Yakima Res., Washington. Flashy, brightly colored parrot and tulip motifs on white bkgrd. A myriad of wonderful colors in tri-cut and seed beads. Expertly made. Tile bead dangles. Back is red corduroy, green satin ribbon bound. Blue calico lined. Exc. cond. 14.5"W and H. Est. 560-800
(Right) **TRI-CUT FULLY-BEADED FLAT BAG** c.1920
Collected on the Yakima Res., Washington. Clear transparent bkgrd. with diamond shaped motif in t. pink, t. red, t. blue, t. yellow, t. forest green. Mustard wool bound, navy wool backed. Gold patterned calico lining. Exc. cond. 9"W x 10.75"L. Est. 300-500

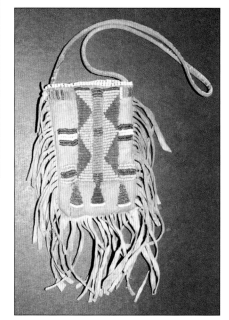

Small Bags

Belt Pouches, Purses, and Strike-a-lites

(Left) YAKIMA LARGE FULLY-BEADED FLAT BAG c.1940
Striking symmetrical geometric design in trans. red, iris red, t. yellow, white pearl, and cobalt opaque beads outlined in black tri-cuts with white background. Back is blue-grey velour, bound with red velour. Lined with campy cartoon print! Perfect cond. 15"L x 12.5"W. Est. 300-500 **SOLD** $250(02)

(Right) YAKIMA LARGE FULLY-BEADED FLAT BAG c.1950
Fantastic floral motif in t. violet, t. pink, t. cobalt, and t. blue pansies in a pumpkin colored basket with five color green leaves on a white ground. Corner geometrics are black, yellow, and red. Back and binding are turquoise patterned corduroy. Interesting lining is white and blue Wedgewood patterned cotton. 16"L x 13.5"W. Perfect cond. Est. 400-750

CROW BEADED STRIKE-A-LITE POUCH c.1870
Classic Crow geometric patterns, slightly diff. each side in lovely pastel early bead colors: rose w. heart, Crow pink, lt. blue, cobalt, t. forest green, white, apple green, and gr. yellow. White edge-beaded top. Nice patina. Buckskin fringes on all sides are 3"L. Pouch: 4"L x 2.5"W. Carrying strap hangs 7". Exc. cond. Est. 650-1200. **SOLD** $650(98)

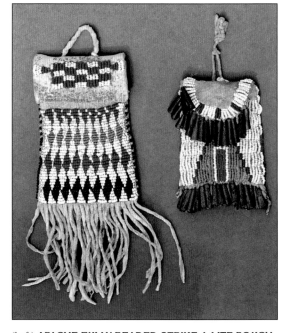

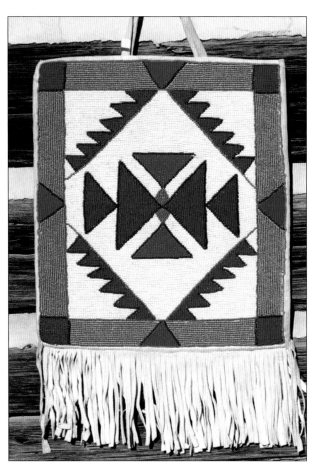

LARGE GEOMETRIC FULLY-BEADED FLAT BAG c.1940
Collected on the Yakima Res. Bold pattern in white, coral, cobalt, t. cobalt with brick outlines. 14"W x 15.5"H + buckskin fringed bottom 6"L. Exc. cond. Est. 500-700 **SOLD** $400(98)

(Left) APACHE FULLY-BEADED STRIKE-A-LITE POUCH c.1880
Classic and desirable all-over diamond pattern in white with rose w. heart, cobalt, and Sioux green. Flap has checkerboard pattern in white and rose w. heart. Bead edging on sides is alt. cobalt and pumpkin. On very heavy hide elk? with faint remnants of red ochre. Twisted bottom fringes 3"L. 7" total L. Exc. cond. Est. 800-1200

(Right) PLAINS FULLY-BEADED STRIKE-A-LITE POUCH c.1890
Lane-stitched and sinew-sewn. White bkgrd. with step triangle in Sioux green outlined with cobalt; rectangle "door" in rose w. heart outlined in white. Flap has alt. cobalt and white border. Tin cone fringes on flap and bottom. Remnants of yellow ochre on back and top thong. Beautiful patina. 4" total L. Est. 800-1250

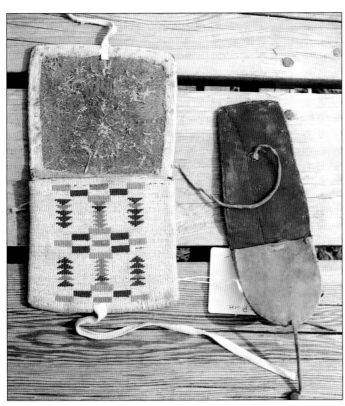

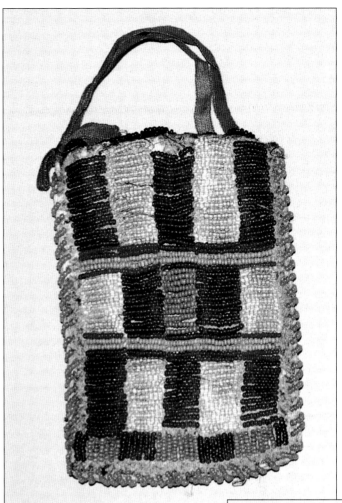

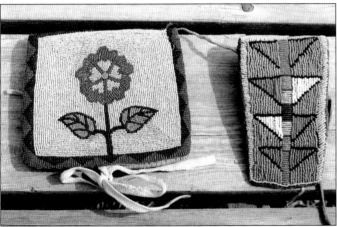

(Left) **NEZ PERCE BEADED CORN HUSK BELT POUCH** c.1890
RARE. Flap has ALL CUT BEADS in 13°-16° in exquisite symmetrical flower pattern: lt. blue bkgrd. with tiny rose w. hearts, gr. yellow, cobalt with pale Arapaho green, and t. bottle green foliage. Border is rose w. heart and t. dk. cobalt. Finely woven corn husk has delicate unfaded yarn patterns in mustard, burgundy and apple green. 5.25" x 4.75"W. Buckskin ties and back straps. Nice patina overall. Exc. cond. Est. 950-1650 **SOLD $1102(05)**

(Right) **UTE FULLY-BEADED BELT POUCH** c.1880
Pred. Chey. pink bordered with Crow pale blue. Triangles in mustard, Arapaho pale green, and white outlined in black. Central panel stripes are tiny cuts in mustard, Crow pink, lt. blue, and rose w. hearts. Varying sizes (13°-18°) of same bead color make this a very interesting piece. Deep purple muslin lined. Flap is 5" x 3", tapering to 2.2"W. U-shaped pouch is double layer of buffalo? stitched to gusset of buckskin with back straps and buckskin straps. Exc. cond and superb age patina. Est. 950-1800 **SOLD $1202(05)**

SIOUX FULLY-BEADED POUCH c.1880
Sinew-sewn and lane-stitched. Front is lovely t. rose, clear, apple green, Chey. pink, and navy cuts. Edges and back borders beaded in gr. robin's egg blue; top edged in black. Red silk ribbon straps. Dark patina on buckskin back. Exc. cond. 4.5"L x 3"W. Est. 250-400 **SOLD $175(99)**

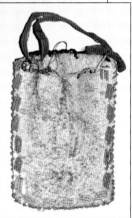

SIOUX SMALL BEADED BUCKSKIN BAG c.1880
Sod Buster Museum at Moccasin, Montana. One side has apple green cross with t. dk. cobalt and gr. yellow. Other side has gr. yellow motif with t. dk. cobalt and apple green. Nice light natural age patina. Buckskin hanger. 5"H x 4.5"W inc. 1/2"W fringes. Est. 195-350 **SOLD $125(04)**

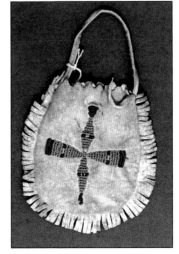

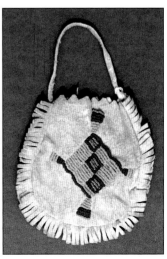

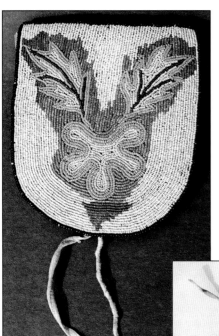

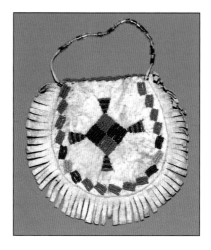

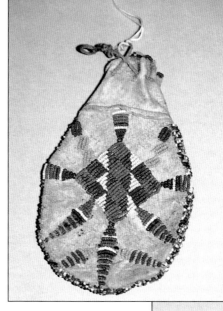

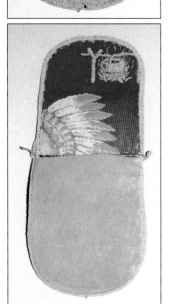

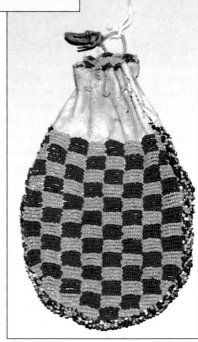

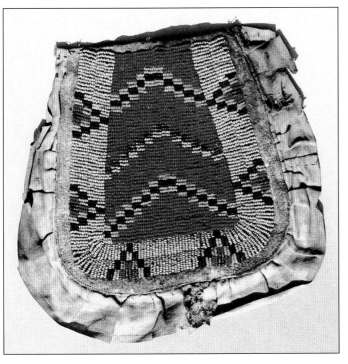

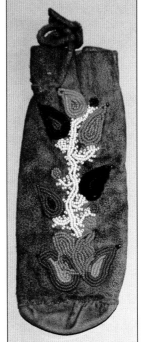

ATHAPASCAN BEADED "GOLD POKE"
c.1890
Upper Yukon, Canada. Used to hold gold dust from the Klondike, or more likely, a souvenir to bring home empty!! Beaded on both sides in characteristic stylized floral patterns with a few metallic beads at leaf points. White stem with beautiful pastels: t. rose, C. pink, apple green, gr. blue, gr. yellow, dk. cobalt, and t. turquoise. 6.5"L. Exc. cond. Nice patina. Est. 400-650 **SOLD $325(00)**
 See four similar examples in Duncan, Kate C. *Northern Athapaskan Art.* University of Washington Press, 1989: 144 and color plate 29.

SIOUX FULLY-BEADED BAG c.1890
Lane-stitched central panel is gr. orange with diagonal step patterns in lt. turquoise, gr. yellow, dk. cobalt, and clear. Double lane-stitched border: lt. turquoise with dk. cobalt, gr. yellow, and gr. orange step-triangles. Heavy buckskin has nice age patina. 1-1/8"W gathered muslin ribbon trim along outside edges. Nice overall patina. 6.5"L x 6.5"W + trim. Est. 350-600 **SOLD $400(04)**

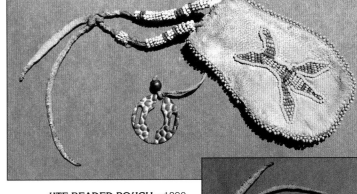

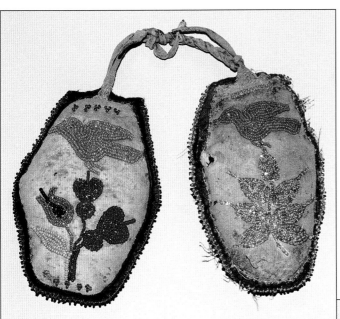

UTE BEADED POUCH c.1890
Front and flap are fully beaded in typical tiny geometric patterns in pastel shades with black. Partially-beaded back side has abstract shape with pastel old colors. Interesting cut-out brass token charm. Wrapped beaded handles. Completely edge-beaded in Chey. pink. Apx. 3"W x 5". Est. 350-500 **SOLD $350(00)**

CREE BEADED MEDICINE BAGS
c.1870
RARE. Unique. Possibly double-balls or game? Twin buckskin pouches partially cut beaded with similar bird and floral motifs in lovely pastel shades: periwinkle, t. rose, Crow pink, t. pale green, apple green, Crow pale blue, rose. w. heart, and cobalt. Silk ribbon bound (faded). One has t. gold edging, the other has t. rose. Attached with braided buckskin. One pouch has 1" opening on side revealing calico liner containing seeds! Supple and intact. Each is 4.5"L x 3"W. Est. 300-600 **SOLD $200(99)**

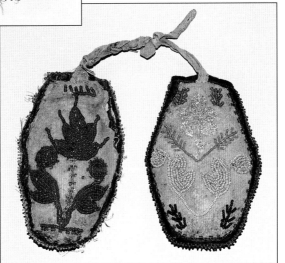

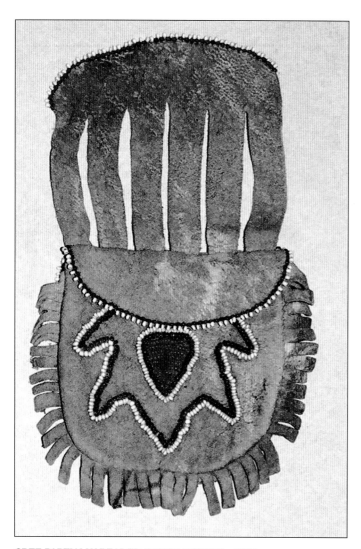

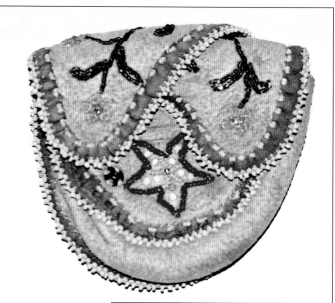

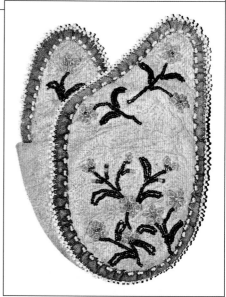

ATHABASCAN BEADED POUCH c.1880 Unusual double pouch with forget-me-nots in gr. robin's egg blue, and forest green cut stems. All bound with green braid and C. pink and lt. blue edge-beaded. T. red star motif on front. Beadwork amazingly intact. Navy silk lining, raveled. 5.5"L open. 4"W. Nice age patina. Est. 375-500 **SOLD $400(02)**

CREE PARTIALLY-BEADED "TRICK POUCH" c.1880
This is a fine example of this style pouch, which was made so that people could not easily discover how to open it. Rose w. heart, white, and t. cobalt abstract motif. Edge-beaded flaps in white and rose w. heart and cobalt. Nice overall patina. 7.5"L x 4.5"W. Est. 200-400 **SOLD $225(05)**

(Left) UTE? FULLY-BEADED WHETSTONE CASE c.1880
Beads are strung horizontally. Design in wonderful old colors: periwinkle, white, pumpkin, gr. blue, cobalt diamond, and stripe motif. Flap has t. rose bead edging. Bottom flap has gr. blue bead edging with tin cones. Very dark patina, may be older. Apx. 7"L. Est. 500-750
(Right) BLACKFEET BEADED PAINT POUCH c.1880
Entirely red-ochred, holds red ochre paint. Front is appliqué-stitch apple green with two t. rose and cobalt crosses. Top four tabs and sides edge-beaded with bright gr. blue (apx. 75% intact). Tied with blue muslin. VG cond. 7"L. Est. 375-600 **SOLD $450(98)**

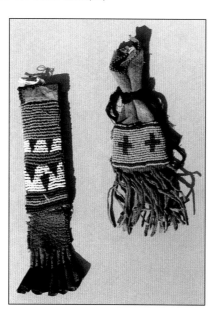

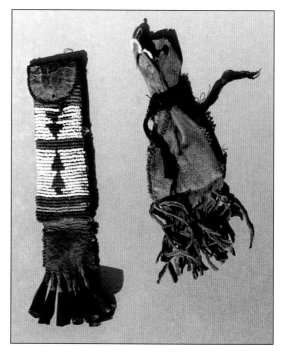

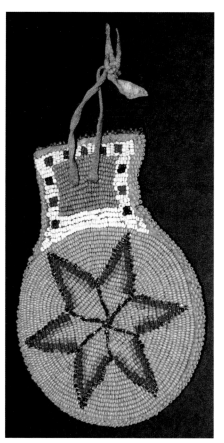

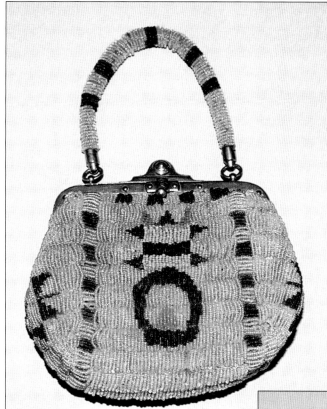

SIOUX FULLY-BEADED HANDBAG c.1900
Clear background lane-stitched with delicate and unique floral cut bead patterns in t. dk. cobalt, Crow pink, and apple green. Bead wrapped handle in same colors. Every inch covered in beads. Pink silk lining somewhat disintegrated. 8.5"H x 5.5"W. Est. 475-800 **SOLD $500(05)**

UTE FULLY-BEADED POUCH c.1900
Characteristic unusual color combinations and designs, compared to Plains tribes.* Diff. appliqué beaded designs each side with rolled gr. yellow beaded edges: 1) 6 pt. star is red w. heart and Sioux green with silver tri-cut outline on Chey. pink bkgrd. Top is purplish Chey. pink bordered with white and red w. heart and dk. cobalt squares; 2) red w. heart, periwinkle, emerald green, and pumpkin bordered in Sioux green. Top opening is edge-beaded in Sioux green. Buckskin hanger. 5"L x 3.5"W. Est. 550-950 **SOLD $450(05)**
*See Bates, Craig D. "Basketry, Parfleches and Clothing of the Ute People." in *Ute Indian Arts and Culture,* Wroth, Wm. ed. Colo. Springs Fine Art Center, 2000: 143-173 for more information.

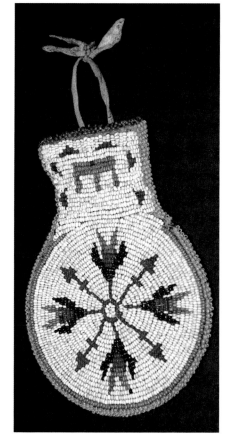

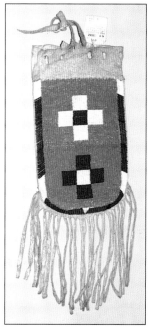

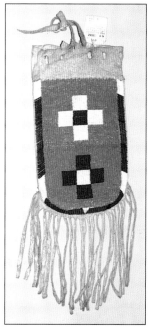

BLACKFOOT BEADED BAG c.1920
Old tag reads *"Made by Blackfoot Louise Standing Alone in the early 1920's."* Appliqué-stitched bold pattern has apple green background. Double crosses are white and cobalt; striped border same colors with red. Heavy buckskin top and long bottom fringes (8"). Canvas backed. Nice age patina. 22"L, includ. fringe. 8"W. Est. 300-500 **SOLD $325(04)**

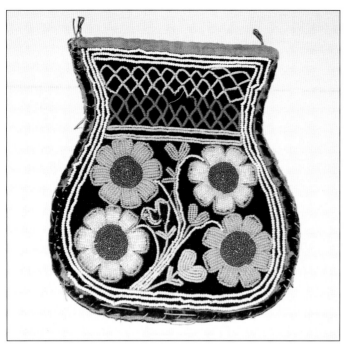

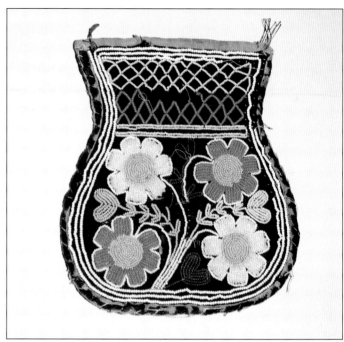

MALISEET or MICMAC BEADED POUCH c.1850
RARE. ALL very tiny beads, 16°s. Gr. blue, gr. yellow, t. rose, Chey. pink, Arapaho pale green, white, and clear. Beautiful four flower motifs. Bordered in white. Black velvet. Silk binding completely gone. Same design in diff. colors each side. A few beads missing each side. 6"H x 4.5" top. Muslin lined. Est. 475-900 **SOLD $500(04)**
 See Faulkner, G. F., N.T. Prince, and J. S. Neptune. "Beautifully Beaded, Northeastern Native American Beadwork." *American Indian Art Magazine*. Winter 1998: 34 for similar documented Maliseet example c.1850.

Iroquois Beaded Pouches

 These 19th century bags have embossed beadwork, which is defined on page 6. For more information on the manufacture and history of Iroquois beadwork, see "A New Look At Beaded Iroquois Whimsies" on pages 82-87 as well "Worldwide Bead and Quillwork Traditions" (which pictures an Iroquois bag needlework pattern designed for white women, c.1900) on page 135.

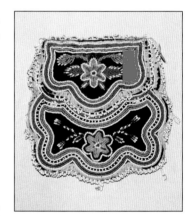

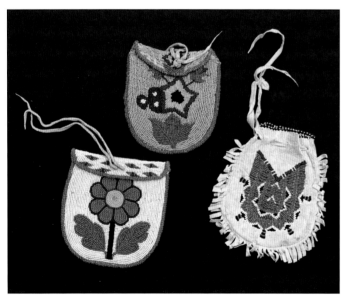

SHOSHONE FULLY-BEADED LADIES BELT POUCHES c.1930
Harold L. Shilling Collection
(Left) Central floral pattern on white bkgrd. appliqué stitched. Orange petals and roll beaded edges. Gr. green, yellow, with red, dk. cobalt, and pale blue accents. Buckskin tie thong and loop back. Exc. cond. 6"H x 5.5"W. Est. 195-275 **SOLD $160(01)**
(Center) Lt. blue bkgrd. floral pattern in gr. green, yellow, red, dk, cobalt, and white with orange roll beaded edges. Buckskin tie thong and loop back. Exc. cond. 5.5"H x 5.25"W. Est. 175-250 **SOLD $160(01)**
(Right) **ARAPAHOE BEADED U-SHAPED POUCH** c.1930
Harold L. Shilling Collection. Diff. pattern each side: Sioux green, dk. red, pumpkin, black, and white. Buckskin fringes and drawstring top. Top edge-beaded in black, white, and red. Sinew-sewn. Exc. cond. 7"L x 6.5"W. Est. 175-300 **SOLD $215(01)**

EARLY TUSCARORA BEADED PURSE c.1840
Black velvet with tiny 14°? seed beads in delicate floral symmetrical pattern: C. pink, gr. pale green, gr. blue, and white. Silk ribbon faded and disintegrating and white bead edging in need of repair, otherwise pristine condition of cloth and beadwork. 4.5" sq. Est. 175-300 **SOLD $200(99)**
 See Faulkner, G. F., N.T. Prince, and J. S. Neptune. "Beautifully Beaded, Northeastern Native American Beadwork." *American Indian Art Magazine*. Winter 1998: 36 for a similar and less elaborate documented example.

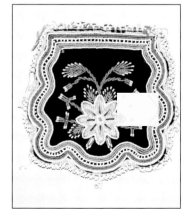

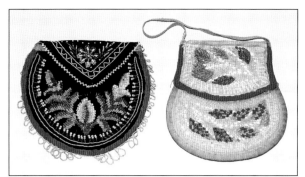

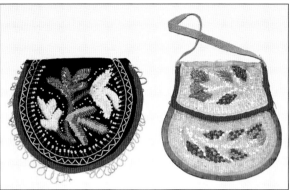

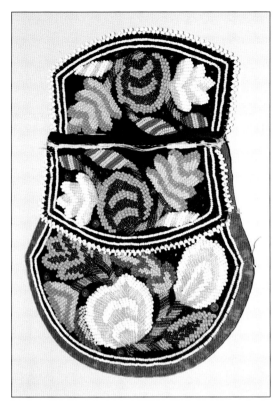

IROQUOIS POUCH c.1870.
Probably Tuscarora. Black velvet with beautiful stylized floral motif in wonderful old colors: C. pink, gr. yellow, pumpkin, gr. blue, t. forest green, t. rose, lt. blue, white, and clear. Mixed seed and pony beads and brass sequins. White seed bead double borders with white pony beaded edging. Bottom bound with red muslin. Plain muslin lined. Black muslin bound top. Pale yellow silk ribbon inside binding at top—mostly disintegrated, intact on inside. A few white seed beads along border missing, otherwise exc. cond. 6"L x 6.5"W. Est. 175-300

IROQUOIS POUCHES
(Left) c.1860. Black velvet flap and bag, diff. design each side. Unusual tiny seed bead loop fringes and sewn borders, all size 14° Chey. pink. Central embossed beadwork is combo seed and pony beads in luscious old pastel colors. Muslin and chintz lining. Red muslin bound. Some loop fringes missing. Easy repair. 7"W x 6.25"L. Est. 250-450 **SOLD $375(03)**
(Right) c.1850. Clear pony and basket beaded bkgrd. with typical stylized leaf patterns in beautiful pastel ponies and basket beads. Same both sides. Flap bound with wool red Fox braid. Bottom bound with plain muslin. Dk. patina of age. Fox braid carrying strap. 6.5"H x 6.5"W. Top silk binding disintegrated and faded. Est. 175-395 **SOLD $200(03)**

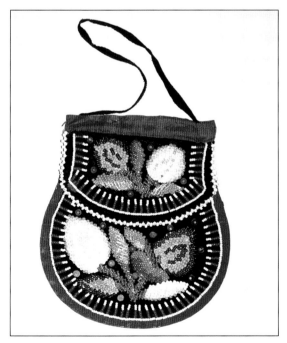

IROQUOIS POUCH c.1850.
Same both sides. Emboss seed-beaded in gr. blue, pony trader blue, Crow pink, white, clear, gr. green, t. cranberry, and gr. mustard; brass sequins. Black velvet with red muslin binding. Red silk ribbon at top. White pony bead edge-beaded flap. Black velvet handle. Wonderful patina. Amazing pristine cond. 6.5"L x 6"W. Est. 325-550 **SOLD $350(03)**

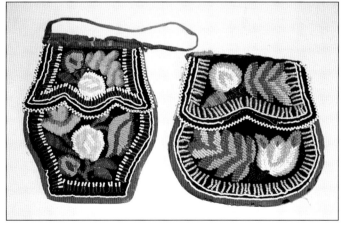

IROQUOIS POUCHES
(Left) c.1860-1880. Beautiful early seed bead colors: gr. blue, gr. yellow, Chey. pink, t. rose, t. gold, opal. white, forest green with edge-beaded flap in white ponies. Brass sequin trim. Old twill tape strap-red silk top binding partially disintegrated. A few white border beads missing, all others intact. Exc. shape. 7"L x 6"W. Est. 275-500 **SOLD $325(00)**
(Right) c.1860-1880. Pony bead colors same as previous with addition of pumpkin, periwinkle, rose w. heart, and lt. blue. White seed bead borders have a few inches missing beads, also apx. 25% pink/lt. blue border seed beads missing on one side. Top is slightly frayed; binding worn on edges. Good cond. 7.25"W x 7"H. Est. 250-450 **SOLD $248(00)**

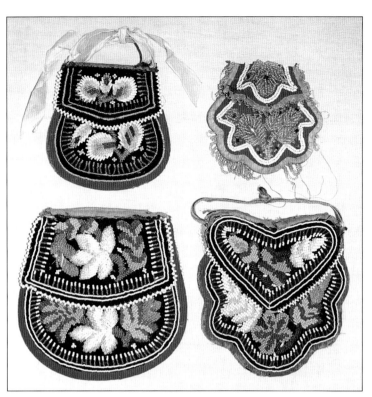

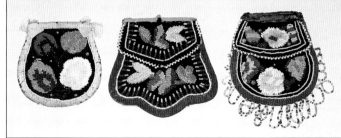

IROQUOIS POUCHES

(Left) c.1860. Black wool with four stylized floral motif same each side: 1) white, clear 2) Crow pink, t. rose; 3) gr. blue, t. cobalt; 4) t. gold, gr. pumpkin. Stems are t. bottle green embossed ponies. Interesting disintegrating pale green silk ribbon sewn over red muslin binding! Exc. cond. Interesting little piece. 4.25"H x 4"W. Est. 150-250 **SOLD $150(03)**
(Center) c.1860. Typical seed and pony beads in stylized leaf patterns (both sides) on black velvet. Red muslin pouch binding. Only a few white beads missing. White edge-beaded flaps. Nice patina. Pretty color combos. 5.5"W x 5"H. Est. 175-300 **SOLD $200(03)**
(Right) c.1860. Typical lush pastel florals in seed beads outlined in Crow pink seeds.(both sides). Black velvet with red muslin binding. Interesting edges, flap has alt. lt. blue and white pony bead edging; pouch has "salt and pepper" beautiful seed bead colors in loop fringes. Green silk top binding. 4.5"W and H. Est. 175-400 **SOLD $175(03)**

IROQUOIS POUCHES

Left to right (top to bottom): c.1860-1890. Mostly seed bead abstract floral with pumpkin and gr. blue border outlined in one clear row and one opales. row seed beads. Exceptionally nice design and colors. Wide white silk ribbon handle. Red muslin binding worn thru in a few spots. Overall exc. cond. 5"H x 5"W. Est. 225-400 **SOLD $175(01)**
c.1860-1890. *Probably Tuscarora.* All clear pony beads with silver-lined basket beads on red wool. Muslin bound. White pony beaded double border. Clear loop fringes and edge beadwork on flap. 1/3 fringes missing. 5"W x 4.5"L. VG cond. Est. 150-225 **SOLD $100(01)**
c.1860-1890. Pony and seed beaded. 7"H x 7"W. A few beads missing. Overall exc. cond. Est. 250-350 **SOLD $255(01)**
c.1860-1890 Unusual heart-shaped flaps. Seed and pony beads. A few beads missing one side only and 1" or so of white pony bead edging missing. Red muslin binding faded and tattered. 6"H x 6.5"W. Est. 225-350 **SOLD $180(01)**

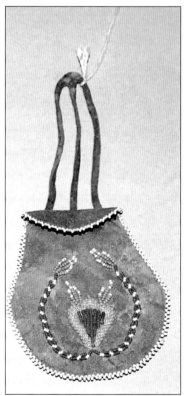

IROQUOIS PARTIALLY-BEADED "TRICK POUCH"

c.1880
RARE. Delicate pastels in same design both sides, "braided" apple green and white stem and embossed abstract floral motifs in gr. blue, clear, Chey. pink, and gr. yellow. Tiny size 16° or smaller white bead edged. Supple buckskin. 3.5"H x 3.25"W. Exc. cond. Est. 150-300

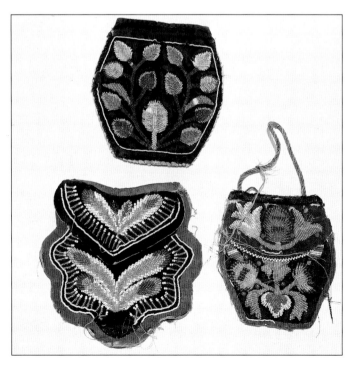

IROQUOIS POUCHES c.1860-90.

All three of these pouches are from the Colin Taylor Collection in England. Each is emboss beaded both sides on black velvet.
(Top) Unusual abstract leaf pattern in varying sizes of seed beads (12°-16°) in exquisite colors incl. a wonderful opalescent pale blue. Binding (prob. silk) is missing. One side beads completely intact; other side two to three small sections of beads missing. Velvet well worn. Beautiful piece. Exc. cond. 7.5"L x 6"W. Est. 275-450 **SOLD $300(02)**
(Bottom left) A more typical style marked *"Tuscorora?"* Characteristic clear pony beads with white and some pastels outlined with white seed beads. Red muslin (worn) binding with red silk top binding intact. Nice scalloped configuration. Good cond. 7" sq. Est. 225-350 **SOLD $250(02)**
(Bottom right) Another atypical piece with unusual beads: gorgeous w. center rose ponies, gr. pumpkin ponies, and seeds. Diff. flap design each side. about 10% beads missing. Red muslin binding well worn. Burgundy silk ribbon top binding is frayed. Handle intact. Very early piece. Interesting variety of early cotton print linings. Fair cond. 6"L x 5"W. Est. 200-350 **SOLD $225(02)**

Moose-hair Embroidered Containers

The art of bark and moose hair embroidery was a result of interaction between Huron, Micmac, and Maliseet women and French-Canadian nuns. Prior to the contact period, Indians did moose hair embroidery on their clothing. In the early 1700s, the Ursaline nuns started to make bark items decorated with moose hair embroidery from materials supplied by the Indian people for this craft. By 1810, the convent stopped this craft, which is when the Huron-Wendat tribe nearby at Lorette, Quebec "took over the trade." A tourist industry developed with the opening of the Erie Canal in 1825, and when shops opened at Niagara Falls in the 1840s they became a major outlet for these now scarce and valuable items.

For more history and numerous photos of similar moose hair and/or bark souvenir items, see:

Phillips, Ruth B. *Trading Identities.* Seattle: University of Washington Press, 1998: 103-196.
Sotheby's American Indian Art Catalog, New York, May 13, 2005: 13-14.

The following three cigar cases were made in imitation of the style of manufactured leather cases and were a particular specialty of the Huron-Wendat tribe. They were popular souvenir items for men. Some were made covered with cloth like the following wall pocket. (Phillips, p. 234)

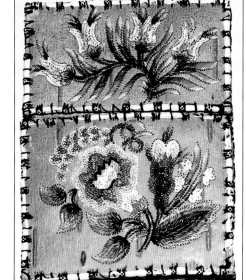 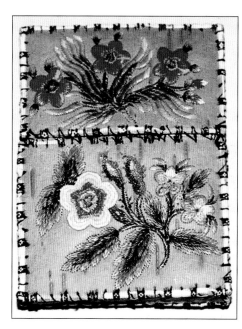

HURON? MOOSE HAIR EMBROIDERED BARK CIGAR BOX c.1840
RARE. Purchased in England's Portobello Rd. Market. Each side has a different exquisite floral pattern: 1) primarily red-orange and white flowers with intricate leaf patterns; 2) blue and white flowers. Intricate leaf pattern along all four sides with white and black complex border patterns all edges. Pristine unfaded cond. 4" x 3" x 5/8"D. Est. 950-1500 **SOLD $750(03)**

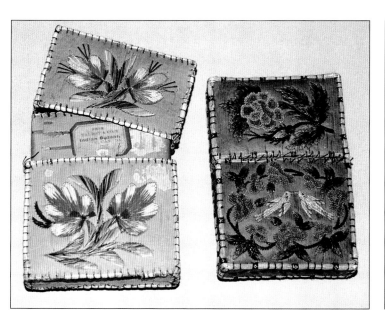 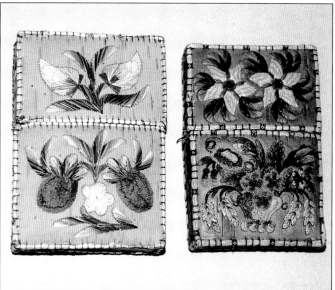

HURON? MOOSE HAIR EMBROIDERED BARK CIGAR BOXES
Preston Miller Collection. Each is apx. 2.5" x 3.75"H.
(Left) c. late 19th century. Label says, *"from TALBOT & CO's Indian Bazaar, Quebec Canada."* Purchased by the author Oct. 30, 1965 for $6.00 at Windsor Art Gallery in Baltimore, Maryland. Bright unfaded orange and dk. red flowers one side; lt. blue and white flowers on the other plus rose colored French knot flowers. Exc. cond. Est. 900-1500
(Right) c. early 19th century. Very intricate floral motifs in blue, white, and greens with reds and yellows faded with age. Opposite side has two kissing white doves. French knot flowers each side. Exc. cond. Est. 900-1500

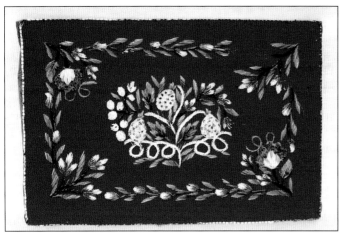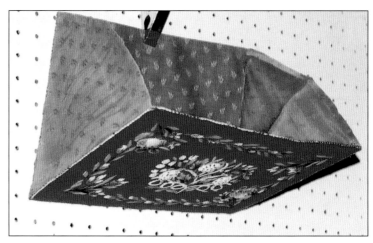

HURON MOOSE HAIR FLORAL EMBROIDERED WALL POCKET c. 1840-60.
Made for wealthy Victorian era persons to hang on their walls. Most often they were used to hold letters and important documents. They are often seen in old photos of the interiors of homes belonging to Hudson's Bay Co. employees, religious leaders, school teachers, etc. Surviving examples of these Victorian wall pockets are very rare. This one has fine moose hair embroidered in beautiful floral designs on fine red wool trade cloth. There is some hair eaten away by moths on the upper right side. (It is almost impossible to find moose hair embroidery of this age that does not have some minor moth damage to the hair.) The pocket and lining are made from a muted green raw silk with tiny woven floral patterns. 8.5" x 13.5". Exc. and pristine cond. Est. 650-1200

Photo Essay: A New Look At Beaded Iroquois Whimsies

by Carolyn Corey

The Erie Canal was completed in 1825 and by 1850 railroads and boats carried travelers to the popular Niagara Falls region. Tourist shops were opened and as early as 1844 a guidebook states that bead and bark work "of every description" is to be found at the Old Curiosity Shop and Indian Store. "...Niagara Falls is the greatest market for splendid Indian work of every variety in the United States." The local Iroquois tribes of Tuscarora and Mohawk people had an old beadwork tradition, and the novelty items they now created were perfect for Victorian tastes and decorating schemes. (Faulkner, p. 39) These items became a major source of income for many Iroquois women whose husbands and sons had re-located to big cities—such as New York, Buffalo, Boston, and Toronto—to work in the high steel construction industry. (Phillips, p. 262-3) It is interesting that these "fanciful whimsies...had little basis in the material culture of the people who made them." (Faulkner, p. 40)

The Tuscarora work was initially in clear glass beads. Their earliest work was on red wool cloth and/or pale blue or white silk. Floral patterns, crowns, and ovals were their choice of subject matter. The Mohawk bead workers were more "flamboyant," using more colors and opaque beads, bugle beads, and brass sequins on a variety of bright materials—e.g., hot pink wool, also sateen and velvet. They also loved to use animal motifs. Dates beaded onto whimsies became a later fad and supposedly didn't start until 1890. The dated whimsies pictured here range from 1898 to 1913. Place names beaded on whimsies, e.g. "Niagara Falls" etc., began around 1870. Production dropped off after the Depression and World War II. (*Ibid*, p. 40-41) Preston Miller recalls seeing Iroquois people selling baskets, pincushions, and whimsies at the York County Fair in Pennsylvania in the late 1940s.

Reference sources for this section:

Faulkner, G. F., N.T. Prince, and J. S. Neptune. "Beautifully Beaded, Northeastern Native American Beadwork." *American Indian Art Magazine*. Winter 1998: 32-41.

Phillips, Ruth B. *Trading Identities*. Seattle: University of Washington Press, 1998. (See p. 21 for an excellent map showing NE Indian reservations and villages as well as major tourist areas.)

Tooker, Elizabeth. *Lewis Morgan on Iroquois Material Culture*. Tucson: University of Arizona Press, 1994.

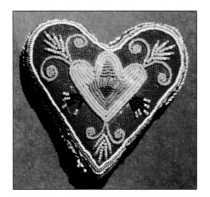

EARLY IROQUOIS HEART-SHAPED PINCUSHION c.1840-60
Author's Collection. Possibly Tuscarora. Red wool top with tiny 14°-16° seed beads in non-embossed delicate design. White edge-beaded with border of narrow dk. blue silk ribbon. 3" x 3.5". Lewis Morgan documents a similar early heart-shaped pincushion collected in the late 1840s. (Tooker, Plate 13) The old tradition of pincushions made as gifts for absent friends may have originated in early 19th century England with "soldier's hearts," as shown in Phillips, p. 230.

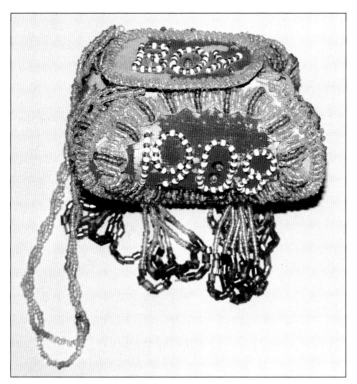

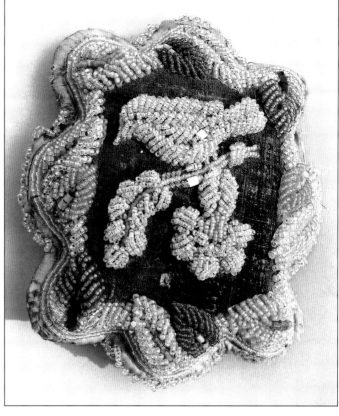

IROQUOIS BOX
"1908". Probably Mohawk. Typical embossed pony beads pred. clear with t. green and white. Clear and gray basket bead dangles. Bright pink wool is apx. 50% missing. Chintz lined. All beads intact except one side of clear beaded handle. 5"W. Hangs 12"L. Est. 75-150 **SOLD $70(99)**

IROQUOIS BEADED PINCUSHION Late 19th century.
This style of whimsey was sometimes mistakenly called a pillow. In fact, it was commonly used on Victorian ladies' dressers to store long hat pins. Desirable bird and flower motif on purple velvet bordered with leaf motifs. All pony beads—mostly clear with transl. periwinkle, transl. pale green, t. yellow, and t. rose with a few basket beads. Clear bead edged scallops, apx. 50% missing. Back is faded purple sateen. 8.5" x 7". Est. 75-150 **SOLD $54(02)**

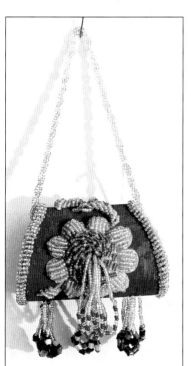

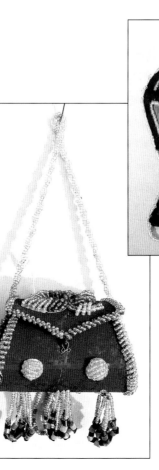

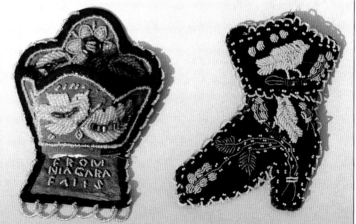

IROQUOIS BEADED PURSE 19th century.
Rose fine wool covered with clear pony rolled edge and hanging strap. Clear pony lower loop dangles with shades of blue, yellow, and green basket beads.
Beautiful rose on back has t. rose ponies with clear and pony trader blue pony bead loop dangles. T. blue and t. green leaves on flap. Pink cotton sateen lining. 4.5"W. Hangs 10"L. All beads unusually intact. Est. 125-250 **SOLD $135(02)**

(Left) **IROQUOIS BEADED WHISK BROOM HOLDER** c.1880
"Niagara Falls." Nice colors: blue-grey wool bkgrd. (frayed in several places) bound with burgundy cotton. Bird and flower motifs in clear pony beads and gold basket, with lettering and trim in Chey. pink seed beads. Clear loop trim and dangles 90% intact. 7"L. Est. 65-110 **SOLD $65(98)**
(Right) **GREAT LAKES BEADED SLIPPER** c.1890
Dk. brown velvet attractive seed beaded pictorial: two birds in gr. yellow and t. rose with t. turq and lt. blue floral pattern. Gr. yellow loop dangles, 90% intact. Black wool backed. 7"L. Est. 60-125

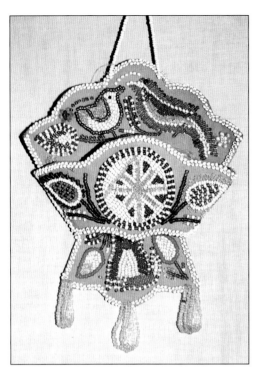

IROQUOIS BEADED WHISK BROOM HOLDER c.1890-1910
Author's collection. Canadian flag plus bird and cat motifs. Colorful array in all pony beads: white, brass, t. cobalt, gr. blue, t. green, t. red, t. pink, and bottle green. Not embossed but appliqué beadwork. Faded pink cotton. Exc. cond. 8"L x 7.5"W. Est. 125-250

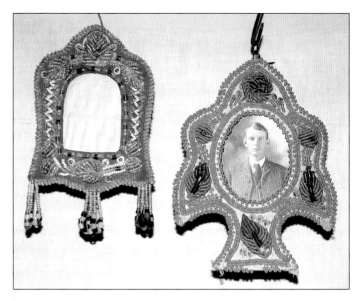

(Left) Same picture frame as in center of photo below; see description below.
(Right) **IROQUOIS BEADED PICTURE FRAME**
Author's collection. Pale yellow cotton with pred. t. gold embossed floral with pastels, basket beads, and brass sequin trim. Loop dangles missing. 7"L. Est. 75-150

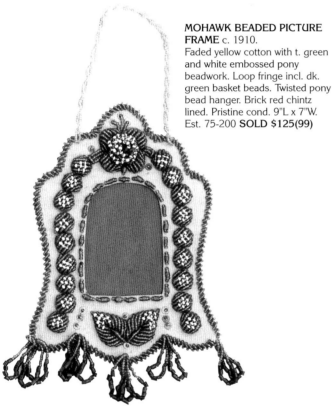

MOHAWK BEADED PICTURE FRAME c. 1910.
Faded yellow cotton with t. green and white embossed pony beadwork. Loop fringe incl. dk. green basket beads. Twisted pony bead hanger. Brick red chintz lined. Pristine cond. 9"L x 7"W. Est. 75-200 **SOLD $125(99)**

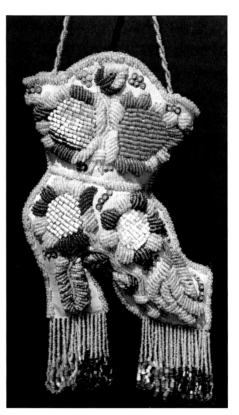

IROQUOIS LARGE BEADED BOOT Late 19th century.
Author's collection. Probably Mohawk. Faded peach-colored cotton with large embossed flowers that have pastel basket bead centers. Note bird on toe! Brass sequin trim. Bead loop fringe is clear ponics with gold, grey turq., and rose basket beads. Twisted pony bead hanger, Beads all intact. Exc. cond. 11"H x 8"W. Est. 250-400
A similar boot is pictured in Phillips p. 229, and labeled "Kahnawake Mohawk."

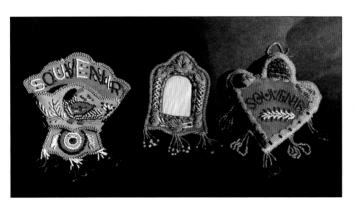

(Left) **IROQUOIS? BEADED WHISK BROOM HOLDER** c.1920
Author's collection. Colorful bird as central motif in mustard, white, t. dk. and lt. blue, and t. red and white l. red ponies. White satin bugle beads with periwinkle ponies form branch. Periwinkle pony-beaded edges. *"Souvenir"* in beadwork. Faded pink cotton. 7"L + bead loop dangles in white ponies and t. green basket beads. (Note: Beadwork is appliquéd, not embossed). Est. 75-150
(Center) **IROQUOIS BEADED PICTURE FRAME**.
Author's collection. Hot pink cotton with clear, apple green, and white embossed pony beaded leaf pattern. Brass sequin and t. grey basket bead trim. Beaded loop dangles are clear ponies with t. gold, t. green, blue satin, and yellow-lined basket beads. 6"L + dangles. Exc. cond. Est. 60-125
(Right) **IROQUOIS BEADED HEART WHIMSEY**
Author's collection. Hot pink cotton with pastel and clear ponies as well as t. pink and t. grey basket bead embossed beadwork. Bead loop dangles. 7"H and W. Exc. cond. Est. 85-175

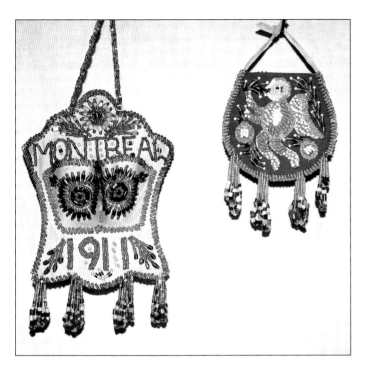

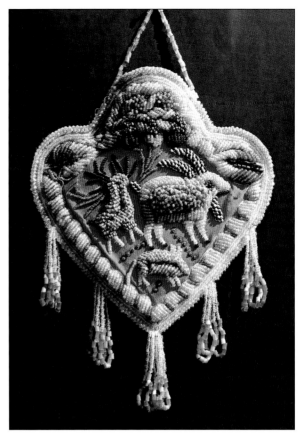

(Left) MOHAWK MATCH HOLDER
Author's collection. "MONTREAL" and *"1911."* There is an almost identical one pictured in Phillips, p. 237, which is identified as Kahnawake Mohawk and is displayed at the mission church there. Pale yellow cotton with t. gold basket beads and ponies of the same color. Also embellished with pink satin, t. bottle green, and t. cobalt basket beads. Dk. green chintz backed. 8"L + bead loop dangles. Exc. cond. Est. 85-195

(Right) IROQUOIS WHIMSEY POUCH
Author's collection. "1913" beaded on flap in alt. white and t. gold ponies with brass sequin trim. Dk. blue cotton background. Rolled bead edges are t. gold ponies. Back has charming embossed angel motif in same colors plus t. grey basket beads. Bead loop fringes in ponies and basket beads. Red chintz lining. Exc. cond. 6"L incl. Fringes. Est. 75-150

IROQUOIS PICTORIAL WALL HANGING Late 19th century.
Author's collection. Probably Mohawk. Fanciful animal motifs on hot pink cotton: embossed goat, deer, and mouse on popular heart shape. Floral border in clear ponies with pastels. Animals are clear, gr. yellow, Chey. pink, lavender, black, and white. Bead loop dangles are clear with lt. blue satin basket beads. A few moth holes, otherwise exc. cond. 10.5"L and W. Fringe 3"L. Est. 250-500

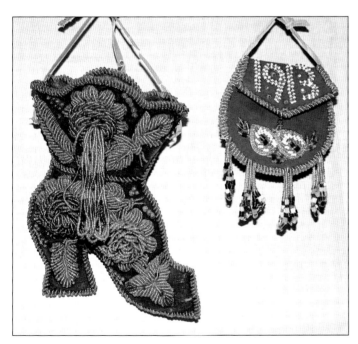

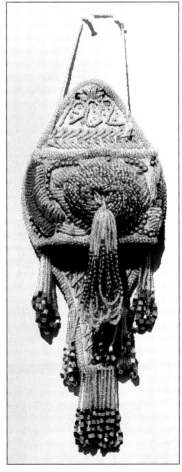

IROQUOIS BEADED SNOW-SHOE-SHAPED WHIMSEY
Author's collection. "1902" beaded in gr. yellow ponies. Lavishly embossed central flower in clear and t. pink ponies has 4" loop dangles. Profuse brass sequin trim. Mostly clear ponies with t. green and gr. blue pony leaves. Pastel basket bead and clear pony side and bottom loop dangles. 12"L + dangles. Exc. cond. Purchased in 2001 for $150. Est. 250-450

(Left) IROQUOIS LARGE BEADED BOOT Late 19th century.
Author's collection. Probably Mohawk. Lavishly embossed beaded flowers and leaves over dk. green velvet. Predominantly t. gold with different pastel bead color for each flower: t. rose, t. blue, and t. green with a few brass sequins. Long bead loop fringes hang from upper flower. Gold velvet ribbon hanger. Chintz back. Nap only slightly worn, all beads intact. Exc. cond. 9"L x 7"W. Est. 200-350
(Right) Front of previous pouch.

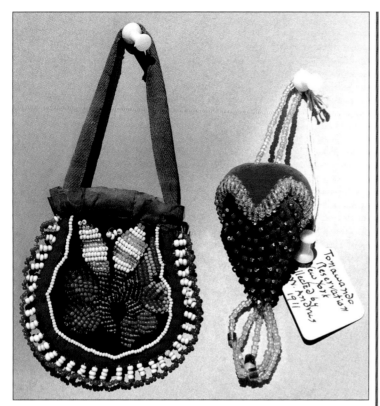

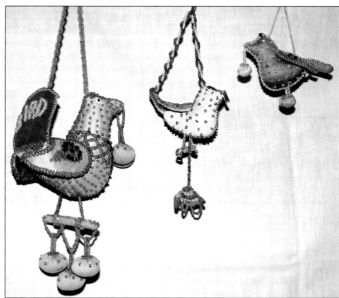

(Left) **IROQUOIS TINY BEADED POUCH** c.1850-1880
Author's collection. Probably Tuscarora. See documented 1849 bag with identical style of beadwork and cloth in Phillips, p. 162. This is not a whimsey but I placed this little bag here as a reminder that large quantities of Iroquois beaded bags were also sold in New York souvenir shops at an early period. This style is not exclusively a "tourist" design, but was worn by Iroquois people with their traditional clothing. Black velvet with red cotton binding. Fancy bead edging in white ponies with gr. blue seeds. Beautiful pastel seed beads in abstract floral: white c. rose, Chey. pink, gr. blue, t. grey-green, etc. Top binding is faded silk ribbon. Twill tape hanger. Nice age patina. Exc. cond. Pouch is only 2.5"L. Est. 95-175
(Right) **SENECA SMALL BEADED PINCUSHION**
Tag says "*Tonawanda Reservation New York, Collected by C. W. Andrus in 1911.*" "Strawberry" shaped rose velvet/green cotton clear ponies and rose w. heart seed beads. 2.5"L + bead loop dangles. Exc. cond. Est. 75-125

(Left) c.1900. Same size, color, and beads as bird below. Probably made at the same time, same maker as below. *"Bird"* beaded on back of tail. No date. Est. 175-350
(Center) c.1900. Small bird is pale yellow cotton with t. gold and clear ponies. Pink ball and perch hangs below. Bird apx. 3" x 3.5"W + 3" drop. Cloth has a few small tears, otherwise good cond. Est. 75-125
(Right) c.1900. Pink polished cotton bird, same size as previous one. Clear pony and t. green basket bead ornamentation. No perch, two balls. Faded, good cond. Est. 80-135

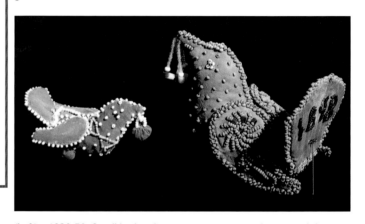

(Left) c.1930-50. Small bird in deep turquoise cotton velveteen with hot pink balls. White bead trim, more sparingly decorated than earlier pieces. 3" x 3.5"W. Est. 25-50
(Right) *"1898"* on back of tail. Yellow cotton with lt. blue pony beads; t. cobalt, white, and blue satin basket beads. Est. 150-300

Iroquois Beaded Bird Whimsies

It is believed that most of the birds were made by Mohawk bead workers. Many birds have dates on the backs of their tails, as illustrated here. They were made in the late 19th century up until the late 1930s. (Faulkner, p. 39-41)

This style of whimsey is becoming rare and hard to find. These are stuffed with sawdust. I have been able to restore the missing beads on these birds from my collection and even loose stuffing on body or balls using bits of old nylons. But that can only be done if the cloth is intact. Those that are exposed to sun and/or have prolonged exposure to light result in deterioration of the cloth. See photo of sad bird on next page!

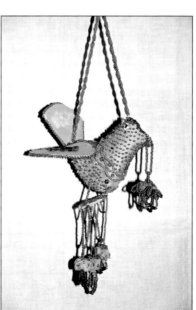

"1907" beaded on front of tail. Yellow cotton with t. gold, t. green, t. grey-blue pony beads, and gold basket beads. Perch with three balls. Slight fading, but fabric in good cond. Balls and bird have been restored. Bird apx. 6"W. Hangs 12"L. Est. 150-300

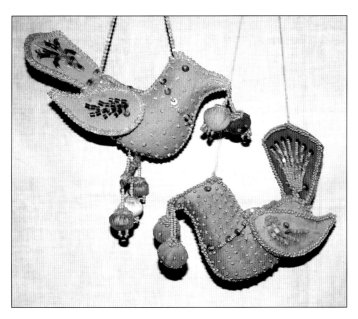

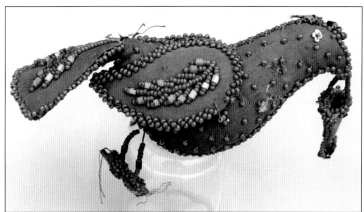

"1898" on tail back (not shown) Gr. blue ponies with lt. blue satin basket beads. Cornucopia hangs from beak. Perch is broken and balls are missing. This sad bird cannot be restored because the cloth is disintegrating. Value is for beads only. 6" x 4.5"H. Est. 25-40

(Top)"1904" on tail back. Pale pink cotton with clear ponies, brass sequins, and t. grey basket beads. Balls are hot pink, white, and faded blue. Bird 4"L + drop x 6"W. Est. 175-350
(Bottom)"1903" beaded on tail back. Hot pink cotton with lt. blue ponies, white satin basket beads, and brass sequins. Yellow cotton tail and under wings. Two balls hang from beak. Bird 4"L x apx. 6"W. Est. 150-300

More whimsies, i.e. boats, trinket boxes, boots, etc., are pictured in:
Miller, Preston, and Carolyn Corey. *The Four Winds Guide to Indian Artifacts*. Atglen, PA: Schiffer Publishing Ltd., 1997: 112-114.

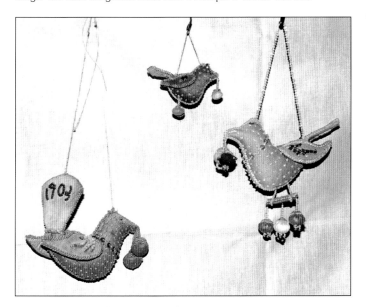

(Left to right) Back of previous bird. Same as previous photo. Front of previous bird.

Miscellaneous Containers and Beaded/Quilled Items

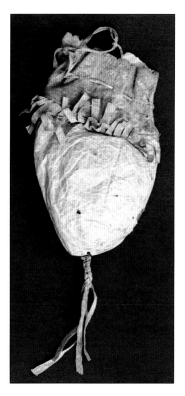

SIOUX BUFFALO BLADDER BAG 19th century
These were used to store food, i.e., pemmican. Top is buckskin with drawstring and 1.5"L fringe. Bottom buckskin drop is partially braided. Bag 9.5"L x 6"W + 8"L drop. Bladder has a few insect holes. Est. 250-475 **SOLD** $425(04)

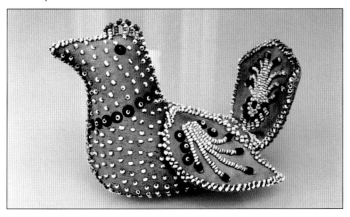

"1901" on tail back (not shown). Faded cloth was pink (seen under wings). White ponies, brass sequins, and t. grey basket beads. Crest is white and t. green ponies. Nice overall patina adds to charm and elegance, good cond. 6" x 4.5"H. Est. 150-250

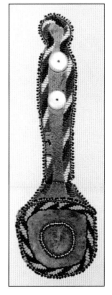

APACHE BEADED POCKET WATCH CASE c.1880
Classic diagonal stripe borders in tiny size 14° beads: gr. yellow, t. rose, white, and t. brilliant blue. Entirely edge-beaded in opal. white and black. Two mother-of-pearl buttons. Apx. 3/4" break in border and a few edge beads missing. Dark beautiful patina. 8.5"L. Est. 200-350 **SOLD** $175(99)

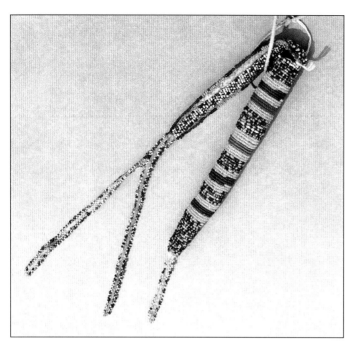

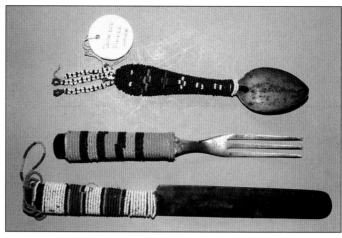

SIOUX BEADED SILVERWARE c.1890
Rosebud, South Dakota. From the Conyngham Collection. Three pc. set with bead-wrapped handles: SPOON has cobalt with tiny geom. in gr. yellow, rose w. heart, Sioux green, and white with 2" beaded loop dangles. FORK is gr. yellow with lt. blue and cobalt stripes. KNIFE has white with rose w. heart, gr. yellow, and dk. cobalt. Periwinkle short loop dangles with one long loop dangle; gr. yellow and rose w. heart. 2.5" All beads intact. Hard to find an original set like this. Exc. cond. Est. 300-600 **SOLD $400(00)**

PLATEAU FULLY-BEADED HAIR PARTER CASE c.1890
Heavy rawhide case for carrying a wooden hair parter is bead wrapped in stripes of opalescent clear, t. rose, t. gold, t. blue, gr. blue, and "salt and pepper." Buckskin flap is unusual because it is beaded on both sides: "Salt and pepper" panels both sides edge-beaded with gr. yellow, t. dk. cobalt, and rose w. hearts. Drops on bottom and flap (7"L) are "salt and pepper" edge-beaded. 7"L + 2.5" bottom drop. Est. 550-800 **SOLD $425(05)**

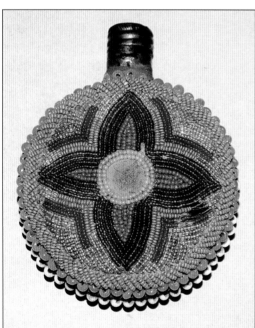

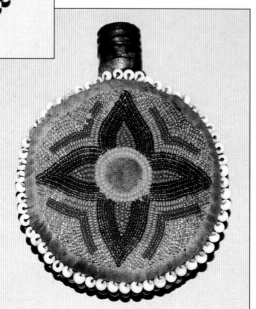

CREE BEADED TOBACCO CANTEEN c.1890?
RARE. Stylized four petal motif each side in beautiful pastel tones: t. rose, t. gold, periwinkle, gr. blue, apple green, and milky white. One side has lt. blue rolled bead edging and large gr. blue ponies; other side large white ponies, seed beads missing. Thread sewn over muslin. Metal screw-top lid. 4.5"H x 3.5" diam. VG cond. Est. 800-1200 **SOLD $950(05)**

SIOUX QUILLED BUFFALO HORN c.1890?
Preston Miller Collection. This is the nicest one we have ever seen. Red, purple, and white quill wrapped rawhide slats bound at top with faded red Fox braid embellished with brass sequins. Quill wrapped thong drops are: 1) purple, yellow with small claw dangles wrapping all around top of horn; 2) red and orange with tin cone dangles and red horsehair (3"L). Tin cones with red horsehair around entire bottom of slats! (apx. 90 of them!) Nice large horn has 3" top diam. Apx. 5% of quills missing. Un-restored original condition. Est. 950-1500

Parfleches (Painted Rawhide Containers)

This folding style was used by Indian people to store dried meat, blankets, clothing, etc. Early ones were made of buffalo hide but after the Reservation period elk or cowhide was more commonly used.

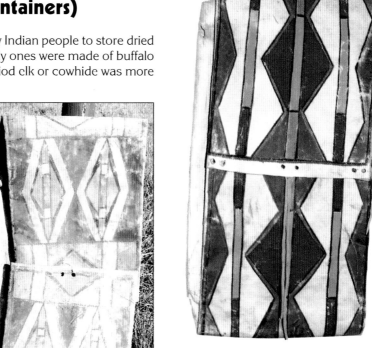

INTERMONTANE PARFLECHE c. 1900. *Collected on the Nez Perce Reservation in Idaho. The design has both Crow and Nez Perce characteristics.* The pristine condition of this parfleche makes it hard to know whether it is before or after 1900. The colors are still bright: red, yellow, green, orange, and cobalt blue. A large 15" x 28". Exc. cond. Est. 950-1800 **SOLD $1300(04)**

PLATEAU FOLDING PARFLECHE c.1880
Beautiful muted colors: red, green, and yellow with wide outlines in cobalt blue. Very fine patina of age. 13.5" x 27"L. Est. 950-1500 **SOLD $1102(05)**

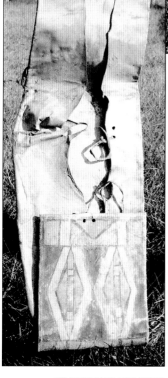

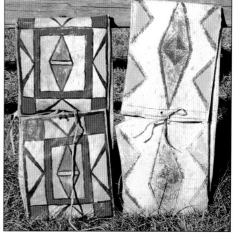

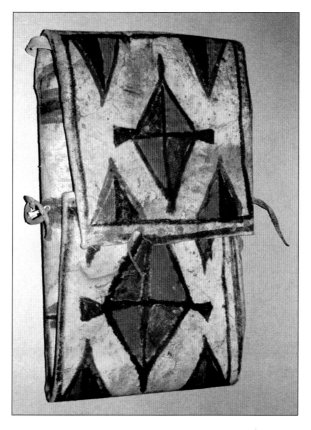

BLACKFEET FOLDING PARFLECHE c.1870
Collected from Umatilla Indians Reservation in Oregon. This style and design is typical Blackfeet. Rich varied patina (shows age) on heavy rawhide that appears to be buffalo. Red ochre, deep green, and dk. cobalt motifs and outlines. Same color stripes on inside. 9" x 15.5"L. Exc. cond. Est. 1000-1500 **SOLD $1100(01)**

(Left) PLATEAU FOLDING PARFLECHE c.1900
Bright primary colors: red, apple green, and yellow outlined in indigo. 25" x 12"W. Nice rich patina. Exc. cond. Est. 800-1200.**SOLD $475(99)**
(Right) PLATEAU FOLDING PARFLECHE c.1890
Diamond and triangle motifs: Yellow ochre, cobalt, dk. green, and red ochre. Creamy yellow heavy rawhide with excellent patina. Exc. cond. 27"H x 11"W. Est. 700-950 **SOLD $675(00)**

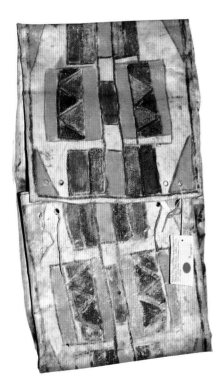

OLD PAINTED RAWHIDE PARFLECHE c.1870. *Collected on the Nez Perce Reservation in Idaho. However, the design is a bit unusual and could be Kootenai or Flathead.* Good patina, which shows Indian, use. The designs are in cobalt, red, yellow, and green Indian paint. Exc. cond. 15" x 26". Est. 950-1500 **SOLD $800(04)**

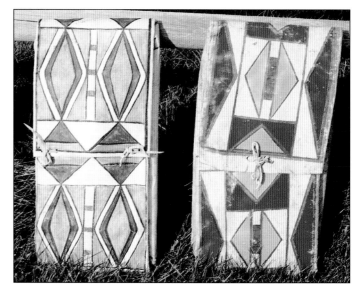

(Left) **PLATEAU FOLDING PARFLECHE** c.1900
Brightly painted blue-grey, red ochre, yellow ochre, and dk. green outlined in deep cobalt. Nice yellow waxy rawhide. Green lines outline back (not shown). 28"L x 13". Exc. cond. Est. 850-1200 **SOLD $850(05)**
(Right) **PLATEAU FOLDING PARFLECHE** c.1900
Heavy duty rawhide is much older than some of the paint. Dk. green original paint along borders. Central green outlines amended with orange. Yellow and red are newer, prob. over fading same colors. Cobalt re-painted as well. These colors were very likely added by an Indian to "freshen it up." 29" x 14". Est. 750-1200 **SOLD $750(05)**

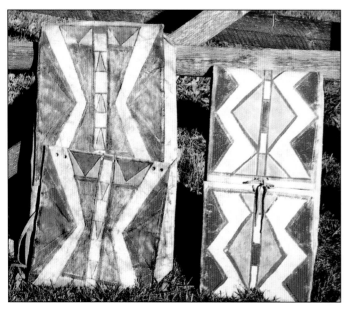

(Left) **YAKIMA PAINTED PARFLECHE** c.1910
Complex geometric motifs are dk. blue-green yellow, red and dk. green. Dk. patina rawhide. Buckskin ties. 15"W x 29"L. Est. 750-1200 **SOLD $850(04)**
(Right) **CROW PAINTED PARFLECHE** c.1890
Beautiful clear primary colors: soft green, red, and yellow, broadly outlined in cobalt blue. Buckskin ties. Rawhide has desirable natural yellowish-waxy patina. Superb condition. 12.5"W x 25"L. Est. 950-1800 **SOLD $1400(04)**

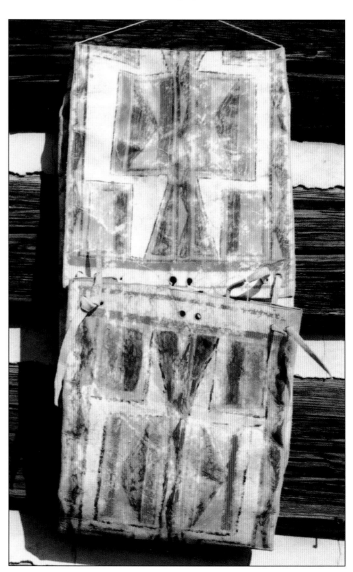

FLATHEAD FOLDING PARFLECHE
c.1870
Characteristic design motifs in yellow ochre, red ochre, and two shades of dk. green outlined in black and bordered in red. Inside flaps also painted in diff. designs, similar colors. 22"L x 10"W. Est. 950-1600 **SOLD $950(99)**

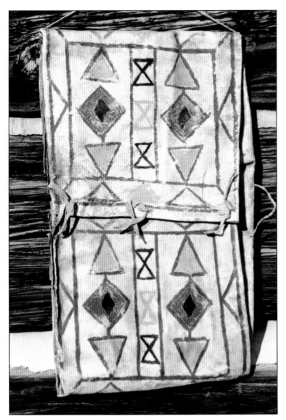

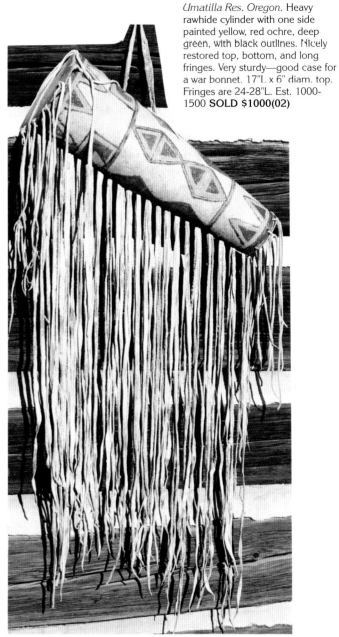

PLATEAU CYLINDER PARFLECHE c.1900?
Umatilla Res. Oregon. Heavy rawhide cylinder with one side painted yellow, red ochre, deep green, with black outlines. Nicely restored top, bottom, and long fringes. Very sturdy—good case for a war bonnet. 17"L. x 6" diam. top. Fringes are 24-28"L. Est. 1000-1500 **SOLD $1000(02)**

BLACKFEET PAINTED PARFLECHE CASE c.1880
From Montana. Cobalt outlined with red diamonds, yellow ochre triangles, and hourglass patterns in yellow and black. Unusual design. Shows heavy patina of use and age. 19" x 12". Est. 700-1250 **SOLD $850(01)**

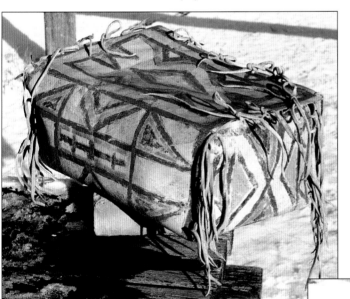

CLASSIC SIOUX PARFLECHE BOX c.1880
RARE. Beautiful designs and patina of age. Colors are yellow ochre, dk. green, cobalt blue, orange, and pale red, finely outlined in dk. brown. Laced with buckskin ties on all sides. 6.5"H x 9.5"D x 15"L. Est. 2500-3500 **SOLD $2650(03)**

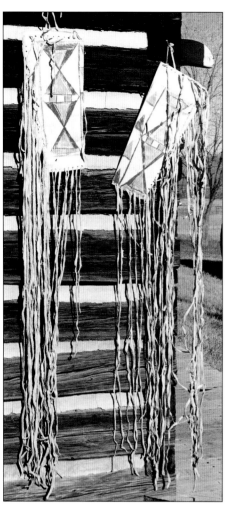

**PR. of PLATEAU FLAT CYLINDER
PARFLECHES** c.19th century
Probably horse parade gear. Cobalt outlines
with yellow ochre, red ochre, and green
triangular motifs, both sides. 2" hole on one
side. Nice yellow waxy patina of natural age.
Laced with long heavy buckskin fringes up
to 54"L. 18" x 5.5" x 8.5". Est. 500-900
SOLD $550(02)

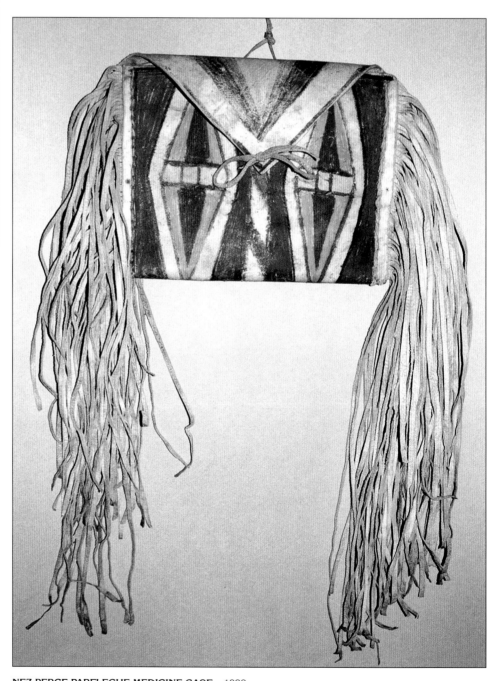

NEZ PERCE PARFLECHE MEDICINE CASE c.1880
Painted designs on front and flap are dk. green, yellow ochre, red ochre, cobalt, and indigo outlines. Very
heavy elk? hide. 18"L buckskin fringe each side. Bag is 8" x 10". Exc. cond. and patina. Est. 1500-2500
SOLD $2100(99)

3. Tipis and Tipi Gear,
Musical Instruments, Toys and Games

Tipis, Models, and Accessories

OLD FLATHEAD TIPI and DEW CLOTH c. 1940s.
Belonged to Louise Conko. Made from white canvas, this tipi is 11 ft. H. at the back. It is machine sewn. There are a few finger sized holes that would be best if repaired so they don't tear further. Also there is one 5-6" tear on the left flap—easily repaired with a simple patch. It's in good condition and can still be put to good use. Est. 150-400 **SOLD $225(00)**

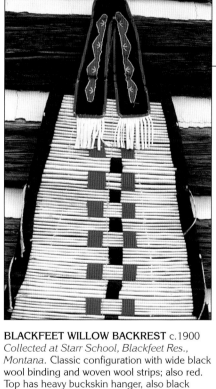

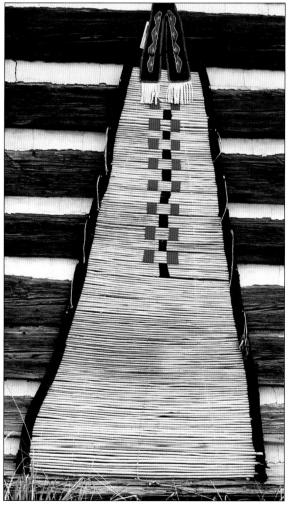

BLACKFEET WILLOW BACKREST c.1900
Collected at Starr School, Blackfeet Res., Montana. Classic configuration with wide black wool binding and woven wool strips; also red. Top has heavy buckskin hanger, also black wool beaded and buckskin fringed piece; red cotton bound and canvas backed. Buckskin tied thong side drops have lt. blue basket beads with remnants of hawk bells. One pr. of thongs has brass thimbles with narrow red braid fringes. 65"L x 37"W bottom x 11"W top. Willow has nice age patina. Est. 1200-2500 **SOLD $1200(01)**

CORNHUSK TIPI DANGLE ORNAMENTS c. 1880.
RARE. This style was made by Cheyenne Indians and attached to the front and flaps of specific tipis. They were beautiful to look at and made a nice rattling sound when blowing in the wind. Yellow dyed cornhusk strips wrapped on leather with mountain sheep toes and red yarn attached to the ends. Two of the toes have broken off, otherwise exc. cond. Apx. 10"L. Est. 300-550 **SOLD $325(02)**

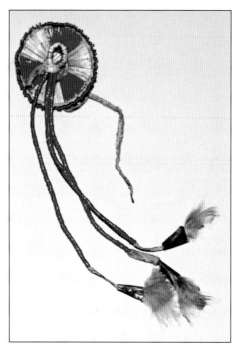

SIOUX QUILLED ORNAMENT c.1870
Turtle Mtn, Res. Collected by Maurice Oliver of Oberon No. Dakota betw. 1870-1920. Most likely, this piece was a tipi ornament. Sewn quillwork rosette in alt. green and red quills. T. blue seed bead edge. Three (6") thong drops are red quill-wrapped with tin cones and green fluffs. Buckskin back has thong ties. Excellent patina. Remarkably intact and unfaded. 1.5" diam. Est. 200-400 **SOLD $250(03)**

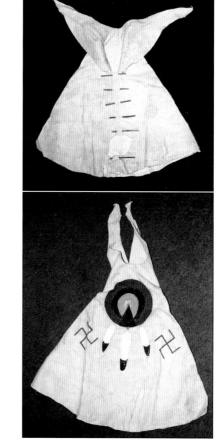

ARAPAHOE BUCKSKIN TIPI COVER c.1930-40
Harold L. Shilling Collection. "Good luck" swastikas painted in cobalt; 5" concentric circle is lime green, burgundy, black, and yellow with three painted feather motifs. Twigs form tipi pins. 23"H incl. flaps. 21"W bottom (folded flat). Est. 200-300

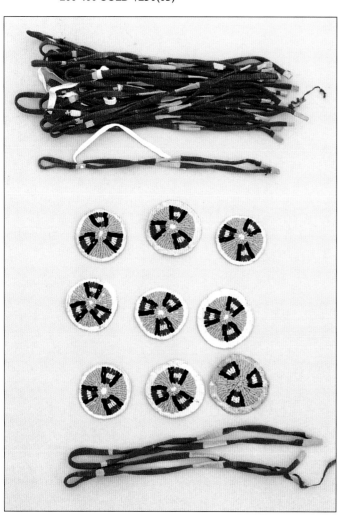

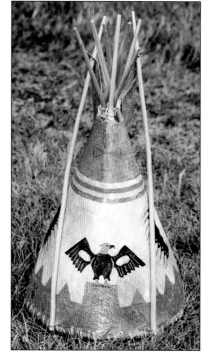

BLACKFOOT "CAMPY" PAINTED TIPI MODEL c.1910?
Painted rawhide designs in faded blue and orange with buckskin painted "door." Wooden dowel poles. Apx. 12"H. Laced to wooden base. Est. 350-600 **SOLD $375(99)**

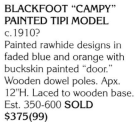

CHEYENNE TIPI ORNAMENT SET
Craig D. Bates Collection. Nine beaded rosettes are mustard yellow, red, black, and lt. blue on buckskin; 2" diam. Eighteen raffia-wrapped thong dangles are rose-red and yellow ochre. 18" loop hangs 9"L. Est. 250-400 **SOLD $225(05)**

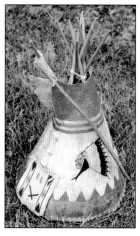

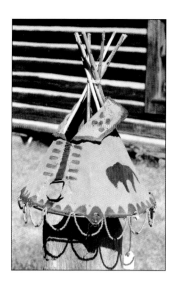

MINIATURE BLACKFEET BUCKSKIN TIPI c.1915
Traditional designs with red ochre stylized rocks along bottom, black buffalo each side, and red ochre "star" motifs on flaps. Hand-carved stick poles and lamp shade metal base. Lt. blue with red and black seed bead loop fringes on base. 8" diam. apx. 11"H. Hand-tanned hide. Est. 100-200 **SOLD $80(99)**

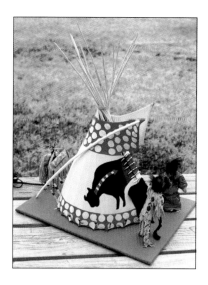

BLACKFEET TIPI DIORAMA c. 1940.
Made on the reservation in Montana. Tipi is made from canvas with traditional painted Blackfeet Buffalo Medicine designs. In addition, there are two fully clothed Indian dolls standing in front and a tripod of painted parfleche medicine bundles in the rear. The diorama if mounted on a 14" x 18" board covered with green felt. Apx. five of the poles have broken off at the top. This is a truly authentic model as only an Indian could make. Est. 250-400 **SOLD $275(00)**

Cradleboards and Accessories

SIOUX FULLY-BEADED LIZARD FETISH c.1880
RARE. Simple but very nice black and white seed beaded top with cross and square motifs. White edge-beaded. All sinew-sewn. Tin cones with yellow horsehair appendages. Back has Sioux green bead hanger. Buckskin and cones shows genuine patina of age. Exc. cond. 8"L x 2.25"W. Est. 800-1200 **SOLD $925(00)**

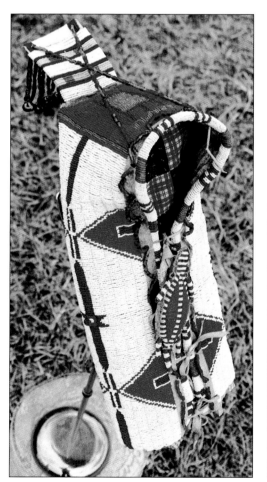

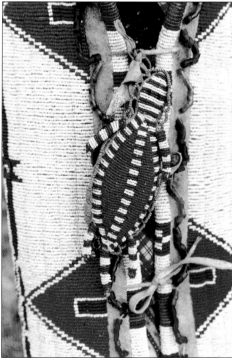

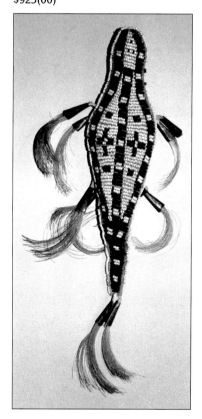

SIOUX FULLY-BEADED DOLL CRADLE c.1890?
Superbly detailed, lane-stitched in white, beautiful rose-red w. heart and cobalt traditional design elements. Top motif has additional t. gold beads. Front opening is rolled bead wrapped in white and rose-red w. hearts, embellished with alt. loops of t. blue and t. gold basket beads. Back tab (painted parfleche) is white, Sioux green, and gr. yellow; held by crossed strands of basket beads. Drops on tab are basket beads with tiny brass hawk bells. Beaded lizard fetish on front is same colors with periwinkle beaded edging. Red and white gingham check lining. Amazingly intact. Carefully preserved. Pristine condition. Size apx. 20"H + tab x 9"W Est. 8,000-15,000 **SOLD $9500(00)**

BACK TAB FROM OLD CRADLE BOARD c.1870.
The beadwork is lane-stitch with lt. blue background; designs in apple green, corn yellow, and cobalt blue. Sinew beaded on Indian tan buckskin and backed with old patterned calico. The whole thing is mounted on a piece of parfleche type rawhide that was originally attached to the back of a Cheyenne/Sioux style cradle. 17"L (including fringe) x 3.75"W. Exc. cond. Est. 200-350 **SOLD $325(05)**

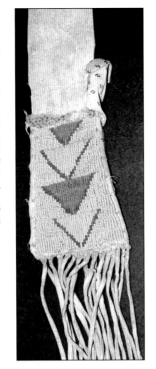

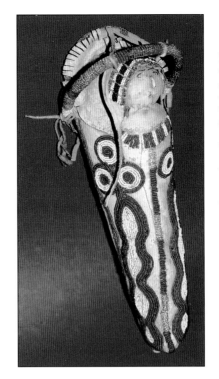

PLATEAU BEADED DOLL CRADLEBOARD c.1860?
EARLY and RARE. Preston Miller Collection. Doll cradleboards like this were passed down from generation to generation. The configuration of doll boards is completely unlike the full-sized boards, which usually have a fully-beaded rounded top. Buckskin doll and cover with wonderful patina. Partially beaded in intense t. blue, white, t. gold, t. pink, Sioux green, and clear seed beads. Features on doll's face are remnants of dk. blue thread. Front loop protector bead wrapped. 13"L. Est. 5000-8000

*See Mercer, Bill. *People of the River*. Portland Art Museum, Oregon, 2005, 174-175 for three more examples and information.

LAKOTA QUILLED CRADLE c.1875?
RARE All sinew-sewn. Classic red-line single band sewn quillwork on buffalo hide. Spaced 6" yellow quills with dyed dk. blue fluffs. Top back red quill wrapped rawhide slats with yellow and green concentric circle pattern and apx. 6" buckskin fringes. Front rolled edge-beaded in lt. blue with gr. yellow and dk. cobalt. Buckskin skirt. Dark patina of age. Quillwork apx. 90-95% intact and unfaded. 27"L. Quilled and beaded top is 16"L. Wonderful unrestored collectible. Est. 1500-3000 **SOLD $1500(01)**

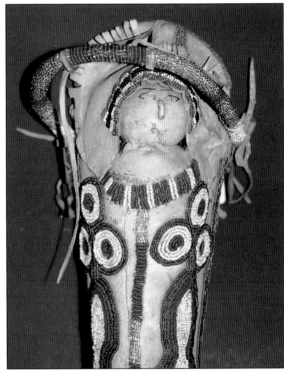

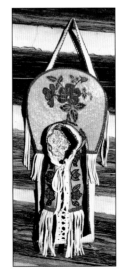

CANADIAN METIS BEADED DOLL CRADLE BOARD c.1920
Tri-cut beads appliqué stitched: white satin bkgrd. with t. dk. red, red, t. gold, and t. green. Periwinkle outline. T. red lazy-stitched borders and edge beadwork in hood and back strap. White brain-tan with fringes. Calico lined. New cond. Probably old beadwork recently made into cradle. 17.5"L x 8.25"W. Est. 350-500 **SOLD $250(00)**

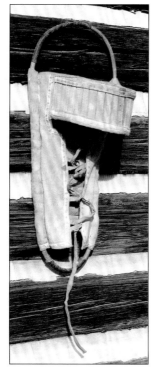

APACHE CRADLE BOARD
c.1900?
Made from bent willow and pine slats with yellow hopsacking trimmed with machine embroidered seam binding, faded colors. Lacing intact. Exc. patina and cond. 26"H x 11"W. Est. 195-400 **SOLD $225(00)**

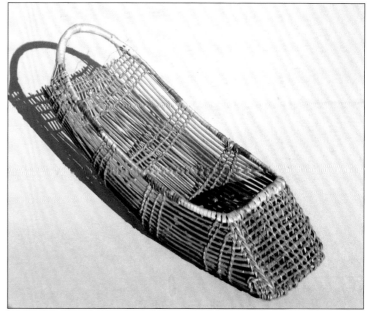

NO. CALIFORNIA MINIATURE BASKETRY CRADLE Late 19th century *Hupa tribe of N.W. California.* Fine hazel or willow, characteristically open twined. Nice age patina. Exceptional piece in rare perfect cond. 10"L x 4"W. Est. 200-500 **SOLD $150(04)**

This style was called a "slipper foot" cradle basket and was common to the southern Oregon and northern California coast. The example shown is missing the small, round, sunshade that should be attached to the top. Also missing in the example shown in Woven History, *p. 34.*

See two similar examples from the Peabody Harvard Museum in Turnbaugh, Sara P. & William A. *Indian Baskets.* West Chester, PA: Schiffer Publishing, 1977: 43 and 178.

PAIUTE BASKETRY CRADLE c.1900?
Characteristic twined willow, laced with dark bark (prob. sumac) in diagonal patterns on hood, back, and front. Hood has light red stain applied for additional decoration. Lovely age patina. Exc. cond. 19.5"H x 9" top W. Est. 400-600 **SOLD $575(04)**

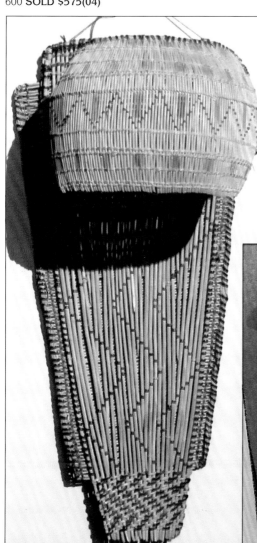

CENTRAL CALIF. TOY CRADLES c.1900
Mono or Washo. Peeled willow? with buckskin lacings.
(Left) Hood has woven yarn pattern. Buckskin bound. 13.5"H x 6.5"W x 5"D hood.
(Right) Diagonal and zigzag patterns and edges coiled with shiny cherry bark. Yarn tied to top. 12"L x 6" x 5"D hood. Exc. cond. Est. 450-600 each; **SOLD $475(02) each**

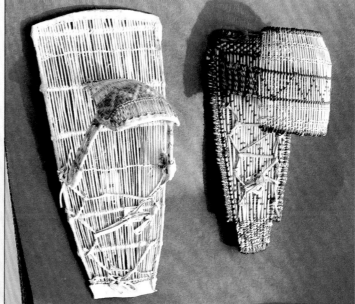

Dolls

Indian-made Dolls

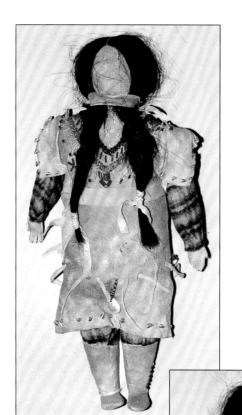

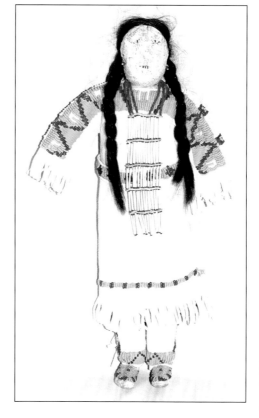

PLATEAU FEMALE DOLL c.1920
Probably Salish.
Characteristic stylized large head with broad shoulders. Real hair braids. Grey plaid body with simple flat buckskin hands. Buckskin dress and hi-top mocs are beaded in tri-cuts: t. cranberry, t. iris, t. aqua, t. and opaque pumpkin satins, and t. pale yellow. Red and t. rose small bugle beads. Sleeve and dress hem have pink iridescent tiny shells. Old monie cowrie dangles with multi-colored beads. 14.5"H. Est. 350-600
SOLD $312(03)

(Left) SIOUX FEMALE DOLL
Contemp.
Buckskin head and face are unmistakably old; eyes and mouth are alt. white and cobalt seed beads. Braids are real hair. Buckskin dress has beaded yoke in mustard, lt. blue, cobalt, and white. Matching beaded belt, fully-beaded mocs, and buckskin beaded leggings. Breastplate is strung natural porcupine quills and red seed beads. Pink chintz body. Exc. cond. 15"H. Est. 200-400

(Right) ASSINIBOINE FEMALE DOLL c.1940?
Made by Juanita Tucker, Ft. Belknap Res. in Montana. We have several of her dolls in our collection, but none this early. Rare example of a doll in everyday dress—pale green rayon tiny floral patterned with pale yellow silk ribbon trim. Red velvet leggings. Partially-beaded buckskin mocs. Characteristic ochred partially-tanned buckskin face and arms. Red wood bead necklace; alt. red and green wood bead bandolier. Fine yarn braids. Leather concho belt with brass spots. Narrow white silk ribbon headband with tiny feather. 12"H. Exc. cond-lt. patina. Est. 300-500

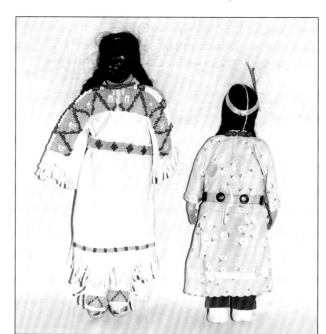

Skookums and Other Non-Indian Made Dolls

We now can be more precise in dating these wonderful collectibles, thanks to this wonderful book, now out of print:
Mitchell, Lesley. *SKOOKUM, The Great Indian Character Doll.* Bloomington, Ind., 1999.

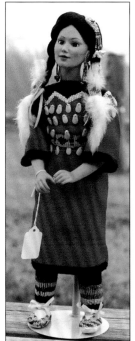

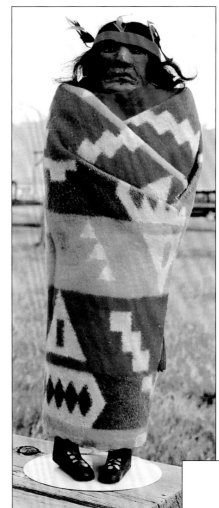

CROW-STYLE FEMALE DOLL Contemp. *By Judy Belle from Danbury Mint.* Traditional red wool dress with miniature cast elk teeth, white pearl bead outlined yoke, colorful beaded earrings, braid wraps, and beaded buckskin belt. Navy wool leggings beaded in lanes of lt. blue, pink-lined, green-lined, and t. red. Same bead colors on belt, mocs, and other accessories. She holds real parrot feather fan (omitted in photo). Beautiful porcelain face with realistic glass eyes. Complete with original box and numbered certificates from Mint. 16.5"H. New cond. Est. 100-250 **SOLD $100(00)**

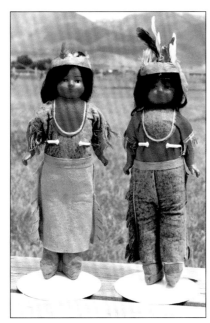

PR. OF OLD INDIAN STYLE DOLLS c.1930 Celluloid faces with black wool hair and dk. muslin covered legs. Outfits entirely made of wool felt in golds, greens, and browns. Tapestry fringed sleeves. Feathers in headbands—intact on male, broken on female. She even has white lace-edged bloomers! 12"H. Clean and exc. cond. Est. 180-295 pair **SOLD $180(98)**

"M.F. WOODS" DOLL c.1910-1930 *RARE. UNUSUAL LARGE SIZE. Maker stamped on bottom of foot. Full name was Mary Frances Wood and she originated this style of doll BEFORE Skookum Dolls in 1913. Her company was in business until the '30s.** Characteristic hand-painted realistic face (crepe paper covered plaster) with glass stickpin eyes. Black realistic hair. Orange wool felt feather headband forms back trailer with feathers. Red cotton "shirt." Cotton blanket is yellow, green, and rust geometrics. Wooden painted moccasins. Exc. cond. 16"H. Est. 300-600 **SOLD $450(05)**
**See Mitchell, p. 39.*

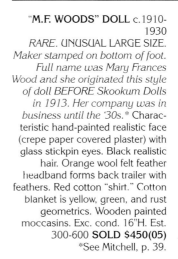

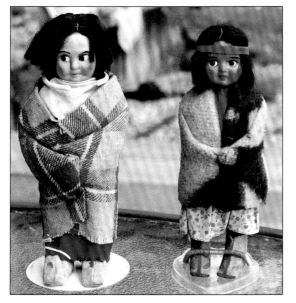

(Left) **CHILD** c.1930-40 Felt covered feet; mohair hair. Unusual plaid blanket. 7"H. Est. 80-125 **SOLD $80(01)**
(Right) **CHILD** c.1935-40 Painted leather covered feet, red leather headband, real hair, missing bead necklace. Identical to one shown on p. 21-22 in *Mitchell.* Has foot tag shown on p. 18. 6.5"H. Est. 95-150 **SOLD $125(01)**

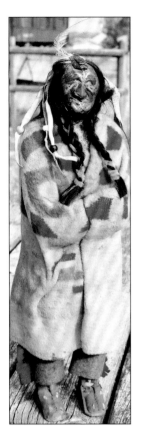
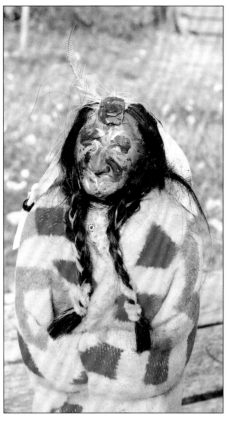
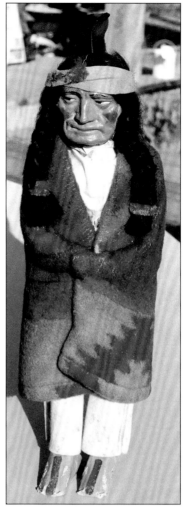

MALE SKOOKUM DOLL
c.1940s
Wonderful craggy face. Unfaded green, royal blue, and rust blanket. Off-white felt leggings. Masking tape painted mocs. Black mohair braids with yellow felt headband and complete orange feather. Shiny chintz floral shirt. Exc. cond. 13.5"H. Est. 225-400 **SOLD $135(02)**

EARLY and RARE MALE SKOOKUM DOLL c.1915-20
Dark celluloid face (war-painted) simulates the real apple style of this same period. Unpainted eyes. Real hair braids; adhered hair ornaments are buckskin thongs with glass Crow beads and top knot feather. Chenille yellow braid ties. Pale green, gold, and rust blanket. Calico floral print shirt. Wool felt leggings, faded purple with red fringes. Painted real leather mocs. Wood feet and legs. Sisal-stuffed muslin body. apx. 16"H. Exc. cond. Great patina. Est. 300-500 **SOLD $255(02)**
 "Some very early examples have primitive features and unusually dark complexions…and black painted outlines around their eyes." (Mitchell, p.16)

LARGE MALE SKOOKUM DOLL
Pre-1946, as determined by the label on the foot (not shown). See *Four Winds Guide to Indian Artifacts*, p. 140, for a similar example that shows label. This is a prime example of a choice Skookum—real hair on realistic composition face (perfect cond.) wearing wrapped Beacon blanket (shades of tan, olive green, and pumpkin) over deep blue wool felt leggings with gold felt fringes. Painted leather mocs. Single trailer bonnet is leather with alt. green and orange feather fluff trim. Bead drops on either side are seed, tile and long facet (two) beads. 17"H. Perfect cond. Nice patina of age. Est. 350-700 **SOLD $550(00)**

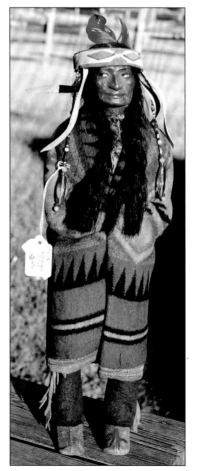
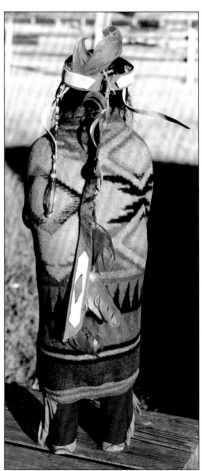

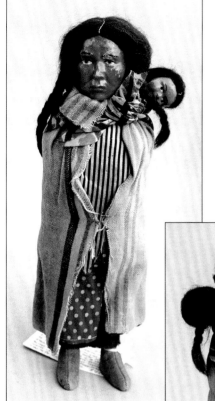

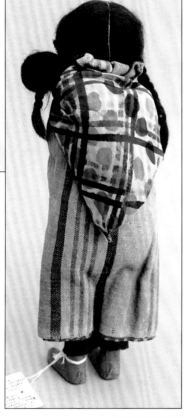

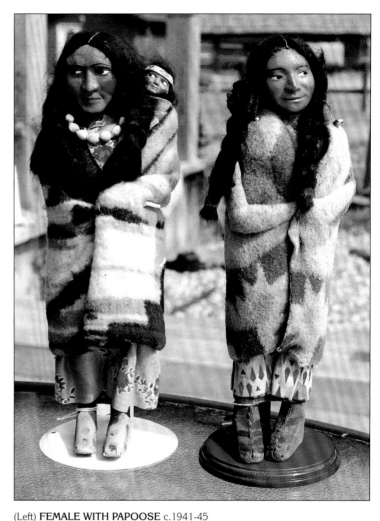

EARLY SKOOKUM FEMALE WITH BABY c.1900
We have never seen a Skookum **looking straight ahead** or wearing a fine wool striped blanket and patterned silk scarf! Early red with white polka dot calico underskirt and black stripe muslin top. (Judging by cloth alone, I would guess early 20th century.) Wool hair. Composite faces; nose chipped and forehead worn. Baby (unmarred) face also looks straight ahead! Navy wool felt leggings, brown felt mocs. Sawdust stuffed. 12"H. Est. 350-600 **SOLD $300(00)**

(Left) **FEMALE WITH PAPOOSE** c.1941-45
Masking tape painted covered feet, wooden bead necklace, mohair hair, calico dress. Exc. cond. 12.5"H. Est. 275-395 **SOLD $275(01)**
(Right) **FEMALE** c.1930-40
EYES LOOKING LEFT! These are **rare,** as most were looking to the right! Painted leather "mocs," double layer calico dress, mohair hair. 12.5"H. Exc. cond. Est. 350-550 **SOLD $350(01)**

FEMALE WITH BABY PAPOOSE c.1941-45
Dated by the change from leather, which was scarce during WWII, to painted masking tape covered feet. Also wooden rather than glass beads (necklace and earrings). Yellow pipe cleaner laced buckskin headband. Calico dress, cotton blanket wrapped, mohair hair, buckskin tie with red feather fluffs. Blanket is coral, grey-blue, and mauve. Has oval tag on foot from this period. Exc. cond. 16.5"H. Est. 450-650 **SOLD $450(01)**

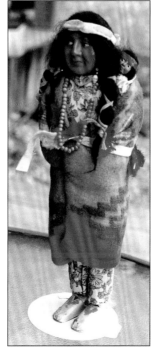

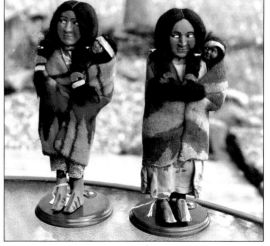

(Left) **FEMALE WITH PAPOOSE** c.1930-40
Includes Certificate of Authenticity from the Thivener Collection, #1154. Painted leather mocs, orange, purple green blanket, mohair hair, orange and blue pipe cleaner hair ties. 11"H. Exc. cond. Est. 275-450 **SOLD $275(01)**
(Right) **FEMALE WITH PAPOOSE** c.1941-45
Painted masking tape mocs, grey-blue blanket (threadbare on lower right), rose pipe cleaner hair ties, mohair hair. 11"H. Est. 275-450 **SOLD $275(01)**

Musical Instruments:
Flutes, Drums, Rattles, Etc.

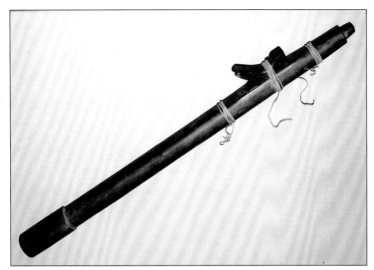

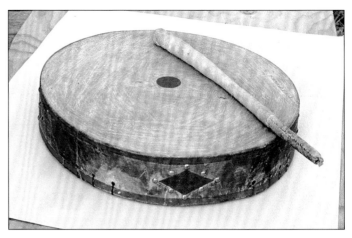

CROW? CEREMONIAL HAND DRUM c. 1940s.
The surface is painted yellow with central purple circle in old style Indian paint. The wooden sides have two blue stripes and four red diamonds surrounded by brass tacks. Rawhide head held on with a rawhide lace, and the hand holds are done in the old way with rawhide and buckskin. A few small holes in the drum head have been stitched with sinew (Indian style); appears to have been done before the drum was constructed. There is a 1" tear in the head but it still has a very good sound. 15" diam. x 3" deep. The old style beater is completely covered with white buckskin. Est. 300-500 **SOLD $100(99)**

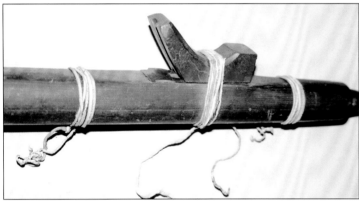

SIOUX COURTING FLUTE c.1890.
RARE. It is very unusual to find an old love flute! Still plays with a beautiful sound. Catlinite carved air block (stopper). Fine buckskin thongs. 20.5"L. Est. 900-1800 **SOLD $900(02)**

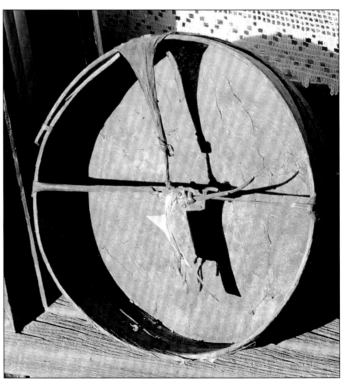

PLAINS "BUFFALO DANCER" HAND DRUM c.1890
Crude figure painted in black and red old Indian paint. Thin rawhide is buckskin laced onto wooden frame. Could be much earlier, patina of considerable age. Has a waxy darkness of antiquity. 9" diam. Est. 750-1500 **SOLD $750(98)**

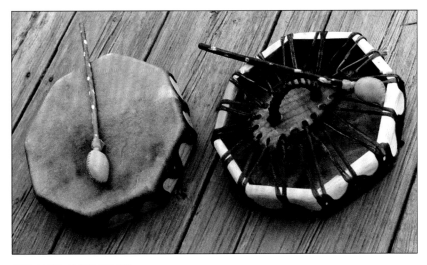

CHIPPEWA HAND DRUM
Made and signed by "Terry Wind, Red Lake, Minn." (Left) Very well-constructed of 3/4"W pine. Heavy rawhide top laced with rawhide. Rawhide wrapped handle. Carved natural drumstick is 14"L. 3" leather covered beater. Exc. cond. 13"W x 3" deep. Est. 100-175 **SOLD $125(99)**
(Right) SAME. Est. 100-175 **SOLD $125(99)**

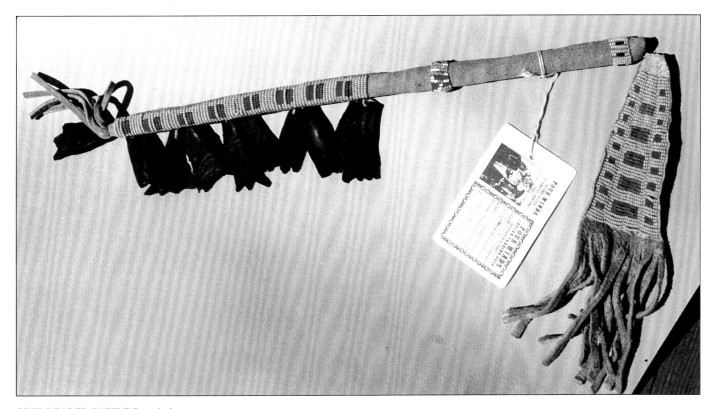

CREE BEADED RATTLE Pre-1940
Buckskin covered branch with red stained carved buffalo hoof/horn dangles. Partially beaded handle in lt. blue with red w. heart and cobalt. Beaded fringed buckskin drop is lt. blue with cobalt and gr. apple green. Sinew construction, thread sewn beads. Exc. cond. Nice patina. 14"L. Est. 300-500 **SOLD $425 (02)**

Games: Hand Games, Shinney Stick, Etc.

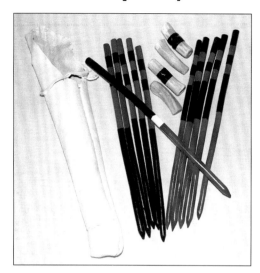

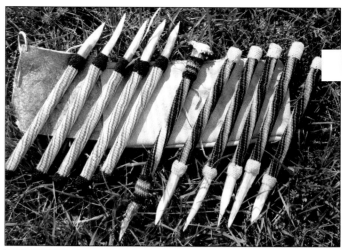

BLACKFEET STICK GAME SET Contemp., by Jeremiah Spotted Blanket.
12"L red and black painted wooden sticks and pointer. "Bones" are 2.5"L carved antler; two plain, two with black. Comes in brain-tan buckskin case. Est. 75-125 **SOLD $50(01)**

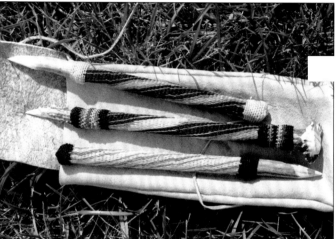

Antler tipped pointers (12"L) are five black, with natural, yellow, orange, and red diag. stripes; and five natural, with red, orange yellow, and black diag. stripes. Counter (13"L) has antler end. Smoked brain-tan carrying bag. Unique and expertly made set. Exc. cond. Est. 250-500 **SOLD $325(98)**

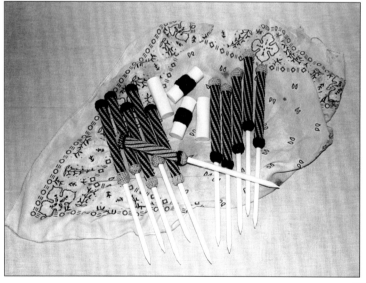

KOOTENAI HORSE HAIR WRAPPED STICK GAME SETS
Contemp.
Made by Harry Lozeau, Flathead Reservation, Montana. Counters and pointer are 10"L half-hitched in natural black and white horsehair over white painted sticks. White painted wooden "bones" are two plain; two black half-hitched. Perfect cond. Est. 200-300 **SOLD $200(01)**
See Ayer, Max A. "Kootenai Indian Stick Game Party." *True West Magazine.* July, 1989, 52-54. This account of a white woman's attendance at a gambling event on the Flathead Res. (near present day Elmo) in Fall 1898 includes photos of the Indians there as well as a general idea of how the game is played. Today these games are just as important as dancing at the summer Powwows and frequently continue long into the night.

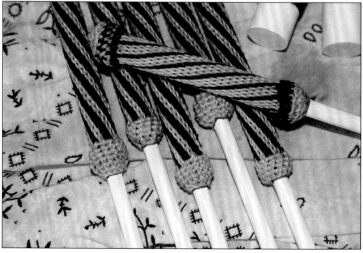

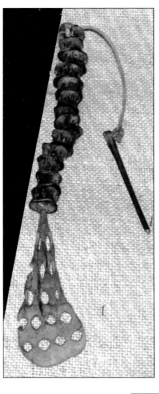

OLD STICK and BONE GAME
c.1900?
Bone vertebrae discs have remnants of purple pigment; strung on buckskin and tied to carved stick. Buckskin tab has cut perforations. Nice patina. 19"L. Est. 200-300 **SOLD $130(98)**

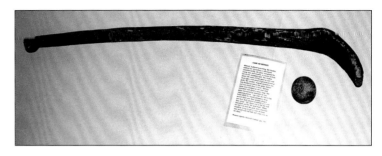

CROW SHINNEY GAME (Stick and Stone Ball) 19th century. 36"L stick has good aged patina. Includes 2" diam. stone ball. Comes with printed game description. VG set. Est. 300-400 **SOLD $275(00)**

ALASKAN ESKIMO YO-YO GAME c.1900.
Interesting four sided balls made from walrus hide and dangling on braided sinew from a carved ivory toggle. You hold the toggle in your hand and spin the balls in opposite directions to see how long you can keep it going. *Included is a history from the Yugtarvik Regional Museum in Bethel, Arkansas. It tells of three probable tribal sources of the yo-yo's origin; for instance, the one from King Is. has to do with boys learning sexual prowess…"since the game is a little ribald…the girls stay strictly away."* 20"L with age patina and exc. cond. Est. 65-175 **SOLD $75(05)**

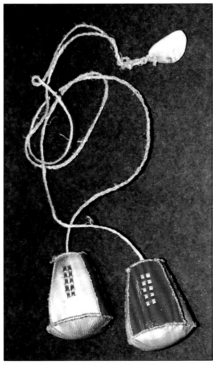

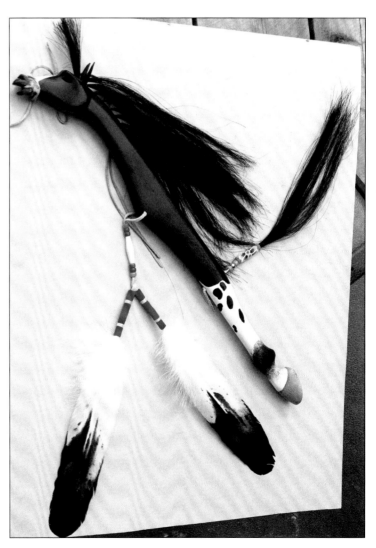

CHEROKEE/CHOCTAW PAINTED HORSE DANCE STICK Contemp. Expertly hand-carved and painted Appaloosa with horsehair mane. Artist also hand-painted the two red wool wrapped "eagle" feathers that hang in drop with bone hair pipe and Crow beads. Horsehair suspension has peyote beadwork. Horse stick 25"L. Feather drop apx. 20"L. Est. 400-550 **SOLD $400(01)**

4. Basketry

Baskets (Regional Listing)

Suggested reference book for this section:

Turnbaugh, Sara P. & William A. *Indian Baskets*. West Chester, PA: Schiffer Publishing, 1977.

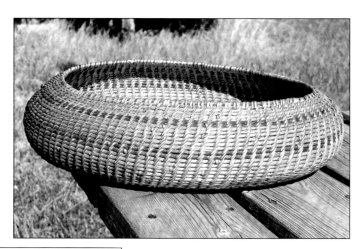

LARGE WASHOE OVAL BASKET Early 20th century *Harold L. Schilling Collection. Basin region. RARE* oval form with incurving rim, utilitarian basket. Diagonal twilled (horizontal coils) called "gap-stitch coiling."* Unpeeled stems forms two subtle horiz. stripes. Expertly made. Superb patina, perfect cond. 14"W x 16"L x apx. 4"H. Est. 375-800 **SOLD $325(01)**
*See Gogol, John, editor. *American Indian Basketry #12.* "Washoe Basketry," Marvin Cahodas. 1983. Examples and extensive discussion of this technique, 12-13.

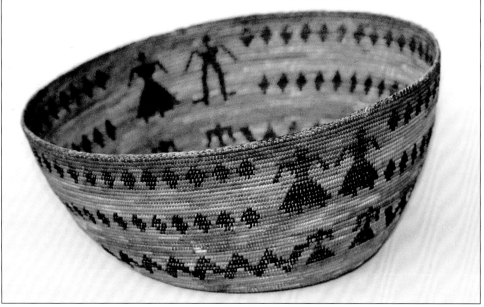

YOKUTS FIGURAL BASKET
So. Calif. –Desert region. Possibly from the small Yokuts section called "Tulare." RARE. Characteristic horizontal zig-zag and diamond bands with human figures. Very fine coiling of willow or grass fibers with black bracken fern contrasting designs. Nice subtle age patina. This basket has a slight slope that can be altered by careful steam restoration, which would raise the value considerably. Apx. 12" diam. Est. 10,000-25,000 **SOLD $9500(00)**
See Turnbaugh, pp. 203-205.
James, G. W. *Indian Basketry.* NYC· Dover Publishing, 1972 (reprint from 1909), 58-59.

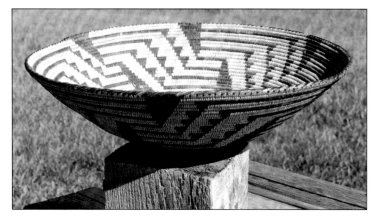

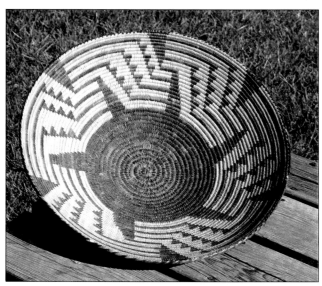

LARGE ROUND PIMA BASKET Early 20th century *Harold L. Schilling Collection. "Pima…from Sacaton, Ariz…"* Coiled cattail foundation stitched with willow in typical dramatic radiating design and rim stitched in black devil's claw. 17" diam. Pristine condition. Apx. 5" deep. Est. 1200-1800 **SOLD $1550(01)**

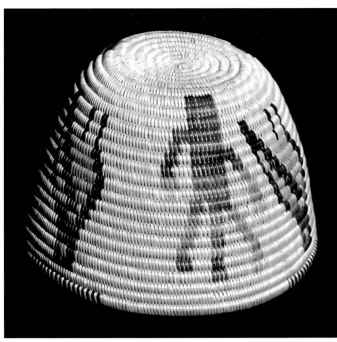

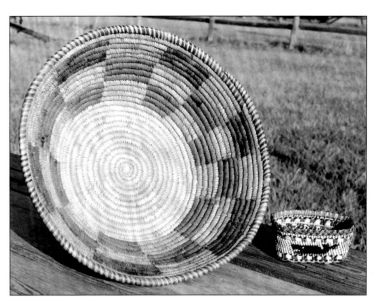

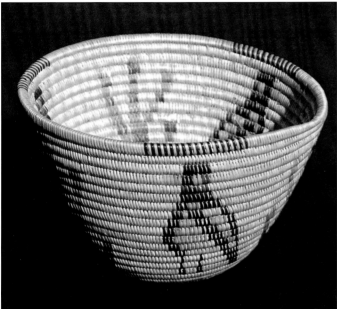

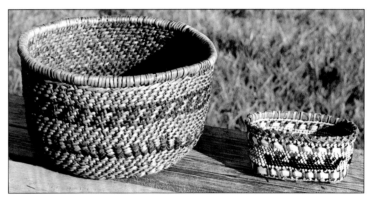

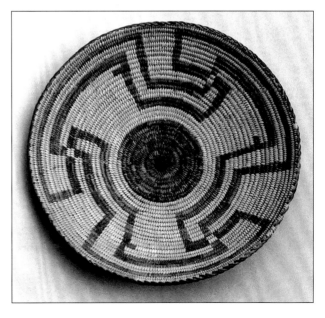

(Left) **PAGAGO COILED BASKET** c.1920
Southwest. Bear grass wrapped coils form dk. brown checkerboard pattern. Light patina shows age. 11" rim diam. 4"D. Est. 95-200 **SOLD $105(01)**
(Right) **TINY MAKAH FIGURED BASKET** 20th century
N.W. Coast. Unfaded dyed grass twining; four man canoe in red and black, black whale with black birds at ends. Typical cedar bark plaited rectangular base. Cedar braided rim. Exc. cond. 3.75" x 2.5" x 1.75"H. Est. 90-175 **SOLD $150(01)**

(Left) **HAVASUPAI TWINED BASKET** c.1900
Southwest. Stiff unpeeled sumac twigs form warp; willow? wrapped with black devil's claw decorative bands. Beautiful in its simplicity and textural design. Very sturdy. Exc. cond. 7" diam. x 4"H. Est. 250-450 **SOLD $225(03)**
(Right) Makah basket described in previous photo.

PANAMINT FIGURAL COILED BASKET
So. Calif.–Desert region. Harold Schilling Collection. Fine coils sewn with yellow willow. Bird and cactus motifs probably done with black dyed bulrush root and yellow juncus stems.* Apx. 6"H x 6"W. Est. 1800-3000 **SOLD $2100(00)**

*For similar pictured examples see Gogol, John editor. *American Indian Basketry Magazine, #19.* "Panamint-Shoshone Basketry," Bruce Bernstein, 9; and "The Panamint Basketry of Scotty's Castle," Beth Sennett-Walker, 1985: 16-17.

PIMA COILED BASKET
19th century
Southwest. Classic dk. brown fret patterns: willow stitched over coiled cattail. Rim stitched with devil's claw. Beautiful all-over patina. 14" diam. Exc. cond. Est. 375-550 **SOLD $400(00)**

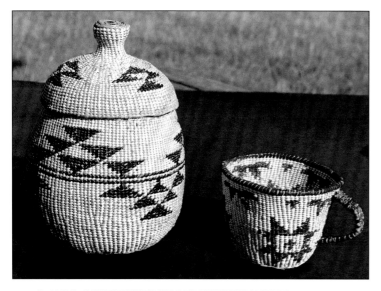

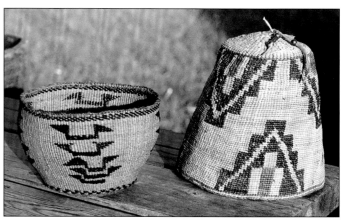

(Left) NO. CALIF. TWINED LIDDED TRINKET BASKET
Harold L. Schilling Collection. Hupa or Karok. Half-twist overlay willow with dark maidenhair fern geometric elements. Superb cond. Apx. 8"H. Est. 500-800 **SOLD $650(01)**
See very similar example in Turnbaugh, p. 179.
(Right) NO. CALIF. TWINED TEACUP c.1930s
Harold L. Schilling Collection. Documentation reads *"…made by a Maidu Indian nr. Hat Creek, CA east of Redding in the Sierra Nevada mtns. This cup was made by using alder twigs for the framework, the black from the Maidenhair or Five Fingered fern, the light color from bunch grass and the brown from the top of the alder root…"* Apx. 3"H. Est. 200-450 **SOLD $160(01)**

(Left) MODOC TULE BASKET 19th century
N.E. Calif. Interesting black vertical motifs (prob. maidenhair fern) on this full twist overlay twined basket. Tule is an exceptionally flexible and durable fiber. 6.5" diam. x 4"H. Exc. cond. Est. 300-475 **SOLD $320(00)**
(Right) NEZ PERCE BASKETRY HAT (FEZ) c.1900
Plateau. Shiny lt. twined bear grass with very attractive and desirable step-triangle motifs in dk. brown and dk. gray. Top buckskin thongs have small cobalt facets and brass bead trim. 1.5" rim tear. Still sturdy and wearable. 7" diam. 7"H. Est. 600-900

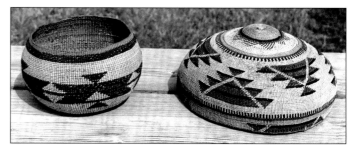

(Left) NO. CALIFORNIA SMALL TWINED BASKET c.1880
Pomo or Hupa/Karok. Exquisite little piece with same fibers as the following hat. Fine weave. Pristine cond. 6" at widest part. Apx. 3"H. Est. 400-650 **SOLD $575(03)**
(Right) HUPA/KAROK TWINED BASKET HAT c.1880
N.W. Calif. Unusual shape and large size. Fantastic, very fine weave and complex design; twined conifer root overlay, maidenhair fern, and sedge root? Pristine cond. 7.5" diam. 4"H. Est. 800-1200 **SOLD $800(03)**

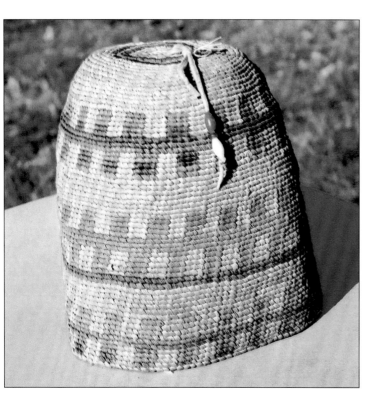

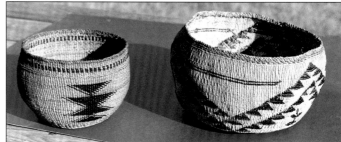

(Left) MODOC TWINED BASKET c.1900
N.E. Calif. Characteristic very flexible full-twist overlay fine twining. Conifer root with black fern? classic triangular motifs; rim edge is rust-brown sedge? 4.5"H x 6" top diam. 4" bottom diam. Nice patina. Exc. cond. Est. 375-600 **SOLD $400(98)**
(Right) KLAMATH TWINED BASKET c.1900
N.E. Calif. Similar fibers and technique as preceding basket. "Flying geese" triangular patterns in dk. brown. Rim edge is lt. gold-brown fiber. 8.5"W diam. top x 5"H x bottom 6" diam. Est. 450-600 **SOLD $450(98)**

NEZ PERCE CORNHUSK FEZ c.1890?
Plateau. ALL CORNHUSK bands of designs in dk. green, faded blue, and muted orange. Buckskin thong drop on top has blue and white old elliptical barleycorn trade beads and cobalt "donut" ring bead. This hat may be as old as 1880 or earlier, judging by patina and old trade beads. Stands 7"H x 7" diam. Exc. cond. Est. 475-650 **SOLD $500(04)**

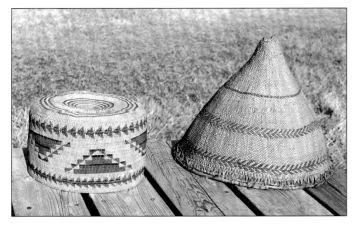

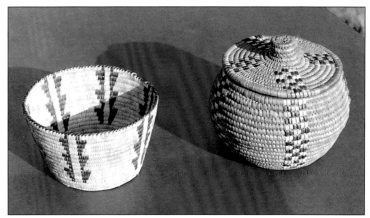

(Left) **KAROK TWINED BASKET** c.19th century
N.W. Calif. Beautiful conifer root overlay. Stacked triangle border designs and typical central geom. motifs. Bottom has concentric rings. Pristine cond. Glossy black maidenhair fern and sedge? rust color. with 10" diam. 6"H. Very fine piece. Est. 600-850
(Right) **PAIUTE CONE-SHAPED BASKET** 19th century
Basin region. Plaited utilitarian basket has willow branch rim and three bands of black chevron motifs. Wonderful dark patina of age. 13"H. 14" diam. Exc. cond. Est. 300-450 **SOLD $210(99)**

(Left) **PAPAGO FINELY COILED BASKET** c.1920
Southwest. Bear grass or yucca fibers with devil's claw vertical patterns and rim edging. Rows are less than 1/4"W (apx. 3/16"). Beautiful and elegant piece. Top rim diam. 5.5", bottom 4" diam. 3"H. Pristine cond. Est. 150-250 **SOLD $125(98)**
(Right) **THOMPSON RIVER LIDDED COILED BASKET** c.1900
Plateau. Knob top. Split conifer root coils with bear grass and cherry bark imbrication in vertical "checkerboard" patterns on lid and sides. Exc. cond. Very sturdy piece. 6"W pt x 5.5"H. Est. 250-500 **SOLD $200(98)**

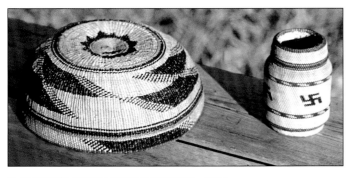

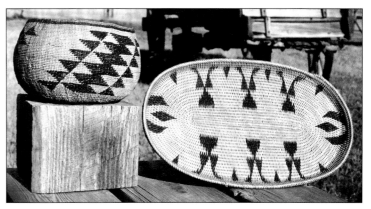

(Left) **YUROK FINELY TWINED BASKET** c.1870
N.W. Calif. tribe. Characteristic half-twist overlay conifer root with contrasting geom. motifs in shiny black fern stem and golden sedge? 7" diam. x 3"D. Unusually pristine cond. Est. 400-600 **SOLD $475(98)**
(Right) **MAKAH FINELY TWINED BASKET** c.1910
N.W. Coast. Characteristic wrapped twine squaw grass and dyed grass with black swastika motifs and bands in burgundy, orange, and brown. So fine that in 1" there are 22 rows. Characteristic cedar bark checkerboard bottom square. 2.25" w. part x 3.5"H. Est. 200-350 **SOLD $250(98)**

(Left) **NO. CALIF. TWINED BASKET**
Labeled "Lower Klamath River." Half-twist overlay, finely twined conifer root in characteristic triangle and trapezoid motifs in dk. and lt. brown. Perfect cond. 4"H x 7"W. Rim 6" diam. Est. 450-650 **SOLD $425(02)**
(Right) **SO. CALIF. COILED OVAL TRAY**
Possibly Mono or Panamint? Single rod sewn with yellow willow. Interesting design elements appear to be black devil's claw. Superb condition and aesthetics. 13" x 7.5" x 3/4"D. Est. 300-600

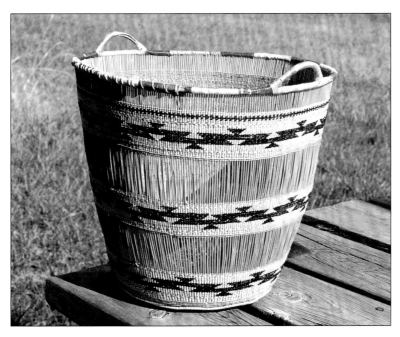

LARGE HUPA BASKET
N.W. Calif. Harold L. Schilling Collection. Very long and charming story of basket maker, Maude Hailey, who made this "waste basket" in the 1920s. Fibers are peeled alder branches, black from maidenhair or 5-fingered fern, brown is alder root bark and light native bunch grass (background). A few rim stitching breaks. Two rim loops. Open vertical warp twining alt. with twined char. geometric pattern bands. 11"H x 12" rim diam. Est. 600-900 **SOLD $500(01)**

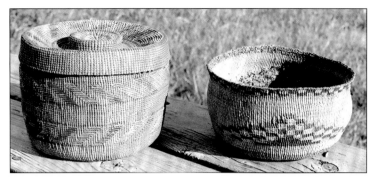

(Left) HAIDA LIDDED TWINED BASKET
N.W. Coast. Unusual configuration. Characteristic spruce root weft with dyed green narrow bands with false embroidered dyed bear grass decoration in gold and terra cotta diagonal stripes. Beautiful subtle colors. Rich age patina. 6.7" diam. x 5"H. Pristine cond. Est. 375-800 **SOLD $500**(05)
(Right) KLAMATH TWINED BASKET with QUILL PATTERN
N.W. Calif. Characteristic flexibility due to cattail or tule rush construction. Central protruding step-pattern includes yellow porcupine quills and dk. brown elements (possibly hazel). Checkerboard pattern along rim. Pine root? (med. brown) base and rim. Pristine cond. 6.25" diam. x 3.5"H. Est. 350-700 **SOLD $375**(05)

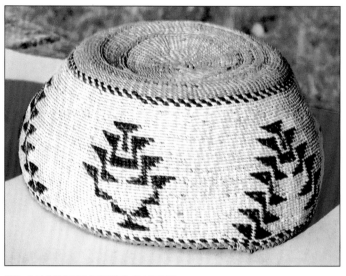

NO. CALIFORNIA TWINED BASKET c.1900
Modoc tribe of N.E. Calif. Highly desirable quail top knot pattern. Flexible tule foundation with dk. brown/black motifs and natural bear grass ground; lt. brown pine root? base and rim trim. Perfect cond. 8" diam. x 4"H. Est. 450-650

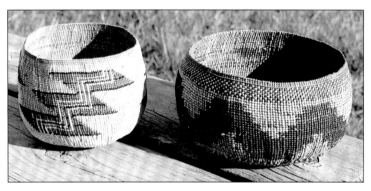

(Left) HUPA/KAROK TWINED BASKET
N.W. Calif. Half-twist overlay decoration (interior shows no design) is black maidenhair fern and red alder dyed fern. Exquisite design motifs. Stiff willow warp with conifer root, bear grass? weft. Apx. 4" rim diam. Est. 300-600 **SOLD $350**(05)
(Right) KAROK TWINED BASKET
N.W. Calif. Characteristic use of red alder dyed fern; bold central step zigzag motif. Fine conifer root? overlay with stiff willow warp. Pristine cond. 5.5" rim diam. x 3.5"H. Est. 250-650 **SOLD $275**(05)

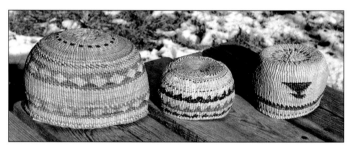

(Left) KLAMATH TWINED BASKET
N.E. Calif. Harold L. Schilling Collection (Jenny Clinton, c.1931). Tag reads "…made from the stalk of the cattail (light), dark color from the 'wocus' or pond lily and the med. brown from the young willow bark." Full-twist overlay. Durable. 6" rim diam. x 4"H. Exc. cond. Est. 250-400 **SOLD $275**(01)
(Center) SMALL HUPA TWINED BASKET
N.W. Calif. Harold L. Schilling Collection. Handwritten tag says made for him by Maude Marshall,13 years old, in 1934. Charming story included with documentation of materials. Characteristic fine half-twist overlay (design shows on exterior only) and horizontal bands of triangles in black maidenhair fern and brown bunch grass; foundation is thin peeled alder. Bottom is lt. brown colored root. 4" diam. x 2.5"H. Exc. cond. Est. 200-350 **SOLD $225**(01)
(Right) SMALL KLAMATH TWINED BASKET
N.E. Calif. Harold L. Schilling Collection. Tag says made by Jenny Clinton, c.1931. Characteristic strong and flexible tule fiber and full-twist overlay (design shows on both surfaces) with varying dk. brown willow bark, simple band, and a few triangle motifs. Quite nice. 4.5" rim diam. x 3"H. Very durable due to flexibility. **Est. 175-250 SOLD $150**(01)

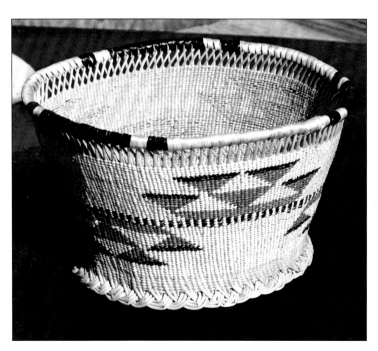

HUPA TWINED BASKET
N.W. Calif. Harold L. Schilling Collection. Included is the fantastic four page handwritten original story by Harold of obtaining this basket when he was surveying Indian children in No. California in 1930. He reached the basket maker when traveling by boat to a remote area along the Klamath River where he was told that "I was the 1st white man they had seen…in six years." Materials are peeled alder root warp with twined bear grass, black maidenhair fern, and pine root in triangular motifs. Half-twist overlay; open twining with crossed warp nr. rim. Note unusual curved warp pedestal base. Pristine cond. 7" rim diam. 4"H. Est. 400-650 **SOLD $450**(01)

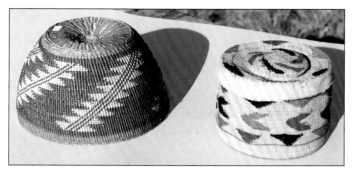

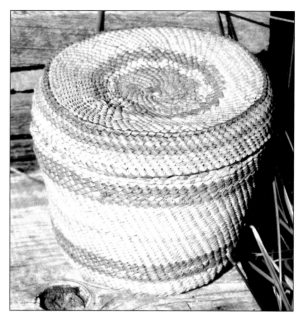

(Left) **KAROK TWINED BASKET** c.1890
N.W. Calif. Beautiful diagonal patterns in red alder or cherry bark (?), natural bear grass and pine root. Pristine cond. 7" diam. x 4"D. Est. 500-750 **SOLD $475(04)**

(Right) **ALEUT "RATTLE TOP" LIDDED BASKET** c.1900
Eskimo. Western Arctic. RARE. Characteristic "linen-like" very fine weave with unfaded yarn triangular and chevron motifs in turquoise, burgundy, and black. Remarkable perfect condition. "Rattles" are prob. pebbles or shot that make a sound whenever the basket is moved. Most rattle tops were made by the Tlingit tribe and frequently have tops broken off. 5" diam. 4"H. Est. 500-800 **SOLD $500(04)**

MAKAH TWINED LIDDED BASKET c.1940
Olympic Peninsula. N.W. Coast. Char. wrapped twine squaw grass and dyed grass. Faded bands of green, brown, and red on lid and sides. 3" bottom diam. 4" lid diam. 3.5"H. Est. 75-125 **SOLD $75(98)**

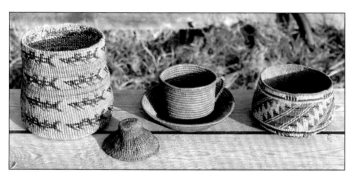

(Left to right) **WASCO "SALLY" BAG** 19th century
Columbia River region. Twined hemp with characteristic nat. dk brown stylized sturgeon figures forming all-over horiz. pattern. Exc. cond. 6" bot. diam., 5" top diam. 6"H top has trimmed rough edge. Est. 700-1200 **SOLD $600(99)**

TLINGIT PUPPET/DOLL HAT
N.W. Coast. RARE. Char. shape of man's ceremonial hat. Stiff twined fibers are faded green and red, dyed with natural spruce root? Nice patina. Exc. cond. 3.38" diam. x apx. 1.5"H. Est. 100-200 **SOLD $85(99)**

ESKIMO COILED CUP and SAUCER c.1920
6" saucer, 3" diam. x 2.5"H cup with braided handle. Remnants of red embroidery. Nice patina. Fine coiled fibers. Est. 125-200

SHASTA TWINED BASKET 19th century
No. Calif. Expertly made fine overlay design shows on surface only. Conifer root with maidenhair stem (black), lt. bear grass? and rust colored fiber form diagonal bands; bottom (not shown) has interesting patterns. Firm and pristine cond. 5" diam. bottom. A fine example. 2.75"H. Est. 450-600 **SOLD $465(99)**

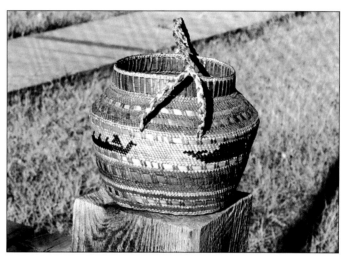

MAKAH TWINED BASKET WITH HANDLE
Olympic Peninsula. N.W. Coast. Wrapped twine grass and cedar root with woven cedar strips. Figural scene in black; two five person canoes, typical whale and bird motifs. Bottom twined stripes are bright pink with dyed green cedar strip. Two color grass handle. Lovely shape and pristine condition. 5-3/4"H. 5" diam. rim. 7" widest part. Est. 300-450 **SOLD $250(02)**

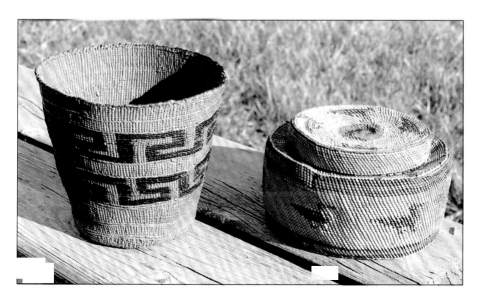

(Left) **TLINGIT TWINED BASKET.** c.1900 or earlier.
Characteristic very finely woven spruce root and fine warp materials create a "soft" or non-rigid basket with delicate and beautiful texture. Double band of dk. brown fret designs are undyed glossy maidenhair fern. 5"H x 6" diam. rim. Pristine cond. Est. 250-700 **SOLD $400(05)**
 See Lobb, Allan. *Indian Baskets of the Pacific Northwest and Alaska.* Portland OR: Graphic Arts Publ., MCMXC, 21-29.

(Right) **MAKAH TWINED LIDDED BASKET** c.1930
Olympic Peninsula. N.W. Coast. Cedar bark and bear grass in wrapped twine technique; bird motifs are dk. green with orange and black. Nice age patina. Characteristic plaited cedar bark bottom. 6" diam. x 3.25"H. Lid is 4.25" diam. Exc. cond. Est. 190-400 **SOLD $225(05)**

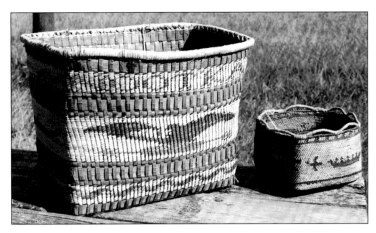

(Left) NOOTKA LARGE BASKET
N.W. Coast. Wrapped twine with overlay and cedar plaited interior, bottom and borders. *RARE* tribal name *"NOOTKA B.C."* in purple dyed grass along top. Colorful and unfaded eagle on arrow one side; popular whale on other. Two ends each have two fishermen in canoe. Natural grass wrapped rim. Unusually large 10"H x 13.5"W x 9"D. Est. 400-500 **SOLD $500(05)**

(Right) MAKAH TWINED BASKET c.1880
Olympic Peninsula. N.W. Coast. Old typewritten tag reads: "Purchased from Oregon Historical Society, Portland Ore. in 1968. They were reducing their basket inventory. K. L. Mohuey." Twined natural lt. brown with dk. brown wrapped twined motifs of whale, four fishermen canoe and five fishermen canoe, eagle, and birds. Characteristic plaited cedar grass bottom. Natural grass wrapped loop top. Exc. condition and patina. 6" square. Est. 400-500 **SOLD $400(02)**

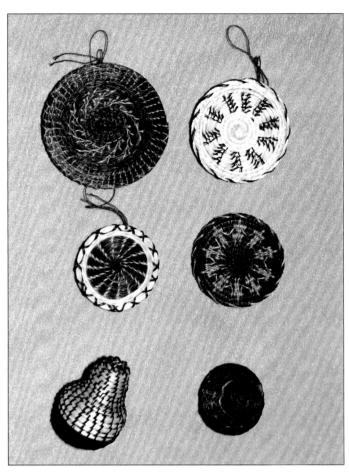

PAPAGO MINIATURE HORSEHAIR COILED BASKETS
(Left to right, top to bottom) 1) 2" diam. black with white stripe and foliage motif; 2) 1.6" diam. white with black stitch designs; 3) black with white border stitched in both colors. 1.38" diam. 4) fantastic figural (black with white) humans holding hands. Price tag reads $100. 1.5" diam. 5) Interesting gourd shape olla, black base with white top. 1.5" 6) Charming black hat with white band.1.25" diam. Est. 200-350 **SOLD $120(98)** 6 piece lot
 *See Gogol, John editor. *American Indian Basketry #11.* "Papago Horsehair Basketry," 1983: 3-8.

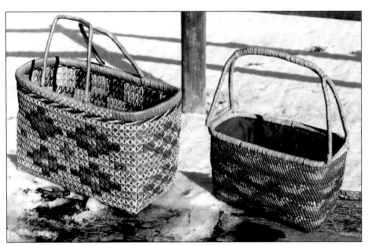

NORTH-WEST COAST BASKETS WITH HANDLES *Nootka/Makah tribe.*
(Right) Twined cedar bark with natural bear grass, unusual all-over bird pattern. Bottom is characteristic wide plaited cedar root. Dk. red chintz lined. Wrapped handle and rims all intact. Exc. cond. 9" x 5"H (11"H incl. handles) x 5.5"D. Est. 220-375
(Left) Plaited cedar bark sewn with interesting cross-stitch patterns in natural and dyed bear grass: lt and dk. brown, blue, and red. Cedar bark wrapped rim and handles. Bottom is characteristic wide plaited cedar root. All in perfect cond. 11" x 7"H (12" incl. handles) x 6.5"D. Est. 125-250 **SOLD $150(03)**

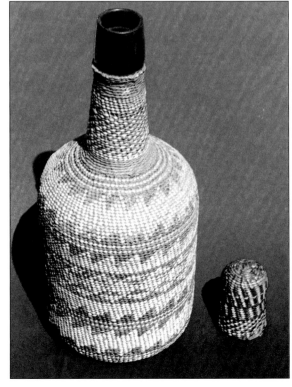

NO. CALIF. TWINED BOTTLE
Pitt River Tribe. Beautiful brown tones of conifer root and glossy fern in geometric motifs. Nice patina. 11"H x 4.5" bottom diam. Exc. cond. Est. 900-1500 **SOLD $900(02)**

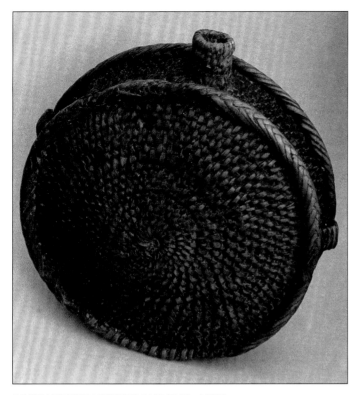

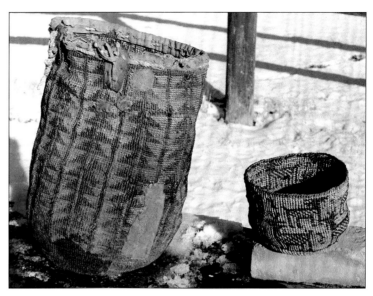

SOUTH-WEST BASKETRY CANTEEN c.1870?
Labeled Shoshone but probably Apache. Coiled willow with redbud; pitch-covered. Exceptional patina of age, lovely red-brown color. A few breaks on rim only. Very sturdy. 8" diam. apx. 4" deep. Est. 350-600 **SOLD $325(00)**

(Left) **WASCO/WISHRAM TWINED ROOT BAG** c.1870?
*Columbia River region. Similar baskets collected by Lewis and Clark c. 1805 originated from a very early tradition.** Cornhusk twined "Sally bag" with attractive stacked triangles in cedar or spruce root (?). The original canvas binding is now worn through in spots, revealing perfect rim. Well used and carefully patched long ago with buckskin; some have buckskin loops. Overall effect is of a beautiful patinaed texture of age and Indian-use. Braided cord string across top. Soft fibre woven bottom. 14.5"H x 8" diam. Est. 600-875 **SOLD $625(03)**
 *See actual bag collected by Lewis and Clark in Turnbaugh, p. 77.
(Right) **WASCO/WISHRAM TWINED FIGURAL BASKET** c.1890
Columbia River region. Highly desirable deer and man motifs. Very flexible fibers are probably hemp; figures are dark grass or dyed cornhusk. Rich patina of age, yet unfaded motifs. 6" top diam. 4.25"H. Exc. cond. Est. 875-1250 **SOLD $1000(03)**

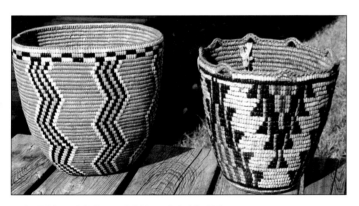

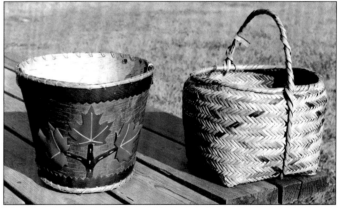

(Left) **PUGET SOUND IMBRICATED BASKET**
Labeled Suquamish. Cascades region of the Pacific Northwest. Character-istic flat rim and rim design called "beading or ribboning."* Superb over-all appearance. Very fine coiling and uniform imbrication; imbricated vertical zig-zag motifs in three contrasting shades of natural lt., dyed black, and yellow bear grass over coiled spruce root. 9.5"H x 8.75"D. Pristine cond. Est. 1600-2600 **SOLD $1400(00)**
 What makes this basket exceptional is the uniqueness, pristine cond., and unusually perfect workmanship. John Gogul, basketry expert, thinks it may be Cowlitz, due to the symmetry and fineness. Origin of specific tribal baskets from this area is difficult to determine exactly.
 *See Lobb, Allan. Indian Baskets of the Pacific Northwest and Alaska. Portland OR: Graphic Arts Publ., MCMXC, 64-88.
(Right) **KLICKITAT IMBRICATED BASKET** c.1890
Cascades region of the Pacific Northwest. Cedar root coiled with character-istic loop rims or "ears." Exterior imbrication is four natural shades of bear grass, cherry bark, and cedar bark. Classic very desirable pattern of step-chevrons. Buckskin loops through two "ears" ready to tie to berry picker's waist. Perfect cond. 9"H. 8.5" diam. Est. 1850-2800 **SOLD $1650(00)**

(Left) **IROQUOIS BIRCH BARK BUCKET** c.1950
Made from three pieces of nat. brown bark fibre laced and reinforced with willow rims at top and bottom. Decorated on two sides with three (3") maple leaf motifs painted red, green, and brown. One of six leaves missing, otherwise exc. cond. 12" top diam., 8" bottom diam. 9"H. Est. 75-150 **SOLD $65(98)**
(Right) **CHOCTAW CANE SPLINT BASKET** c.1920
Southeast. Strong coiled handle goes around entire basket. Nice herring-bone weave pattern. Dyed design bright green, yellow, and red on inside. Faded on outside, otherwise exc. cond. 14"H. 9" sq. bottom. Rim 11" diam. Est. 100-150 **SOLD $100(98)**

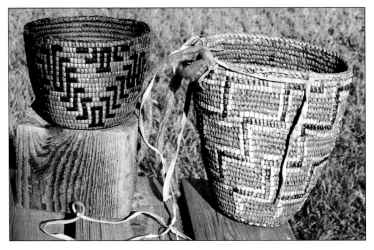

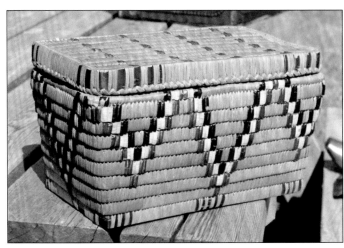

(Left) COWLITZ COILED BASKET
Cascades region. Spruce root coiled with imbrications of light bear grass and black cherry bark? in "flying geese" pattern. Superb dark patina. Top rim has old 1" break. 5"H x 6"W. Est. 350-550 **SOLD $350(02)**

(Right) WARM SPRINGS COILED BERRY BASKET
Plateau. Spruce root with partial imbrication, all-over step pattern in lt. bear grass and shiny bark. Braided willow? rim. Leather thong laced through top of basket; rawhide strap and cloth strip as well as the distorted shape from use while wet indicate long-term Indian use. Shape can be reversed for a perfect basket. 8.5"H x 8"X 5.5". Est. 350-500 **SOLD $300(02)**

THOMPSON RIVER COILED BASKET TRUNK c.1890
Canadian plateau. Split conifer root coils with white bear grass, black and nat. cherry bark imbrication in step triangle patterns. Small size, 11.25"L x 7.5"W x 6.5"H. Exc. cond. Good patina. Est. 400-650 **SOLD $325(98)**

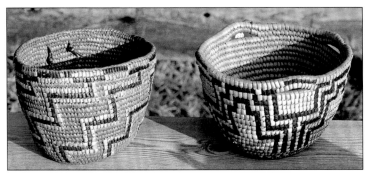

(Left) SUQUAMISH IMBRICATED BASKET 19th century
Cascades region of the Pacific Northwest. Coiled cedar root with cherry bark and nat. bear grass imbricated step patterns. Patina shows Indian use. Exc. cond. 4.5"H x 5"W. Est. 300-450 **SOLD $275(99)**

(Right) PUGET SOUND IMBRICATED BASKET 19th century
Cascades region of the Pacific Northwest. Char. loop rim top. All-over pattern is fully-imbricated; nat. lt. bkgrd. bear grass with black and dk. brown step pattern. Pristine cond. 4.25"H x 6.5" diam. Est. 300-450 **SOLD $300(99)**

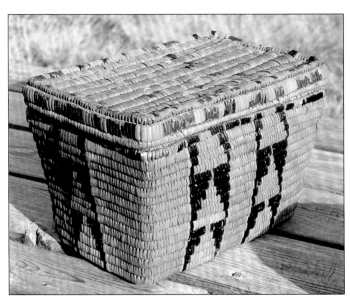

SALISH IMBRICATED BASKETRY HAMPER 19th century
Thompson River–Fraser River, Canada. Dynamic stacked triangle vertical panels are black and nat. bear grass; nat. red cherry bark along lid rim and top. Very good design elements. Some imbrication worn on lid only, otherwise exc. cond. 8"H x 12"L x 8"W. Est. 400-600

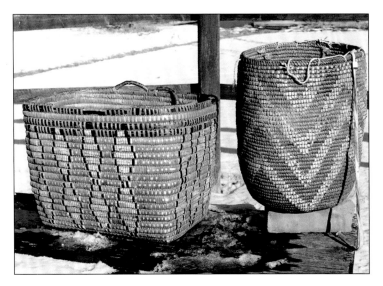

(Left) FRASER RIVER (SALISH) IMBRICATED HAMPER c.1900
Canada. Complex diamond motifs on all four sides are lt. and dk. imbricated bear grass (98% intact) over cedar root coils. Beautiful over-all design. Top "beading" is alternating strips of shiny cherry bark and lt. bear grass. Rim is partially broken; one handle needs re-attaching, other is missing. Front rim loops need re-attachment. Minor repairs for a splendid piece. 13" x 16.5" top dimensions. Est. 400-700 **SOLD $435(03)**

(Right) PLATEAU STORAGE BASKET c.1900
Collected on the Warm Springs Res. in Oregon. Nice visual piece, as well as showing Indian use. Sturdy imbricated utilitarian basket is coiled cedar root with lt. bear grass chevron patterns. Braided string across rim for securing a canvas lid. Leather carrying loops. 13.5"H. 10.5" x 9" rim. Exc. cond. Light patina. Est. 435-650 **SOLD $400(03)**

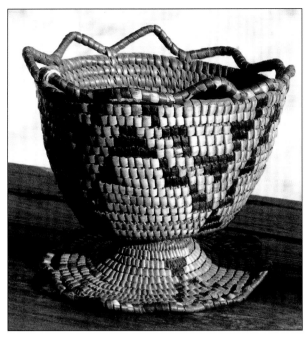

PUYALLUP BASKET COMPOTE 19th century
Cascades region of the Pacific Northwest. Fully-imbricated all surfaces. Unusual configuration. Char. loop rims that are also imbricated with alt. lt. and brown bear grass. Nat. lt. bear grass with dyed black triangular patterns. Loop rims also around bottom. 6"H x 6.5" top diam. 6" bottom diam. Nice patina. Exc. cond. Est. 400-600 **SOLD $475(00)**

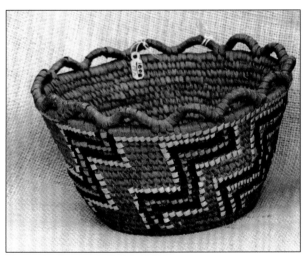

NISQUALLY IMBRICATED BASKET 19th century
Cascades region of the Pacific Northwest. Toklen Hotel Collection, Wash. Displayed at this hotel turn of the 20th century. Tasteful and colorful imbrication in step patterns: natural, dk. and lt. brown with pale orange and yellow dyed bear grass. Loop rims intact. Nice patina. 7" diam. 4.5"H. Exc. cond., good patina. Est. 400-500 **SOLD $325(99)**

(Top left) **JICARILLA APACHE BASKET** c.1920
No. New Mexico. Deep bowl-shaped with faint color rows: red, orange, and pale green. Characteristic five rod thickly sewn coiling, probably sumac. 1/2" break on rim, otherwise good cond. Nice patina. 10" diam. apx. 5" deep. Est. 125-350 **SOLD $125(00)**
(Bottom left) **PAIUTE CEREMONIAL BASKET** c.1920
Basin region. Single rod coarsely coiled. Purple "7" designs. Has remnants of corn meal, so prob. not a tourist item. 12" diam. Nice collectible. VG cond. Est. 200-400 **SOLD $160(00)**
(Right) **NAVAJO WEDDING BASKET** c.1950
Southwest. Traditionally made by the Paiute. Actual Navajo-made baskets are quite rare. Good example of this coiled style. Red ring motifs with black step-triangles. Exc. cond. Very sturdy. 15" diam. Est. 250-400 **SOLD $200(00)**

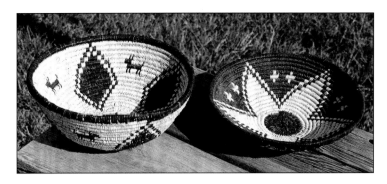

(Left) **YAVAPAI COILED FIGURAL BASKET** c. 1930s
Southwest. Harold Schilling Collection. Similar to Apache. Dog and diamond motifs. Characteristic simple black geometric forms. Bear grass with dark devil's claw. Est. 300-500 **SOLD $295(00)**
(Right) **YAVAPAI COILED BASKET** c. 1930s
Harold Schilling Collection, Southwest. Similar to Apache. Five petal central flower that Schilling calls "the squash blossom" pattern (could also be a star). Characteristic stylized negative "coyote track"/cross forms. Bear grass with dark devil's claw. Est. 300-500 **SOLD $275 (00)**
See Turnbaugh, pp. 54-58.

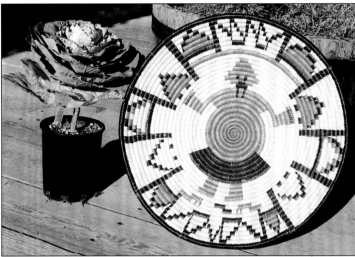

SERI LARGE FIGURAL COILED TRAY 20th century
Northern Mexico tribe. Black and rust dyed bear grass design motif is human figure with step triangle border. Natural bear grass bkgrd. Exc. cond. 20" diam. x 3.5"D. Est. 300-450 **SOLD $275(98)**

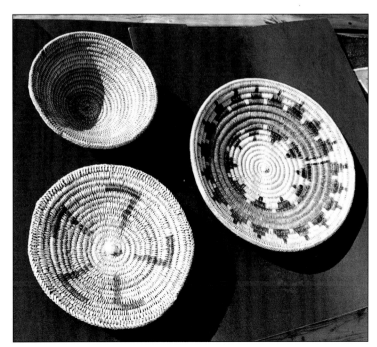

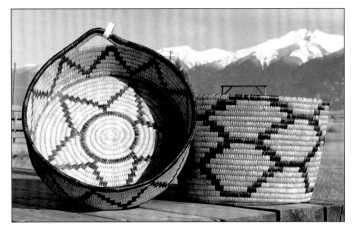

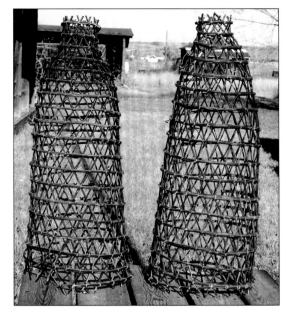

Utilitarian Baskets

(Left) **PAPAGO COILED BASKET WITH RIM LOOPS** c.1950
Southwest. Bear grass with dk. brown devil's claw; five pt. star on bottom, zig-zag on sides. 15"W (handle sides) x 4"H. Exc. pristine cond. Nice yellow patina Est. 150-300 **SOLD $85(98)**

(Right) **PAPAGO COILED BASKET** c.1950
Southwest. Bear grass with devil's claw all-over pattern on sides. 13" diam. x 8.5"H. Pristine cond. Nice yellow patina. Est. 150-300 **SOLD $85(98)**

NORTHWEST FISHING WIERS
From an old fishing company nr. Portland, Oregon. These are hard-wood, possibly cherry? Reinforced with heavy string. 29"H. 27"H. Est. 100-200 pair **SOLD $100(02)**

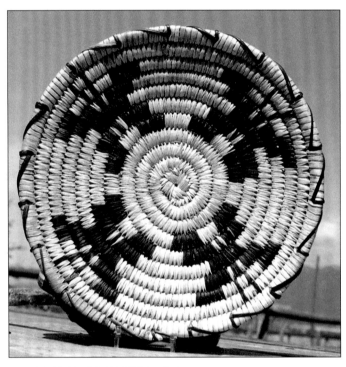

PAPAGO SHALLOW BASKET c.1940
Southwest. Char. thick coiling with black (devil's claw) edging. Dyed black bear grass stylized butterfly motifs. 9.5" diam. Exc. cond. Shows light patina of age. Est. 75-125 **SOLD $85(99)**

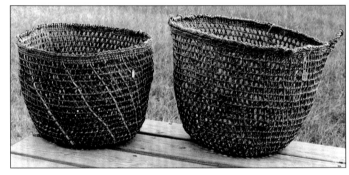

LARGE NORTHWEST STORAGE BASKETS c.1870
From the Toklen Hotel in Toklen, Washington. These baskets were on display in the dining room (as seen in old photos).
(Left) Open twined of cedar root. Very flexible; beautiful texture. Apx. size and configuration of a bushel basket. Decorative diagonal strips of lt. and dk. cedar bark. 15" rim diam. One handle remaining by one end. Est. 375-500 **SOLD $350(02)**
(Right) Largest one 17" rim diam. One handle intact, other in bottom. Est. 375-500 **SOLD $325(02)**

LARGE HOPI WICKER BASKET c.1900
Southwest. Purchased in 1960 from Plume Trading Co. for $5. Old tag still on. Unique plaited weaving technique characteristic only to Hopi: raised center section, faded yellow and green willow with black; stiff sumac foundation. Raffia wrapped rim. 13" rim diam. x 5"D. Exc. cond. Est. 350-500 **SOLD $325(01)**

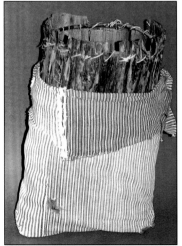

FLATHEAD CEDAR BARK BERRY BASKET c. 1930s.
Belonged to Adeline Adams and later to her daughter, Louise Conko, on the Flathead Reservation in Montana. Covered with blue and white pillow ticking cloth for protection. Has some bark damage around the rim but still solid and good display piece. 16" tall. These are hard to find because most were worn out and discarded. Est. 200-350 **SOLD $230(04)**

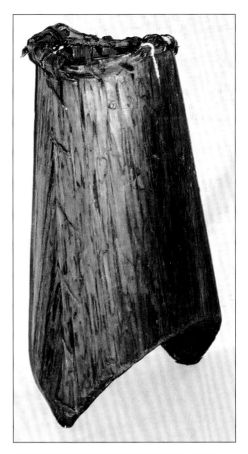

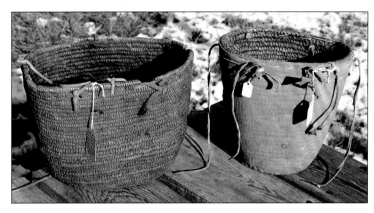

(Left) **FLATHEAD CEDAR BARK BERRY BASKET** c.1870
Purchased from the late Agnes Vanderburg, Arlee, Montana, in 1970. She got it from Paul Alex c.1940. He kept it by his bed to hold his personal smoking materials: pipe, tobacco, and smoking utensils. Sturdy twined basket has beautiful rich patina of age and Indian use. Berry residue still inside. Original buckskin long ties still on back; front one replaced with aged shoelace. 8"H x 9.5"W. Est. 1000-1800

(Right) **FLATHEAD CEDAR BARK BERRY BASKET WITH CANVAS COVER** c.1870
Purchased from Ida Brock, Spokane, Washington, in 1972. Ida bought it from Rose Lassaw, who said it used to belong to Chief Charlo. Same construction as previous basket. All original buckskin ties and dark patina cover from use and age. Wonderful ethnographic museum piece. 7.75"H x 8"W. Est. 1100-1800

Note: These baskets are priced higher because of their historic connection.

FLATHEAD CEDAR BARK BERRY BASKET
c.1900
Near Four Winds, at the base of the Mission mountains on tribal land, there are cedars with large sections of bark cut out over the years for this purpose. Constructed of a sturdy solid piece of cedar bark lashed with cedar strips. Folded when fresh from one long section. We also have several in our collection that are sewn with cord string. 15"H x 6" diam. Est. 200-300 **SOLD $200(04)**

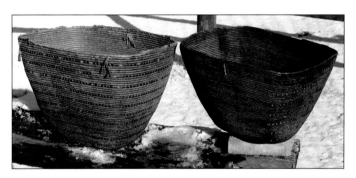

THOMPSON RIVER (SALISH) STORAGE BASKETS c.1860-1900
Canadian Plateau. (Left) Simple imbricated shiny cherry bark horizontal motifs over finely coiled spruce root or cedar bark. Rich dk. patina from Indian use and age. 9" x 6" bottom flares to 13.5" x 18" rim. 13"H. Several original buckskin loops attached to top. Rim breaks from use. Wonderful sturdy Indian-used piece. Est. 450-700 **SOLD $485(03)**
See Lobb, Allan. *Indian Baskets of the Pacific Northwest and Alaska.* Portland OR: Graphic Arts Publ., MCMXC, 90 for an almost identical basket dated 1860. Also, see 1914 photo of an Upper Thompson River woman making similar basket in Turnbaugh, p 163.
(Right) Similar with very dark patina, prob. from berry storage. 9.5" x 6" bottom flares to 12.5" x 17" rim. Several rim breaks. Imbrication looks like dk. horsetail root and lt. bear grass. Original braided jute top loops. Est. 250-575 **SOLD $250(03)**

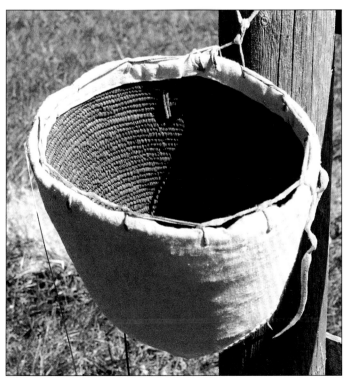

FLATHEAD COILED BERRY BASKET c.1890
Belonged to Louise Conko. A utilitarian basket used when berry picking. The canvas cover was added later, c.1940. Buckskin ties and straps. Interior shows nice patina of berries. Exc. cond. 9.5"H x 12"W x 10" deep. Est. 200-400 **SOLD $225(99)**

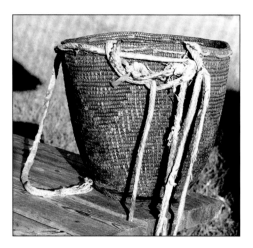

PLATEAU LARGE BERRY BASKET WITH TUMPLINE c.1900
Collected at Warm Springs, Oregon. Sturdy utility basket with imbricated shiny bear grass patterns. Heavily used; shows stains and wear from Indian use and has 1/2" rim break. Long tumpline made of plaited hop string has pink and black pattern. Buckskin tied to basket top. 12"H x 13"W x 11"D. Est. 300-600 **SOLD $300(00)**

Cornhusk Bags

The following bags are made of twined cornhusk and were primarily used by the Indians themselves for storage of dried herbs and vegetables. They were also traded as far away as the Plains and used in medicine bundles to store rawhide rattles, etc. by other tribes, i.e., Crow and Blackfeet.

These flat root storage bags were twined from hand-spun native dogbane (aka Indian hemp), which was false embroidered with cornhusk strips and/or yarn. After 1900, cotton string, which was used to train hop vines, was substituted for dogbane on many bags. After digging areas became inaccessible with increased white settlement, large bags were not needed and smaller bags became popular to carry as part of a traditional outfit.

Day, Julie, ed. *Woven History: Native American Basketry of the Clark County Historical Museum.* "Basketry from the Southern Plateau," Mary Dodds Schlick. Vancouver, WA: Clark County Historical Society, 2004: 11.

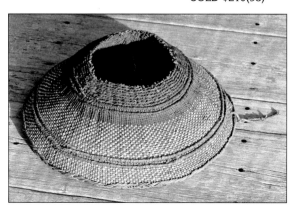

EARLY CALIF. HOPPER MORTAR BASKET WITH STONE BASE Pre-1870
John Quigley Collection from Frontier Town, Helena, Montana. Twined redbud, and hazel, willow, or pine with typical rhomboid forms on exterior only (half-twist overlay). Heavy patina of age and Indian use. Rim is half missing, otherwise exc. cond. 13" rim diam. Center opening 6" diam. Est. 200-500 **SOLD $160(01)**

See Turnbaugh, p. 192 for full-page illustration of a very similar example.

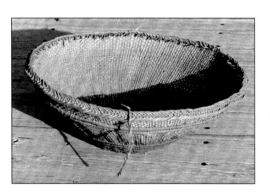

HUPA TWINED BASKETRY HOPPER c.1870
No. Calif. tribe. Ethnographic collectible. Utilitarian piece used over stone mortar for grinding. Stiff warp reinforced with four bands willow? on outside. 16.5" rim diam. x 6"D. Hole 6" diam. Exc. cond. Est. 200-400 **SOLD $210(98)**

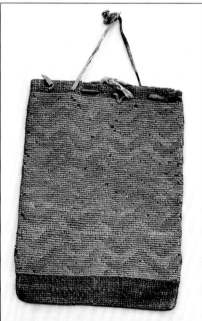

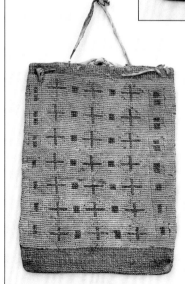

PLATEAU OLD CORNHUSK BAG 19th century
Bags like this were already in existence when Lewis and Clark made their journey to the Northwest. This one appears to be old enough to date back to the early 19th century. Natural undyed hemp/dogbane pattern of crosses and squares one side and faint pattern of all-over zig-zags on other. Hemp/dogbane bottom and top with buckskin drawstring. Exc. cond. and fantastic patina. 7.25" x 9.5"L. Est. 650-950 **SOLD $750(02)**

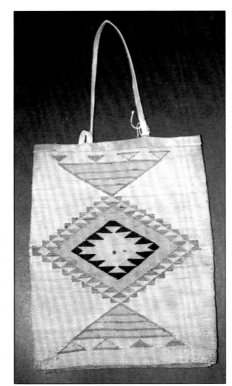

NEZ PERCE CORNHUSK BAG c.1890-1910 *ALL CORNHUSK.* Good geometric designs, diff. each side somewhat faded from age. Show Indian use. Hemp bottom. New buckskin bound top and handles. 10" x 12"H. Good cond. Est. 450-800 **SOLD** $450(99)

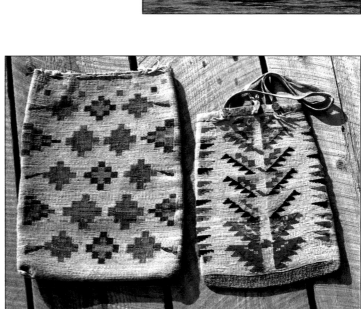

NEZ PERCE LARGE CORNHUSK BAG c.1900 Diff. all-over diamond pattern each side: 1) yellow cornhusk centers with some outlined in black yarn, some in brown dyed cornhusk; 2) fancy patterns are yarn—purple centers with three shades blue and bright green outlines. Hemp top and bottom. Buckskin drawstring. Exc. cond. 13"W x 18"H. Est. 900-1500 **SOLD** $800(98)

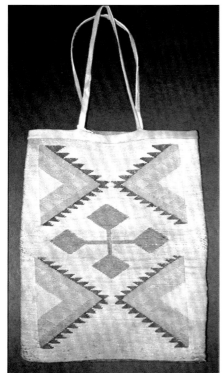

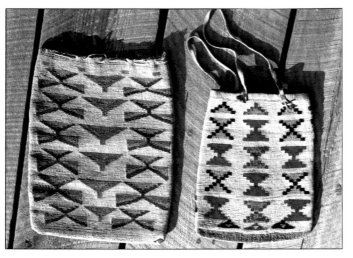

(Left) **NEZ PERCE LARGE STORAGE BAG** c.1890? *ALL CORNHUSK.* Superb unfaded design motifs in red, blue, pink, and black cornhusk. Bottom in woven hop string. Top is hemp? with string line. Exc. cond. Nice patina of age. 15"W x 19"H. Est. 1100-1500 **SOLD** $1200(03)

(Right) **NEZ PERCE CORNHUSK and YARN BAG** c.1920? Bright unfaded yarn, complex triangular motifs; diff. design each side. Buckskin bound top. Long buckskin handles attached with trans. blue pony beads one side; ind. head buttons and Crow beads on the other. Hemp bottom. Exc. cond. 12"W bottom. 16"H. Est. 1000-1250

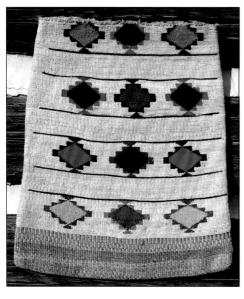

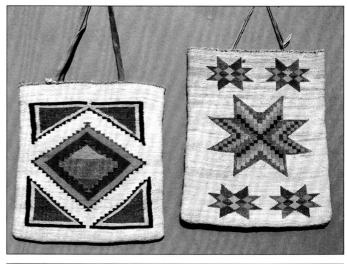

LARGE NEZ PERCE CORNHUSK BAG
c.1900
Made on Warm Springs Res. Oregon. Rich vibrant unfaded yarn-woven designs, different each side. Hemp bottom. 16"W x 18"H. Exc. cond. Est. 750-1000 **SOLD $875(01)**

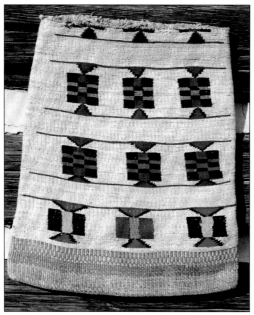

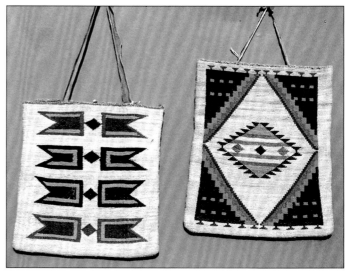

(Left) **NEZ PERCE CORNHUSK BAG** c.1900
Finely twined cornhusk with diff. yarn designs each side: 1) eight "pennant" shapes are black, green, dk. purple, dk. teal, and pink; 2) central diamond is pinks, red-violet, yellow-orange, and dk. green. Triangles in corners are emerald, white, and black. 8" x 9"H. Exc. unfaded cond. Est. 925-1300 **SOLD $1000(05)**

(Right) **NEZ PERCE CORNHUSK BAG** c.1900
Finely twined cornhusk with diff. yarn designs each side: 1) dk. green, burgundy, blue-grey, orange, turquoise, purples, and pink; 2) eight pointed stars are dk. turquoise, burgundy, pink, orange, and blue-grey. Pristine unfaded deep colors and beautiful designs. 8" x 10"H. Buckskin handles. Est. 925-1300 **SOLD $1100(05)**

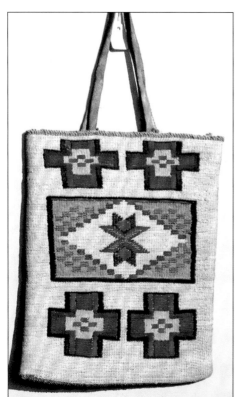

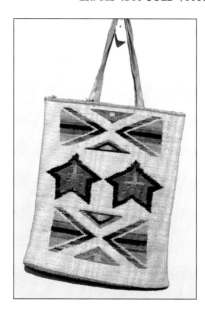

NEZ PERCE CORNHUSK BAG
c.1900
One side is ALL CORNHUSK elaborate designs in muted red, black, purple, orange, green, and yellow. Other side has yarn designs in blue-green, three shades purple, pale green, dk. green, and coral. Perfect condition with nice light patina of age. Buckskin handles. Hemp bottom. 9.5"W x 11.25"L. Est. 750-1250 **SOLD $725(04)**

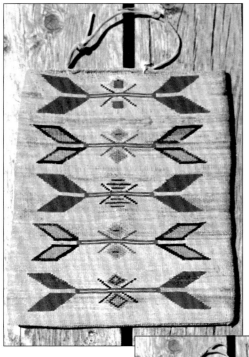

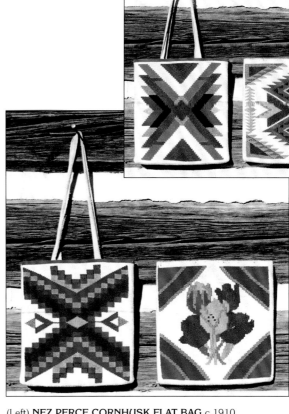

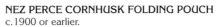

NEZ PERCE CORNHUSK BAG

Very fine weave and rich patina. Double hourglass motifs and diamond in fine yarns one side. Other side has intricate geometric patterns in all cornhusk designs. 9 x 12". Est. 900-1500 **SOLD $1200(99)**

(Left) **NEZ PERCE CORNHUSK FLAT BAG** c.1910
Brilliant geometric yarn patterns, diff. each side: burgundy, pink, coral, greens, blues, purples, dk. red, black, and pumpkin. Beautiful pristine bag. Buckskin handles. Red grosgrain ribbon binding. 10"H x 9"W. Est. 650-850 **SOLD $650(98)**

(Right) **NEZ PERCE CORNHUSK FLAT BAG** c.1910
Bright floral pattern on one side, geometric the other. Yarn colors are purples, gold, greens, pink, turq., and coral. Exc. cond. Nice patina. 9.5"W x 9.75"H. Est. 650-850 **SOLD $650(98)**

NEZ PERCE CORNHUSK FOLDING POUCH

c.1900 or earlier.
Beautiful colorful and complex designs. Only the flap has yarn motifs; other two sides are ALL cornhusk. Flap lined with calico and bound with lt. green (faded) grosgrain ribbon. Buckskin handle and ties are strung with early white tile beads. Shows use; not worn, just slight stains. Lt. patina of age. 7.5" square. 14.5" opened. Est. 600-750 **SOLD $625(03)**

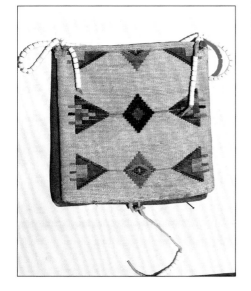

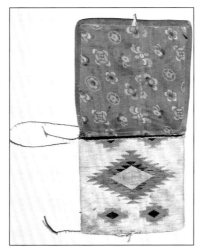

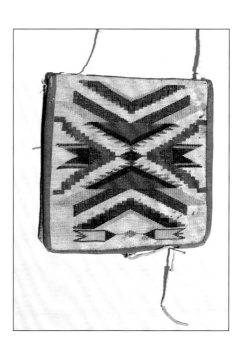

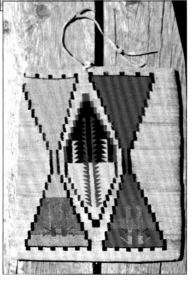

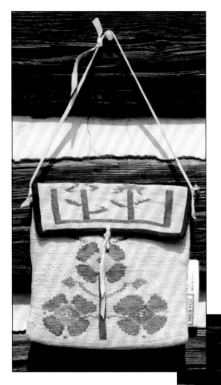

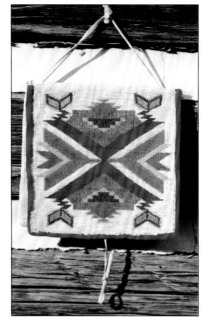

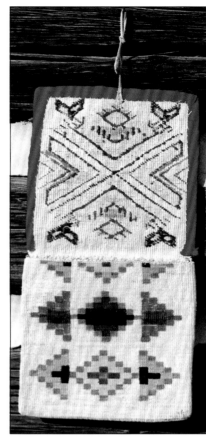

NEZ PERCE FOLDING CORNHUSK BAG c.1900
Each panel has completely different woven yarn design. Inside has step-diamond pattern. Many beautiful colors: burgundy, yellow, terra cotta, lt. blue, purple, yellow, and green. Red velveteen bound. Someone "enhanced" the green with magic marker—only noticeable on back panel (not shown). Est. 300-450 **SOLD $325(01)**

NEZ PERCE CORNHUSK FLAP BAG
c.1900
Collected at Nespelem, Washington. RARE. Floral designs with butterfly in bright unfaded motifs: pinks, greens, purple, blue, orange, black, and red. Designs on both sides and flap. Very fine weave. Green cotton lined; flap binding black Fox braid. Superb workmanship. Original buckskin handle and flap ties. Pristine cond. 8" square with flap closed. Est. 900-1500 **SOLD $1000(03)**

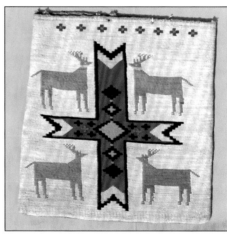

YAKAMA/WASCO CORNHUSK BAG
c. 1890-1900
Possibly made by Cecilia Totus. She is pictured holding a very similar bag that she made, on display at the Portland Art Museum. Superfine cornhusk with unfaded fine yarn deer and cross on one side, and six pointed star and arrows on the other. Pristine cond. 11" x 12"H. Est. 4000-6000 **SOLD $2000(94)**
*See Mercer, Bill. *People of the River.* Portland Art Museum, Ore., 2005: 116-117.

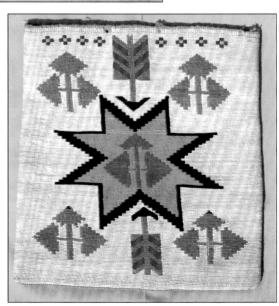

5. Textiles and Pottery

Navajo Rugs (Including Rio Grande and Northern Mexico)

Suggested reference books for this section:

Ben Wheat, Joe. *Blanket Weaving in the Southwest.* Tucson: University of Arizona Press, 2003.

James, H.L. *Rugs and Posts.* West Chester, PA: Schiffer Publishing Ltd.,1988.

Rodee, Marian. *Weaving of the Southwest.* Atglen, PA: Schiffer Publishing, Ltd., 2003.

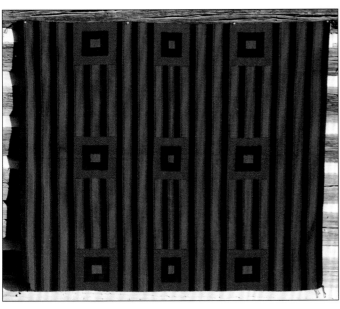

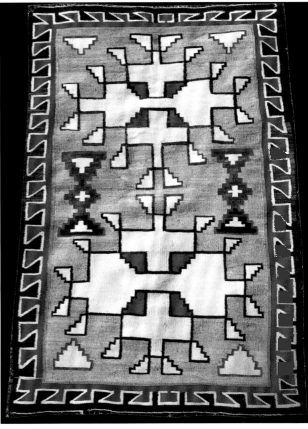

KLAGETOH NAVAJO RUG c.1900
A marvelous design in nat. grey-brown hand-spun bkgrd., with off-white, nat. dk. brown, and rich red complex all-over pattern and fancy border. Narrow inside border of lt. blue. Fine tight weave. Exc. cond. Est. 1400-1800 **SOLD $1300(99)**

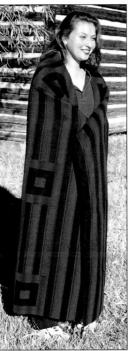

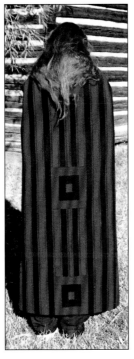

NAVAJO RUG–1st PHASE REVIVAL WEARING BLANKET
Contemp. *Weaver's tag, "Marlene Harrison."* Exceptionally beautiful colors of rose-red, deep violet, and black; tight med. weight. Exc. pristine cond. 64.5" x 54"W. Est. 1750-2800 **SOLD $1750(98)**

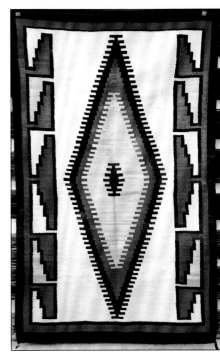

KLAGETOH NAVAJO RUG c.1930s
Central concentric serrated diamond pattern with step-triangle side borders. Natural hand-spun in rose-red, varying natural dk. browns, and natural tan on cream ground. All-around double border ls dk. brown and rose-red. Gorgeous rich colors. Heavy floor rug. 1" hole in central lt. tan diamond, otherwise exc. clean cond. 45" x 70.5"L. Est. 900-1300 **SOLD $875(05)**

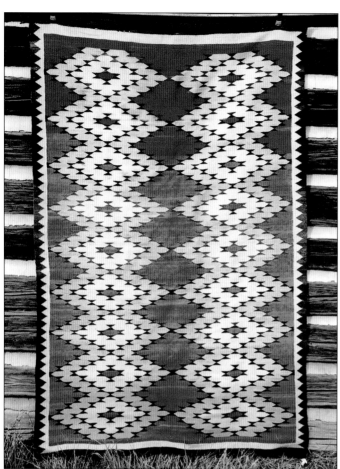

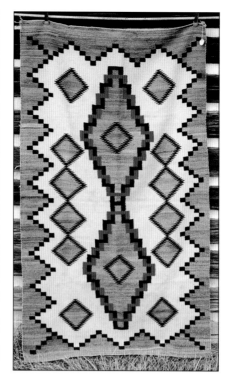

CRYSTAL NAVAJO FLOOR RUG c.1930
Beautiful pattern with fine tight weave. Central natural lt. brown diamonds have scarlet and nat. dk. brown linked borders. Lt. brown small diamonds with dk. brown serrated edges. Border is lt. brown triangles with dk. brown step-square edges; cream ground. Characteristically finely detailed. 45.5" x 80.25"L. Exc. cond. Est. 750-1500 **SOLD $802(05)**

LARGE EARLY NAVAJO FLOOR RUG c.1920s
Lovely all-over diamond patterns in cream, nat. lt. grey, varying lt to bright reds outlined and bordered in nat. dk. brown. Hard tight weave. A few small stains, otherwise exc. cond. 52" x 79"L. Est. 600-950 **SOLD $802(05)**

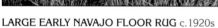

NAVAJO SHIPROCK YEI RUG c.1970
Tag reads: *"Shiprock Trading Post, Shiprock, New Mexico with rug # . Weaver is Pricella Atcitty."* Very fine tight weave in comm. yarns, lovely earth colors: greys, browns, cream, burgundy, golds, yellow, and black. Pristine cond. Est. 700-900 **SOLD $751(99)**

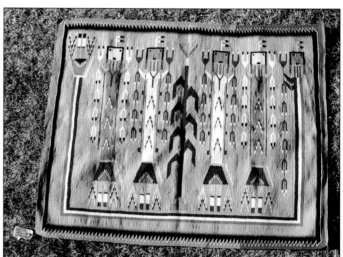

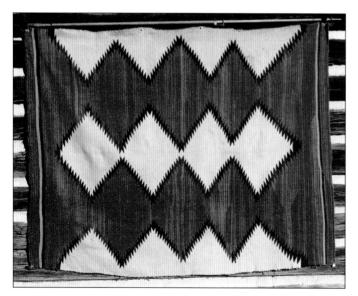

TRANSITIONAL NAVAJO BLANKET c.1900
Dramatic cream serrated diamond pattern on beautiful soft varying rose-red bkgrd. Natural dk. brown serrations; gold and dk. brown stripe either end. Very thick, dense, and heavy hand-spun weave. Floor piece. 60" x 78". Est. 875-1250 **SOLD $875(00)**

STORM PATTERN NAVAJO RUG c.1960?
Tag reads "competition blanket from Benson, Arizona." Comm. yarn in several tones of brown: chocolate, terra cotta, beige, grey, and white with additions of yellow and rose outlined in green. Complex pattern. Pristine cond. 35" x 46.5". Est. 600-900 **SOLD $590(00)**

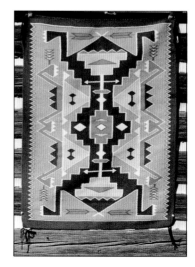

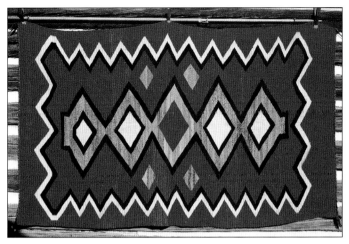

GANADO(?) LARGE NAVAJO FLOOR RUG c.1900-1910
Characteristic rich red bkgrd. with bold simple design elements; thick, soft hand-spun yarns with white, dk. brown, and natural undyed grey/brown. Beautiful variations in tones. Exc. cond. 86" x 52". Est. 700-1000 **SOLD** $710(01)

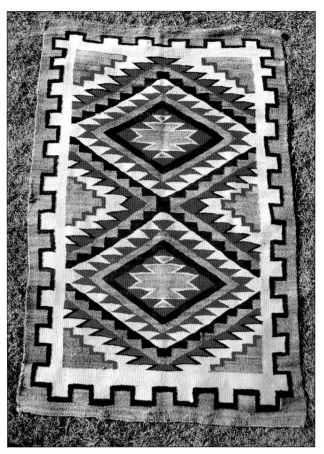

LARGE NAVAJO "EYE DAZZLER" RUG c.1910
Soft, heavy hand-spun yarns in dynamic all-over pattern: red, nat. lt. and dk. brown, cream. One 2" tear (easy repair) and one corner tattered, otherwise exc. unfaded cond. 48" x 75". Est. 700-950 **SOLD $651(99)**

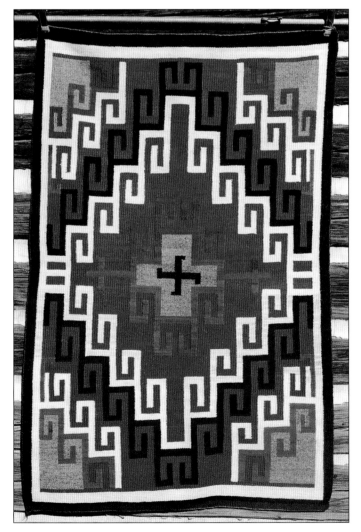

GANADO(?) NAVAJO RUG c.1940
All-over fret and cross motif with deep red bkgrd. Design in white, black natural grey, and unusual indigo blue. Very dense fine weave. Slightly soiled. Perfect cond. 72" x 39". Est. 1100-1300 **SOLD $1150(01)**

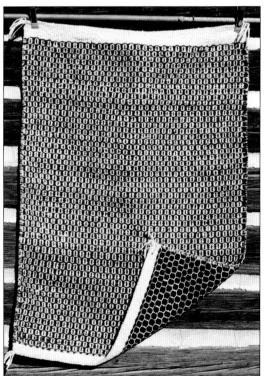

DOUBLE WEAVE TWILL NAVAJO DOUBLE SADDLE BLANKET c.1950
Thick white and black yarns in all-over honeycomb pattern on one side, and all-over lozenge pattern on the other. Very thick and heavy. Suitable for rug. Exc. cond. 50" x 35". Est. 400-550 **SOLD $300(01)**

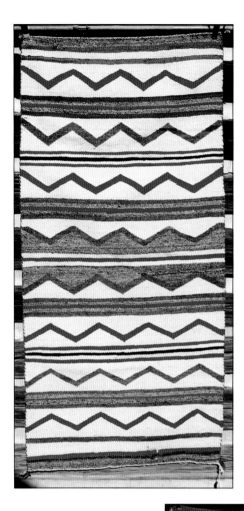

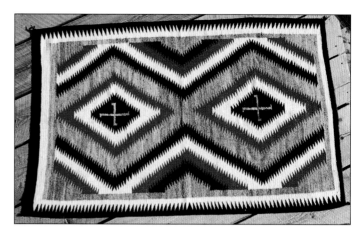

NAVAJO DOUBLE SADDLE BLANKET c.1920
Thick dense hand-spun in beautiful pattern: cream and natural grey with horizontal stripe and zig-zag patterns in rich red and brown mix. Floor rug. 33" x 68". Two small tears near one end. Est. 375-500 **SOLD $400(02)**

NAVAJO SWASTIKA MOTIF RUG c.1920
Swastika or "whirling log" design used pre-1940s. Fantastic finely detailed serrated diamonds in natural dk. brown, cream, and varying red on varying lt. brown/grey ground. Soft and dense weave. Superb cond. 43" x 68.5". Est. 450-750 **SOLD $500(03)**

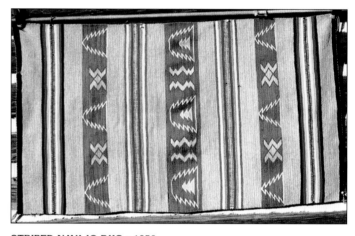

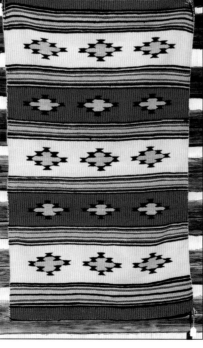

CHINLEE NAVAJO RUG c.1940 or earlier. Gorgeous colors and design: soft rose red and black, beige and lt. grey stripes, with black and natural pale grey diamond motifs. 35" x 58". Exc. cond. Est. 375-600 **SOLD $475(04)**

STRIPED NAVAJO RUG c.1950
Vegetable dyed and red, tan, nat. grey, white, and black with attractive designs within nat. dk. brown bands. Firm and dense. Exc. cond. 37" x 66.5". Est. 500-700 **SOLD $515(00)**

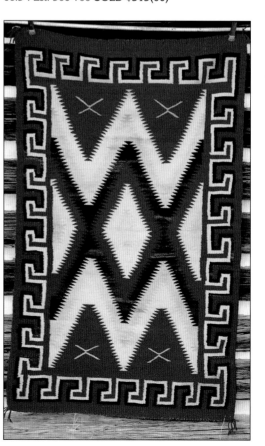

GANADO NAVAJO RUG c.1930s
Characteristic rich bright red ground with bold serrated diamond pattern bordered in fret motif that is natural dk. brown with nat. lt. grey and cream. Exc. cond. 39.5" x 63"L. Est. 500-750 **SOLD $552(05)**

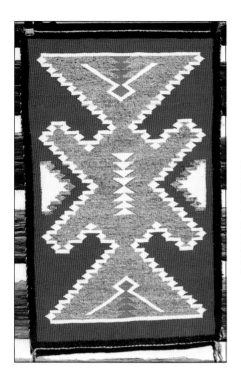

SMALL GANADO NAVAJO RUG c.1930
Dense, hand-spun characteristic deep red with natural grey, deep gold, and cream central motif with black borders. Very nice. 24" x 37". Est. 200-325 **SOLD $210(02)**

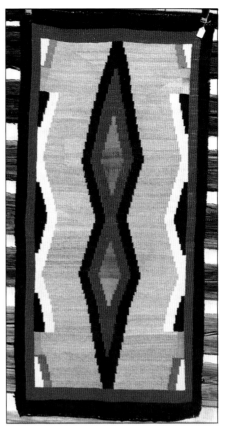

KLAGETOH NAVAJO RUG c.1930
Classic double serrated diamond central motif bordered with serrated triangles and red and black borders. Typical colors of the region: nat. varied grey background with black, cream, tan, lt. brown, and black. Slightly tattered edges; two small holes within border only. 65" x 31". Est. 500-750 **SOLD $600(01)**

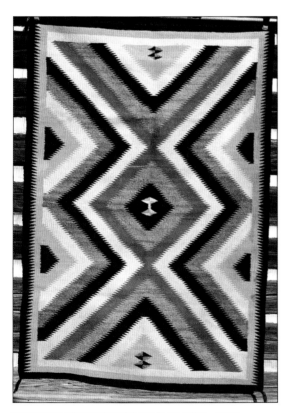

WESTERN RESERVATION NAVAJO RUG c.1930
Classic outline-style central diamond motif; colors are tan, lt. brown, nat. varied grey, black, and cream. Perfect cond. 67" x 46". Est. 750-1200 **SOLD $700(01)**

NAVAJO VEGETABLE DYE RUG c.1970
Original tag reads: "Weaver: Zonnie Gilmore; Area· Chinle, AZ…Paul's Indian Store Escalon, CA…" Lovely soft tones: mustard, rose-brick, white, natural lt. and dk. brown in detailed stripe and step patterns. Very fine weave. Superb cond. 32" x 48". Est. 250-500 **SOLD $275(03)**

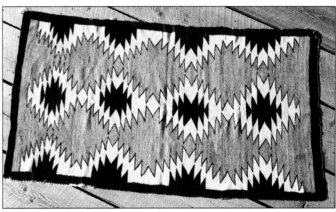

EARLY NAVAJO RUG c.1910-20
Beautiful serrated designs in natural varying lt. and dk. brown with cream. Orange single row border at ends. Fine and tight weave. A few breaks in yarn edging on long sides, otherwise exc. cond. 33" x 61.5". Est. 450-600 **SOLD $465(03)**

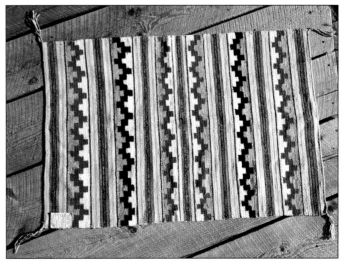

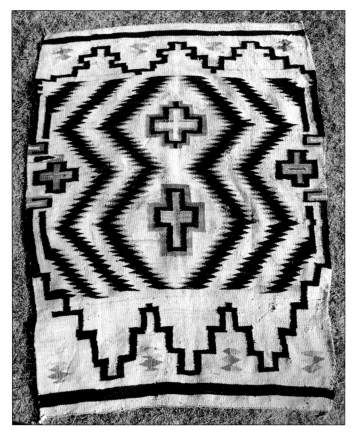

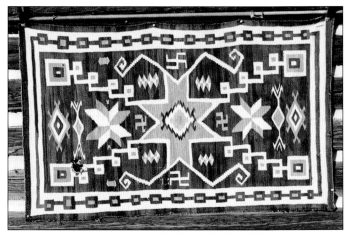

2 GRAY HILLS NAVAJO RUG c.1910-20
All natural dk. brown, two shades lt. brown and cream. Characteristic complexity of design and dense tight weave of fine hand-spun yarns. Eight point stars, swastikas, and box link border. 66" x 39". One fist sized hole needs re-weaving, others hardly noticeable: Two tiny holes and 3" x 1.5" break. Est. 300-500 **SOLD $300(00)**

EARLY LARGE NAVAJO "POUND" RUG c.1890-1900
Thick, soft and dense hand-spun wool pred. white with nat. dk. and lt. brown, faded purple, faded red; very nice pattern. Exc. floor piece. VG cond. Has a few tatters on side, some coarse repair holes. 64" x 84". Est. 400-600 **SOLD $375(99)**
 See Rodee, pp. 70-79 for history and more examples of "pound" rugs and blankets.

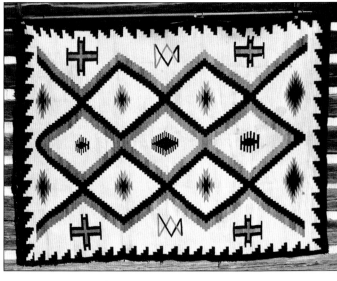

EARLY NAVAJO FLOOR RUG c.1900-10
Soft, thick heavy all natural hand-spun in colors to match any decor: cream ground with varying lt. brown and varying dk. brown. Exc. crisp design motifs. Lovely step triangle border. A few minor stains and a few yarn breaks, otherwise exc. cond. 88" x 64". Est. 625-900 **SOLD $600(00)**

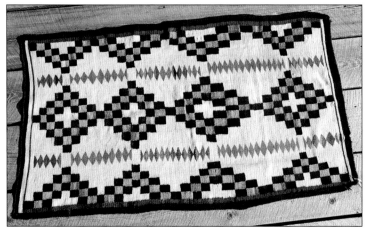

EARLY STEP-DIAMOND PATTERN RUG c.1915
Superbly soft fine weave with interesting designs. Cream ground with diamonds in "checkerboard" pattern in alternating natural dk. and lt. brown squares forming central cream cross negative design. Stacked small diamond columns are orange and varying grey. Outside straight borders are red and dk. brown. Exceptional design, color balance, and weave quality. One corner tattered, otherwise exc. cond. 60" x 35". Est. 500-800 **SOLD $500(03)**

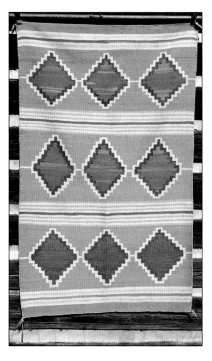

WIDE RUINS NAVAJO RUG c.1940
Classic vegetable dye in varying golds, cream, and natural grey step outline diamond and stripe pattern. Exc. cond. 36"W x 57" Est. 400-575 **SOLD $425(02)**

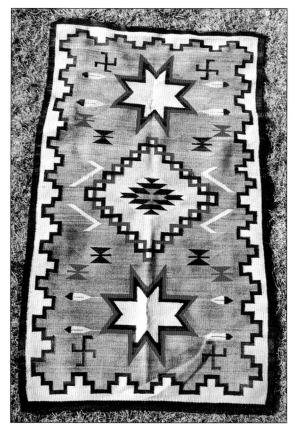

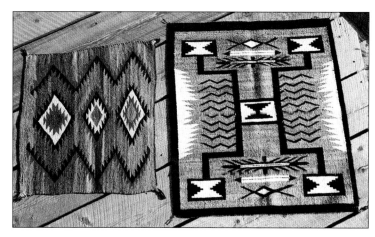

(Left) NAVAJO SMALL DAZZLER RUG c.1910
This early homespun rug has a beautiful varying lt. brown ground with serrated motifs in varying rose/red, dk. brown, and cream. 25.5" x 29". Perfect cond. Est. 250-450 **SOLD $260(03)**

(Right) NAVAJO STORM PATTERN RUG c.1970
Stylized variation of pattern first introduced in 1910 by J. B. Moore of Crystal Trading Post. * All natural heavy home-spun yarns: varying grey ground with dk. brown/black and white. Thick floor rug. 33" x 38". Exc. cond. Est. 300-450 **SOLD $285(03)**
 *See James, pp. 85-87.

NAVAJO STAR and DIAMOND PATTERN RUG c.1910
Fine, dense weave nat. grey and cream with nat. brown and black and rich red. Lovely complex pattern includes stylized feathers. Exc. cond. 40" x 68". Est. 500-850 **SOLD $500(99)**

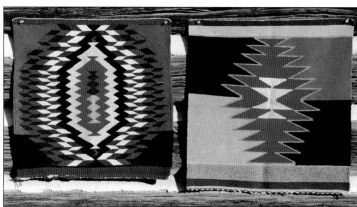

GERMANTOWN SAMPLERS c.1910
RARE These two weavings were made with fine 4-ply yarns from Pennsylvania available between 1880-1910.
(Left) Tomato red, indigo, burgundy, beige, black, and mustard. complex diamond patterns. Very beautiful, very fine weave. Colors are bright and unfaded. Slightly frayed on edge apx. 2". Otherwise exc. cond. 20.5W x 20"L. Est. 200-500 **SOLD $200(98)**
(Right) Tomato red, soft green, red, lt. lavender, nat. grey, black, and pale yellow. Central serrated diamond patterns. Very fine weave. Colors are bright and unfaded. Slightly frayed on edge, only apx. 1". Otherwise exc. cond. 21"W x 22"L. Est. 200-500 **SOLD $185(98)**

WESTERN RESERVATION NAVAJO RUG
c.1920-30
Natural grey hand-spun with dramatic white figures outlined in deep red and black serrations. Dense fine weave. One (2") repaired hole. All else in perfect cond., incl. tassels and edging. 50" x 31. Est. 200-400 **SOLD $250(01)**

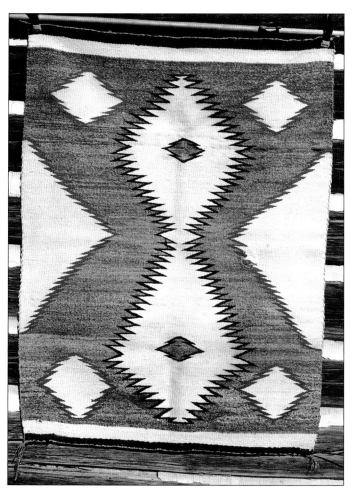

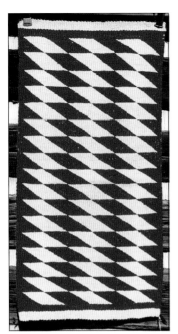

NAVAJO GALLUP THROW c.1930
Thick, hand-spun, all-over diamond pattern in dramatic red and cream with black borders. Pristine cond. 18" x 33.5". Est. 150-300 **SOLD $150(02)**

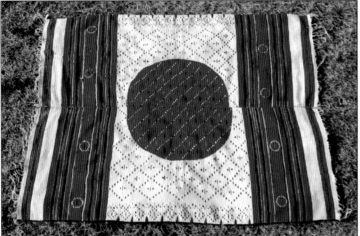

LATE SALTILLO MEXICAN RUG c.1920
Northern Mexico. Pred. brilliant red-orange central and stripe motifs with narrow bands of lt. green, lavender, black, and orange. Seam down center of two pieces sewn together. Several tiny fray holes. Blanket weight fine loose weave. Good cond. Warp fringe ends. 79" x 60.5"W. Est. 200-400 **SOLD $104(98)**
 See Rodee, pp. 29-35.

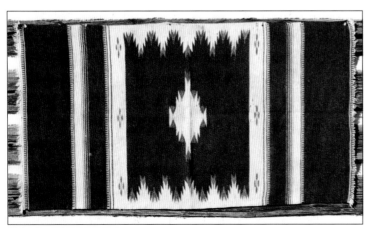

CHIMAYO THROW c.1940
New Mexico. Very fine weave, lt. weight. Brown-black, cream with blue and red. Warp fringe. 55" x 29". Considerable small dirt stains, some red bleed through. Est. 100-200 **SOLD $60(98)**
 See Rodee, pp. 39-53.

Pottery

Pre-Historic Period

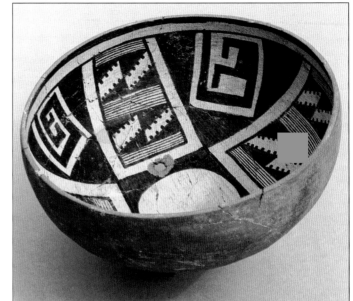

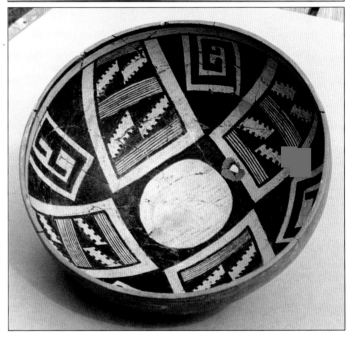

SALADO "KILLED" POLYCHROME BOWL c. 1050-1300 A.D.
Inked label says:" Very Rare 'Killed' Salado (Gila Polychrome)." "Kill" hole was usually found on Mimbres culture pottery of this same period. Salado was a culture area in present day Arizona. Bold and very well-executed black and white geometric slip elements over redware. Professionally restored from shards. 12" diam. x 5.5"H. Est. 1200-2000 **SOLD $1500(05)**

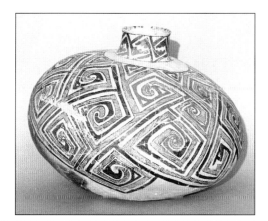

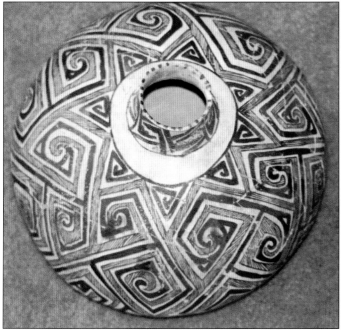

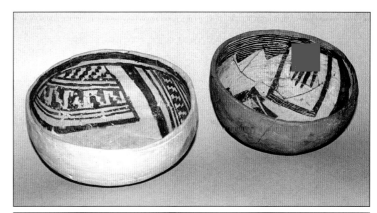

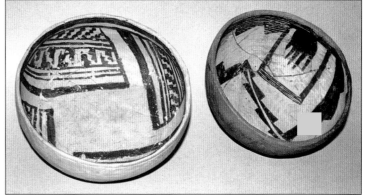

LARGE ANASAZI-TULAROSA OLLA c.1200 A.D.
Fabulous all-over black on white spiral maze pattern. 14"H. 10" diam. Apx. 20% restoration. Re-constructed from shards. Black smudge kiln marks. Est. 1200-1500 **SOLD $800(99)**

(Left) **ANASAZAI-KAYENTA BOWL** 1350-1500 A.D.
Grey with black geom. interior designs. Shard re-constructed. Apx. 10% expertly restored. 7" diam. x 3"D. Est. 300-500 **SOLD $215(98)**
(Right) **SALADO PINTO POLYCHROME BOWL** 1250-1300 A.D.
Dynamic interior design in black over buff includes rare two human hands motif. Red exterior with black smudge marks. Only apx. 3% restored; several shard re-construction. Wonderful piece. 3.5"D x 6.5" diam. Est. 450-600 **SOLD $325(98)**

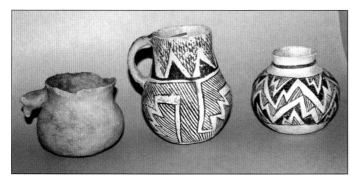

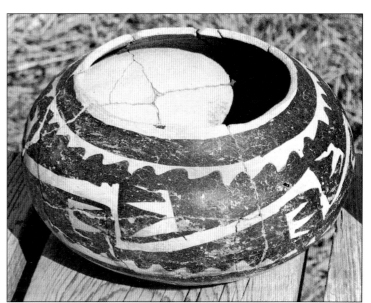

(Left) **OLLA WITH ANIMAL HEAD LUG** 900-1100 A.D.
Plain grey ware with chipped rim but no restoration or reconstruction. Interesting piece. 3.5" diam. x 5"H. Est. 250-350 **SOLD $225(98)**
(Center) **ANASAZAI CHACO BLACK ON WHITE PITCHER** 900-100 A.D.
RARE. No restoration; quarter-sized spot shard reconstructed nr. bottom. Handle intact. One tiny old chip on rim. Remarkable cond. 5.25"H x 5.25" diam. Est. 500-650 **SOLD $550(98)**
(Right) **ANASAZAI CHACO BLACK ON WHITE SMALL OLLA** 900-1100 A.D.
Two shard reconstruction Apx. 15% expert reconstruction. Lip chipped. Indented bottom. 4"H x 4.5"W. Est. 300-400 **SOLD $200(98)**

SALADO-GILA POLYCHROME SEED JAR c.1400 A.D.
Reconstruction but no restoration. Lively, bold design bands on exterior in black over buff. Red bottom. 7" diam. 4"H. Est. 250-400 **SOLD $225(99)**

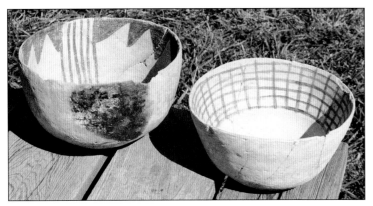

(Left) ANASAZAI DEEP BOWL c.1100 A.D.
Black on white. Design in interior very bold. Apx. 10% restoration. Made of shards. 8.25" diam. 5"H. Est. 150-250 **SOLD $125(99)**
(Right) ANASAZAI BLACK ON WHITE BOWL c.1000 A.D.
Interior has simple vert. and horiz. line pattern. Made of shards. 10% restoration and enhanced design. 8" diam. 4"H. Est. 80-120 **SOLD $70(99)**

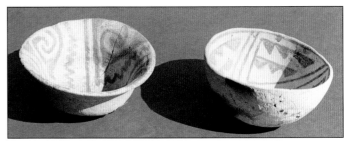

(Left) HOHOKAM MINIATURE FLARE RIM BOWL c. 900 A.D.
Red on buff. This is a whole piece with pressure crack 1/2 diam. 10% restoration and design enhanced. Nice spiral and zig-zag all-over pattern. 4.5" diam. 2"H. Est. 100-175 **SOLD $95(99)**
(Right) ANASAZAI-MINIATURE BOWL c.1050 A.D.
Reconstructed but no restoration. Design enhancement only. 4.5" diam. 2"H. Est. 125-200 **SOLD $150(99)**

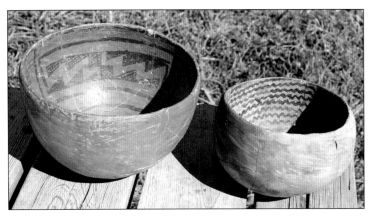

(Left) ANASAZAI-PUERCO DEEP BOWL c.1100 A.D.
Beautiful deep red with black interior clear and dynamic patterns: zig-zag, etc. Apx. 10% restoration from shards. 9" diam. x 5.5"H. Est. 350-600
(Right) MIMBRES BLACK ON WHITE DEEP BOWL c.1050 A.D.
Grey with horiz. zig-zag all-over patterned interior. 30% restoration. 7.5" diam. x 4.5"H. Est. 200-300 **SOLD $125(99)**

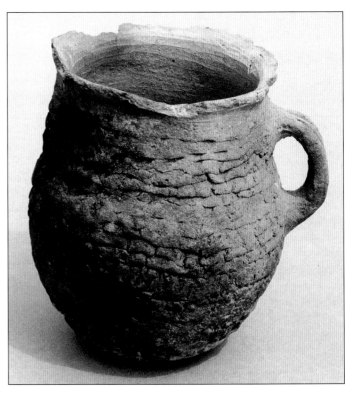

"PUEBLO II" CORRUGATED PITCHER WITH HANDLE c. 900-1100 A.D.
Consignor notes: "Kaibab, Utah." Good patina of fire darkened smudges. Nice texture of deep ridges. Rounded bottom. 5.5"H x apx. 4"W + handle. Exc. unrestored cond. Est. 250-400 **SOLD $275(05)**

(Left) HOHOKAM PLATE c.1100-1300 A.D.
Apx. 30% expertly restored. Re-constructed from four shards. Lots of shiny mica in pottery with black smudge on terra cotta. Apx. 8" diam. x 1.75" deep. Est. 75-125 **SOLD $60(98)**
(Center) SALADO RUGIS-WARE CORRUGATED BOWL 1200-1400 A.D.
Bottom is coiled. White on orange. No restoration. Reconstructed from four shards. 3"H x 7" diam. Est. 150-200 **SOLD $160(98)**
(Right) HOHOKAM SCOOP DISH 100-1300 A.D.
Black smudged over terra cotta with lots of silvery mica. Apx. 25% expert restoration. Reconstructed from three shards. 3"D x 7" diam. Est. 75-150 **SOLD $100(98)**

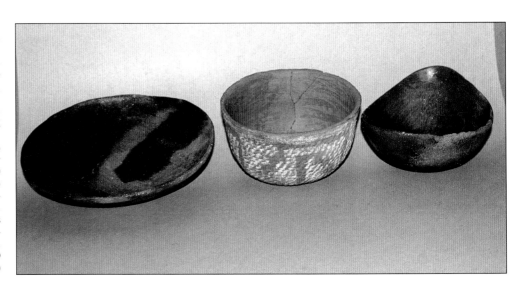

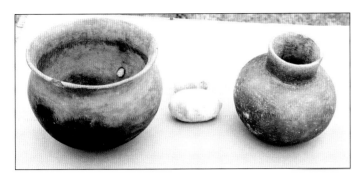

(Left) **PAPAGO REDWARE COOKING POT and TWO GOURDS**
Nice darkened patina smooth from use. Rounded bottom. Fragment of rope thru hole on side. Lipped top apx. 8" diam. 6.5"H. One of the small gourds has a carved figure done long ago. Est. lot 75-125 **SOLD $75(05)**
(Right) **KENTUCKY WATER JUG** 1200-1500 A.D.?
Tag reads: "Water Bottle from Reedsville Kentucky." Wonderful surface patina of age. 6.5"H. Opening 3.25" diam. Rounded bottom. Exc. unrestored cond. Est. 175-350 **SOLD $200(05)**

20th Century Pottery

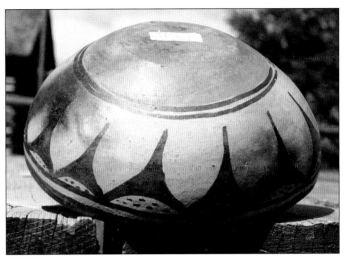

PUEBLO POLYCHROME BOWL
Possibly San Ildefonso. Shown upside down. Red bottom with curving black rim design of black on cream. Interior is plain cream. Nice designs, exc. cond. Smudge marks. 6" diam. 3"H. Est. 300-400 **SOLD $175(99)**

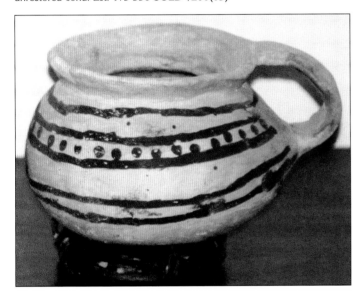

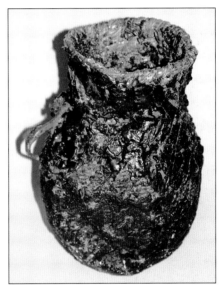

APACHE PITCH WATER JUG c.1880
Willow sealed with pinon pitch. Original willow handles intact. 9"H. Apx. 6" widest part. Exc. cond. Est. 100-250 **SOLD $125(05)**

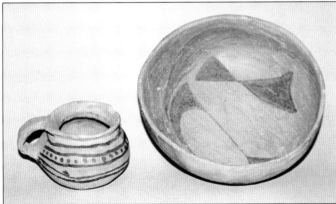

(Left) **ANASAZAI-JEDDITO MUG** Apx. 1300-1600 A.D.
Black on yellow in nr. mint cond. (a few superficial chips on rim). 3" diam. 5"H. Est. 150-250
(Right) **ANASAZAI-MATSAKI BOWL** c. 1500 A.D.
Polychrome with abstract animal and triangular figures. 5% restoration, 50% design enhancement. Reconstructed from shards. 8" x 3"H. Est. 150-200 **SOLD $130(99)**

SANTA CLARA REDWARE JAR (SEED POT)
Highly polished thick with pale orange and blue-grey slip geometric motifs outlined with white slip. No bottom marks. 6.5"H x 3.5" diam. bottom flaring to 6.5"W. Exc. cond. Est. 150-350 **SOLD $150(05)**

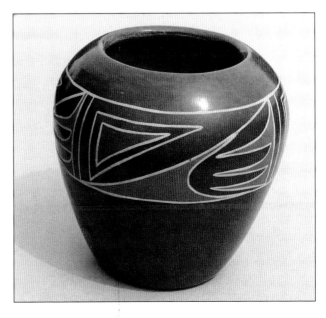

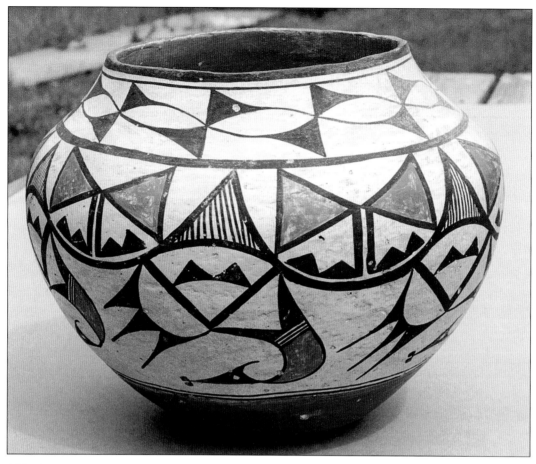

ACOMA LARGE POLYCHROME JAR c.1900-1950
Orange and black over white slip in typical hatched and solid curving motifs. 8.5"H x 11"
widest flared part. No bottom marks. Est. 700-950 **SOLD $702(05)**

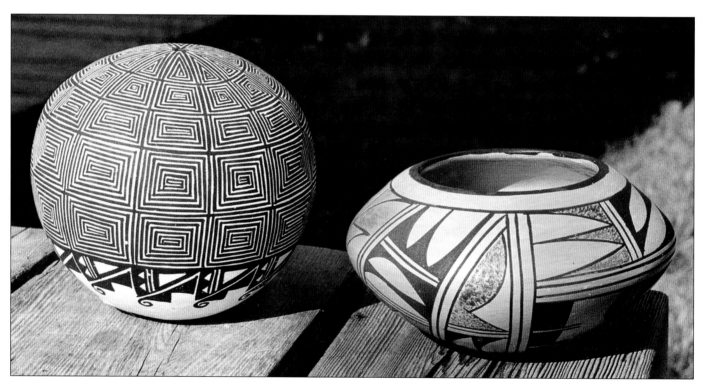

(Left) **ACOMA SEED POTTERY** Contemp.
Signed "M.G." "Acoma" (Mary Garcia) with line drawing of church. Spherical. White with all-over intricate fine line pattern.
One tiny worn area (1/4" sq.) black only, otherwise, exc. cond. 4"H x 5"W. Est. 95-175
(Right) **HOPI POLYCHROME BOWL** Contemp.
Signed "C. Collatteta." Flared shoulder. Buff with black and pale orange complex motifs characteristic of Sikyatki revival
pieces. Exc. cond. 5.5"H x 3.5"W. Est. 85-175 **SOLD $85(00)**

6. Photo Essay: Worldwide Beadwork and Quillwork Traditions

by Carolyn Corey

European, Asian, Mexican, North and Central American Examples

References for this section:

Allen, Jamey D. *An Essay on Beadwork*. 2000. (www.thebeadsite.com/bbi-jda.htm) This is part of the late Peter Francis Jr.'s bead site.

Clabburn, Pamela. *Beadwork*. Aylesbury, Bucks. UK: Shire Publications, 2001

Jargstorf, Sibylle. *Glass Beads from Europe*. Atglen, PA: Schiffer Publishing, Ltd., 1995.

Phillips, Ruth. *Trading Identities*. Seattle: University of Washington Press, 1998.

Robinson, Belle, editor. *Priscella Bead Work Book*. Boston, MA: Priscilla Publishing Co., 1912.

We have included non-native beadwork items in this book because many have been misidentified as being made by American Indians. We have seen improperly attributed pieces like them in antique malls, at auctions, on eBay, and in private collections. Many of these non-native made objects are mistakenly put on the market today as Indian-made, so buyer beware!

By 1492, Christopher Columbus and other early explorers were introducing glass beads to Native Americans, and it was during this same era that small drawn-glass "seed" beads were becoming readily available around the world. These tiny beads were first manufactured in the late fifteenth century in Venice, Italy, and graded by size, 5° (apx. .12") to very small size 22° (apx. .04"). (Dubin, p. 43) As a result of the early trade of English steel needles and thread, beadwork traditions developed in many countries.

Beadwork as we know it is a relatively modern art form. It demands large quantities of small uniform beads as well as textile skills and supplies, i.e., needles and thread: "it takes the availability of beads, supplies, skills and the production of many types of beadwork items to instigate an actual beadwork tradition." (Allen) The European tradition of making needlepoint and tapestry works probably formed the basis for modern beadwork. "European fiber skills are quite refined, and there is reasonable evidence for women (primarily) practicing these crafts since early Greek times and earlier." (Allen)

By the 19th century, in America and abroad, the "feminine crafts of all kinds assumed great importance and there were many magazines published that gave clear instructions for making beaded objects for the house and person." (Clabburn, p. 8.) In the 1850s, when the Niagara Falls trade was booming, several books and magazines pictured Indian-style beadwork. One such publication, *A Lady's Newspaper, 1859,* displayed a pattern for an Iroquois bag, similar to those shown on pages 79-80. According to Phillips, these bags are "probably the most popular single item made by Iroquois women." She further suggests that this shape was derived from a Victorian ladies' chatelaine bag. (Phillips, p. 220) In a 1912 American ladies' magazine, patterns are given for Indian bead weaving, beaded knitting, beaded crocheting, and bead embroidery on canvas, cloth and velvet. There are detailed instructions on how to make an "Apache loom" as well as patterns for making a Mojave Indian belt just like the pictured original. (Robinson, p. 4.)

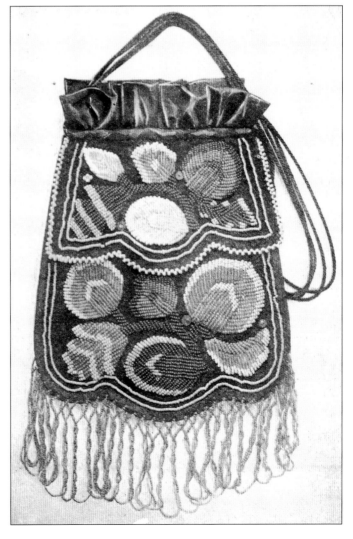

"No. 1514. BAG OF INDIAN EMBROIDERY"
In 1912, one could obtain for 10¢ a paper pattern that was an exact replica of this Tuscarora bag on velvet! *Priscella Bead Work Book, p. 16.*

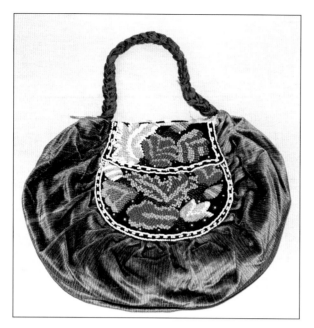

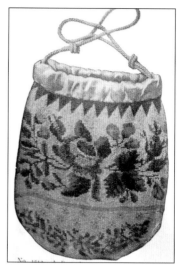

This original piece has been documented as being knitted by a woman who lived from 1738-1830. The background bead is described as "opal" with dk. red upper triangular border rose/red roses with blue forget-me-nots. A black and white block pattern of this bag could be purchased for 15¢ in 1912. *Priscella Bead Work Book, p. 16.*

VICTORIAN IROQUOIS-STYLE HANDBAG c.1880-1910
Incorporated into the bag is an emboss beaded pouch that may very well be non-Indian made, as the entire piece seems to be constructed at the same time. Handbag is stone blue rayon velvet with braided handle. Exc. shape, unique piece. Lined with beige rayon grosgrain. Hangs 14"L. Est. 125-225 **SOLD** $150(02)

The next several photos show early bead knitted purses. Similar styles were made in Europe as well as America. These solidly beaded 19th century purses were "knitted" from spools strung with beads on a thread, following a numbered paper pattern.

According to Robinson, "While crocheting and weaving and canvas embroidery are the preferred methods of making a bag of a solid design of beads these days [1912], yet, all honor must be given to the forerunner of them all, the old knitted bag of our great-grandmother's day." (p. 4.) Clabburn states that "bead crochet did not come into fashion until the early part of the 19th century so there is no bead crochet until that time." Instructions for making crochet beadwork were commonly available in the late 19th and early 20th centuries. (p. 29.) Note that crocheting is a kind of knitting that is done with a single hooked needle. (See example and additional description of crochet work under Beaded Snake, p. 140.) Knitting can be defined as a close texture formed by interlooping of successive series of loops of yarn or thread done with two straight needles. (See good drawings of these techniques in Clabburn, p. 38.)

Flowers were the most popular motif; roses and the color red signified love and forget-me-nots and the color blue meant the same thing. Sometimes, the initials of the girl's name were incorporated into the floral motifs. (Jargstorf, p. 130) Very complex pictorial designs with castles and hunting scenes were also popular. (See Clabburn, cover photo and Robinson, p. 17.)

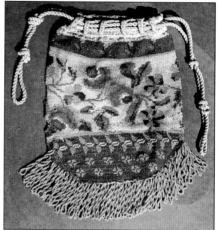

Preston Miller Collection. This bag is very similar to the early rose bag shown above. Note the "opal" or opalescent bead bkgrd. same as above bag. The beads are quite tiny, apx. size 18°. Note the rich color of the gr. blue loop fringes. 8" x 5"W. A similar 19th century rose motif bag is labeled "tobacco bag from Germany," in Jargstorf, p. 130.

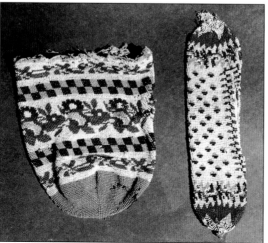

Preston Miller Collection. (Left) Another 19th century rose motif purse in similar bead colors. Beads are apx. size 14. Note gr. blue bottom, apple green, Chey. pink, and gr. yellow beads—same colors found on American Indian beadwork of this period. Detail photo: interior of same purse showing knitted thread patterns.
(Right) The 8.5" sausage shaped purse has a 2.5" slit opening. These are referred to as "miser's purses" or "gentleman's purses." See additional examples in Clabburn, pp. 12 and 26. Also see Jargstorf, p. 130 for full-color photo of 19th century one made in Germany.

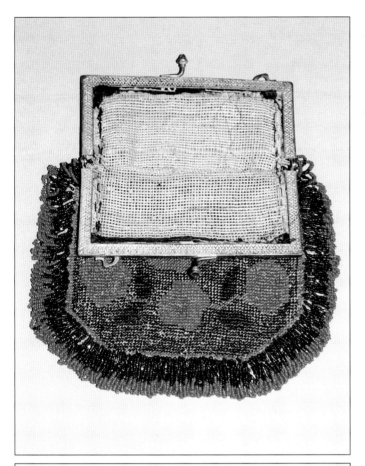

The following piece appears to be an example of "Berlin woolwork," which originated in Europe and gained popularity around 1850. Frequently sewn on canvas, beads are used to "highlight and outline the design" with a background of cross stitch in wool or silk. See more examples in Clabburn, pp. 9-11. Phillips defines this "non-native needlework" as a form of tapestry using "restamped designs," usually floral motifs, and brightly colored yarn. (p. 199)

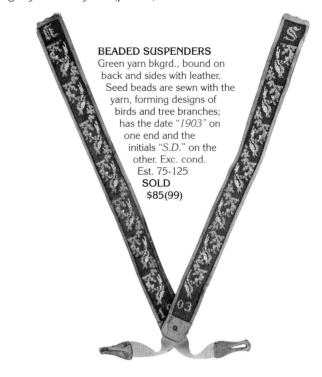

BEADED SUSPENDERS
Green yarn bkgrd., bound on back and sides with leather. Seed beads are sewn with the yarn, forming designs of birds and tree branches; has the date "*1903*" on one end and the initials "*S.D.*" on the other. Exc. cond.
Est. 75-125
SOLD
$85(99)

FULLY-BEADED PURSE c.1920
Author's Collection The beads on this piece were sewn directly onto the fabric, one bead at a time, to create a needlepoint type of texture. Only with very close scrutiny can one tell that it is not crocheted or knitted. The charming bluebird and rose motifs may be pre-printed on the loosely woven cotton fabric; the lining is missing (may have been silk) so that the backing is clearly visible in the interior. Tri-cut black bkgrd. with red roses and t. green trim. Loop fringes are black tri-cuts and red beads, all intact. Embossed metal closure has cobalt blue glass trim. Apx. 9"L x 6.5"W. Exc. cond. Est. 85-150

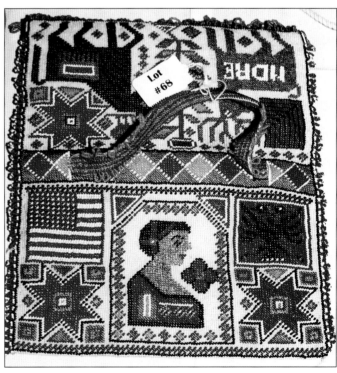

EUROPEAN FULLY-BEADED PICTORIAL PURSE
Manitou Indian Arts Auction, Great Falls, Montana # 68, 2000. American flag and Albanian flag with figure of woman on one side; other side has deer and horse motifs and letters "*NDRE.*" Loom-woven in brightly colored seed beads with bead loop fringes on three sides. 5" x 9". Auction estimate as an American Indian object was 300-400 **SOLD $75(00)**

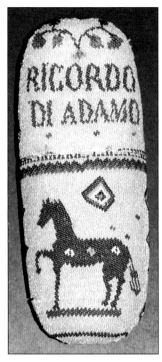

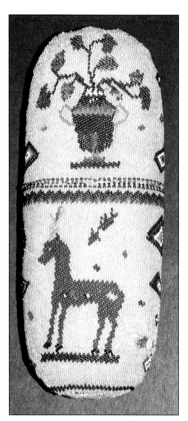

EUROPEAN PICTORIAL FULLY-BEADED CASE

Red and blue horses with vase of flowers. Italian words *"Ricardo di Adamo,"* which translate as "Memories of Adam." This piece was probably made around a form; crocheted or knitted. It was sent to us for our auction by a consigner who thought it was an American Indian piece and we subsequently returned it.

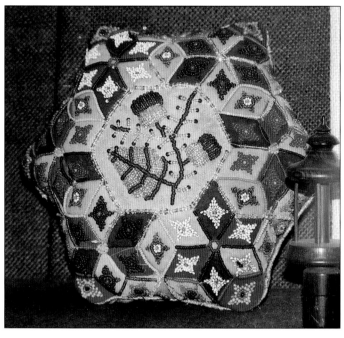

SCOTTISH BEADED PILLOW 19th century

Saffron Walden Museum, England. Six pointed star shape. Appliqué-beaded thistle is central motif surrounded by diamond shaped cloth appliqué, sewn down with beadwork. Apx. 16".

The Scotch thistle motif appears to have been introduced to Canada and the St. James Cree in the early 19th century by a Scottish immigrant doctor who worked for the Hudson's Bay Co. The traditional Indian items created with this motif include an octopus bag, double-peaked hoods, and wall pocket.

Oberholtzer, Cath. *Six Degrees of Separation: Connecting Dr. John Rae to James Bay Cree Objects in the Royal Ontario Museum.* Oxford, England: Rupert's Land Colloquium, 2002: 211-23.

EUROPEAN? FULLY-BEADED PUZZLE BAG

1890

Ivan Zimmer Collection. Displayed for many years in his Sod Buster Museum at Moccasin, Montana. Sold at auction in Lewistown, Montana in April 2003. Loom-woven seed beaded with classic Greek urn motif and geometric-style flowers. Bead dangle fringes with brass beads tips. Handle is bead-wrapped. Apx. 7" x 10". **SOLD $600(03)**

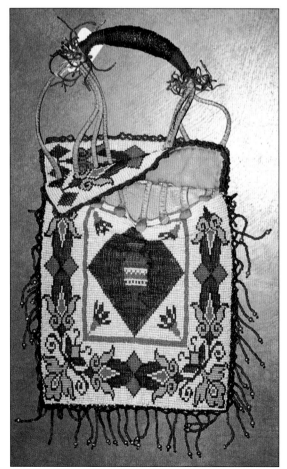

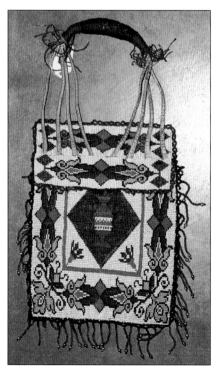

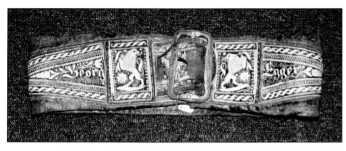

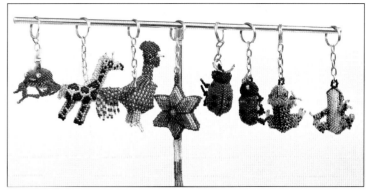

CENTRAL AMERICAN 3-D BEADED KEYCHAINS Contemp.
Completely made in a colorful array of seed beads using brick/peyote net beadwork. Crab, giraffe, rooster, star, ladybug, and frog are shown. 2"-3"H. Est. 12-20 each

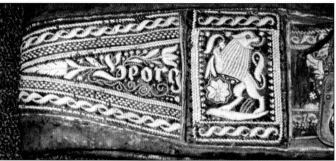

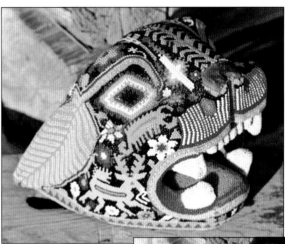

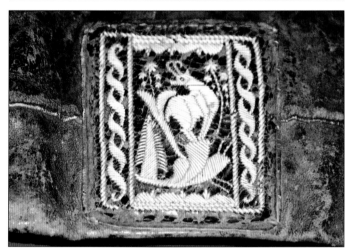

MEXICAN HUICHOL PANTHER SCULPTURE
Fully covered in a colorful array of seed beads inlaid into wax. Technically, not considered beadwork. Note deer, scorpion, and double eagle motifs.

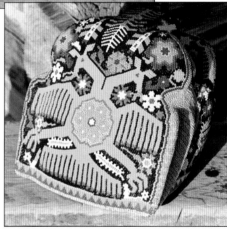

EUROPEAN QUILLED BELT

From Salzburg, Austria. Natural undyed peacock quills sewn into personalized design for a *"Georg Egger."* This belt appears to be part of a "Lederhosen" ensemble (i.e., the decorated straps that hold up the pants). This type of embroidery is called "Federkielstickerel," meaning feather quill-embroidery. It is an Alpine craft still practiced today. The type of goat in the detail photo is called a "Gamsbock" and only lives in the Alps. This belt was for sale in an ethnic arts store with unknown provenance. Several have shown up on eBay with no provenance. Est. 95-200
 Ellen Kraus, personal communication, 5/03.

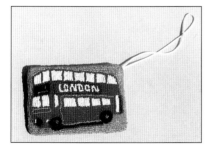

CHINESE APPLIQUÉ-BEADED COIN PURSE Contemporary.
London bus design on both sides. Available in many designs, including flowers, flags, etc. 4" x 6". We bought several of them for re-sale, which we sold to Indian people in our trading post! Est. 10-25

The author purchasing the London bus bag at Portobello Market in London in 2002 from a Chinese family.

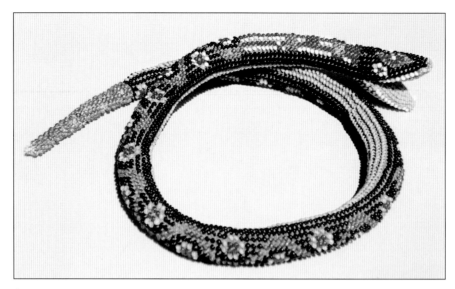

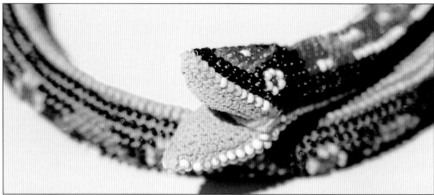

TURKISH BEADED SNAKES

*Author's Collection. Made by Turkish prisoners of war during WWI in camps in Egypt, Mesopotamia, Greece, and Britain (Isle of Man). The beads were provided by the British.** Characteristic Turkish/Balkan crocheted beadwork stuffed with cotton. Note that the entire piece has no seam but is done in the round. This is characteristic of crocheted items. "Crochet beadwork is where beads are threaded on to the working thread of the crochet work and then the bead is pulled up to lie on the 'wrong' side between the stitches." (Clabburn, p. 30) Note detail photo showing crochet stitches on mouth. 18.5"L. A few beads missing underneath, otherwise good cond. *Purchased on eBay from a dealer in London, England for $95(05).* Est. 95-150
*See www.mysite.wanadoo-members.co.uk/beadworksnake/page5 for more details.

Listed on eBay as a "1917 American Indian Beaded Snake–Rare." We informed the seller of the correct provenance so that he later changed it to Turkey. This snake is crocheted in larger pony beads rather than seed beads; colors include white, t. gold, t. red, cobalt, and gr. blue. Although it doesn't look it in the coiled position shown, this snake is a very long 67". There are several breaks and tears so that the original lettering is incomplete: *"SOLHERA?"* but *"1917"* is intact. Although it is in need of repair, we purchased this snake for $200 in 2005. Est. 100-175, more in better condition.

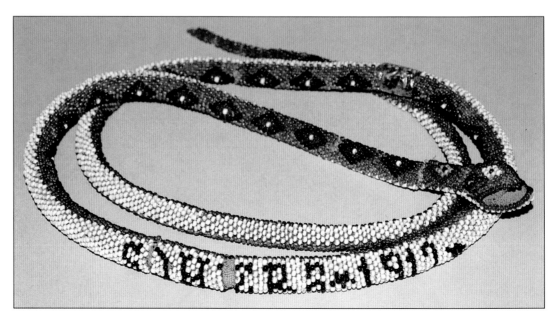

African Beadwork

References for this section:

Drewal, Henry John, and John Mason. *Beads, Body and Soul: Art and Light in the Yoruba Universe*. Exhibition Catalog from UCLA Fowler Museum, 1998. This book documents the historical and spiritual aspects of the beadwork tradition of the Yoruba tribe of Nigeria, Africa.

Fisher, Angela. *Africa Adorned*. New York: Harry N. Abrams, 1984.

Phillips, Tom, editor. *AFRICA The Art of a Continent*. Exhibition Catalog, London, Royal Academy of Arts, 1995.

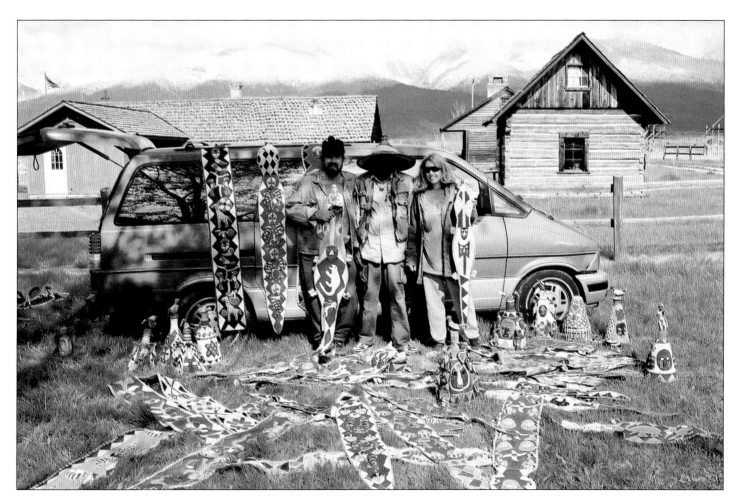

The authors at Four Winds with African bead trader Dramani Trawali, from Gambia, and his assortment of beaded pieces from Nigeria.

African Fully-Beaded Veiled
Hat "Crowns" with Bird Effigies

The following fully-beaded sculptural "crowns" are the type worn by the royalty of the Yoruba tribe of Nigeria in West Africa. They date c. 1940 to the present. Traditionally, only those with royal blood—connecting to the first ruler—can wear a beaded crown with a veil.

The crown artist begins by singing special offerings. Then the conical basket is constructed of palm reeds covered with cotton strips stiffened with cornstarch paste and sun-dried. Next, threaded beads are sewn to the sculptural forms. The entire process takes one bead worker up to two weeks to complete. Every inch is covered with **thread sewn** seed beads, apx. sizes 9°-10°. (Drewal and Mason, p. 64.)

Today there are about fifty Yoruba *Obas* (rulers) who still wear crowns and claim to be descendants of the first mystical king of life…"the veil of beads protect his face from commoners looking directly at so powerful a being." (Fisher, pp. 96-99.) Each crown has a stylized face at the front that represents royal ancestors (sometimes on all four sides). The top usually features a bird, an image associated with the power of women and their procreative powers. Without this female power, kings cannot rule. (Phillips, p. 425). The birds atop these hats are made to attach separately, with a heavy wire spike at the bottom. Each bird is uniquely beaded and measures apx. 7"L x 4"H.

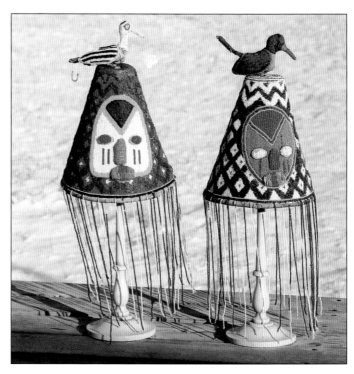

(Left) Brightly colored all-over diamond and zig-zag patterns in t. green and brick. Sculptural facial features are red, blue, and t. cobalt; yellow outlined over white background. The top egret has black and white striped wings with white head and t. green tail. Alt. t. red and white bead strung veil. Lined with soft blue and silver metallic stripe cotton. 14"H. 8.5" diam. Est. 100-300
(Right)T. grey and white all-over diamond and zig-zag patterns with periwinkle bkgrd faces. Sculptural features are brick, white, and green. Top egret is cobalt with pumpkin outlines. Beaded veil is alt. white and t. red. 14"H. 8.5" diam. Est. 100-300

Fantastic sculptural beaded birds perch upon the fully-beaded hat, which also has two stylized 3-D faces. Crown is beaded in red, cobalt, and lt. blue; birds have an additional pale green, apple green with orange and yellow accents. 5" bead strings on top bird are black and red. 12"L bead strings hang from rim. 19"H x 9.5" diam. Exc. cond. Est. 250-500 **SOLD $350(98)**

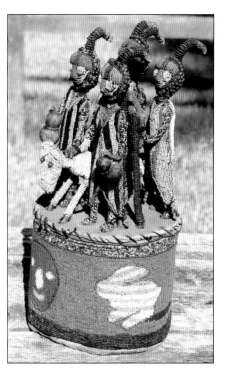

Unusual Yoruba beaded crown with 3-D figures and goat. Five standing men with tribal headdresses carry real gourds and walking sticks. Incorporates larger trade bead in motifs on cobalt ground. 18"H x 9" diam. Est. 600-1000

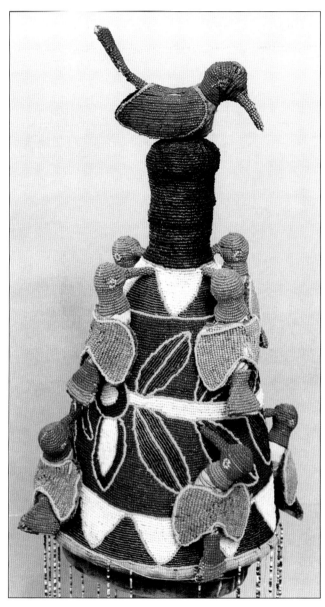

Wonderful 3-D sculptural egrets with Sioux green wings outlined in yellow and red heads and tails cling to fully-beaded "crown" with bold stylized leaf and triangular patterns. Crown colors are t. red, t. green, brick, t. cobalt, and white; all yellow outlined. Black top knob is crowned with jaunty bird with cobalt head and pumpkin/turq. striped wings bound with red muslin; yellow beak. 13"L bead strings of veil are varied colors. 8" diam. 19"H. Est. 300-500

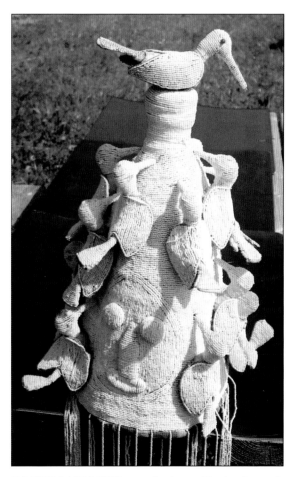

ALL BEADS ARE WHITE except for the two blue bead eyes of the top egret. This crown probably has sacred significance— worn only by a priest or ruler for use in special ceremonies. Two sculptural stylized faces, either side. 20.5"H. 10" diam. Est. 300-500

 See Drewal and Mason, p. 206, for a similar example and discussion of significance.

Yoruba Fully-Beaded Throne Chairs—"Seat of Power"

Every inch of these is covered with SEWN beadwork. Superb large scale stylized design elements of leaves and flowers "evoke the healing blessing presence" of the divinity of Osanyin, spirit of leaf medicine and beads. (See Drewal and Mason, p. 214, for a photo example.)

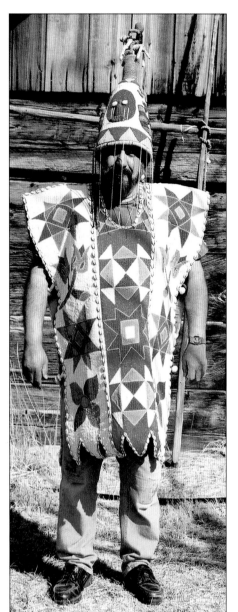

Preston poses in fully-beaded Yoruba tunic and "crown."

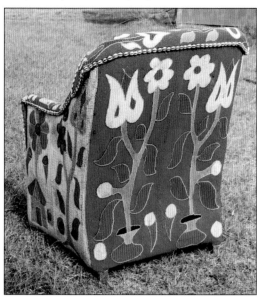

Back and bottom front have cobalt bkgrd. with red leaves, Sioux green stem with white and red abstract floral outlined in yellow. Side panels and seat are white bkgrd. with addition of lt. blue motifs. Front is varying dk. to med. red bkgrd., same motifs as back in diff. colors. Top and arms are blue and red panels, similar beadwork colors bordered with old cowrie shells. Chair is wood covered with wicker. Lightweight but sturdy. 36"H x 24"W x 32"D. Est. 1500-2000

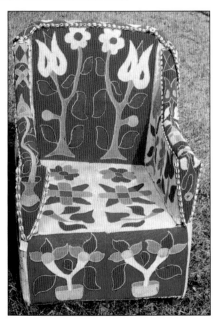

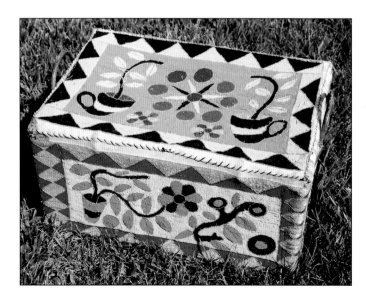

YORUBA FULLY-BEADED CHEST c.1950
Interesting designs of leaves, probably symbolic of the leaf and bead divinity, *Osanyin*. Lt. blue, white, orange, cobalt, black, and white. Colorful cotton lined wicker with wooden side handles and latch. 14"D x 18"W x 27"L. Est. 500-900

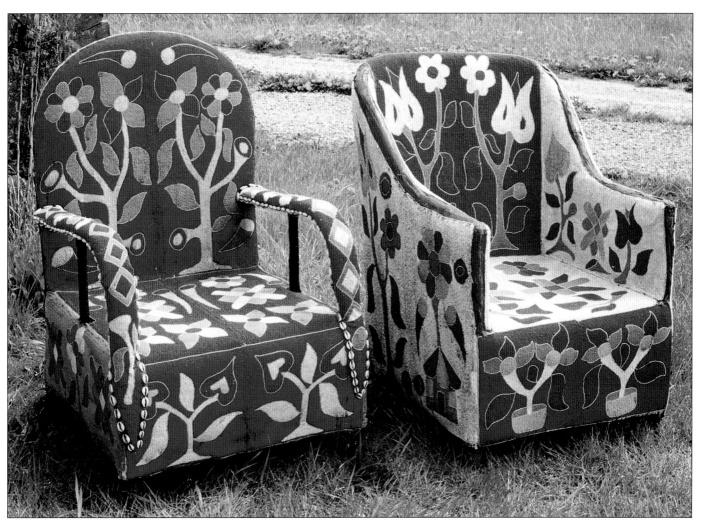

(Left) Open arm-style has blue bkgrd. on back and bottom front; red bkgrd seat and Sioux green bkgrd. sides. Abstract floral in Sioux green, white, red, and cobalt, outlined with yellow. Red bkgrd. arms have concentric diamond motifs with cowrie shell borders. 39"H x 24"W x 32"D. Est. 1000-1800 **SOLD $1250(04)**
(Right) Same chair as previous description.
　　See Drewal and Mason, p. 214, for a less spectacular example that is only partially beaded.

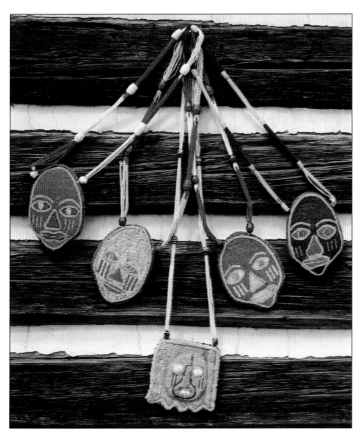

AFRICAN (YORUBA) FULLY-BEADED NECKLACES
Sewn seed-beaded oval face pendants, 6.5"H x 4.75"W. Cotton backed. Each hangs 24"L. Est. 30-75 each. (Left to right) Red face: twelve strings of white alt. with red seed beads interspersed with white large Dutch-style trade beads. White face: twelve seed bead strings in alt. red and lt. blue form necklace interspersed with seven large t. cobalt wire-wound Dutch-style trade beads. Black face: twelve strings of white alt. with red seed beads interspersed with t. cobalt large Dutch-style trade beads. (Center) Similar, but appears to be older than other pendants. Pendant is 5.5" square lt. 3-D beaded sculptural face. Seed bead nine string necklace interspersed with large t. cobalt and yellow swirled trade beads. Hangs 30"L. Est. 40-85

Yoruba Beaded Wall Hangings

Amusing, fully-beaded figural scenes in rich colors, pony-beaded, have been made in West Africa since the middle of the 20th century. Top loops are usually wrapped with black beads. Each piece incorporates large cowrie shells. (NOTE: on African pieces, cowries are mounted with **bottom opening** showing—opposite on all Native American-made items.) Lined with dark patinaed muslin and/or striped woven cotton.

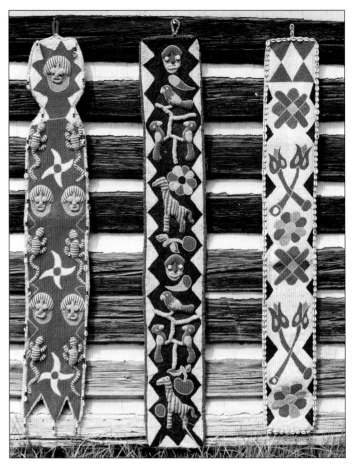

(Left to right) *Author's Collection.* Three different fully-beaded styles are shown here: 1) 3-D lizards and faces with cowrie dangles and side embellishment; 2) rectangular panel has fanciful 3-D giraffes and parrots along with 3-D faces; 3) rectangular panel with abstract floral motifs on white, bordered with cowries. All have bead-wrapped hangers. 62-65"L x 9-10"W. Est. 150-300 each

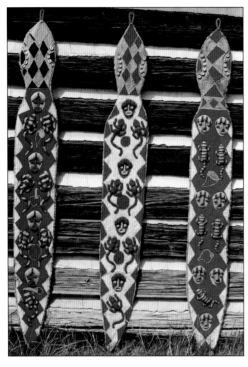

Three "snake" shaped panels each have seven small 3-D lizards and 3-D faces. Fully-beaded in red, lt. blue, black, clear, and white predominant colors. Back lined with woven striped cotton. Bead-wrapped hanging loops. 36"L x 9"W. Est. 135-250 each **SOLD $195(05)**

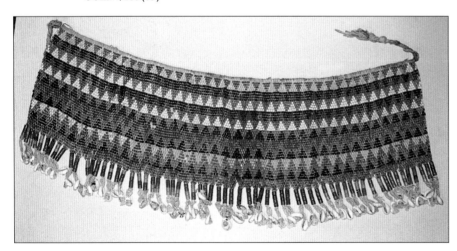

GLASS "TILE" BEAD APRON. c. 1940. *From Bentei Tribe of Africa.* These are the small 3mm tile beads that often show up on early American Indian items. They are "brick stitched" together with cord string and have dangles of larger beads (5mm) tipped with cowrie shells. Colors are various shades of blue, red, orange, yellow, and white. 25"L x 9"W. Exc. cond. Est. 80-150 **SOLD $95(99)**

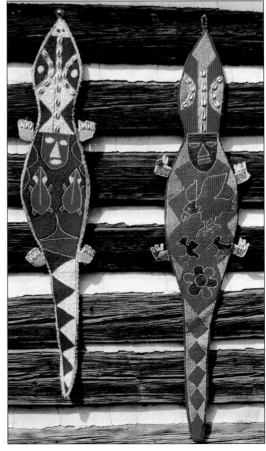

Fully-beaded lizard-shaped panels, feet embellished with cowrie "toes." 28-30"L. Est. 65-125 each **SOLD $75 each (04)**

146

7. Photo Essay: "Indianness" in the White Culture

by Preston E. Miller

A Short History of
The Improved Order of Red Men

More than three hundred years have passed since the United States was a vast wilderness inhabited mostly by red men. Only a short time, given the total history of the world, since a few hardy European colonists settled the eastern shores and learned by experience to govern themselves as a nation without a king. The story of the patriotic societies that participated in this history is directly related to and celebrated in the history of The Improved Order of Red Men.

When these colonials arrived in the New World, they found a country inhabited by a people who were the very prototype of liberty, independence, manhood, and democracy—which they were seeking for themselves. These native inhabitants were a race of people who would rather sacrifice their lives than their personal liberty. Most notable among them was the League Of The Iroquois, or Six Nations. It was this confederation of various tribes of red men whose system of government suggested to our forefathers the idea of a democratic and free government for themselves, resulting finally in the formation of our present republic.

The extravagant and unreasonable conduct of England towards the colonists resulted in the organization of secret societies throughout the colonies to resist this tyranny. Some called themselves the Sons of Tamina, after the famous Sachem of the Delawares, while the name Sons of Liberty was the general name applied to all of these patriotic organizations. All of these societies made use of Indian dress, ceremonies, symbols, and nomenclature in order to hide their identities from the uninitiated. Much of our history was influenced by the role these organizations took in the problems that led up to the gaining of independence from the mother country. It was the Sons of Liberty (Liberty Boys), Sons of Tamina, and others that eventually led to the organization of The Improved Order of Red Men.

It was these Liberty Boys that the British troops fired on at the Boston Massacre in 1770. Later, in December of 1773, after three ships bearing taxed tea arrived in Boston Harbor, these same Sons of Liberty disguised as Indians rushed down to the wharf and in a few hours threw 342 chests of tea into the Boston Harbor. History has recorded this event as The Boston Tea Party. Dressing as Indians to hide their identities from the British was not an effort by the Liberty Boys to blame this event on Indian people. Instead, since it was their custom to dress in this manner for their own secret rituals and ceremonies, why not hide their identities from the British by donning their ceremonial Indian clothing?

In David Ridgely's 1841 *Annals of Annapolis* (as quoted by Lemke, 1964), it is recorded that "In the year 1771 the Sons of Liberty adopted the title 'Sons of Saint Tamina' or 'Saint Tamina Society.' They set apart the first day of May to celebrate their patron who was the Native American Chief Tammany. In his youth, he was famed for his exploits as a hunter and warrior, and, known from beyond the Father of Waters to the Great Salt Lake where his deeds were recounted at every council fire." Chief Tammany was probably a Lenni Lenape/Delaware and lived during the first half of the 1600s. He devoted his life to the arts of peace. Legend tells us that he introduced maize, beans, tobacco, and domesticated plum trees and onions into Indian agriculture. His government was of the patriarchal kind, mild but firm. His people looked up to him as their father, and referred all their differences and disputes to him. His was a land of plenty and his people were contented and happy. Their watchword was "Tammany and Liberty."

Ridgely further states that on the first day of May, members of the society would meet and erect a May Pole decorated with wild flowers. Forming a circle, hand in hand around the pole, they performed the "War Dance" and other customs they had seen exhibited by the "children of the forest." Many in attendance wore a piece of buck tail in their hats. At a signal, members of the Tamina Society dressed as Indians would enter, singing "War Songs," giving the "Whoop," and dancing in the style of the native people.

On May 12, 1789, about two weeks after General George Washington had taken the oath of office as the first president of The United States, the organization known as the Tammany Society or Columbian Order was instituted in the city of New York. The 12th day of May was adopted as the anniversary of the order, instead of the first of May as previously celebrated by the old Saint Tamina Societies, and was celebrated by a Grand Festival on the banks of the Hudson River. Tents or wigwams were erected about two miles from New York City, the Calumet of Peace was smoked, and the tomahawk was buried. Various Indian dances and other recreations were enjoyed until the close of the day.

The society was divided into thirteen tribes, corresponding with the thirteen original states of the union. Each of the tribes was assigned a "Totem." New York was given the eagle; New Hampshire, the otter; Massachusetts, the panther; Rhode Island, the beaver; Connecticut, the bear; New Jersey, the tortoise; Maryland, the fox; Pennsylvania, the rattlesnake; Delaware, the tiger; Virginia, the deer; North Carolina, the buffalo; South Carolina, the raccoon; and Georgia, the wolf. The words "Friendship and Freedom" were adopted for the society's motto.

In the period 1789-90, a bitter dispute arose between The United States and the Creek Indians. This threatened serious consequences, and in order to reach a peaceful settlement about thirty Creek chiefs were invited to visit "The Great Father," General Washington, in New York City. "The Tammany Society, on learning of this proposed visit, and desirous to conciliate the Indians, determined to receive them with a great display of ceremony and savage pomp. The members were accustomed to dress in Indian costumes, and on this occa-

sion wore feathers, moccasins, and leggings, painted their faces in true Indian style, and sported huge war-clubs, knives and tomahawks." (Lemke, p. 170) Together they smoked the Calumet of Peace and the Indians were pleased with a speech given to them by the Grand Sachem, William Pitt Smith. Before the Indians' departure to their own territory, they entered into a treaty of peace and friendship with Washington, whom they named, "Beloved Sachem of the Thirteen Fires." Thus it may be said that a dreaded war with the Creek Indian Nation, at that time one of the most powerful, was averted and peace secured mainly through the efforts of the Tammany Society.

A similar group to the Tammany Society was the Kickapoo Amicable Association, described in the 1964 version of *The Official History Of The Improved Order Of Red Men* as follows:

> "Still another society which used the forms and ceremonies of the Indians, and which is brought to our notice under the name of the 'Kickapoo Amicable Association,' which existed in the city of Washington, D.C., in the year 1804, and which not only adopted the usages, forms, ceremonies, and costumes of the Indian race, but also gave to its members Indian names and, following the custom of the Indian race, bestowed the name of an animal or other natural objects upon them. Among the manuscripts of the 'Oldest Inhabitants Association' of Washington, Vol. 1., is a document that is a copy of the original certificate of membership issued to a member of this association named Washington Boyd, under the date October 20, 1804. The document is in a cipher, made by spelling backwards the words composing the certificate."

The *Official History* notes that the certificate reads as follows:

> "For Verbea, or The Beaver, Washington Boyd, Esq., United States of America
> To the members of the Kickapoos of Washington City, reposing due confidence in the benevolent and humanizing disposition of our beloved friend the Beaver, have adopted him and given him this in the name of our ancient and honorable fraternity according to the rules of our association."
> "J. Lamb, secretary Washington Tribe."
> "Long Live the Kickapoos"

The recorded history that connects the Improved Order of Red Men to these earlier patriotic organizations is almost nonexistent. It appears as though there was a split in the ideologies of members of the Tammany Society sometime during the early 1800s. One group, which would later become the Red Men, continued to carry on the social, ceremonial, and patriotic activities while an opposing group became the upholder of Jeffersonian politics in New York City.

Without a doubt, the seeds for the Red Men were being planted before and during the American Revolution. The idea of using the Iroquois Confederacy as a model for the government of the United States is historically documented. The wearing of Indian clothing, practicing of Indian rites and ceremonies, giving of Indian names to members, organizing into tribes, smoking the calumet or peace pipe, meeting in wigwams, identifying leaders as Sachems, etc. was a common link in the minds of potential Red Men members.

Current Red Men (I.O.R.M.) histories propose that the first organization of their order took place in 1813 at Fort Mifflin, located on an island in the Delaware River, about four miles below Philadelphia. During the War of 1812, due to an expected British invasion of Philadelphia, over seventy volunteers stationed themselves at the fort to protect the city. It was these volunteers who first envisioned and organized the Red Men. The preamble of the Red Men's Society states "at that Fort, originated the Society of Red Men; instituted not only for social purposes, but to relieve each other in sickness or distress, and in the event of battle, solemnly pledges at all personal hazards firmly to adhere to each other in defense of our country's cause." Not much is known about the activities of the newly formed order during this period of time. The earliest recorded membership list is dated 1817 and contains both English and Indian names of seventy-six members and their dates of Adoption.

The earliest record of this period is an original *Society of Red Men Minute Book* containing entries from June 25, 1822 through May 15, 1827. The current location of this book is unknown. Recorded histories from this period are sparse and may still be hidden in some attic, library, or museum. During this time, it appears as though members of existing tribes had gained the reputation of being a group of "drinkers," with a membership from the lower rungs of society's ladder. In order to overcome this negative opinion, it was decided—by members in Baltimore, Maryland—to apply to the Maryland Legislature for an act of incorporation under the name Improved Order of Red Men. The charter, organizing the Great Council of Maryland, was granted on March 14, 1838.

Following this incorporation, membership growth was a bit slow but rituals, degrees, designs for new regalia, and plans about the order's goals were being developed. In subsequent years, efforts were directed towards making the order more well known in order to attract new members. In 1847, The Great Council of the United States was organized and the Improved Order of Red Men was on its way to becoming a large fraternity, with its roots and organization completely based on American traditions. This is especially interesting since most other fraternal organizations have roots connecting them to European or biblical traditions. The Improved Order of Red Men now operates under a charter granted by a Special Act of Congress of the United States and is the only fraternity in the land to enjoy this distinction. This charter was approved on April 17, 1906, and bears the signature of President Theodore Roosevelt.

By the mid-1920s, there were tribes in forty-six states, including Alaska, the Philippine Islands, Panama, and the Hawaiian Islands, with membership totaling over one-half million. Tribes and memberships continued to be strong during most of the 1930s. Since then, the numbers have been getting smaller, which seems to follow the pattern for most fraternal organizations.

The following chart is taken from the *Ward-Stilson Regalia and Supplies catalog of 1914*. It shows the tremendous growth that took place between 1850 and 1910:

Year	Tribes	Members
1850	45	3,175
1860	94	9,096
1870	296	23,784
1880	491	27,214
1890	1078	97,164
1901	2444	217,125
1910	3904	403,723

Until about 1960, the qualifications for becoming a member of the Improved Order of Red Men included "being a white citizen of the United States, having a reputable means of support, speaking or understanding the English language, belief in a supreme being and being of sound mind and body." These qualifications are often frowned on by our present politically correct society. But, if we take into account the Revolutionary War history and origins of the early organizers, it is not difficult to understand their reasons for using these membership qualifications. As far as not allowing persons of the Indian or Native American race to become members, I do not feel this is entirely accurate. In my studies, I have uncovered various members who had or were descended from Native American bloodlines.

During the first half of the 20th century, the fraternity gave money to orphans, orphanages, and wives of deceased members, purchased ambulances and equipment for hospitals, and paid funeral expenses for deceased members. In my collections of Red Men material, there are many letters and records from children, mothers, and members expressing their gratitude for checks they received from the Red Men. This is especially evident during the years of the Great Depression in the 1930s. "If every citizen of the United States were a member of the Improved Order of Red Men there would be no need of Orphan Asylums anywhere in this country." This quote, taken from a 1933 Red Men Centennial brochure, makes an important statement concerning membership in the I.O.R.M.

Many more pages could be written about the history and success of this fraternity, but, in order to move forward into the purpose of this section—which is to illustrate the many items from the Improved Order of Red Men that are currently available to the collector—I am going to leave the rest up to your research and recommend the following books and website:

Davis, Robert E. *History Of The Improved Order Of Red Men And Degree Of Pocahontas, 1765-1988*. Waco, Texas: Davis Bros. Publishing Co., Inc., 1990.

Litchman, Charles H. *The Official History Of The Improved Order Of Red Men*. Compiled by The Great Council of the United States. Boston, Mass.: The Fraternity Publishing Company, 1893. (The same book was reprinted by Davis Bros. Publishing Company in 1964; new editor was Carl. R. Lemke.)

Ridgely, David. *Annals of Annapolis*. Baltimore, Maryland: Cushing and Brothers, 1841.

The Improved Order of Red Men website: www.redmen.org

Red Men Collectibles

As I think back in time, I realize that I first began collecting items from the Improved Order of Red Men as a teenager in the late 1950s. I started collecting American Indian items when I was eleven years old and numerous Red Men items found their way into my collection. I remember purchasing some very nice beaded leather costumes for $5.00 each and selling them for $25.00 each. This was quite a profit for a young entrepreneur.

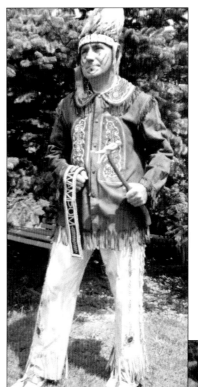

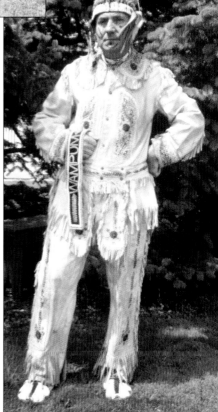

Photos of my father, Preston E. Miller Sr., wearing costumes that I purchased for $5.00 about 1958.

149

Years went by and I never gave much thought to these items as collectibles. It wasn't until about 1999, when I was becoming a bit wary of the increasingly higher prices that genuine Indian collectibles were fetching, that I began searching for related collectibles that hadn't reached their peak. On eBay, I noticed the large variety of Improved Order of Red Men items that were being offered for sale. Most of these were selling for under $50.00. After I did some background study on the history of the fraternity—and with the realization that there was a large variety of items available—the search was on! I was hooked. If, like me, you are looking for fun items to collect that are still reasonably priced, here they are.

Items are available everywhere. You will find them at flea markets; antique shops, malls, and shows; yard sales; and yes, don't forget eBay. The fun part is that when you ask most sellers about their offering they reply, "I think it's from the Red Men but I don't know anything about them." This makes it a buyer's market. But, take my word for it, don't wait too long to start your collection as I have noticed a growing increase in the number of collectors just since I began mine. As far as I know, the following section will be the first price guide ever printed on this subject and it should encourage more price guides, more collectors, and higher prices. So enjoy the following illustrations and price suggestions, but beware, this is only the tip of the iceberg. Remember, the fun is in the search! Happy hunting.

Photographs and Postcards

Photo of Improved Order of Red Men degree team. Members wearing Indian costumes were chosen to confer degrees, adoptions, and perform other rituals. The fellow in the white outfit is the Prophet, while others were named Sachem, Jr. & Sr. Sagamore, Sannaps, Warriors, Braves, Scouts, and Guard of the Wigwam. Notice that several members are holding war clubs, tomahawks, hunter and scalping knives, bows and arrows, and spears. These are indicative of their rank in the degree team. The three men in the front are wearing genuine Iroquois Indian made moccasins. Iroquois Indians did the beadwork on many of these early Red Men suits. Est. 125-200

See Iroquois Whimsies, page 82, for more information.

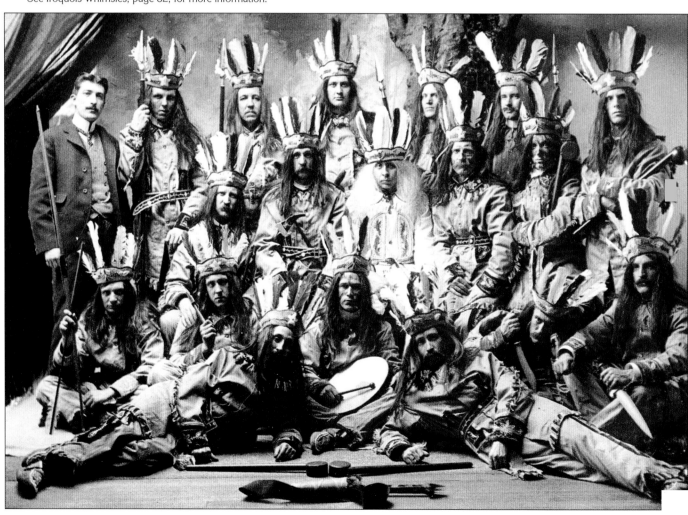

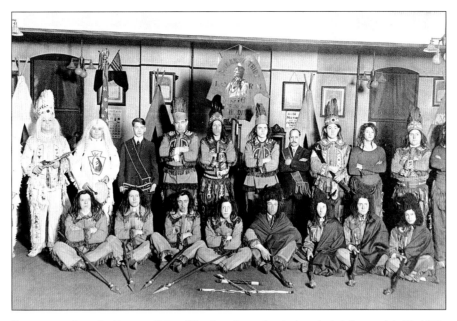

Degree team from the Manangy Tribe of Reading, Pennsylvania, in a photo taken on July 25, 1903. They are holding weapons of their rank and the Prophet is wearing a white costume and holding the Peace Calumet (pipe). Est. 75-125

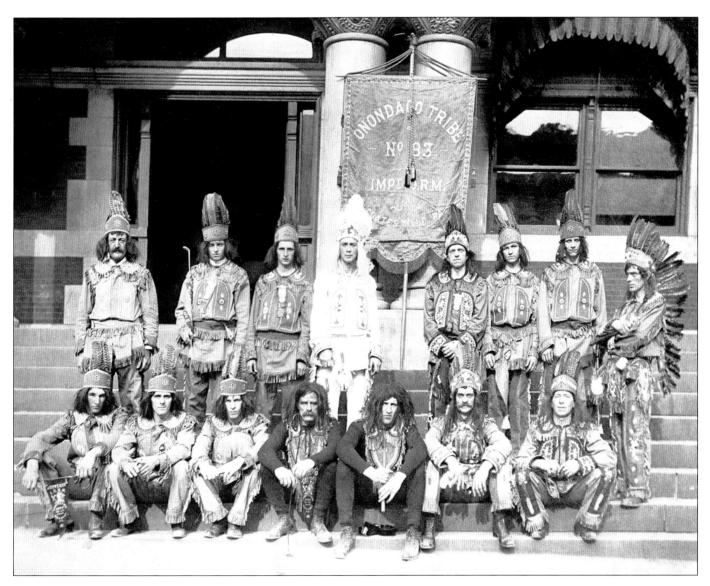

Degree team from the Onondago Tribe #93 of Coatesville, Pennsylvania. The member sitting on the far left is holding a souvenir pennant dated Jun 14, 1910. Est. 75-125

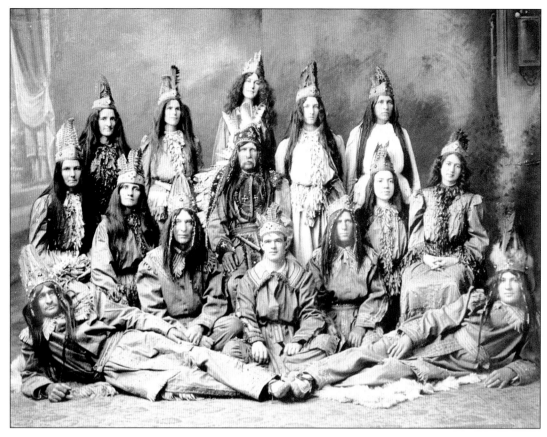

Red Men and Degree of Pocahontas members from a tribe in Hanford, California. The D. of P. was instituted as a way for female relatives to participate in the I.O.R.M. This idea was first introduced at the Great Council of 1854 with a resolution to establish the Daughters of Pocahontas, but it wasn't until 1887 that women were officially accepted within the institution as a female auxiliary to be known as the Degree of Pocahontas. This is a very handsome group with the two relaxed members in the front wearing genuine Iroquois Indian moccasins. Est. 100-175

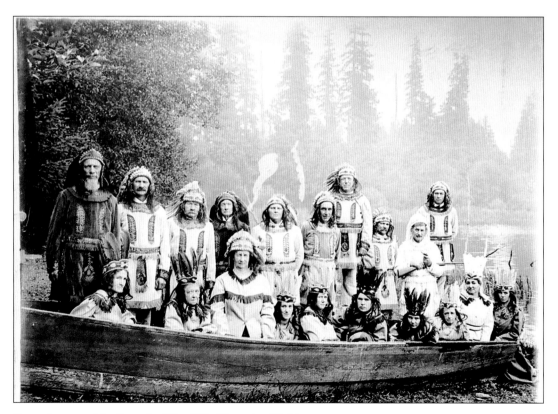

Men and women of the Enumclaw Tribe #35 of Enumclaw, Washington, posed for this picture while sitting in an old beached wooden boat. This photo was from the estate of Fred Bowler, who was a Past Sachem of this tribe. Photo dates from about 1910. Est. 45-75

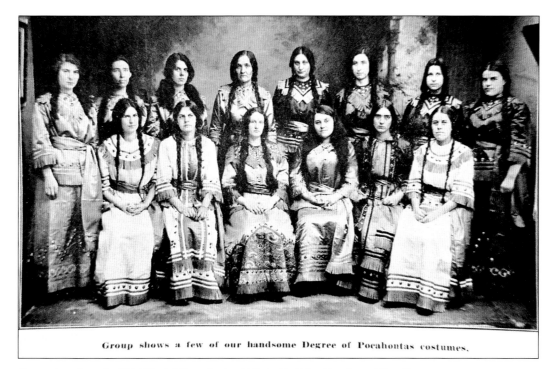

Group shows a few of our handsome Degree of Pocahontas costumes.

Group photo from the 1914 *Ward-Stilson Co. Imp'd Order Red Men Regalia and Supplies Catalog* showing a selection of costumes they made for the Degree of Pocahontas.

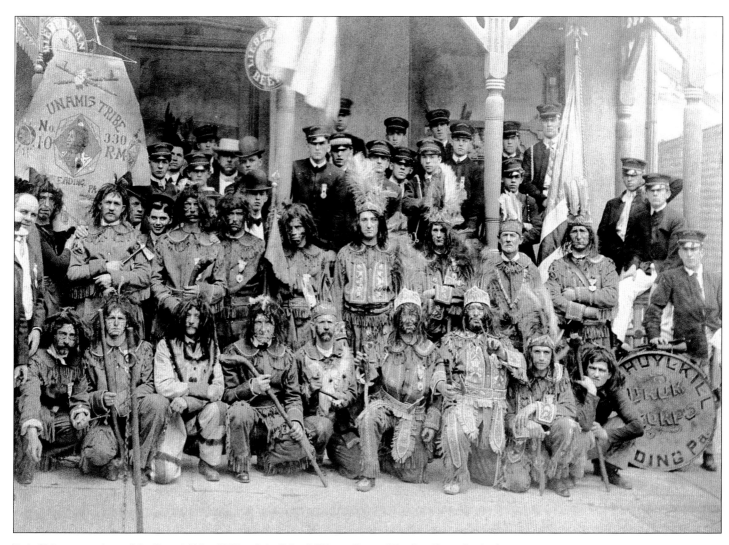

Early 20th century photo of the Unamis Tribe #330 and the Schuylkill Drum Corps of Reading, Pennsylvania. Appears as though they are about to march in a parade. Many are wearing ribbon style souvenir badges. Est. 100-175

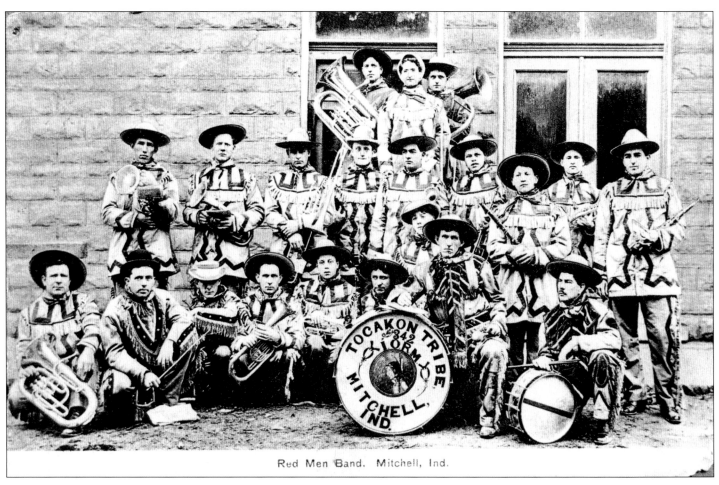

Red Men Band. Mitchell, Ind.

Photo postcard of the Red Men band from the Tocakon Tribe #342 of
Mitchell, Indiana. Dated 1914. Est. 40-60

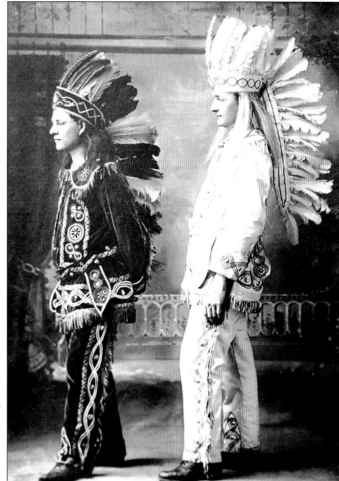

Two Red Men proudly posing to show off their new Indian costumes. Prophets wore the white costumes. Photo by Moor of Vandergrift, Pennsylvania. c.1910? Est. 75-125

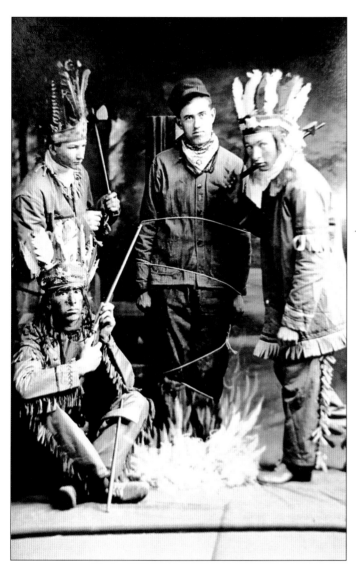

Photo postcard of a "paleface" being inducted into the Improved Order of Red Men. He is being symbolically tied and burned at the stake. Following a ritual ceremony, he will be untied, given an Indian name, and his pale-face-ness will be replaced by becoming a Red Man. c.1915? Est. 75-125

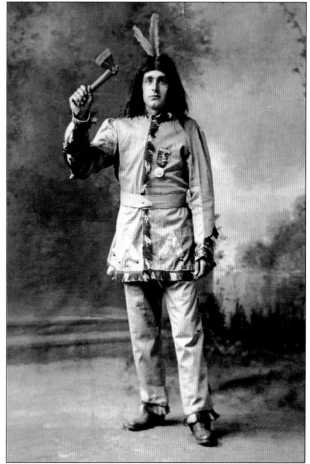

Photo by Rise Gates of Lebanon, Pennsylvania, showing a Red Man with a souvenir badge pinned to his costume. c.1910? Est. 45-65

Sometime in the early 1900s, this little girl had her photo taken with a Red Man. He is wearing a beaded costume and genuine fully-beaded Sioux Indian moccasins in this photo postcard. Est. 20-40

Early tintype of a Red Man. No identification, but probably dates before 1890. Rare. Est. 100-175

Photo postcard of Red Men from Ohio wearing their Regalia Sashes. These were worn for parades and funerals. A member's degree emblem was sometimes on the sash, as can be seen on the fellow standing third from left. To the right is a member with an armful of extra sashes for late arriving members to wear. c.1912. Est. 20-35

Parade and Funeral Badges

These badges usually have the name of the tribe and the city in which it was located printed on the pin or ribbon. They are trimmed with gold bullion fringe and the back ribbon is black so the badge can be reversed for use at funerals.

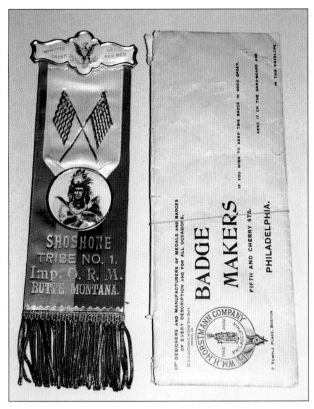

Rare badge from the Shoshone Tribe #1 of Butte, Montana, with original paper envelope from the *Wm. H. Horstmann Co.* of Philadelphia, Pennsylvania. Mint condition. Est. 125-250

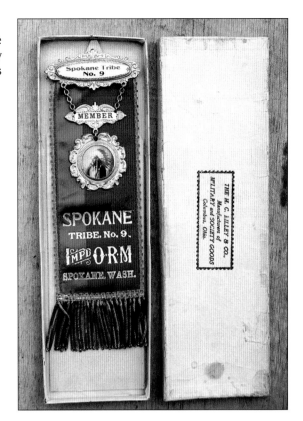

A triple parade and memorial badge with its original box. Described in the *DeMoulin Bros. Catalog* for 1922 as "a parade and a memorial badge; also a metal jewel all combined in one handsome badge. It may be worn either on parade or in wigwam." The back side is black with silver printing. Upper part is celluloid and contains the name and number of the tribe. This one is from the Spokane Tribe of Spokane, Washington. Items from western tribes are more difficult to find. Has gold bullion fringe and sold for $10.70 per dozen in 1922. Mint condition. Est. 125-200

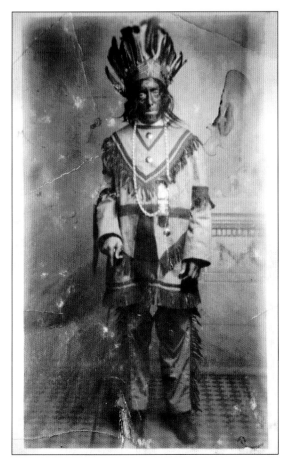

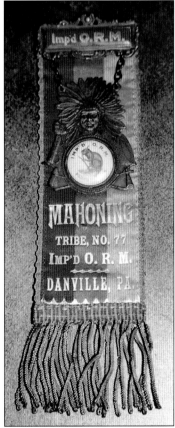

This badge, from the Mahoning Tribe #77 of Danville, Pennsylvania, was collected along with a photo of it being worn by its unidentified owner. It was made by *The Whitehead & Hoag Co.* of New Jersey. Est. for lot 125-200

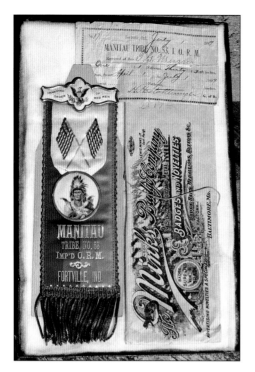

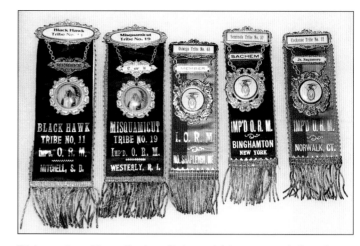

Triple parade and funeral badges. Badge on left is rare example from the Blackhawk Tribe #11 of Mitchell, South Dakota. Est. 125-200. Est. for others 85-150. All are in exc. condition.

Manitau Tribe #53 from Fortville, Indiana. With envelope from the *Minks Badge Co.* of Baltimore, Maryland. Collected with c.1899 dues receipt from same tribe. Mint condition. Est. 125-200

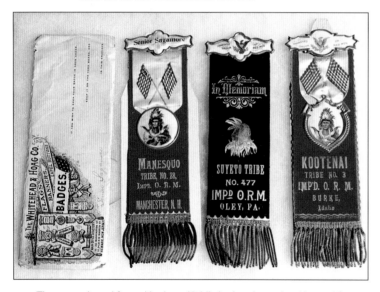

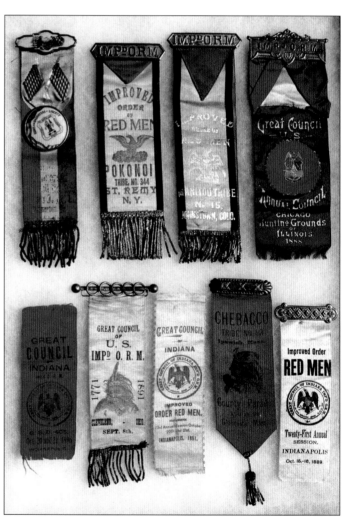

Three parade and funeral badges. Middle badge shows the side used for funerals. Badge on right is rare example from the Kootenai Tribe #3 of Burke, Idaho, with an est. of 100-175. Est. for others 75-125 each

Rare early badges dating from 1881 to 1896. Depending on intricacy and condition, the individual estimate range would be 75-250.

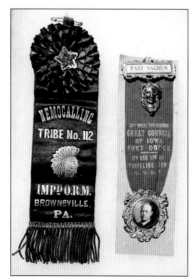

The Nemocalling Tribe #112 badge dates to the late 1800s. The other side is red and the top is a ribbon rosette with a gold metal sequin and bullion star in the center. Est. 100-175. The Past Sachem badge from The Great Council of Fort Dodge, Iowa includes a celluloid covered photo and the date *G.S.D. 416* (Great Sun of Discovery is 1492 when Columbus discovered America). Thus 1492 + 416 gives this badge a date of 1908. Est. 65-100

Souvenir Badges

I'm not sure how many different souvenir badges exist but feel it could approach the one thousand mark. Have fun hunting for them!

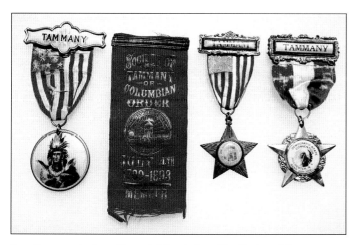

Four Tammany badges. The red ribbon is from The Society of Tammany of Columbian Order and is dated 1893. Rare, Est. 75-150. Est. for others 50-100 each

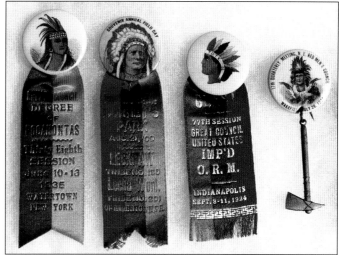

Center badge in this assortment is very intricate and large. It celebrates *"Founders week, Philadelphia, Oct. 1908."* Est. 125-200. Est. for others 20-50 each

Have You Thought of This?

The badge is often the only tangible souvenir that remains in the possession of the member who attended. Very often hundreds and thousands of dollars are spent on music, decorations, flowers, carriages, automobiles, cigars, wine and general entertainment, none of which remain in existence after the convention is over. The badge does, however, and aside from being a souvenir in itself, is a pleasant reminder of all the other good times experienced. In view of these facts, should not a committee give special attention to the selection of a badge that is worthy of the occasion? In view of the large sums of money that go up in smoke, should a committee allow the matter of a few cents to stand in the way of obtaining a suitable badge?

Whitehead & Hoag Co. badge with attachment card. On reverse of card is an explanation about the importance of pins to fraternal organizations. Est. 25-65

Celluloid pins with ribbons. Est. 10-25 each

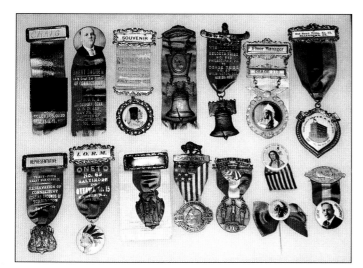

Assortment of ribbon type badges. Variations seem unlimited. Est. range 20-50 each

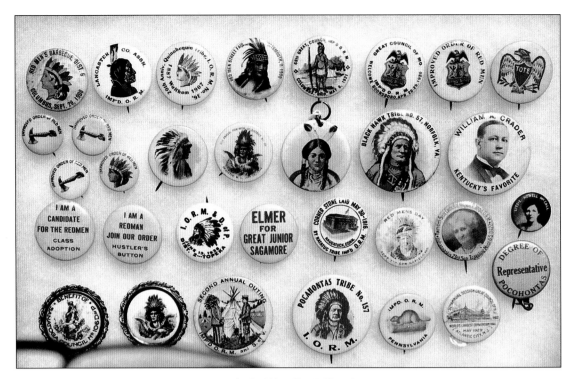

A small selection of the many celluloid pins made for Red Men. Est. 5-50 each

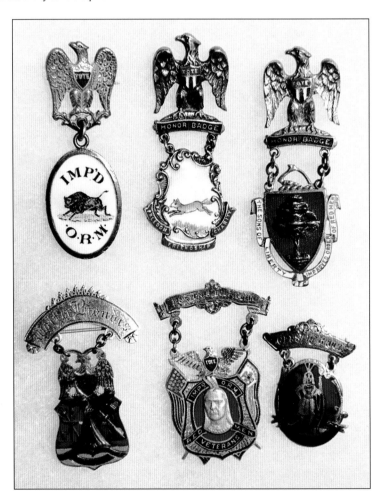

Special presentation badges. Top right is one of the few that includes names for both the Sons of Liberty and the Improved Order of Red Men. Center bottom is a Veteran's badge that was presented to members who belonged for 21 consecutive great suns (years). These most always have the owner's name engraved on them. The design for this badge was adopted by The Great Council in 1892. Bottom left is the official Red Men "badge or totem" adopted in 1871. Bottom right is the official badge for the Degree of Pocahontas that was adopted by the Great Council of 1884. Est. 50-95 each

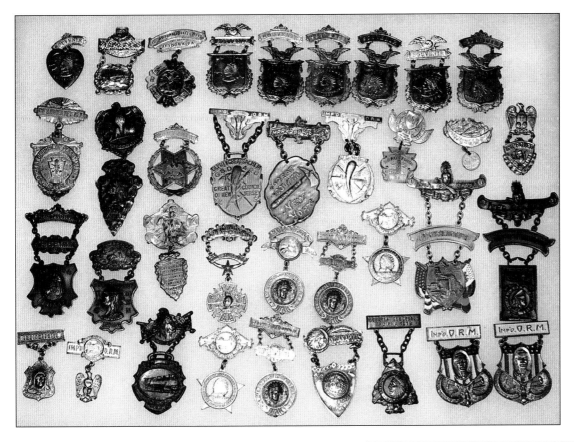

Assortment of metal souvenir badges. Most are made from two and three parts with many variations. Est. range 10-45 each

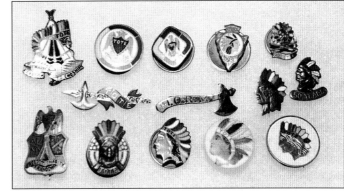

Sample of the many varieties of lapel pins worn by Red Men. Est. 10-35 each

Past Sachem Badges

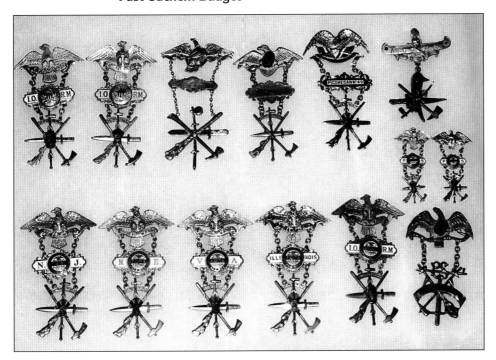

Past Sachem badges. Many have the owner's name engraved on the back. Some versions have the initials of the state in which the tribe was located as part of the enameling. Est. 50-125 each

Miscellaneous Collectibles

The following items are only a sampling of the many and varied items produced for the I.O.R.M.

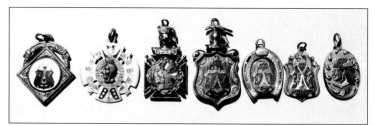

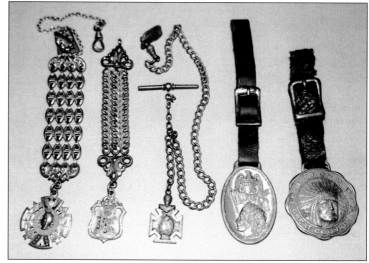

A sampling of the many available pocket watch charms (fobs). Many are gold fill with enamel decoration. Est. 20-55 each

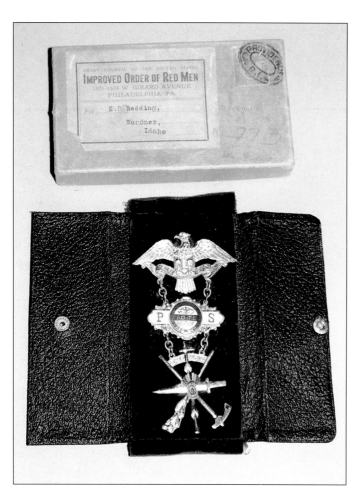

Past Sachem badge with leather carrying case and original cardboard mailing box. Est. 100-175

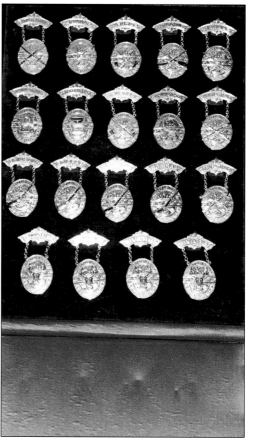

Complete pocket watch fobs. Est. 20-100 each

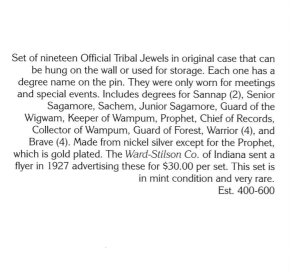

Set of nineteen Official Tribal Jewels in original case that can be hung on the wall or used for storage. Each one has a degree name on the pin. They were only worn for meetings and special events. Includes degrees for Sannap (2), Senior Sagamore, Sachem, Junior Sagamore, Guard of the Wigwam, Keeper of Wampum, Prophet, Chief of Records, Collector of Wampum, Guard of Forest, Warrior (4), and Brave (4). Made from nickel silver except for the Prophet, which is gold plated. The *Ward-Stilson Co.* of Indiana sent a flyer in 1927 advertising these for $30.00 per set. This set is in mint condition and very rare. Est. 400-600

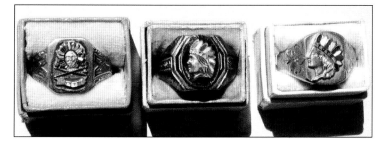

Gold and silver Red Men rings. Est. 25-95 each

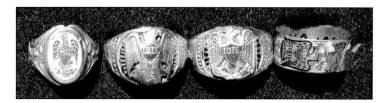

Gold rings with I.O.R.M. emblematic designs. Est. 50-125 each

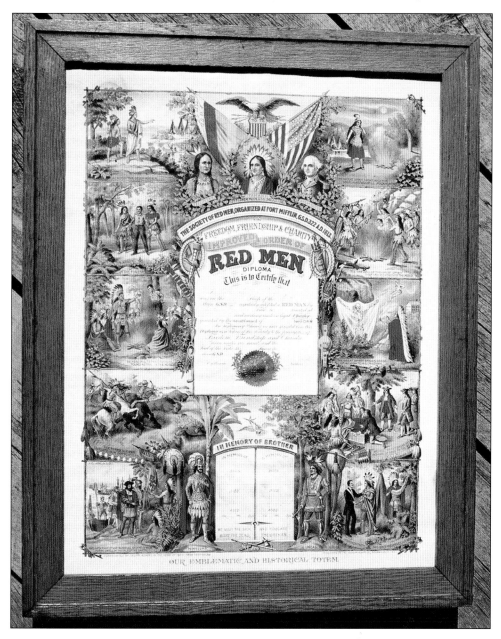

Large lithographed Red Men membership certificate documenting the member's name, tribe, and date of adoption. These are very attractive and full of symbolic meaning. In excellent condition with original frame. Est. 100-200

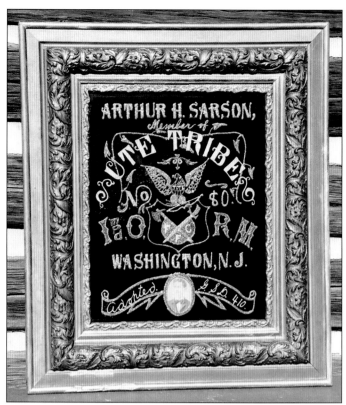

Individual membership certificate, reverse painted on glass with member's photo at bottom center. Est. 100-200

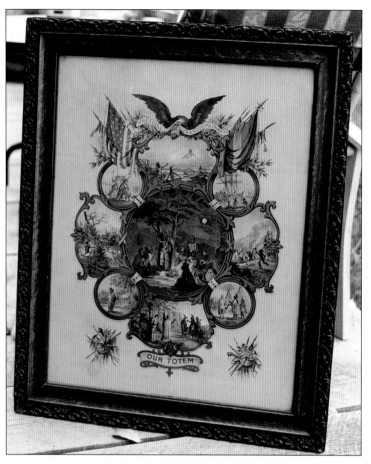

Lithographed totemic print titled *OUR TOTEM*, attractive and rare with symbolic illustrations. Est. 150-250

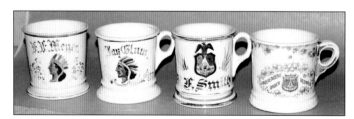

Red Men porcelain mugs. They are often trimmed in gold leaf and include the owner's name. Examples showing Indian's head are scarce. Est. 50-150 each

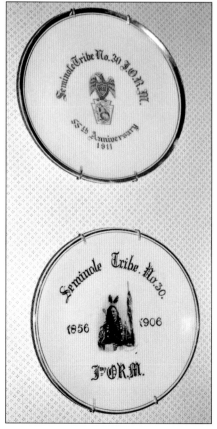

Souvenir plates issued by the Seminole Tribe #30 to celebrate their 50th and 55th anniversary years. Top plate is from 1911 and marked *Limoges, France.* Bottom plate is dated 1906. Est. 25-60 each

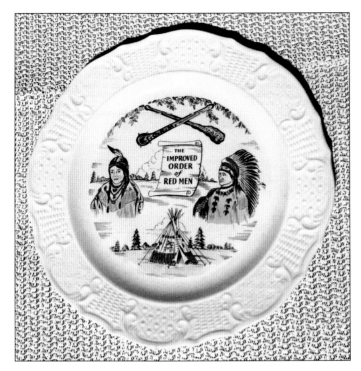

100th anniversary plate from the Red Men of Delaware. Est. 35-50

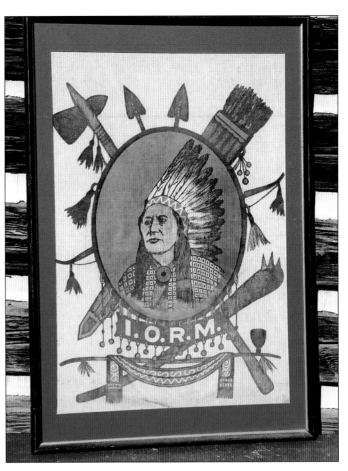

I.O.R.M. banner printed on cloth, c.1930s. Est. 40-100

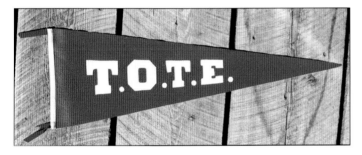

"T.O.T.E." souvenir pennant. This is the totemic phrase that binds members of the Red Men together. It stands for "Totem of The Eagle." Est.15-35

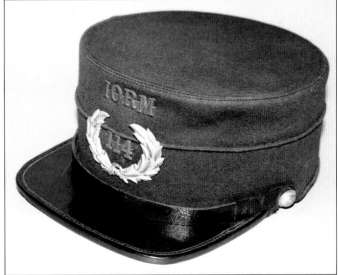

Red Men military style band cap with I.O.R.M. badge, gold wreath, and tribe #114, c.1900. Est. 125-200

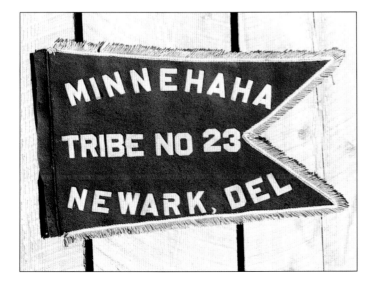

Tribal flag made from felt with cotton fringe, c.1930s. Est. 25-75

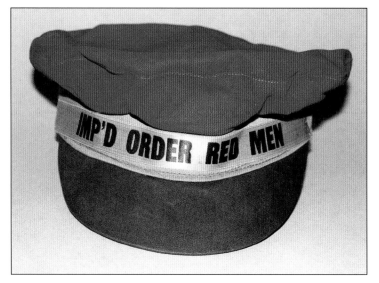

Red Men souvenir cap, c. 1930s. Est. 30-50

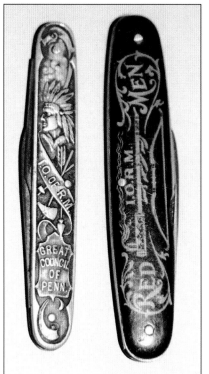

On right is a double bladed nickel silver pen knife, reading *"Great Council of Penna., I.O.R.M."* Opposite side is embossed Liberty Bell, Independence Hall, and the word *"Philadelphia"* with the date 1918. Est. 75-150. Knife on left has celluloid sides showing Red Men and I.O.R.M. emblems. Est. 60-125 each

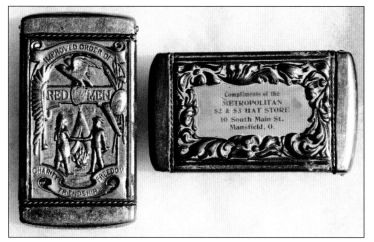

Nickel silver Red Men match safe embossed with Art Nouveau motif which includes Improved Order of Red Men name, eagle T.O.T.E. design, the words *Freedom, Friendship & Charity (F.F.&C.)*. Also shows a white man and Indian shaking hands over a campfire in front of a wigwam (tipi). Some have this design on both sides while others provide a celluloid covered space for owner's name or advertising on the reverse side. Est. 100-175

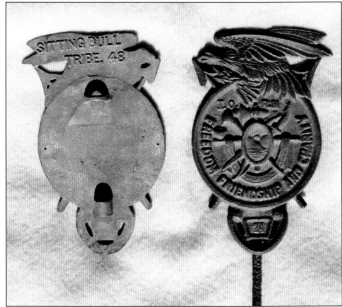

Cast iron I.O.R.M. grave marker. Back is marked *"Sitting Bull tribe #48."* Est. 35-65

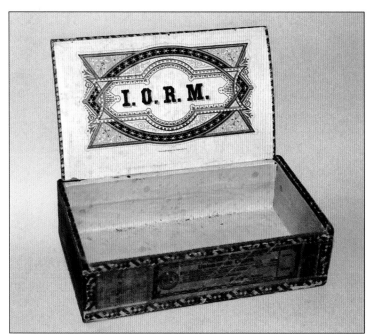

I.O.R.M. wooden cigar box, c.1920s. Est. 50-125

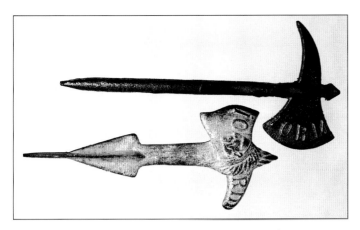

Cast iron I.O.R.M. tomahawk markers. Probably used to mark graves. Est. 40-75 each

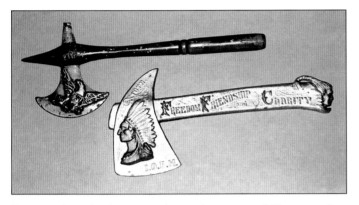

These metal tomahawks appear to be cast from pot metal. The top one is for symbolic use and the bottom is for wall hanging. Est. 40-85 each

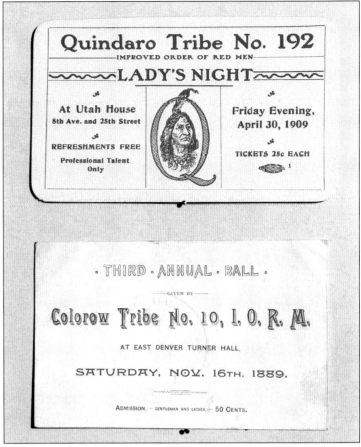

Admission tickets to Red Men events. Be sure to read these because they are very interesting. Notice the bottom one is for the year 1889. Est. 5-15 each

1906 program invitation from Chinclaclamoose Tribe #401 with colored and embossed cover. Red Men tribes held lots of social events and often printed attractive invitations. Collecting them is fun and interesting social history. Est. 15-50

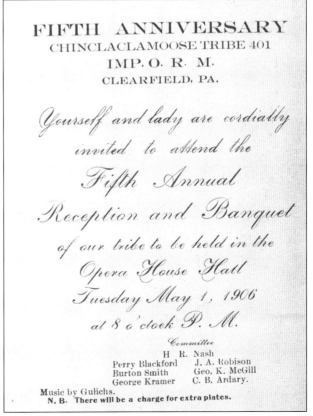

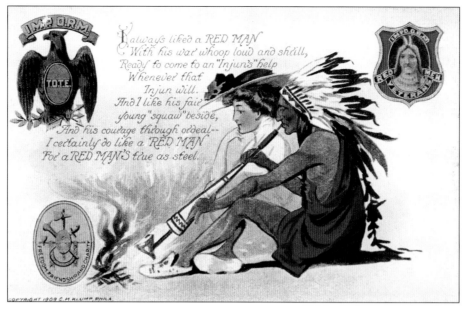

"I always liked a RED MAN" postcard, c. 1909 by C.M. Klump, Phila. Est. 15-35

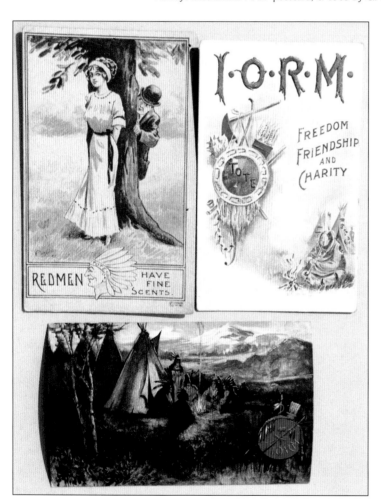

Three Red Men postcards. Postmarks are 1907 to 1910. Est. 5 to 20 each

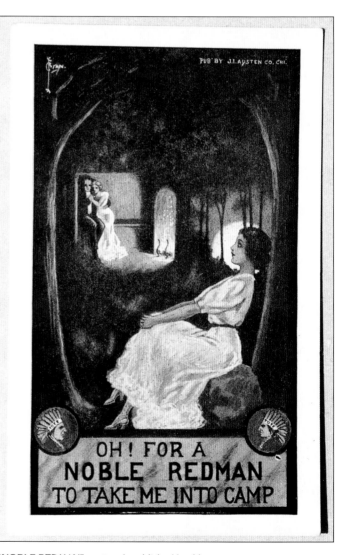

"NOBLE REDMAN" postcard, published by J.I. Austen Co., c. 1910. Est. 10-20

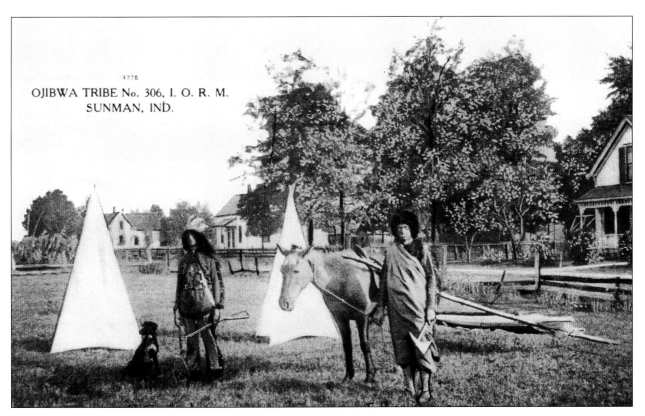

Photo postcard from Ojibwa Tribe #306. Many different photo postcards are available from the years 1900 to 1930s. Most have an est. range of $5 to $100, depending on image and condition.

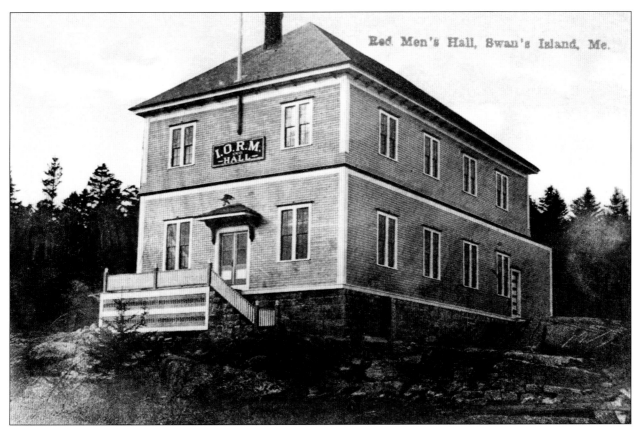

"Red Men's Hall" color tinted photo postcard, postmarked 1921. Est. 5-20

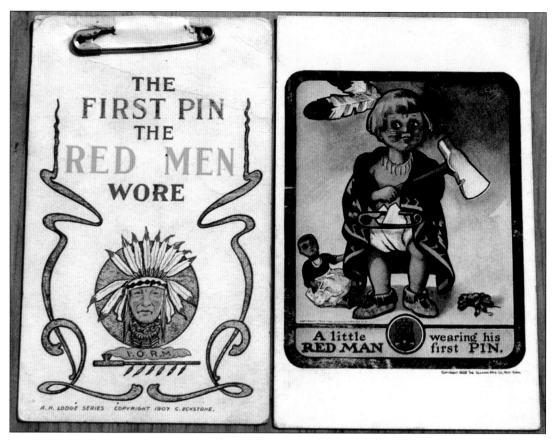

"A Red Man's First Pin" postcards. Two humorous cards lampooning the fact that Red Men are prolific pin wearers. Est. 10-20 each

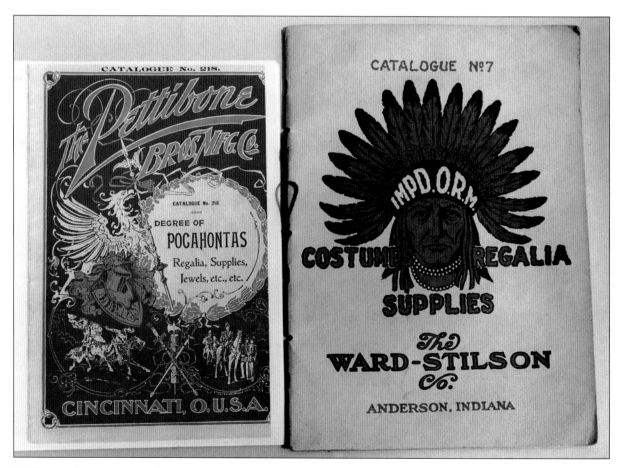

Red Men supplies were available from companies that listed their merchandise in fully illustrated catalogs. Catalog on the left is the *Pettibone Bros. Mfg. Co., Degree of Pocahontas Regalia, Supplies, Jewel, etc.* catalog from the late 1890s; on the right is *The Ward-Stilson Co.* catalog for 1927. Est. range 50-200

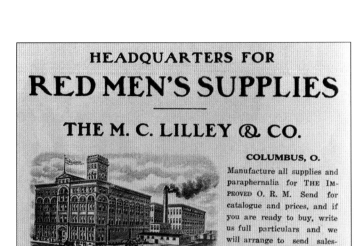
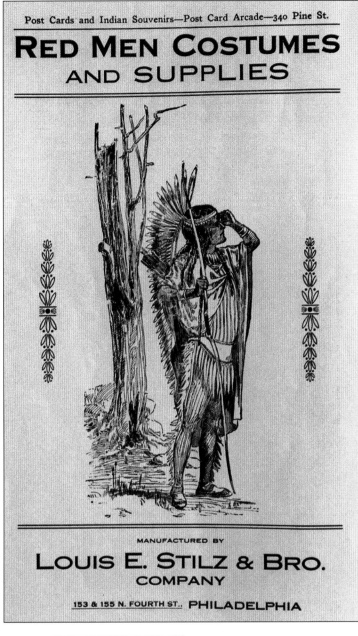

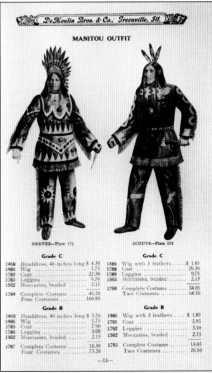

1922 *DeMoulin Bros & Co.* Red Men goods catalog and sample page showing costumes. Catalogs are scare but worth the hunt because they are loaded with information. Est. 75-150

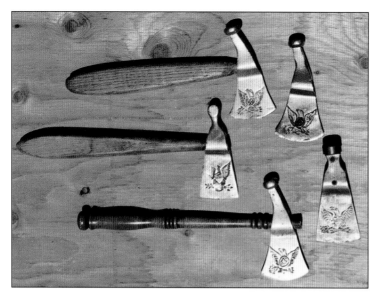

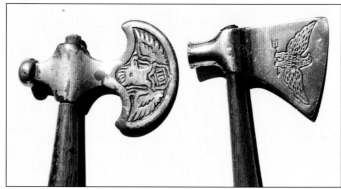

Red Men metal tomahawks are easily identified by the eagle totem with the initials *T.O.T.E.* stamped or molded into the blade. Many variations are available made from iron, nickel silver, brass, nickel plated brass, and aluminum. They are more desirable with their original wooden handles. Est. range 25-150 each

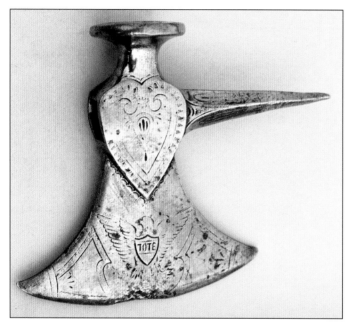

Engraved nickel silver tomahawk head with unusual dagger point at the front end. Other side is equally engraved, including the name Winnemucca Tribe #61. Est. 50-95

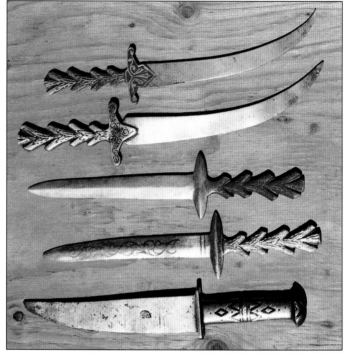

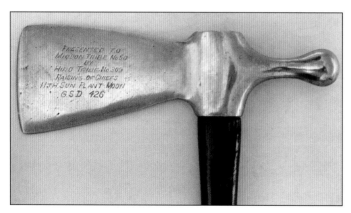

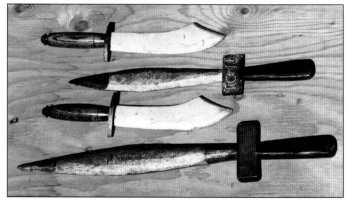

Brass presentation tomahawk dated *"G.S.D. 426"* (1918). Est. 60-150

Ceremonial Red Men knives are available in nickel silver, nickel plated brass, gold plated, and wood. Hunter's knives have a straight blade and scalping knives have a curved blade. Many have rustic handles. Metal est. 15-75, wood est. 5-45 each

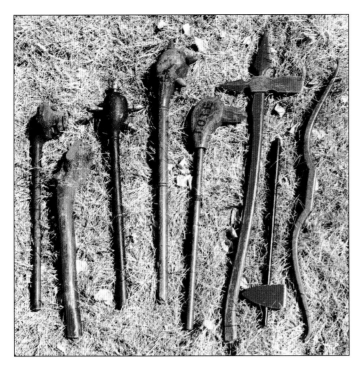

The Red Men used many types of weapons in their rituals. Most are symbolic rather that serviceable. They include clubs, bows, arrows, tomahawks, and spears. Prices vary according to condition, size, and how elaborately they are made. Est. 25-175 each

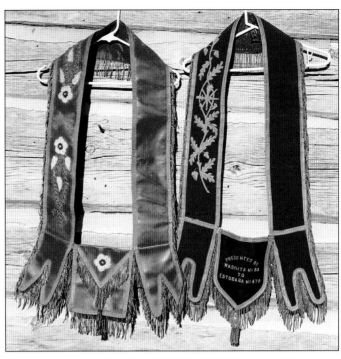

The Regalia of the Red Men is a sash 4-1/2" wide with an emblematic pouch attached that is trimmed and embellished according to its user's degree. These two Regalias are very fine examples. Both are completely trimmed with gold bullion fringe. The one on the left is a Past Sachem Regalia beaded on red leather. On the right is a presentation Regalia with a hand embroidered design in gold bullion and a fancy gold bullion tassel hanging from the pouch. Est. 150-350 each

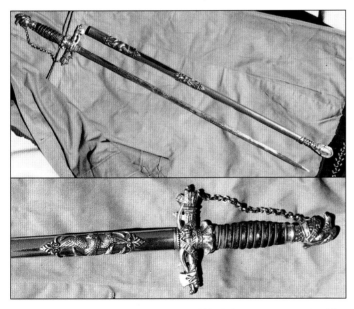

Between the years 1887 and 1918, the Red Men's League was organized for members preferring to wear military style uniforms. Most tribes chose a colonial style uniform complete with a tri-corner hat and sword. The swords are very nice, and today, difficult to find. I have collected three and each is a little different from the other. The most identifiable feature of a Red Men sword is the design on the cross guard. There is a war bonnet pattern where the leather covered grip attaches and on either side of the bonnet are an arrow quiver and a tomahawk. At the bottom of the guard is a bow. At the top of the handle there is an eagle sitting on a knight's helmet. The nickel plated sheaths are decorated with nickel plated cast eagles, crossed tomahawks, and—on one I own—the full figure of an Indian holding a tomahawk. The blades are usually etched with a member's name and sometimes tipis, canoes, tomahawks, quivers, or scalping knives. Swords are among the more desirable Red Men collectibles. Est. 300-800 each

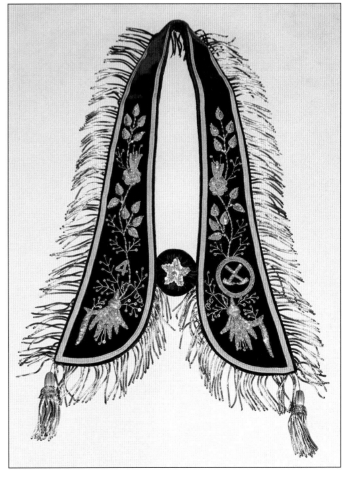

Purple velvet Degree of Pocahontas collar decorated with gold bullion trim. Made by *Fuller Regalia & Costume Co.* of Worcester, Massachusetts. Original printed tag on back is dated 1932 and identifies the owner as Mary Loke of Osceola Council No. 4. Complete with original box. Est. 85-150

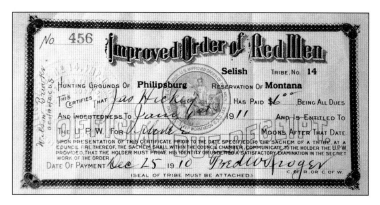

Dues payment receipt from the Selish Tribe of Philipsburg, Montana, dated 1911. Est. 2-6

Three editions of *The Official History of The Improved Order of Red Men*. Contains information about Red Men history, Great Councils, biographies of prominent members, rules, degrees, tribes, phraseology and lots more. Est. 20-75 each

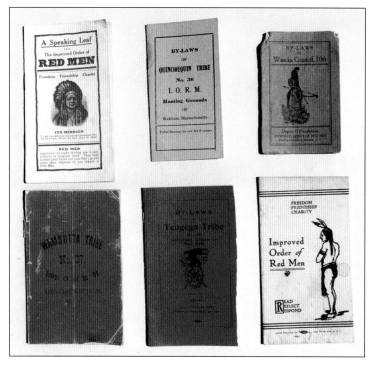

Rules, By-Laws, and information books abound and are easily collected. Est. 2-15 each

Leather bound deluxe editions of *The Official History of The Improved Order of Red Men*. These were printed by The Fraternity Publishing Co., Boston. The red copy was printed in 1893 and the blue in 1909. Est. 75-150 each

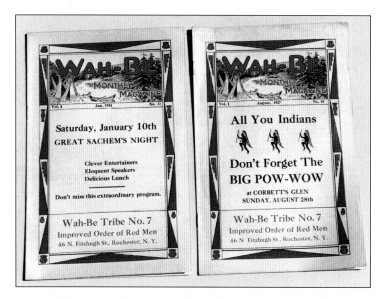

The *Wah-Be*, monthly magazine of the Wah-Be Tribe #7 of New York, is an example of a large number of similar publications printed by the Red Men. They contain lots of interesting information about Red Men history and activities. Est. 5-12 each

Red Men Costumes

Most Red Men tribes owned sets of Indian costumes that they purchased from catalogs sent by numerous fraternal and Red Men supply companies. These catalogs often listed and illustrated thirty or more varieties. Different designs were called by names like Iroquois, Mohican, Pawnee, Pueblo, Arapahoe, etc. The costumes were made from khaki cloth, heavy duck, poplin, silk-finished velvet, leather, silk plush, etc. Decorations were applied using beads, braid, metal concaves (discs), yarn and silk embroidery, ribbon, sequins, hair, buttons, etc. The construction was usually performed in the supply company's factory. Some of the beading was done by Indian people and sent to the factory, where it was sewn onto the costumes. There are some existing photos of a Seneca Indian family doing this beadwork in their New York tenement in the early 1900s. See Iroquois Whimsies, p. 82.

The Siegman & Weil Company, an early supplier of Indian costumes, was located in New York City. They were in business from 1890 to about 1920. In catalog No. 10, dating sometime before 1912, they state: "In issuing this catalog we wish to call attention to the fact that the goods herein represented are the handiwork of genuine American Indians. We have endeavored to make the photographic reproductions

represent the goods exactly as they are, showing the characteristic Indian designs in the beadwork. We would also state that we are prepared to furnish on short notice Indian Costumes of any style not here represented." In this catalog, they describe themselves as suppliers for theatrical, masquerade, and secret society purposes. (Personal communication and copy of catalog from Peter Corey, 2001)

The William J. Dinsmore Co. of Boston, Massachusetts was established in 1887. Their catalog No. 15 is titled *Manufacturing Dealers in Imp'd Order of Red Men Costumes, Regalia, and Degree Furnishings*. This catalog states: "To Our Patrons. In compiling this list we have illustrated only such articles that have been generally accepted as the correct style of goods of this nature, and from the fact of manufacturing these goods in our own work-rooms, and by native workmen, we are enabled to execute at short notice every conceivable style of these goods." The illustration here shows the Dinsmore company's Iroquois moccasins, which were made by native workers and sold to Red Men tribes. Many early photographs include members wearing these Iroquois moccasins. These were made from commercially tanned leather and today are found in many museums and private Indian collections.

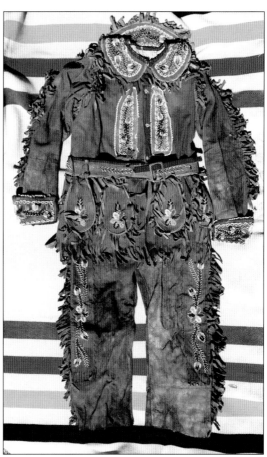

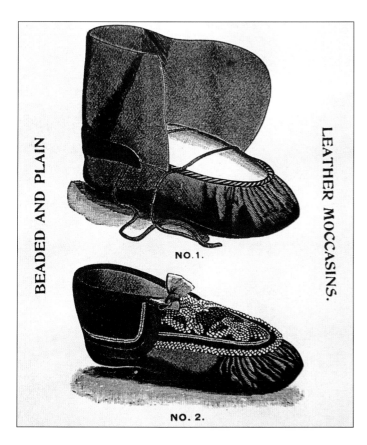

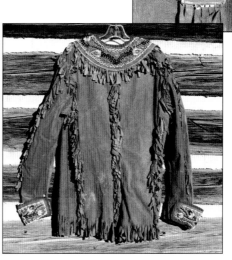

Brown commercial leather costume decorated with size 8° pony/pound beads. Consists of collarette and shirt, pants (leggings), and belt with beaded tabs. Beaded leather costumes were considered the top of the line. Est. 300-600

Today, many collectors, dealers, and museums mistake these costumes as clothing made for use in Wild West shows. Even though some of these ended up being used by shows, and even Indians, their original purpose was to supply the Improved Order of Red Men. The following are some examples from the many styles that were being made. All estimates are for costumes in very good to excellent condition.

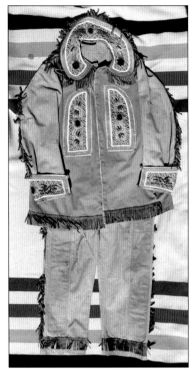

Costume made from cotton duck with size 8° beaded decoration. At the neck is the original label identifying the maker as *Louis E. Stilz & Bro.* of Philadelphia. Est. 125-300

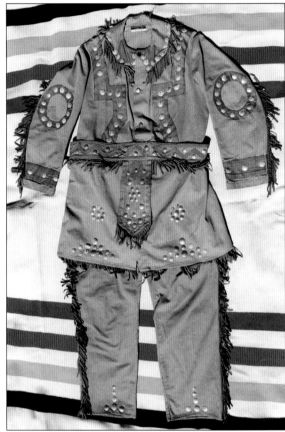

Costume made of cotton duck with maker's label from *The Cincinnati Regalia Co.* of Ohio. It is decorated with leather fringe, blue cloth ribbon, and nickel concaves (discs). Label also denotes it was made for use by a member of the Warriors Degree. Est. 100-250

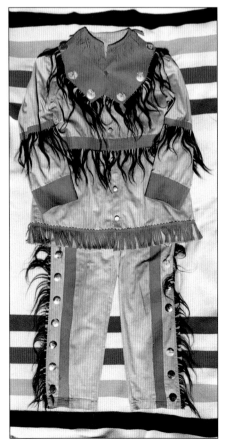

Brown poplin costume with maker's label from *DeMoulin Bros. & Co.* of Greensville, Ill. Decorated with leather fringe, hair (human?), and gilt colored concaves (discs). Est. 100-250

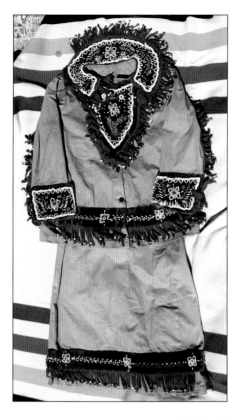

Degree of Pocahontas costume with collarette, blouse, and skirt made from brown poplin cloth. The size 8 beading is done on scarlet silk finished velvet. Red leather fringe is strung with colored glass beads. Women's costumes are scarcer than the male versions. Est. 300-600

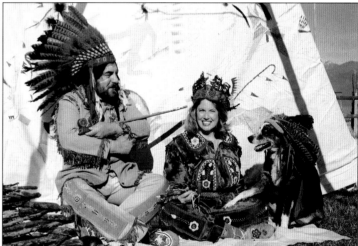

The authors are shown wearing Improved Order of Red Men suits made by the *Louis E. Stilz Company* of Philadelphia, Pennsylvania. Carolyn's suit is made from beautiful green velveteen. Both suits have leather fringe and Iroquois beadwork in size 8° beads. The green headdress Preston is wearing came with Carolyn's suit. Preston is wearing a genuine old pair of beaded moccasins that were made by Iroquois Indians for sale to Red Men organizations. Brownie is wearing a Red Men headdress made from dyed turkey feathers.

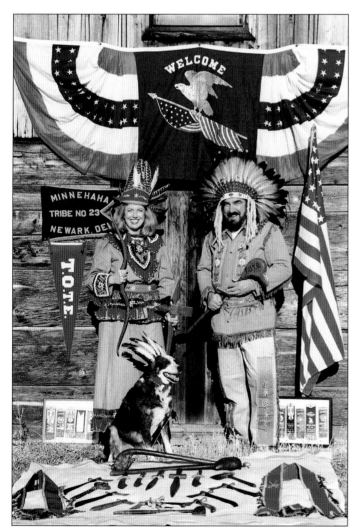

The authors are wearing Improved Order of Red Men suits and surrounded by Red Men items from their collection. Both suits are made from khaki canvas with leather fringe and Iroquois beadwork done in size 8° beads. Preston's suit was made by the *Louis E. Stilz Company* of Philadelphia, Pennsylvania. Carolyn's blouse and skirt were used by the women's branch of the Red Men called the Degree of Pocahontas. The maker of this suit is unknown. Carolyn is holding a wooden bow and tomahawk with a spearhead tip. Preston's wooden club has the Red Men symbolic code word *T.O.T.E.* painted on the head. Their dog, Brownie, is wearing a feather headdress in typical Red Men style. At the bottom of the photo is a selection of clubs, knives, and tomahawks that were used in Red Men rituals. The banners, badges and regalia were also used in Red Men activities.

White People Dressed as Indians: Photos and Postcards

Collecting old photos showing Indians wearing their native clothing has been popular for many years. Today these old photos can sell for hundreds and even thousands of dollars. I myself am guilty of collecting them, but luckily, I started many years ago when a few dollars would purchase the very best. Recently, while searching for something new and still affordable to collect, I discovered old photos of white people wearing Indian costumes. Why not, I thought? It makes just as much sense as a collection of photos showing Indians wearing their outfits.

At first, I was drawn to the many photos of children wearing Indian clothing. These are often found in one-of-a-kind postcards. As I look at them I try to imagine what these children were thinking and feeling while dressed in their costumes and it seems apparent to me that they were proud and excited to be portraying themselves as a member of the Indian race. Some people say that the wearing of Indian costumes by non-Indians is degrading to Indians. I find it to be quite the contrary. Most photos demonstrate an enormous admiration for Indians, especially by the small children. After all, what could be more complimentary then trying to look like the people you admire?

As you can see from the examples I've chosen from my collection, it doesn't take long till you progress from photos of children to many other subjects. Behind it all is that big question of how the wearing of Indian clothing by non-Indians might have influenced and changed our understanding of the Indian culture.

Photo postcards of white people dressed as Indians usually sell for less than $20.00. Photos seldom bring more than $50.00.

Postcard of little girl aiming pistol. Est. 10-20

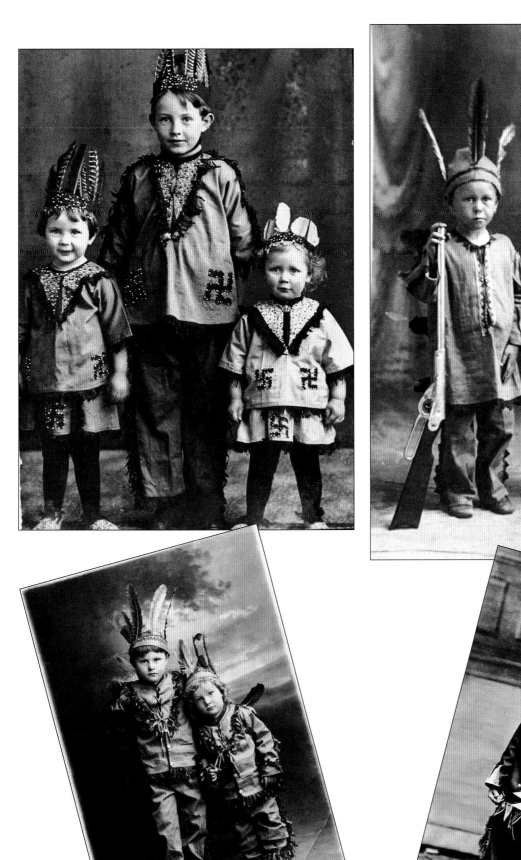

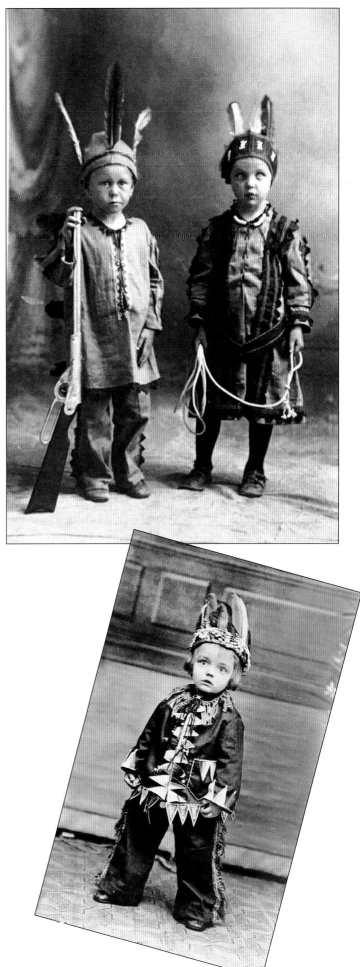

Postcard with "Bob and Dick Whitton" written on back. Est. 10-20

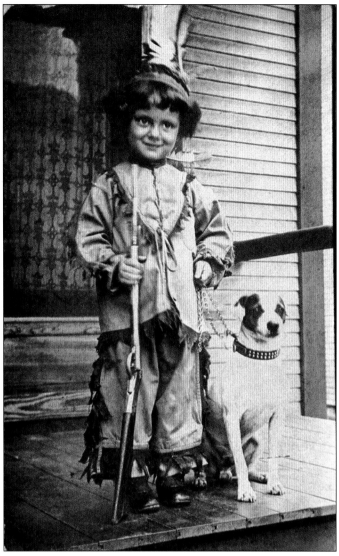

Postmarked 1910 from Columbus, Ohio with "From Norman to Grandma" written on back. Est.15-25

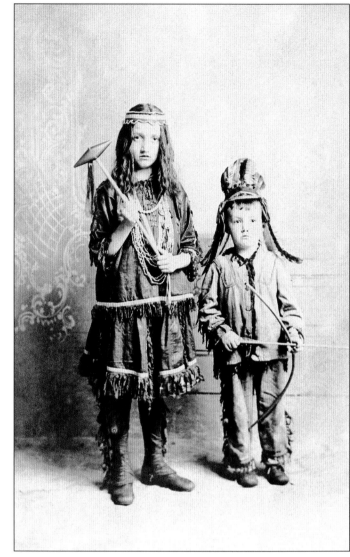

Postcard with girl holding a real stone headed Indian war club. Est. 25-35

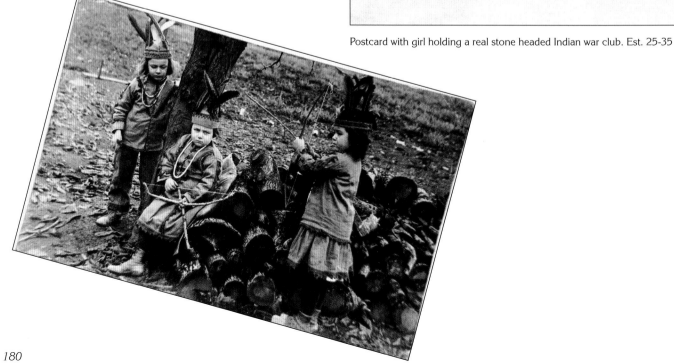

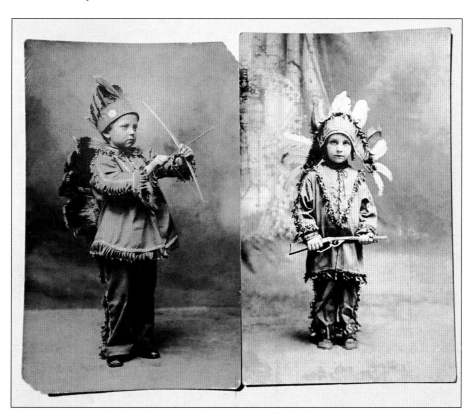

Photo of boy in pedal car holding onto his headdress as he speeds along. Est. 15-25

Card on right is Donald J. Fox with his hobby horse. Est. 20-30

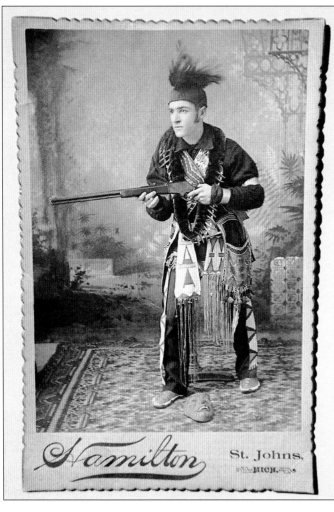

Photo of young fellow with sideburns, wearing many original examples of Indian beadwork. Notice the grizzly bear claw necklace, two Chippewa bandoliers on his shoulders, fantastic pipe tomahawk drop in front (there is probably a tomahawk stuck in his belt but we can't see it), mirror bag pouch on his belt, quilled and beaded moccasins, etc. Of special interest is the hand painted wire gauze Indian face mask lying on the floor in front of his feet. These masks are listed for sale in most Improved Order of Red Men costume catalogs. Photo is 4.25" x 6.5" and by Hamilton of St. Johns, Michigan. Even though the photo is damaged its estimate would be $75-$150

Large (11" x 14" cardstock) photo of a group of white people dressed as Indians and wearing many authentic Indian items. The use of face paint, funky headdresses, tomahawks, and the made-up tipis could link this group to the Improved Order of Red Men. Photographer is Jas. Makery of Duluth. Est. 150-300

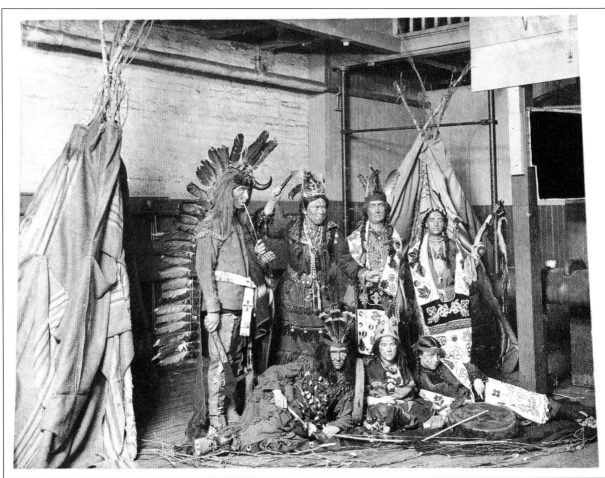

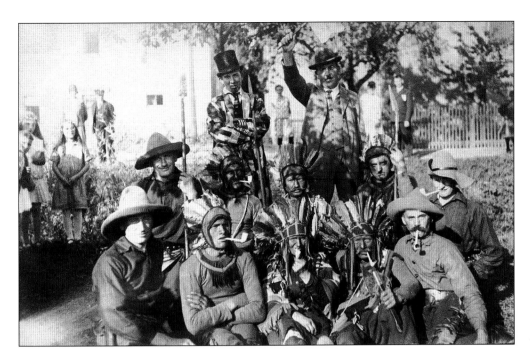

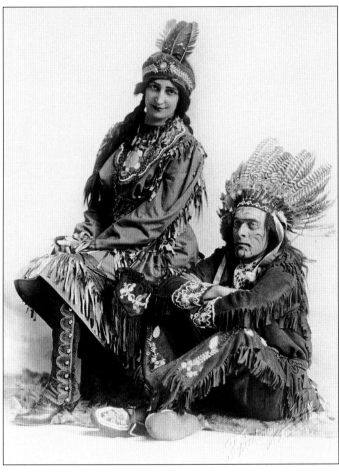

Photo of handsome unidentified couple wearing Red Men style costumes. The man is wearing Iroquois moccasins. Est. 25-50

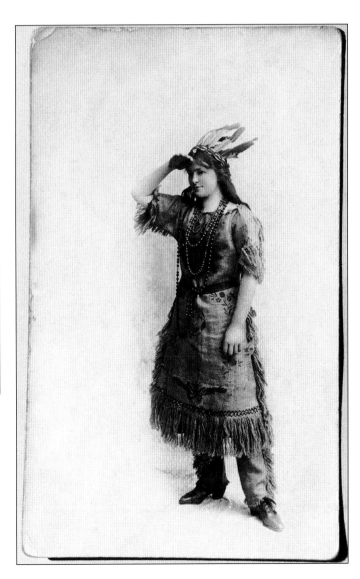

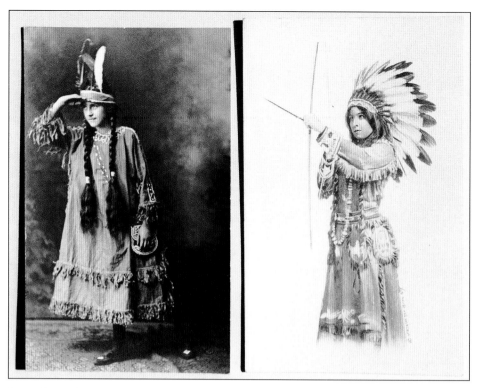

Postcard on right published by *Schlesinger Bros.* of New York. Est. 15-25

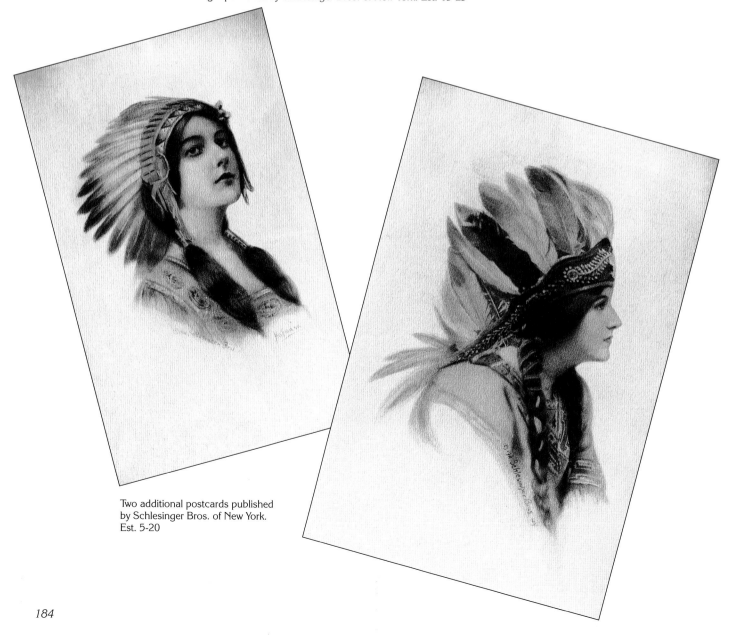

Two additional postcards published
by Schlesinger Bros. of New York.
Est. 5-20

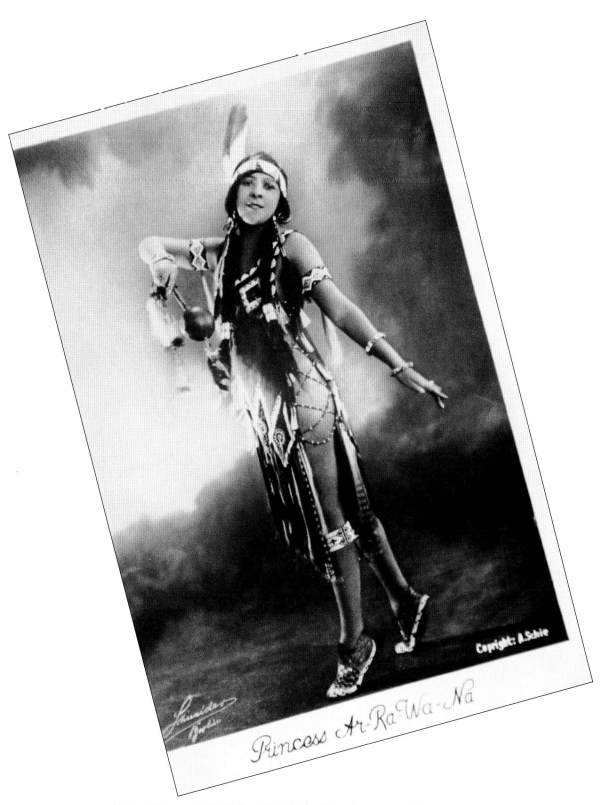

Photo of Princess Ar-Ra-Wa-Na, © C.A. Schire. The princess wrote this message on the back in 1927. "Pleasant memories of your kind interest while in Wisbaden. Hoping we meet in Berlin." She is wearing a nice pair of Sioux Indian moccasins, but little else! Of course I'm just kidding. Nice outfit! Est. 55-85

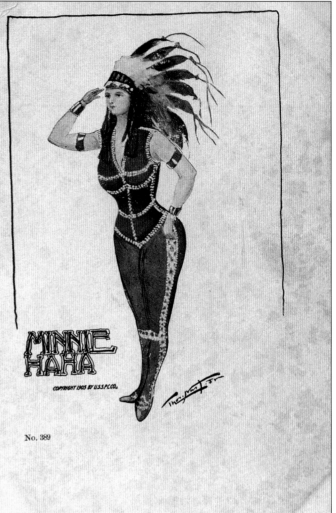

Minnie HaHa postcard, c.1905 by
USSPC CO. Drawing by Thos. Mast
Jr. Est. 5-15

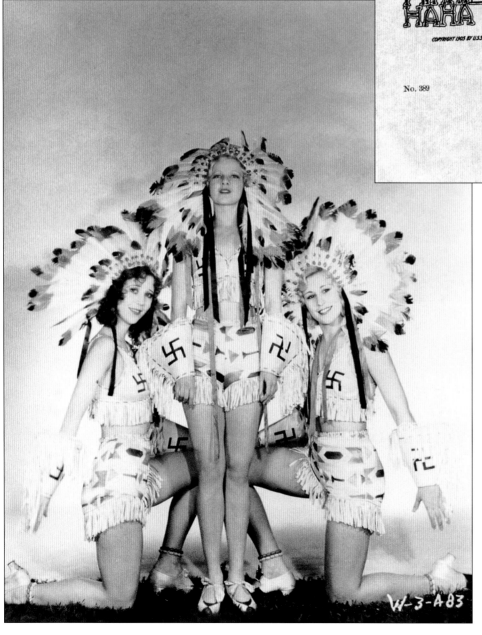

Photo of tap dancers dressed
Indian style in the 1930s. Est.
15-30

Indian-Theme Sheet Music

These last few photos show a collection of colorful sheet music covers from songs with Indian themes. These are from the early 20th century when you could go to the music section in the five and dime store and have the piano player demonstrate the music you were about to purchase. Sheet music can be had for less than $20.00. Prices depend on condition and graphics. Sometimes an interesting title will cause the price to be higher. Of course, the final price will be decided by the buyer. Some examples will be more interesting to you than others.

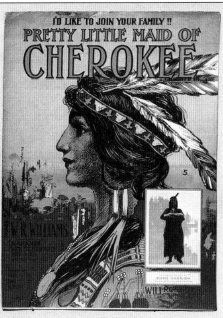
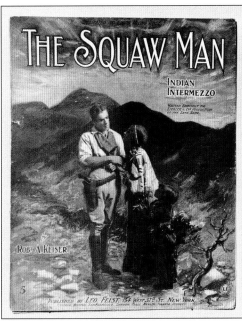
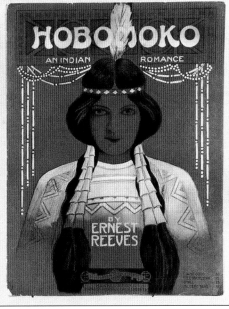
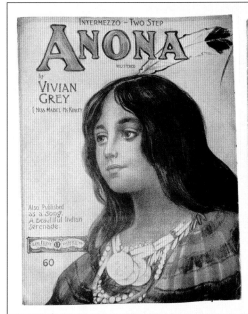
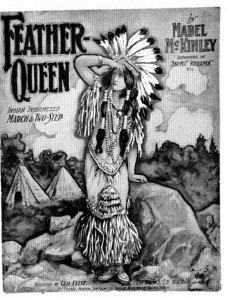

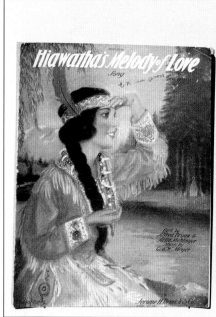

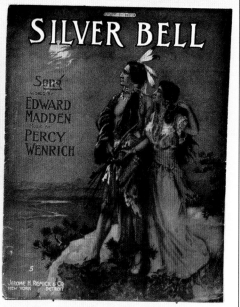

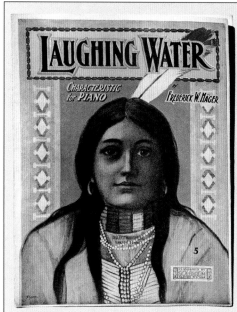

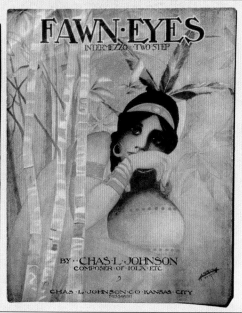

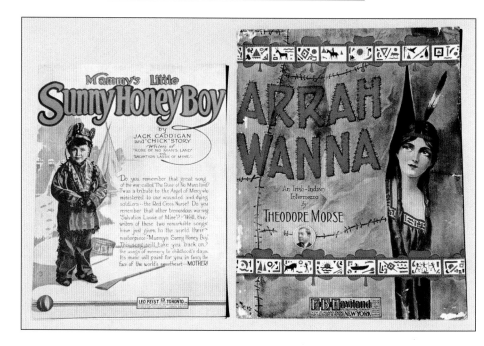

The Tuckahoe Indian Dancers

Beginning in the early 20th century, the Boy Scouts of America based many of their activities on the culture of the American Indian. The Order of the Arrow is a national honorary society to which qualified Boy Scouts are elected. During the early to mid 20th century, many O. A. lodges had groups of young men who performed dances and induction ceremonies. The Tuckahoe Indian Dancers were organized By Jennings B. Koller and his son William about 1945. This group of young men was composed of members of Tuckahoe Lodge #386 of the Order of the Arrow, from York and Adams counties, Pennsylvania. They became quite expert at making Indian outfits and performing their dances. In 1954, they traveled to the O. A. National Convention in Laramie, Wyoming, where they won the first place trophy for being the best Indian dance team in the Order of the Arrow. The Tuckahoe Dancers appeared before club organizations, conventions, schools, PTA fund raising projects, picnics, carnivals, fairs, and on television. The author was a member of this group. This quote is from their program:

These young men have made their own costumes, which are authentic reproductions of those used by the American Indian. They have practiced the dances, and studied the chants of the Indian in order to achieve skill in their interpretation, in the hope that with each presentation there may come a better understanding and a fuller realization of the wealth to be found in the lore of the *First American,* the Indian.

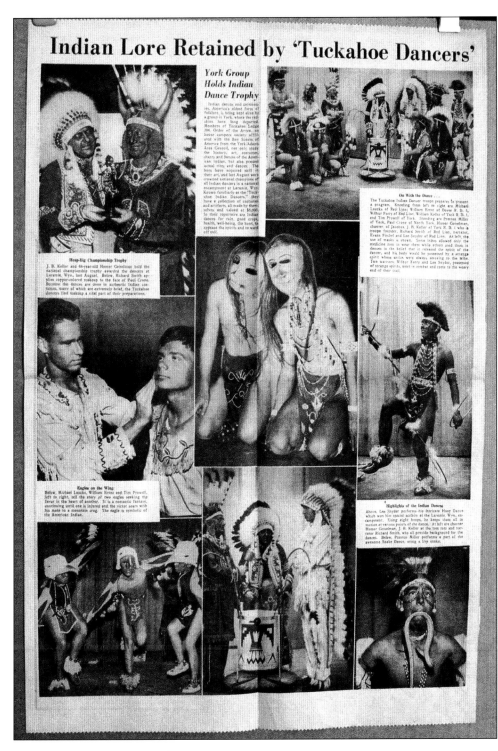

On Nov 21, 1954, this full page story was printed in *The Sunday Patriot News* of Harrisburg, Pa.

The following collection of photos was taken by the Shadle Photography Studio, 58 Beaver St., York, Pa. in 1954.

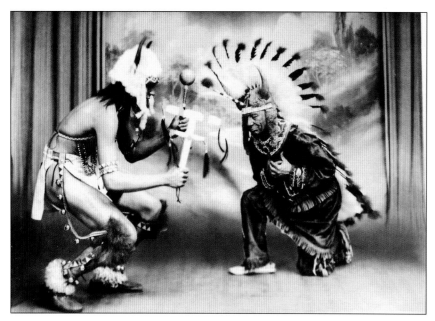

The Death of Red Dog, starring 68-year-old Homer Geiselman.

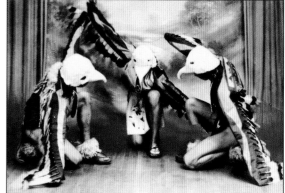

Eagle Dance. "Here we see two eagles seeking favor in the heart of another."

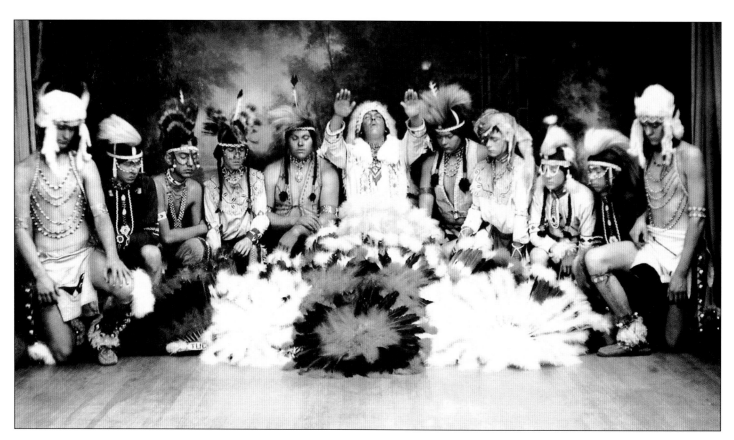

In the final scene of the Death of Red Dog, the dancers have covered his body with their feathered costumes. The author is the third dancer from the left.

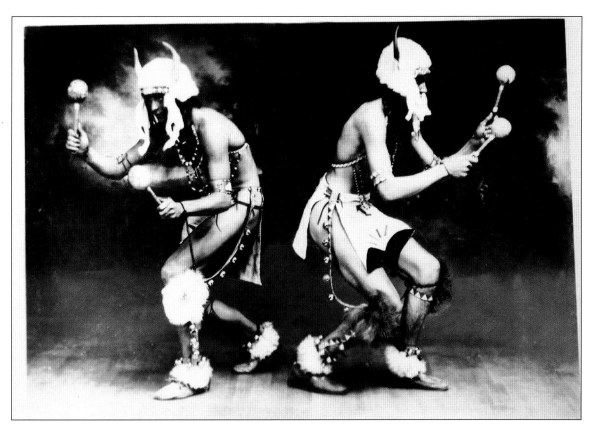

Rattle Dance. "This is not a story dance but one of skill, both
in the handling of the rattles and in the dance steps."

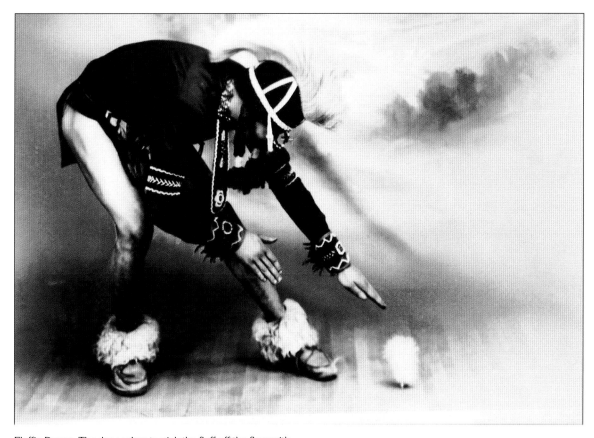

Fluffie Dance. The dancer has to pick the fluff off the floor with
his mouth while not touching the floor with his hands.

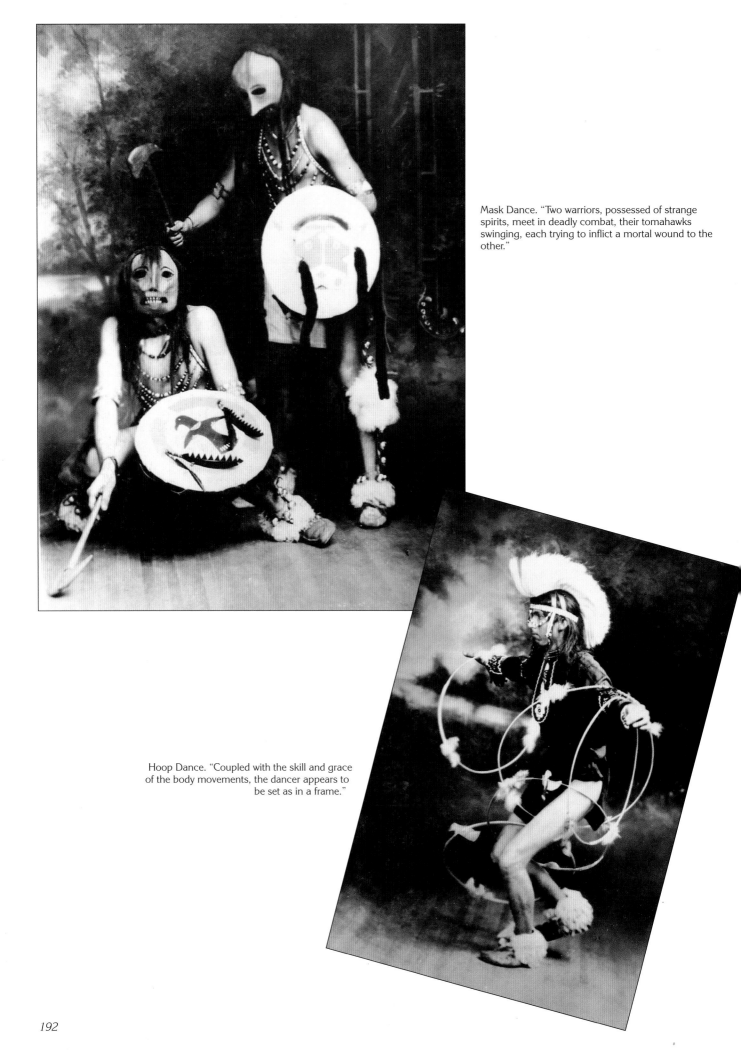

Mask Dance. "Two warriors, possessed of strange spirits, meet in deadly combat, their tomahawks swinging, each trying to inflict a mortal wound to the other."

Hoop Dance. "Coupled with the skill and grace of the body movements, the dancer appears to be set as in a frame."